*The Best of* **LCD**:

## THE ART AND WRITING OF WFMU

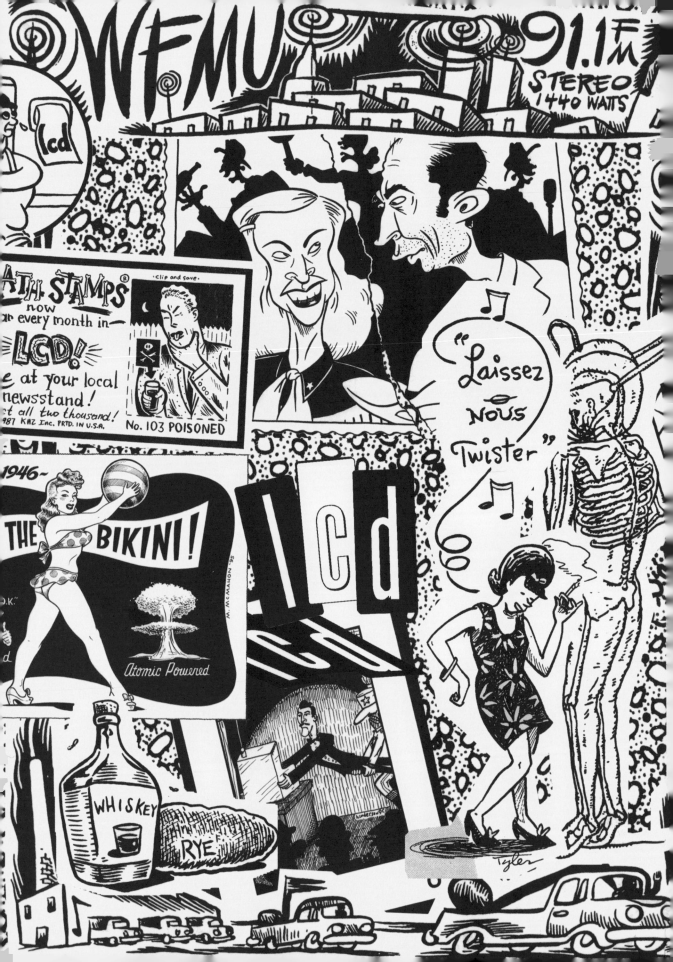

# *The Best of* **LCD:**
## THE ART AND WRITING OF WFMU

Dave the Spazz, editor
Preface by Jim Jarmusch
Introduction by Ken Freedman

Princeton Architectural Press

Published by Princeton Architectural Press
37 East Seventh Street
New York, New York 10003

For a free catalog of books, call 1.800.722.6657.
Visit our website at www.papress.com.

Editor: Linda Lee
Acquisitions Editor: Clare Jacobsen
Designer: Lissi Erwin/Splendid Corp.

Special thanks to: Nettie Aljian, Sara Bader,
Dorothy Ball, Nicola Bednarek, Janet Behning,
Becca Casbon, Penny (Yuen Pik) Chu, Russell
Fernandez, Pete Fitzpatrick, Wendy Fuller,
Jan Haux, John King, Nancy Eklund Later,
Laurie Manfra, Katharine Myers, Lauren
Nelson Packard, Jennifer Thompson, Arnoud
Verhaeghe, Paul Wagner, Joseph Weston, and
Deb Wood of Princeton Architectural Press
—Kevin C. Lippert, publisher

Library of Congress Cataloging-in-Publication
Data

The best of LCD : the art and writing of
WFMU / Dave the Spazz, editor ; preface by
Jim Jarmusch ; introduction by Ken Freedman.
— 1st ed.
     p. cm.
  ISBN-13: 978-1-56898-715-6 (pbk. : alk. paper)
  1.  Disc jockeys—Anecdotes. 2.  Musical
criticism. 3.  Popular music—United States—
History and criticism. 4.  Radio broadcasting—
United States—History. 5.  WFMU (Radio
station : Montclair, N.J.) I. Spazz, Dave the.
II. LCD (Montclair, N.J.)
  ML406.B47 2008
  781.640973—dc22

                              2007008666

## Acknowledgments

Many thanks to anyone and everyone who has ever been involved with WFMU and *LCD*. Special thanks to Alison Harvey for her patience and fortitude in entering text and copyediting this material. Thanks also to Amanda Thackary, Victoria Luther, Masayo Sato, Keith Beardon, Rex Doane, Miriam Linna, Dave Cunningham, Justina Davies, Irwin Chusid, and Hank Arakelian for their invaluable assistance.

You wouldn't believe what **WFMU** 91.1 FM can do to a glass of milk!

EXTRA CALCIUM
MORE VITAMINS
IRON
PROTEIN
DELICIOUS FLAVOR
CARBO-HYDRATES

STUDIO: 201-200-9368
OFFICE: 201-521-1416

SUMMER 1986 DJ SCHEDULE

| Thorsday | Phryday | Saturnday | Sunray |
|---|---|---|---|

**Thorsday**

...pot for people on the go!!

**KEN FREEDMAN**
...sical and ...eological bombast ...om people who ...ould have known ...tter.

**Yvonne** Music with a splattering of radio.

**Russ Layne**
...azz with a splattering of calypso and salsa.

...6:30 Alan Watts Lecture ...es—"If a tree falls in ...forest" radio.

...—9 **Pat Duncan** ...o songs in two and ... half hours. 1-2-3-4!

Mid. Yer 'Ol Pal **IRWIN** ...adio As Radio. ...trocious Music at 10.

...d.-3 **Stan** New Kid in the Candy store.

**Phryday**

9-11 Hypnagogic radio with **Ken**

11-1 Accent on PERCUSSION with **Montego Joe**

1-4 **Kaz** Eclectic with an Anvil.

4-6 **Jeff Claus** Spurious and veritable realms of tempestuous rhythmic aberrations.

6-6:30 **LOW-FI** Home Tape Showcase

6:30-9 **Bill Berger,** yer plastic teen idol/idle. Wacky Germans, Swedes, etc. People on drugs

9-Mid. **Sister Krys** (see Monday at Midnite)

Mid.-3 **Paul Cavanagh** NOT JUST HARDCORE

3-7 Club **Leila** ♣ the only spot in New Jersey to hear bands after 3 A.M. ♣

**Saturnday**

**George**

7-12 **David and Goliath Show w/** George Flores. Radical Christian rock and contemporary ministry.

12-3 **Steve Dondershine** The quiet side of new music, world folk, jazz and ethnic percussion.

3-6 **Radio Hound** Vintage R+B, Gospel, Hillbilly, Rock and Roll, occasional live music.

6-9 **Laurie Es.** Sitcom death chants to make mush of your morals.

9-12 drunken brawl music

Mid.-4 **Ray Franks** Traditional to avant funk.

4-8 **FABIO** Nocturnal emissions: Music for mind and booty.

**Sunray**

8-11 Reggae Schoolroom with **Jeff Sarge** the entire scope of reggae music.

11-2 THE **PATRICK SMITH** SHOW Danceable reggae, lovers rock and soca.

2-5 **Bill Kelly** Mindless teenage brain rot. 60's & 80's garage rock.

5-8 **John Schnall** Phantom B-movie dialogue at 7 p.m.

8-9 Modernistic Radio Hour—A review of this fabulous century with **Professor Arwulf Arwulf.**

9-Mid. The Big Shot Review! musicians and musicoids get their chance to be a freeform DJ for the night. A different visiting luminary every week.

Mid.-3 Radio Living Room. The world, you and me.

**The Immigrant**

# PESKY SPACE ALIENS
## A TRUE STORY
by Jim Ryan

Like many people abducted by space aliens, I have experienced the phenomenon of "missing time." I find myself "Late for appointments" with only the vaguest idea of where I've been.

Aliens usually take me up in their spaceships where they perform tests on me. Maybe they're tests—maybe just sick kicks! It will all come out under hypnosis.

MY NAME IS ELMER J. FUDD. I OWN A MANSION AND A YACHT.

Brain Probe

YO! HOW TALL ARE YOU??

But they're crafty buggers. They invent plausible "cover memories" to explain the "missing time."

USED BOOKS

## WHAT I HAVE LEARNED:

- They are not called "Space Aliens" at all, but "Space Allens," since they're all named "Allen!"
- They are more technologically advanced than us, but still fear us because we're taller than them.
- They don't mind at all if we poison our Earth and blow ourselves up, as long as they get to watch.

But the *really* lousy thing is—all those brain probes they did left me without any decent cartoon ideas!

# TALES OF GREAT RECEPTION!

I used to listen to WFMU at work in my CUBICLE

...THE SIGNAL WAS WEAK EVEN THOUGH MY OFFICE WAS TWENTY STORIES UP

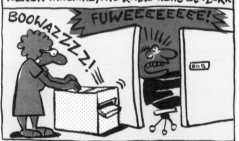

....BUT WHEN SOMEONE USED THE OLD XEROX MACHINE, THE RADIO WENT BERZERK

BOOWAZZZZ!

FUWEEEEEEEE!

BOB

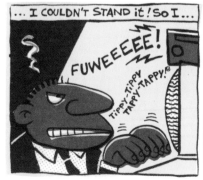

... I COULDN'T STAND IT! SO I...

FUWEEEEE!

TIPPY-TIPPY TAPPY-TAPPY!

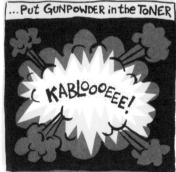

...PUT GUNPOWDER in the TONER

KABLOOOEEE!

...AND I'M NOW IN RAHWAY AND I GET WFMU ALL DAY LOUD AND CLEAR!

weiner

SEND YOUR RECEPTION TIPS TO L.C.D.!

# Table Of Contents

# Table Of **Contents**

*by Jim Jarmusch*

# "THIS IS A PUBLIC SERVICE ANNOUNCEMENT—WITH GUITARS!"—THE CLASH
*"Know Your Rights"*

I've been an avid WFMU listener for many years now. When I'm in New York, I just leave my radio on and set to 91.1 FM. Even when I go out, I leave the radio on just to see how the landscape will have changed when I come back in. It seems at any hour of the day or night something interesting will be floating out of my radio; I need the input.

I became completely addicted to WFMU back in the days of *The Hound Show*— my favorite radio show ever! ("Gimmie a bottle a that red soda water and put some nakkins in a sack!") I also fiendishly followed WILD GIRL and Chris T. Other personal favorites have included, DOWNTOWN SOULVILLE, MR. FINE WINE, RADIO THRIFT SHOP, AUDIO KITCHEN, THE ANTIQUE PHONOGRAPH HOUR, TEENAGE WASTE-LAND, LONDON UNDERGROUND, THE REGGAE SCHOOLROOM, plus lectures by Alan Watts, and Joe Frank's ongoing Work in Progress.

Hands down, WFMU is the greatest radio station on the planet. First, because of the content: an endless river of amazing music from everywhere and DJs with unusual taste and ideas that actively confront and counteract the mainstream mind-rot. And second, no commercials, no playlists, and no evil corporate overlords. It's freeform in the best sense and 100 percent listener supported. WFMU celebrates the imagination and reclaims the gifts of expression often left lying around in the attics, basements, and ditches of our force-fed culture. But I guess if you're looking at this book, you probably already appreciate that...

So, what you're holding in your hands is the ultimate collection of material drawn from the station's ongoing series of program guides: *LCD* ("lowest common denominator"). Unfortunately, the guide hasn't been in print for some years now, but this volume comprises a catalog of artwork and writing from some of our current cultural icons, many of whom I consider to be great personal inspirations. Among them are Joe Coleman, Luc Sante, Nick Tosches, Daniel Clowes, Harvey Pekar, Jim Woodring, Daniel Johnston, Charles Burns, Josh and Drew Friedman, Coop, Kaz, Carol Lay, Rodney Alan Greenblat, and Miriam Linna. And that's not even the half of it! It's like a pirate's treasure chest for your mind.

So keep your damn radio on and set to 91.1 FM and just let the river wash over you. And remember some more wise words from Joe Strummer:

# "NO INPUT MEANS NO OUTPUT!"

# WFMU Catalog of Curiosities

1995
End Times
Edition

CD'
Book
Video
Com

Conspirin' about Waco!    Meditatin' with Shemp!
Rockin' GI's and Postal Workers!    Travelin' the Cosmos
with Joe Meek!    Fifty new Items!

# Introduction

*by Ken Freedman*

I was driving home through New Jersey's industrial wasteland, listening to DJ Bronwyn C doing her weekly feature, *News of the Dead*, when she said, "Every time a cartoonist dies, a star falls out of heaven." I don't recall which cartoonist bit the dust that week or what hole in the heavens was created as a result. This was sometime in the late eighties, when WFMU's audiovisual love affair with the world of underground cartoonists and illustrators was at its height, and it wasn't unusual to hear references to the cartoon world on the air, or to hear weekly radio shows by the likes of Kaz, or interviews with people like Gary Panter or Drew Friedman.

From 1986 to 1998, we published a magazine that thought it was a radio-station program guide, *LCD (Lowest Common Denominator)*. You're now holding the cream of the crop of those years, plus the fruits of other WFMU projects that relied on the generosity of illustrators, who donated their time and work to the radio station that was for many of them their constant studio companion.

Why are cartoonists, artists, and illustrators drawn to the radio, and specifically to WFMU? In the predigital age, I imagine that changing a cassette tape every ninety minutes was prohibitively difficult if one's hands were occupied with a project or coated with ink and wax or the other graphic materials of that bygone age. But multidisk CD players and then iPods smashed that theory to bits.

Newer music technologies have made it clear that radio is more than music, it's a companion, and a sometimes maddeningly eclectic station like WFMU is the kind of provocative, unpredictable companion that many cartoonists wanted to spend their days with. It's sometimes hard for me to remember this, having devoted my life to WFMU and working there full time—I have to turn the station off several times a day, sometimes lunging violently for the volume knob. I've often said that it's the people who never turn the station off that I really worry about.

But fortunately that's left a lot of people to worry about—the misfits and malcontents, artists and weirdos, who make up the community we sometimes refer to as an audience. This book represents a small part of the creative contributions that our audience has given back to us.

When we started publishing *LCD* in 1986, we solicited on the air for cartoons, articles, poetry, and the submissions quickly started pouring in. My favorite part of the day was opening the *LCD* mail. One day I opened an envelope containing black-and-white ink drawings of that most blighted segment of the New Jersey Turnpike—the mile or two of

refineries and flaming towers between exits 12 and 13 in Linden. I had always found this area strangely compelling and beautiful—even as I held my breath whenever I passed through it—and here was an illustration that captured this area in all its noisome glory. The illustration was by Burton Schlatter, who became my good friend and the heart and soul of *LCD* for most of its twelve-year run. After I passed on editorial control of *LCD*, Burt remained its art director and spiritual master, working with one editor after another as they all realized the limitations of working full-time on a publication without pay. Sadly, Burt passed away in 1999 from a life-long heart condition. This book would never have existed without his tireless inspiration, enthusiasm, and humor.

Along the way Burt worked with a number of volunteer editors who all devoted themselves to WFMU and *LCD* at the expense of their personal loves and careers, people like Rex Doane, Keith Bearden, Dave the Spazz, Peter Lucas, and our current art guru, Dave Cunningham. Burt also worked on other WFMU art projects over the years, usually to help raise money for the station and keep us from ever having to turn to The Man for support. The most ambitious of these projects was The Crackpots and Visionaries Trading Cards, which were overseen and brought to realization by Hank Arakelian.

I'm grateful to all these people for devoting their most precious asset, their time, to WFMU, and especially to Dave the Spazz for pulling all of this material together in a volume that bestows an incongruous credibility to the nonsense that we do. But I'm most grateful for working with an "audience" that gives back far more than it receives.

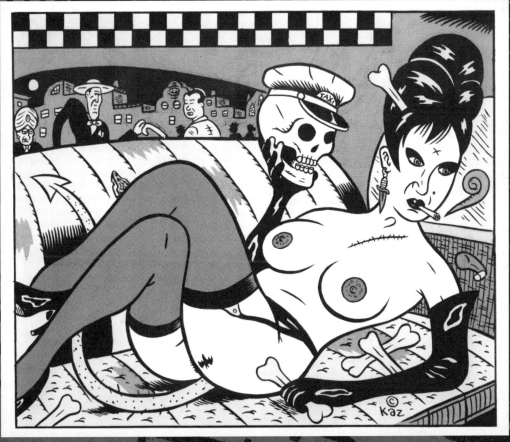

**June 9, 1934**
Maj. Edwin Armstrong's first test of FM from the roof of the Empire State Building. Despite sensational results, David Sarnoff/RCA and World War II manage to keep FM under wraps until war's end.

**July 1, 1965**
FCC "prohibits" FM stations from simulcasting more than fifty percent of programming of parent AM affiliates, paving way for FM rock radio (effectively enforced 1/1/67).

**July 6, 1965**
WBAI staff walks out in dispute over News Department censorship; programming void filled by Steve Post, Larry Josephson, and Bob Fass, who usher in WBAI's golden age of freeform (1965–1972).

**November 20, 1965**
Steve Post's fabled program *The Outside* debuts on WBAI.

**March 18, 1968**
Tom Donahue and KMPX air staff go on strike; staff soon moves over to KSAN.

**May 31, 1968**
First WFMU marathon, Memorial Day weekend. Goal: $3,000 needed to stay on the air full-time through the summer.

**Sometime in 1863**
First rumored use of wireless transmission during Civil War by Union troops transmitting Morse code from a hot-air balloon to a ground station. This claim has never been substantiated.

**April 24, 1958**
WFMU's first ever broadcast. Nothing is known about it. For its first ten years, WFMU serves Upsala College students, broadcasting lectures, Lutheran services, classical music, jazz, and international music.

| 1863 | 1892 | 1934 | 1958 | 1962 | 1963 | 1965 | 1966 | 1967 | 1968 | 1969 | 1971 |
|------|------|------|------|------|------|------|------|------|------|------|------|

**Sometime in 1892**
Rainey T. Wells becomes first radio listener when friend Nathan Stubblefield of Murray, KY, transmits words "Hello Rainey" through the air via mysterious "black box." In the subsequent days and years, many others witness Stubblefield's radio

**November 9, 1963**
The first fundraising "marathon" on non-commercial radio (or TV, for that matter) on Lorenzo Milam's KRAB. The goal was $1,000 in 42 hours. They made it. Milam felt sullied afterwards, for he knew what was to become of his concept. Prior to this marathon, Pacifica stations (and KRAB) had raised money through low level, year-round membership announcements.

**April 7, 1967**
Tom Donahue begins progressive programming on KMPX, San Francisco, declaring, "no jingles, no talkovers, no time and temp, no pop singles," initiating underground commercial rock radio.

**October 21, 1967**
WOR-FM drops freeform; Scott Muni and other progressive DJs bolt for WNEW-FM.

**November 4, 1967**
First WFMU freeform show, Vin Scelsa's *The Closet*, debuts midnight–6am.

**Feb 27, 1962**
Lou "The Duck" D'Antonio begins broadcasting on WFMU. (He retired from WFMU in 1990.)

**May 1962**
FCC ponders congestion on AM dial, conceives of FM non-duplication rule to force FM stations to cease mere transmission of AM sister stations.

**July 1962**
WFMU applies to FCC to increase power from 10 to 1,440 watts, and the increase goes into effect in 1965, giving little WFMU what the FCC calls "Class A" radio coverage of NYC. RCA engineers transcribe erroneous government figure re: terrain measurements in WFMU power boost application, triggering four-year "Border Skirmish" beginning 1989.

**July 30, 1966**
WOR-FM (NY), blaring The Troggs' "Wild Thing," becomes first US "progressive rock" outlet; "countercultural" programming pre-recorded for first three months; format lasts one year.

**April 28, 1969**
Columbia Records adopts hippie-bait marketing ploy: "The Man Can't Bust Our Music," printed on LP inner labels; one week later, label releases first LP by Chicago.

**August 31, 1969**
Fearing Upsala College takeover and feeling general disgust with demise of counterculture, Vin Scelsa signs off as WFMU staff shuts down station. Upsala keeps station dark for ten months. Lou D'Antonio keeps freeform flame burning when station resumes broadcasts.

**November 7, 1969**
"Old Yellow," former WFMU house on Upsala campus, demolished and replaced with parking lot, sealing staff time capsule under asphalt.

*Actual '60s WFMU staffer Terry Lapham*

**May 8, 1971**
Under legal pressure from "The Man," Columbia Records quietly replaces slogan "The Man Can't Bust Our Music" with new motto: "The Revolutionaries are on Columbia."

**August 26, 1971**
ABC's flagship "progressive" station, WPLJ (NY), imposes playlist, taking programming control permanently out of DJs' hands.

**February 23, 2004**
WFMU launches JM24, a second channel of full-time Jewish programming which streams 24/6 over the internet.

**August 25, 1985**
Ken Freedman begins pro-freeform, pro-FMU-independence stint as WFMU Station Manager.

**May 30, 1995**
Upsala College closes, declaring bankruptcy. WFMU is the only part of the college to escape the bankruptcy court's auction block.

**1976–on**
More and more DJs adopt free-form, as Chusid and D'Antonio lead by example and strength of their programming.

**September 1992**
The FCC rules in WFMU's favor, saying that WFMU can keep its power, but it needs to reconfigure its transmission pattern.

**August 29, 1998**
WFMU begins broadcasting from its own building on Montgomery Street in Jersey City.

**1975  1976  1985  1989  1992  1994  1995  1996  1997  1998  2001  2004  2005**

**February 1975**
No-account geezer Irwin Chusid hosts his first show (midnight–2am) on AOR-leaning WFMU, suspended two weeks later for overtly promoting freeform.

**June 1994**
WFMU becomes legally independent of Upsala College but agrees to remain located on campus.

**January 1, 2001**
All WFMU programs are archived for on-demand listening over the internet.

**April 1989**
Four mainstream public stations try to use RCA's 1962 error as a pretext for lowering WFMU's power and raising their own. Litigation lasts three years and costs over $400,000, with one dozen listener-lawyers working for free. WFMU's fundraising capability triples in one year.

**April 1996**
WFMU quadruples its coverage area into New York State's Hudson Valley with addition of 90.1 FM frequency.

**May 29, 2001**
Glen Jones broadcasts non-stop for 100 hours, breaking the Guinness World's Record for longest non-stop radio broadcast.

**September 24, 1989**
WFMU relocates from basement of an Upsala Dormitory into renovated digs at 580 Springdale Avenue (the "Avatar" house).

**June 6, 1997**
WFMU begins broadcasting worldwide on internet.

**September 4, 1997**
WFMU closes on purchase of its new Jersey City home.

**September 11, 2001**
As the World Trade Center collapses, passersby across the river in Jersey City take refuge in WFMU's basement.

SAVE
**WFMU**
UPSALA COLLEGE
E. ORANGE
N.J.

**February 7, 2005**
WFMU gets back into the world of publishing with *Beware of the Blog*.
**blog.wfmu.org**

# Freeform
# Timeline

*1975: New antenna hung*

*by Ken Freedman*

**5**

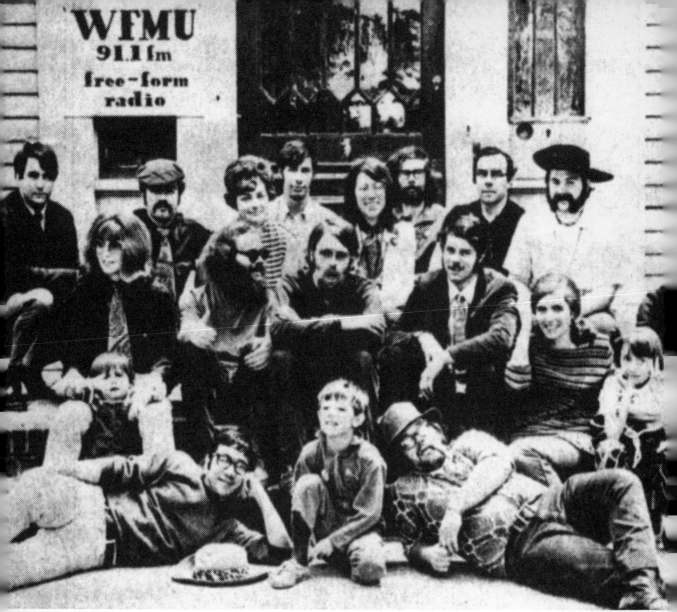

The WFMU Staff in 1969

# A Brief History of Freeform Radio

*by Ken Freedman*

WFMU didn't invent freeform radio, but it has sustained freeform far longer than any other station. The first freeform programs were broadcast on KPFA (in 1949), followed in the early '60s with KRAB and WBAI. In the late '60s there was a nationwide explosion of commercial freeform stations, but most didn't last more than a few years. WFMU has been the only one of the early freeform stations to survive into the present day, with its philosophy and (lack of) format intact.

KPFA-FM in Berkeley was the first "community" or "public" station in the country. Visionary and pacifist Lewis Hill founded KPFA and Pacifica, advocating a station dedicated to free expression that offered access to the airwaves for radical cultural and political ideas. Hill believed that a station could be truly free only if it raised its money from the people who were listening to it. He scrapped plans to support KPFA commercially and began broadcasting low-key solicitations of charitable contributions.

John Leonard was producing collages of music, poetry and satire on his program *Nightsounds* on KPFA shortly after the station signed on in 1949. Hill's ideas, and Leonard's approach, spread to WBAI in New York with Chris Albertson's program *Inside*, and later to the programs of Bob Fass, Steve Post and Larry Josephson, who provided the inspiration to Vin Scelsa, the founder of freeform on WFMU.

Charlie Lundgren with new transmitter, 1969

But no one did more to lay the groundwork for freeform than Lorenzo Milam, a KPFA staffer and disciple of Lew Hill who wanted to take Hill's ideas a few steps further. Milam founded KRAB in Seattle in 1962, heralding an approach he called "Free Forum." Although the early KRAB was somewhat rigid in its approach, Milam loosened up and went on to be the founder of thirty other stations (known at the time as the "KRAB Nebula") in the West, South and Midwest. Milam quit radio when he saw most of his stations descend into internal bickering and identity-based politics and programming.

By the time Vin Scelsa and his cohorts had taken over WFMU by mid-1968, the term "free forum" had segued into "freeform." On WFMU, as on WBAI at the time, this meant a type of radio that encompassed not only eclectic music, collage and satire, but also an intimate, live interaction with the listening audience. WFMU has remained dedicated to this approach for nearly thirty years, losing its way briefly in the '70s following a 1969 staff walkout and Upsala College's subsequent ten-month shutdown of the station.

While the non-commercial strain of freeform radio stretches from the late '40s to the present day, a shorter-lived, commercial version flourished briefly in the late '60s to early '70s. Commercial freeform began on KMPX in San Francisco and WOR-FM in New York. Known at the time as "progressive" or "underground," dozens of such stations emerged around the country as two disparate phenomena came to a head simultaneously. First, the popularization of the counterculture proved a ready market for love beads and fake sitars. Second, the FCC's non-duplication rule, in the works since 1962,

went into full effect between mid-1965 and 1967. The rule prohibited FM stations from merely retransmitting the programming of their AM sister stations. The FM dial had been underdeveloped for decades due to RCA's resistance to the new band and the World War II freeze on new stations. The non-duplication rule forced hundreds of urban FM stations to develop new formats overnight. Many adopted freeform, including WBCN in Boston, WHFS in Baltimore, WXRT in Chicago and WABX in Detroit. Almost all of these stations made a rapid transition to heavily scripted Album-Oriented Rock (AOR) format. Even WFMU aped commercial AOR formats when Upsala College reopened the station in 1970. It took over five years for the freeform idea to bubble back up to the top, and when it did, various musical revolutions (punk, experimental, international) were there to meet it.

Roger Dangerfield reverses polarity, 1969

# NO JUSTICE– NO AIRPLAY!

### by Irwin Chusid

Sister Krys played a track from the Beach Boys' 1967 album *Smiley Smile* late one Monday night. The phone rang. It was some Politically Correct listener who called to Krys's attention that the Beach Boys had played Sun City, and that Mike Love had donated $500,000 to the Parents' Music Resource Center, the anti-smut-in-music lobby (considered by many a pro-censorship task force). "Have you no conscience?" the listener remonstrated. He was indignant. WFMU DJs should set examples. We are taking a stand. Listen up, you puddleful of stinking microbes. Both Dave Brubeck and Benny Goodman have performed in the Soviet Union, the world's pre-eminent totalitarian society. *WE REFUSE* to play either of these Scabs of Oppression on our programs until they apologize or put together an all-star jazz super-session to benefit the Third World. Johnny Cash has played at Folsom Prison. At this notorious institution, inmates are forced to sleep in cells behind bars, and undergo severe "rehabilitation" programs. The food is inedible. The population is subjected to capricious strip searches. *WE REFUSE* to play any Johnny Cash records until all political and non-political prisoners are *FREE!* Cash is a shameless lackey for an unfair and brutal penal system that *OPPRESSES HUMAN DIGNITY*. We're doing some research on other artists who receive airplay on WFMU. We intend to compile dossiers, and accumulate computer data on the conduct, financial contributions, and political affiliations of as many artists as we can in our copious free time. There will hopefully come a day when the only artists featured on WFMU will be those approved by the ACLU, NAACP, NOW, the Mobilization for Survival, the Union of Concerned Scientists, the NJTO, and the Sierra Club. If we have any doubts, we can always check with Dave Marsh, who seems to know more about these matters than any of us.

LENNIE MACE

8

# THE HOUND'S GUIDE TO BUYING RE-ISSUES

*by James Marshall*

Hey Kids, wanna hear Jerry Lee Lewis tell Sam Phillips that he's been possessed by the devil? Rare Louis Jordan radio transcription? Little Richard teaching his band how to play "She Knows How To Rock"? These wonders and many others are all out there, because never before in history has so much bygone popular American music* been available through these newfangled packages called reissues. Yes, what was last week's disposable crap can today serve as an alternative to Bruce Springsteen, or better yet, simply enjoyed as some truly fine music. So how does one weed his way through 13,567 reissues of blues, country, western, swing, gospel, rockabilly, doo-wop, etc., etc.? Like all things in this man's world, it ain't easy, but with these few helpful hints I will at least try to demystify the situation.

**1) DON'T BOTHER READING:** I mean anything by that breed of lowlife known as the "rock critic." For most rock critics, music began with the Beatles, or the New York Dolls. These twerps are the same guys you slapped upside the head for their lunch money in junior high school and they haven't gotten any more likable with age. This is why we are presented time after time with a totally bizarre, oversimplified, and totally revisionist view of the past palmed off as "the history of rock 'n' roll." Rock critics are simply an unpaid wing of the record company promotion world whose job it is to shove the myth of "newness" down your throats. If you must read, stick to books by Nick Tosches and Peter Guralnick, and *Kicks* magazine.

**2) IT'S ALL THE SAME SHIT:** Music is music, so don't get hung up on tags and categories hung on sound like it was God's own packaging label. A great song is a great song, a great voice is a great voice. Almost any genre is made up of 90% crap, so the good stuff is hard to find. You don't have to like it all...and remember—you read it here first.

**3) AVOID RECORD COLLECTORS:** There is a distinct difference between a music lover and a record collector (one who feels he must own a piece of plastic due to its rarity). The latter are truly a frightening bunch, usually overweight, badly dressed, and foul smelling. Take it from me, you don't want to spend much time around these dregs.

**4) FOREIGNERS HAVE FUNNY IDEAS ABOUT AMERICAN CULTURE:** Most reissues of American music come from other countries, especially England, France, and Japan, with Germany, Holland, and Sweden in close pursuit. Don't ask me why. These people filter the experiences of drunk preachers and inbred hillbillies through their own backgrounds (e.g., wearing knickers to school) and come up with some truly odd insights into our own culture. Don't take it too seriously.

**5) GOOD SONGS HAVE GOOD TITLES:** When looking at an album of music you know nothing about, song titles can help—for example: "She's My Witch," "I'm Gonna Murder My Baby," "Mama Keep Your Big Mouth Shut," and "Evil" are all good song titles, and they are all great songs. "I Got The Blues," "Let's Bop," and "I Love You Baby" are less interesting titles, and the performances are much less inspired.

**6) ALL RECORD COMPANIES ARE NOT CREATED EQUAL:** Many record companies (labels) had what you call a sound, a tradition that has all but died off. Sun and Phillips were both good labels, with very different sounds. This may take a while to figure out, but if you're interested, some of my favorite labels are: Chess, Sun, Ace, Savoy, Fortune, Trumpet, Modern/RPM, Atlantic, Specialty, King/Federal, Bullet, Excello, Duke/Peacock, and Capitol.

**7) ETHNOMUSICOLOGY FOR MORONS:** Places with a higher murder or insanity rate usually produced a lot of good music, Memphis and Detroit being two fine examples. Same goes for places with a lot of drunks, like New Orleans and Texas. Eventually you may learn to recognize what gentlemen with beards call "regional styles." For example, black guitar players from Memphis played too loud through broken speakers; this was good. Drummers from New Orleans were usually drunk and fucked up, so if they couldn't find the beat they'd just play a march and call it "second line." Blacks and Italians in New York sang harmony in nonsense syllables; this is called "doo-wop."

You're on your own in this big and funny world, and nobody can tell you what you like. It helps to have friends who think like you, so you can all buy different records and figure out which ones are good and which ones stink. If you can't make friends, try to have lots of money and just buy everything. If you have lots of friends and buy everything this is called the "Billy Miller Method." And someday, God willing, you'll figure out where to find the stuff you really want to hear.

*\* I refuse to use the insane term "roots music." Roots of what? Madonna? Culture Club?*

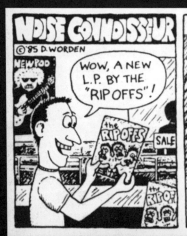
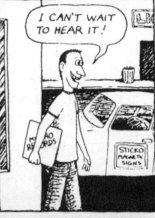
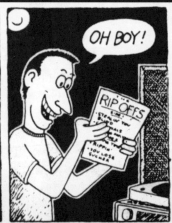
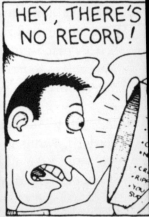

ALEX WALD

DADDY, WHAT DID YOU DO IN THE GREAT CULTURAL WAR?

TULI KUPFERBERG

ALEXANDER ROSS

HONK

HONK

HONK

Ross

## By Bart Plantenga.

To engage in fornication in tandem with Wayne Newton is to flirt with certain metaphysical hazards. That is one conclusion gathered from a recent survey detailing for the first time his Casanova evangelism.

No castrato is he & for 20 years he's been proving this. While Nufond Giant Frogs lay up to 10,000 eggs annually Mr. Newton veritably "lays" 1,500+ humans each year. That's better than 4.1 humans daily, 99% of these unchaste but very necessary liaisons are with women.

It is indeed impossible causes that he champions. This defines his life as a mission. Appointed by God when God spoke to him from a golden spittoon—it is oft claimed—in a lonely Vegas dressing room. He is here to alleviate misery, erase feelings of self-abnegation not only by singing but by allowing his rapt followers to experience hands-on the power & glory of his pelvic evangelism. Faith healing via promiscuity.

Statistics appear to bear out this zealous agenda. Even back in his pre-voice-change days as a regular on the *Merv Griffin Show* he was apparently humbly fulfilling his "duties" without fanfare. He is adamantly opposed to discussing the issue. He likened it to a priest's confidentiality. This reticence did not however extend to his disciples & conjugal partners. They relished recounting tales of bed-dom, horizontal devotion, erectile engorgement & the phenomenon of the "orgasmic platform." 93% spoke of the manifested glory during this phase. Many spoke of invincibility, rekindled lives, bolstered self-esteem, reconstituted faith & joy.

Even considering respondent fabrication & exaggeration the figures are startling. His crusade has touched the lives of thousands of women, making them feel special for an orgasmically spasmodic moment, a moment that will reverberate throughout their inert lives. Lives of woe transformed into ones of hope. Evidence of *joie de vivre* has been corroborated by spouses who have noticed their wives humming or singing "Danke Schoen" at odd times in the day. Few spouses complain because their lives too have been enriched.

Several respondents spoke of reincarnation. One saw her future life. It would be as the cotton crotch of his underwear. Not even the whole pair of undershorts, just the crotch! Now THAT'S devotional humility. Others claim that they were cured of bunions, heartache, psoriasis, chronic halitosis & iron poor blood. He has been credited with saving marriages & preventing suicides.

Most of the men involved—normal-testicled husbands, jealous fiancés & territorial pimps—did NOT feel cuckolded. In fact many spoke of offerings as a tribute to the man & his curative powers. A prowess defamed only by the mortal limitations of man. Many of these spouses claimed experiences of transcendence during the exact moment of transformational bliss, as astral *ménage à trois* with a mega-star via the vortex of the woman's sexual apparatus. Akin, some insist, to the taking of the host or drinking of the wine that is the blood...

Skeptics, though few, adamantly insist that many of his charismatic pop gestures were pilfered from the original King—Elvis. The modern day source of this notion itself goes back to the brash early day of Cassius Clay when he proclaimed himself an evangelical Don Juan.

Skeptics often point specifically to a particular gesture—the wiping of the sweaty forehead with a towel. Elvis made this his latter day signature, often tossing a dozen sweat-bedewed towels into the swooning throng. Much as Veronica's offered handkerchief miraculously preserves the image of Christ.

But now Mr. Newton seems to have done the King one better by introducing stoppered decorator vials of his fermented perspiration potion. Guaranteed to have been scraped with virgin guitar picks from amongst his coveted portly fuselage folds.

THE EVIL

EASTER BUNNY

STEREO

Connie Francis Booze Party!

Be a SOMEBODY

MON TUES WED FAL

WFMU

| MONDAY | TUESDAY | WEDNESDAY | |
|---|---|---|---|
| 6:30 to 9 AM ✡ JEWISH MUSIC IN THE | | | |
| 9AM to 1PM ·Vanilla Bean· Killed off the white stuff, but definitely not blech. | 9AM to 12 Noon Glen Jones Live rituals of de-humanization + Love songs... nothin' but! | 9AM to 12 Noon Ken 29 Melody Hidden within dissonance & vice versa in many styles | ♡ Ale Pick |
| 1 to 4 PM ·KBC· Forgotten soup from the radio. Packrat! | 12 noon to 4PM IRWIN Radio as Radio | 12 Noon to 1PM From the Land of WA: Japanese masters and their music. | Cri sug |
| 4 to 6PM Steve K. Armadillo by the side of the road radio. | 4 to 6 PM Margaret Harris Audacious yet dul-cet, bold yet restra-ined. A strange, heady perfume that will tickle your in-nards or make your head ache. care for a whiff? (yow!) | 1 to 4 PM Bob Rixon Old new thing, non Classical classical, true confessions, Love goddess music! | Reo natir the L |
| 6 to 7PM Solar Sanity with John Downey | | 4 to 6PM Hour of the Duck with LOU | Jazz interv jazz |
| 7PM to 9:30 Synthetic/Pleasure with Richard SPACE MUSIC FOR SPACE HEADS | 6 to 6:30 PM Vigilance w/ Don Langrehr Civil Liberties issues. | 6 to 7PM N.J. Fightback Local and National-al Issues. | L Bac |
| 9:30 to Midnite VAL Bridging the gap from synthesis to SLACK. | 6:30 to 7PM Highways to Health & Wholeness w/Carolyn Thorburn | 7 to 9:30 PM Bob Brainen ROCK-SOUL SOCK-ROUL | P S HH |
| Midnite to 12:30AM "Church of the Sub-genius" Meaty and meaningful! trans-formations from saints to sinners! | 7 to 9:30 PM Terry Moore (political music + other stuff) alternating with Sonny Ochs folk music + other stuff | 9:30 to Midnite →FRANK O'Toole Recipe: take a few tunes sprinkle in some taped fragments, apply my own beat and let simmer. | I (se A |
| 12:30 to 3 AM Sisterkrys Do You Know what noise awakes you... coming from inside your head? | 9:30 to Midnite Jim Price Always a polite time. Good Manners good + friendly. (sic) | Midnite to 3 AM Diane My mother sent my younger sister to pri-vate school after she realized how I turned out | M the |
| 3 to 6:30AM we are off the air! (just listen). | Midnite to 3 AM RAY FRANKS Traditional to avant funk! 3AM to 6:30 AM: NADA! | 3 AM to 6:30 AM DEAD AIR ☒ W/NOBODY! | 3 Yo Fuzz y |

PLASTIC TEEN IDOL

LISTEN & LIVE 4-EVER!

91.1 FM

SLACK!

986 **FRI** **SAT** **SUN**

| FRIDAY | sATURDAY | SUNDAY |
|---|---|---|
| w/ NACHUM SEGAL | **7 AM to Noon** David & the Goliath ✚ Show ✚ w/ George Flores Radical Christian Rock & contemporary ministry. | **6 to 9 AM** Sunday Morning Serenade with → Leila |
| **9 AM to Noon** Steve Dondershine the quiet side of music. World folk, jazz and ethnic percussion. | | |
| **12 noon to 2 PM** "Accent on Percussion" with Montego Joe the big sound of today's and tomorrow's Percussion. | **12 Noon to 3 PM** "WASTED VINYL" w/ ROB : the chance of a lunchtime — radio as it was meant to behave. | **9 AM to Noon** REGGAE SCHOOLROOM w/ Jeff Sarge. |
| **2 to 4 PM** "MONDO" KAZ Sexoloco barbed-wire baby boy droppings. "that little bastard!" | ∥**3 PM to 6 PM**∥ Radio Hound The blues & Coffee Club. | **12 Noon to 2 PM** VANILLA BEAN Third world music, often mispronounced |
| **4 to 6 PM** Jeff Claus Spurious & veritable realms of tempestuous rythmic aberrations. | **6 to 9 PM** Laurie Es. — Sit-Com death, chants to make mush of your morals. | **2 to 5 PM** Bill Kelly A) Teenage wasteland B) Mindless Teen Brain Rot C) Rrreal rock & roll D) Garage rock E) All of the above |
| **6 to 6:30 PM** Thin Air Art: How to be it, How to get it. | **9 to Midnite** John Narucki DRUNKEN BRAWL MUSIC! | |
| **6:30 to 7 PM: LOW-FI** Home taper's showcase **7 to 9:30 PM** ★ Bill Berger P.T.I. Visage/cleavage radio. Jazz new, old acid rock, modern music from other lands. | **Midnite to 3 AM** FABIO Playing those tunes that warm the heart. | **5 to 8 PM** → John Schnall An ironic fist in a poly-styrene glove. |
| **9:30 to Midnite** Sister Krys. (see mon. 12:30 AM) | **3 AM to 6 AM** Cynthia Walton Nocturnal Segues | **8 to 9 PM** "You've got to be Modernistic" w/ Arwulf : Recordings of this century. |
| **Midnite to 3 AM** PAUL CAVANAGH Not Just HARDCORE | Listen to the Phantom of the Movies Video Theatre of the AIR Sundays at 7 PM | **9 PM to Midnite** the Big Shot Review Visiting luminaries illuminated radio rampages. Musical master minds play DJ for a day. |
| **3 AM to 7 AM** LEILA "Shift of the Living Dead!" | give us a Call ⌇ WFMU ⌇ (201) 266-7900 ...we love your voice! | **Mid. to 3 AM:** the Immigrant Radio Livingroom. The world, You, and me. |

ANGE, N.J.

OLD PAL IRWIN

STEPPIN' HIGH

ASHWIN ROOLS'

# CURTAINS FOR US ALL

## BLUEPRINT FOR DISILLUSIONMENT

*by Irwin Chusid*

*IF IGNORANCE IS BLISS, THEN KNOWLEDGE CAN BE THOUGHT OF AS ACQUIRING LIFE'S GREAT DISILLUSIONMENTS. IT STARTS EARLY:*

**First disillusioning experience, age 3:** dirt in the yard does not taste like Nestlé's QUIK, despite the similarity in color and texture. (It took three handfuls to discover this—slow learner.)

**Early in 1959:** George Reeves, the actor portraying Superman on television, shoots himself to death. Any illusions about TV and its verisimilitude to real life were dispelled early on. (A friend confessed to being traumatized at age 4 by seeing Mister Rogers on someone else's TV at their house. She had thought Mister Rogers was her own special friend. She cried, and wrote a letter to the network. She was never the same.)

While I was just a sprite, **I found out that when songs are played on the radio, the singers are not actually in the studio.** Sometimes they are even dead. Furthermore, when you put a dime in the jukebox, the singers are not in the basement of the restaurant, awaiting your selection.

**Around age 7,** I realized that garbage doesn't take itself out. A few years later, I was shocked to find that things flushed down the toilet or washed down the drain do not cease to exist. They go somewhere. We may not have seen the last of them.

**Knowledge of the food chain** was particularly disillusioning. At a tender age, I learned that cats kill birds. Wolves hunt chickens. Big fish eat little fish. (Gosh, it was just like a Warner Bros. Cartoon, only Elmer Fudd was using real bullets on Bugs.) Meat was once alive. A hamburger was an ex-cow. A hot dog was... well, you don't want to know.

Several years later I found out the Ring Dings, Devil Dogs, Hostess Sno-Balls, Twinkies, and Mallomars aren't really food. They rot your teeth and make you fat.

**Someone told me about vitamins.** I thought they would balance my obsession with Drake's cakes, but they didn't. I also learned, around third grade, that, much to my chagrin, One-A-Day Vitamins would not help me take on the schoolyard bully. (Maybe I still hadn't fathomed the broader ramifications of the George Reeves episode.)

It was bad enough discovering I had slimy, oozing, gruesome-looking vital organs inside me. I mean, who needs a liver or a pancreas? But to complicate the matter, biology taught me **there is a whole population of micro-organisms crawling around in there and swimming in my precious bodily fluids. And they didn't even ask if they could come on board!** Some call this education, but Sartre wrote a book called *Nausea* whose title comes closer to describing the realization.

The teen years brought much in the way of disillusionment. First surreptitious sip of Scotch: Yuck! Alcohol tastes terrible! **The stronger the liquor, the worse it tastes.** How could adults get hooked on this stuff? Sooner drink Valvoline.

My teens also brought the knowledge that **if you buy a ticket at Yankee Stadium, you get a lousy seat** and see less than if you had stayed home and watched the game on TV. And there's no announcer calling the play-by-play.

From reading about it so often, I discovered that **being a mega-platinum rock star on the road isn't all enviable fun and games.** Lots of them hate it. They hate it so much they write songs about it, then go on the road and sing them, and give endless interviews complaining about what a wretched ordeal it is. I'm sure you pity these folks tremendously. I know I do.

**From there, it followed that famous people, rich people, beautiful people, *People* magazine people, are not necessarily happier than you and me. But at least they can afford to be miserable.**

Finally, the disillusioning adult years. The process never stops:

➡ Joe Franklin doesn't read his guests' books.

➡ WABC-AM dropped their Top 40 format and switched to all-talk.

➡ Clete Boyer, Graig Nettles, and Mike Pagliarulo got jobs playing third base for the Yankees, and I didn't.

➡ I heard Jean Shepherd, in all his arrogance, tell a packed auditorium of admirers that he hates radio, that he's always hated radio, even when he was the best thing on it.

➡ Country singer Skeeter Davis married some ninth-rate musical hack named Joey Spampinato. She didn't have to settle. My number's in the phone book.

Adulthood also brought the realization that **banks earn more keeping your money than they pay you for letting them keep it.**

**By 1986, I was skeptical—hell, cynical—about everything.** Then I found out that the guys calling themselves Frank Bartles and Ed Jaymes in the commercials are just actors. **Say it ain't so!**

I have no more illusion: if cancer, heart disease, pneumonia or an auto accident don't get you, entropy will. You can't win. Also, in the long run, you can't beat insurance companies, the lottery, banks, credit cards, or used-car warranties.

**No one lives forever. Not Eubie Blake, George Burns, or Joe DiMaggio. No, not even the Ayatollah.**

*IF THE FULL IMPLICATIONS HAVEN'T DAWNED ON YOU YET, KID, LET ME BE THE FIRST TO TELL YOU: THIS IS LIFE. THERE ISN'T ANY MORE. BUT DON'T LET THAT DISILLUSION YOU.*

August 5, 1892: Rainey T. Wells becomes the first radio listener ever when friend Nathan Stubblefield of Murray, Kentucky, transmits the words "Hello, Rainey" through the air via mysterious "black box."

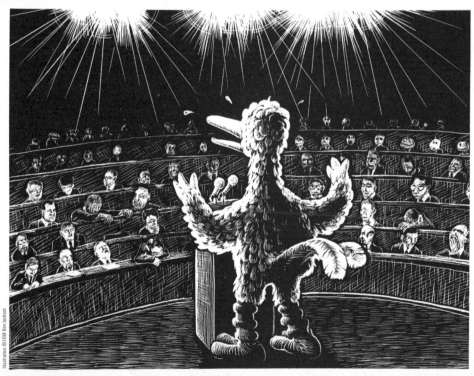

November 8, 1993: Public Broadcasting sends its most eloquent rep, Big Bird, to testify before Congress against defunding PBS.

JIM RYAN

DAVID SANDLIN

GARY PANTER

JONATHAN ROSEN

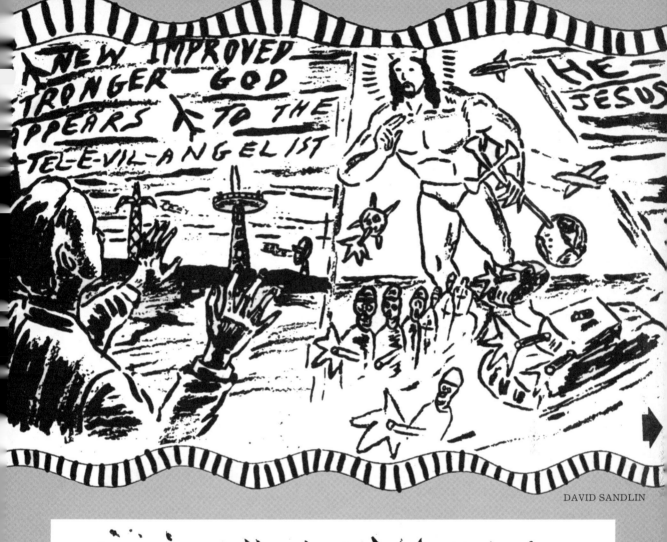

A NEW IMPROVED STRONGER GOD APPEARS ✝ TO THE ✝TEL-E-VIL-ANGELIST

HE JESUS

DAVID SANDLIN

WILDGIRL '82

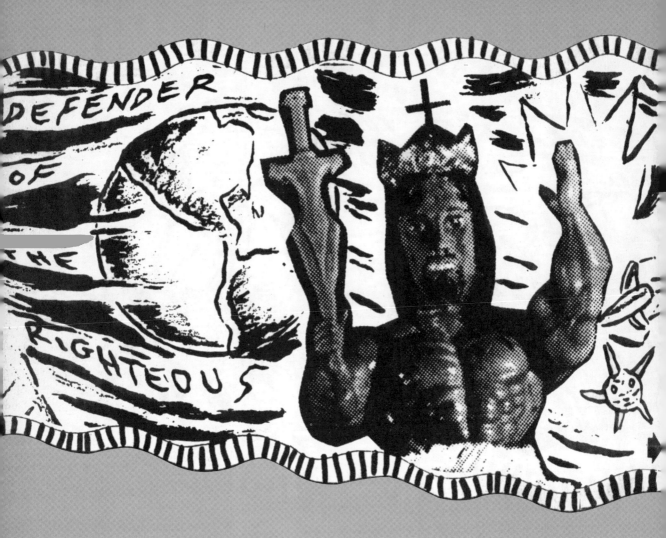

PRIMITIF is plagued by large insects in his hut.

They settle on his back as he sleeps.

So he spends three nights in a neighbouring hut.

When he returns, the insects have gone.

DAVID SANDLIN

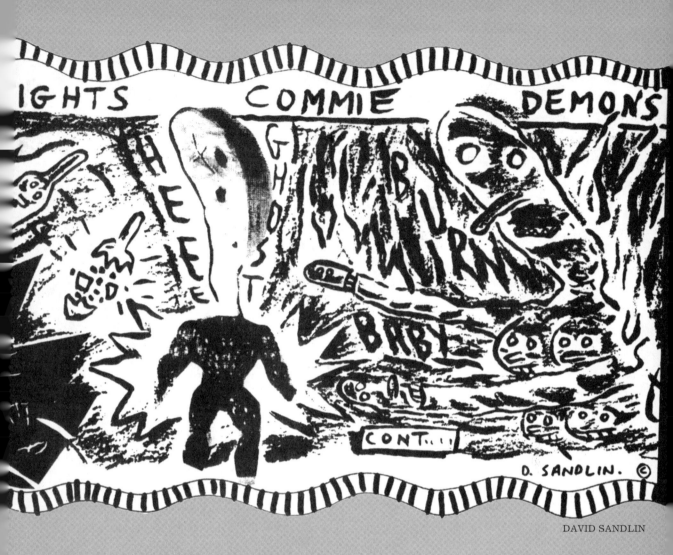

DAVID SANDLIN

DANIEL KIRK

# UPSIDE DOWN & DIZZY

MICHAEL DOUGAN

**M**ONDAY AFTERNOON, SEPTEMBER 10TH 1989

MY FAVORITE PANTS WERE WEARING THIN, SO I DECIDED TO BUY A NEW PAIR. AS I WAS DRIVING MY SCOOTER THROUGH DOWNTOWN, I SAW SOME KAKHIS THAT I LIKED IN THE WINDOW OF THE GAP, SO I PARKED ON THE SIDEWALK AND WENT IN TO CHECK IT OUT.

GA

SWEATER SALE!

**O**N MY WAY INTO THE DRESSING ROOM, I RAN INTO DIZZY GILLESPIE, WHO WAS ALSO BUYING PANTS.

WOW! THERE'S A SHIRTLESS JAZZ LEGEND IN THE DRESSING ROOM RIGHT NEXT TO ME!

THAT'S DIZZY GILLESPIE OVER THERE TRYING ON PANTS...

DID THESE FIT?

NO, I NEED ONE SIZE LARGER.

**D**IZZY TOOK A BREATH, THEN EXHALED, MOMENTARILY PUFFING OUT HIS CHEEKS.

**T**HE NEXT PAIR I TRIED ON FIT A LITTLE BETTER. DIZZY, WEARING A SMART LOOKING SHIRT, STEPPED OUT AND OBSERVED.

WON'T THOSE BE TOO LONG?

THEY'LL SHRINK, WON'T THEY?

WHAT DO YOU THINK?

THEY LOOK FINE...

WHAT DO YOU THINK DIZ?

LOOK O.K.?

YOU HAVE MY APPROVAL.

**I** DECIDED TO BUY THE PANTS.

... AS I'M PUTTING ON THE OLD ONES, I HEAR THE SALESWOMAN TALKING TO DIZZY AND GIGGLING FROM NEXT DOOR...

HAHAHA HEHEE HEE DIZZY YOU'RE SO SILLY HAHAHA—

DO YOU WANT ME TO DO IT LIKE THIS? OR LIKE THIS?

CONCLUSION NEXT WEEK!

# DO NOT READ THIS ARTICLE

## By Irwin Chusid

**Reading is a selfish, anti-social activity.**

It is a solitary pursuit, a hedonistic indulgence, undertaken purely for personal gratification. While reading, it is impossible to carry on a conversation, interact with a group, or do anything useful. Reading will not wax your Camaro.

You can't read while the mind or body is otherwise engaged. The Department of Transportation estimates that thousands are killed or maimed each year on the nation's highways when people read while driving. It's insane.

Drinking and reading is equally dangerous—trying to comprehend the text, you forget to savor the beverage. A close friend, reading while intoxicated, lost control of his attention and crashed into an oncoming paragraph, which he failed to apprehend. (It was a dense piece of literature—Pynchon, I think.) He fractured his glasses and now he can't get insurance.

The Vatican has the right idea. Their list of Forbidden Books includes virtually everything published since 1453. It has to be that way. In order to make distinctions, someone would have to read some of those books, and any one of them could turn out to be forbidden. They should *all* be forbidden.

People who read a lot are usually withdrawn, introverted, and behave awkwardly, unaccustomed to dealing with their peers. At libraries, where the most shameless, orgiastic fondling of texts is encouraged—indeed, where the practice is carried to such an extreme that libraries can be likened to book bordellos—at these places the obsession with reading is so intense that talking—basic communication between one human being and another—is prohibited, usually under threat of expulsion. Hence, only the most surreptitious of verbal exchange is carried on *sotto voce*.

Another friend of mine (the "other" friend—call him "Ralph") is what detox counselors call a "rehabilitated reader." Ralph has been in therapy 6 years trying to kick. He started when he was very young. After his mother would tuck him in and flick off the light, "Ralph" would hide beneath the quilt with an Eveready twin-beam and gratify his basest desires. He would devour page after page of *Hoss Cartwright's Tales of the Ol' West for Young 'uns* aided by the amber beam of that flashlight, ruining his eyes, and his mind. He is now 29 but looks 50.

We all experienced harmless forays into *The Weekly Reader*, the Hardy Boys, or *Highlights For Children*. Some experimented with Judy Blume, or Curious George. Unless the tendency is arrested at an early age, the progression to newspapers and magazines, perhaps even slim novels, is inexorable. Before long, you're hooked on pushover literature, authors like Salinger or Vonnegut. The path of degradation grows more treacherous as the simpler forms become less and less fulfilling, as one develops a tolerance to, say, Sinclair Lewis or Donald Barthelme, and acquires a more serious addiction to Mencken, George Orwell, or Proust. Eventually, nothing less than 800-page treatises on logical positivism will satisfy the fatal craving, if you haven't first OD'd on the collected works of Balzac.

By then it's too late. One staggers through life with one's nose buried in a paperback, or a newspaper, or *Harper's*, passing up opportunities, neglecting health and hygiene, the family be damned.

An illusory perspective takes root: if it isn't in print, it doesn't exist. You become so intently preoccupied with READING READING READING, that you miss life altogether, and die a learned, but sensorily deprived, pathetic, lonely husk of a human being.

If you're considering taking up the reading habit—DON'T! Put down this issue of *LCD*. Watch HBO. Go to the racetrack. Try toll-running on the Parkway. Maybe matrimony, or other forms of gambling. Train pit bulls. Bake banana bread. Learn the Virginia Reel, or revive the art of cakewalking.

Ignore the rest of this column. Take hope from declining SAT scores. Take the flyer from the Book-of-the-Month Club and use it in your kitchen, maybe as an ad-hoc Handi-Wipe. Cut it into circles for coffee filters. The Book-of-the-Month Club would like nothing better than to get you *hooked*, and prey on your weakness. JUST SAY NO! The first three are 99 cents, but you'll go on paying for the rest of your life.

# SOUTHERN EXPATRIOTS

"HOW ABOUT A SLICE OF SHOOFLY PIE?"

by MICHAEL WAYNE DOUGAN ©87

GROWING UP IN THE SOUTH IS WEIRD. IT's ...HARD TO DESCRIBE, BUT ASK ANYONE WHO HAS VISITED; IT IS DIFFERENT...

SEE YOU LATER

OK

AH...YOUTH...

FIRST OF ALL, OLD PEOPLE GET RESPECT.

GIVE GRANDMA SOME SUGARS!

YES 'MAM

mmmmm mmmm ≥ SMACK ≤

... THERE IS AN UNDENIABLE SWEETNESS OF TONGUE. THAT IS OFTEN A DISGUISE FOR HATEFUL REMARKS.

WHY, CHAROLETTE! THAT IS A... GORGEOUS DRESS YOU GOT ON! DID YOUR MAMA GIVE YOU THAT? IT'S So... CHARMING... ...IN A . BOVINE SORT OF WAY...

THE HOT AND HUMID WEATHER IS RESPONSIBLE FOR MANY CRIMES OF PASSION...

NOT HIS WIFE

IT IS ALSO RESPONSIBLE FOR THE CONSUMPTION OF ICED TEA, SKIMPY CLOTHES, DEODORANT, PERFUME, COLOGNE, NO-PEST STRIPS, AND GUNS.

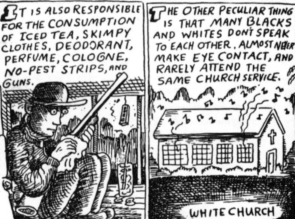

THE OTHER PECULIAR THING IS THAT MANY BLACKS AND WHITES DON'T SPEAK TO EACH OTHER . ALMOST NEVER MAKE EYE CONTACT, AND RARELY ATTEND THE SAME CHURCH SERVICE.

WHITE CHURCH

BLACK CHURCH

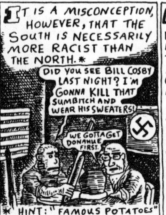

IT IS A MISCONCEPTION, HOWEVER, THAT THE SOUTH IS NECESSARILY MORE RACIST THAN THE NORTH. *

DID YOU SEE BILL COSBY LAST NIGHT? I'M GONNA KILL THAT SUMBITCH AND WEAR HIS SWEATERS!

WE GOTTA GET DONAHUE FIRST.

* HINT: "FAMOUS POTATOES"

AND AS FAR AS ACCENTS GO,...... RURAL NEW ENGLANDERS CAN SOUND EVERY BIT AS STUPID AS TEXANS... BUT A THICK ACCENT IS GENERALLY CONSIDERED A HANDICAP ANYWHERE...

THOSE WHO LEAVE THE SOUTH, FIND A COOLER EMOTIONAL CLIMATE IN NORTHERN CITIES, AND WILL OCCASIONALLY MISS THE SWEATING, LYING... HOLLERING,... THE CHICKEN FRIED STEAK, BISCUITS,.... SERVICE WITH A SMILE,... WARMTH, RESPECT...

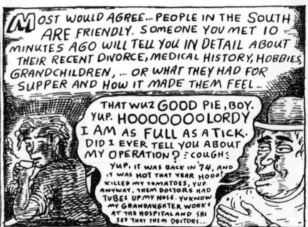

MOST WOULD AGREE... PEOPLE IN THE SOUTH ARE FRIENDLY. SOMEONE YOU MET 10 MINUTES AGO WILL TELL YOU IN DETAIL ABOUT THEIR RECENT DIVORCE, MEDICAL HISTORY, HOBBIES, GRANDCHILDREN, ... OR WHAT THEY HAD FOR SUPPER AND HOW IT MADE THEM FEEL...

THAT WUZ GOOD PIE, BOY. YUP. HOOOOOOOLORDY I AM AS FULL AS A TICK. DID I EVER TELL YOU ABOUT MY OPERATION? ≥COUGH≤ YUP, IT WAS BACK IN '74, AND IT WAS HOT THAT YEAR HOOO! KILLED MY TOMATOES, YUP. ANYWAY, THEM DOCTORS HAD TUBES UP MY NOSE. YUKNOW MY GRANDAUGHTER WORKS AT THE HOSPITAL AND SHE SEE THAT THEM DOCTORS...

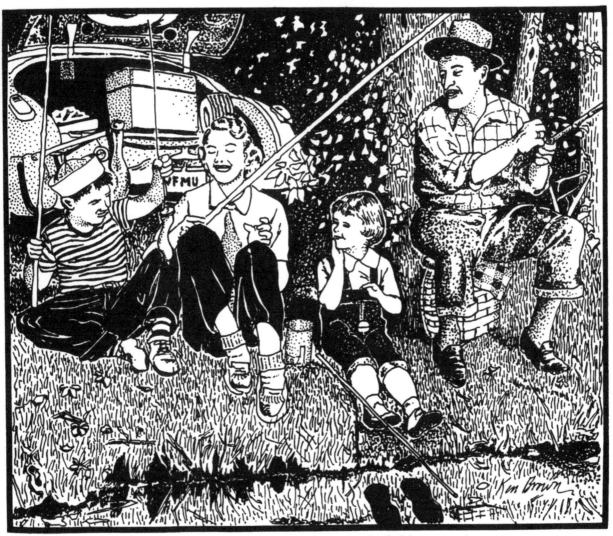

**CALVIN CAUGHT HIS FIRST CONDOM**

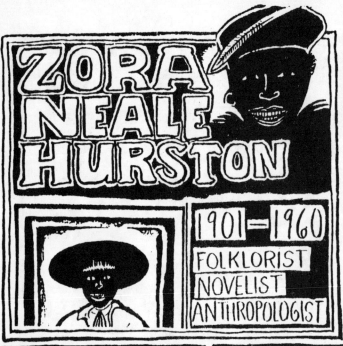

# ZORA NEALE HURSTON

**1901–1960**
FOLKLORIST
NOVELIST
ANTHROPOLOGIST

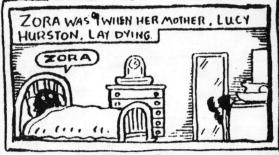

ZORA WAS 9 WHEN HER MOTHER, LUCY HURSTON, LAY DYING.

ZORA

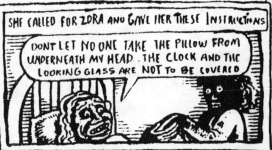

SHE CALLED FOR ZORA AND GAVE HER THESE INSTRUCTIONS

DON'T LET NO ONE TAKE THE PILLOW FROM UNDERNEATH MY HEAD. THE CLOCK AND THE LOOKING GLASS ARE NOT TO BE COVERED

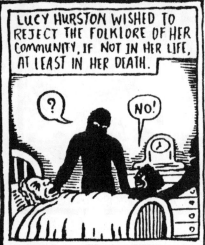

LUCY HURSTON WISHED TO REJECT THE FOLKLORE OF HER COMMUNITY, IF NOT IN HER LIFE, AT LEAST IN HER DEATH.

? NO!

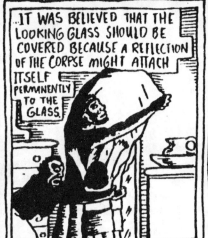

...IT WAS BELIEVED THAT THE LOOKING GLASS SHOULD BE COVERED BECAUSE A REFLECTION OF THE CORPSE MIGHT ATTACH ITSELF PERMANENTLY TO THE GLASS.

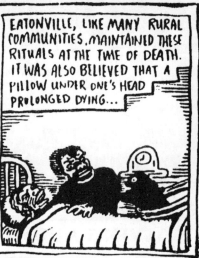

EATONVILLE, LIKE MANY RURAL COMMUNITIES, MAINTAINED THESE RITUALS AT THE TIME OF DEATH. IT WAS ALSO BELIEVED THAT A PILLOW UNDER ONE'S HEAD PROLONGED DYING...

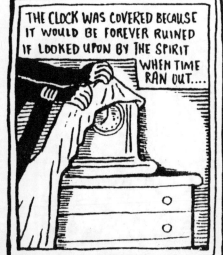

THE CLOCK WAS COVERED BECAUSE IT WOULD BE FOREVER RUINED IF LOOKED UPON BY THE SPIRIT WHEN TIME RAN OUT....

FINALLY, THE BED WAS TURNED TO THE EAST (SO THAT IT WOULD NOT BE CROSSWAYS OF THE WORLD) AND YOUNG ZORA HAD FAILED HER MOTHER'S DYING REQUEST.

"...THAT HOUR BEGAN MY WANDERINGS." ZORA LATER WROTE. "NOT SO MUCH IN GEOGRAPHY, BUT IN TIME. THEN NOT SO MUCH TIME AS IN SPIRIT."

"DUST TRACKS ON A ROAD." Z.N. HURSTON PHILADELPHIA. J.B. LIPPENCOTT. 1942

MICHAEL DOUGAN

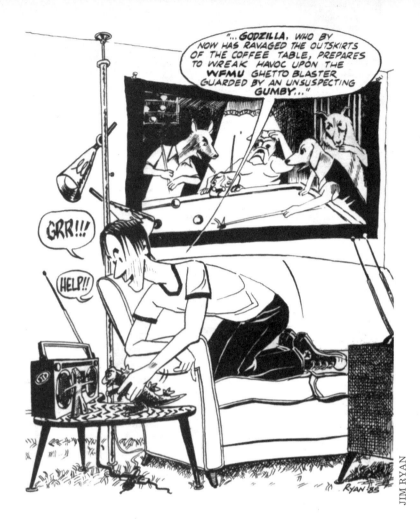

JIM RYAN

# TALES OF GREAT RECEPTION!

# LIVES

by James Marshall
Photo courtesy of Norton Records

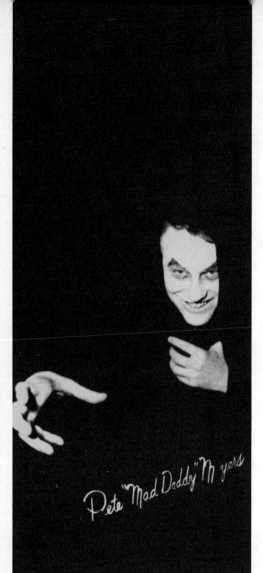

Pete "Mad Daddy" Myers

One of the most unique and tragic of all the great rock 'n' roll disc jockeys was Pete "Mad Daddy" Myers. Born in California in 1928, and educated at the Royal Academy of Drama in England, he began his broadcasting career while serving in the army during the Korean War. After announcing that a giant sea dragon was attacking North Korean troops, he was nearly court-martialed, and returned home. Once back in the states he headed for Cleveland, then America's hotbed of creative radio. He landed on a tiny Akron, Ohio, station in 1957, where he developed his Mad Daddy character, speaking in mind-boggling spontaneous rhyming verse with enough echo to simulate a canyon, and spinning the weirdest rock 'n' roll and rhythm & blues discs he could find. Mad Daddy soon moved to the larger WJW in Cleveland, where he became the favorite of teenagers, reeling off dedications, ads, and all sorts of mania in a never-ending rhyming stream of consciousness. Cleveland's number one station WHK hired him in the summer of 1958, but a 90-day off-the-air clause in his WJW contract threatened to lower his profile. In response he threatened to fill Lake Erie with Jell-O and records and jump out of a plane into the mess. The jello and records proved implausible but jump he did, on

# Pastor John Rydgren

©'88
D. WORDEN

While director of TV/Radio/Films for the American Lutheran Church, Pastor John Rydgren tried his damnedest to reach the 1960's youth with a hippiefied Christian message. What follows is one of many radio productions John wrote and narrated.

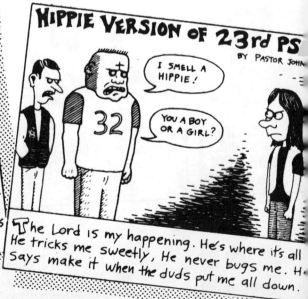

HIPPIE VERSION OF 23rd PS
BY PASTOR JOHN

I SMELL A HIPPIE!

32

YOU A BOY OR A GIRL?

The Lord is my happening. He's where it's all He tricks me sweetly, He never bugs me. He says make it when the duds put me all down.

# OF GREAT DJS:
## MAD DADDY

July 12th, 1958, when he parachuted out of a plane over the lake hollering "Zorro!" His show on WHK proved to be a smash, and he ruled Cleveland's teen kingdom for a year with "Mello Miss Muffin" contests, non-stop "wavy gravy" (his name for greasy R&B records) and other manic frothings from "Dracula Hall." In 1959, WNEW (WHK's parent station) brought the Mad Daddy to NYC. The Mad Daddy was unleashed on WNEW-AM's listeners, but we were more attuned to William B. Williams's "Make-Believe Ballroom" and hated the sounds of this rhyming speedfreak who introduced every song as "The Greasy Chicken." Mad Daddy lasted

one day in NYC, and he was ordered to become Pete Meyers and stick to Perry Como and a smooth, slow-talking delivery. He stayed with WNEW until his contract expired in 1963 and then moved to WINS where he attempted to revive the Mad Daddy character, in a slot following Murry the K's evening broadcasts. He stayed at WINS alternately as the Mad Daddy, then again as Pete Myers until 1965, returning to WNEW-AM when it was obvious that the Mad Daddy was out of his element in the dawning of the Beatles era. On October 4th, 1966, he put his shotgun in his mouth and scattered his brains all over his NYC apartment.

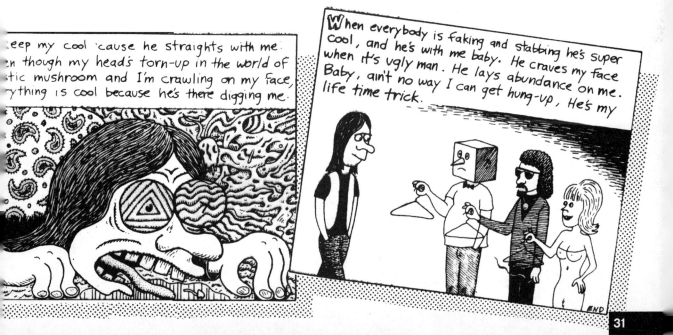

31

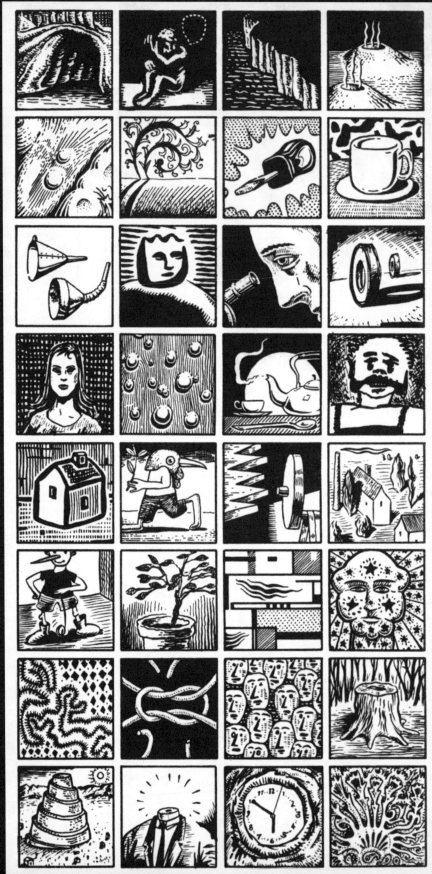

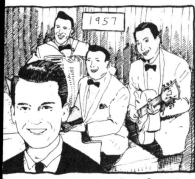

1957

DICK CLARK. MISTER TEENAGER

1987

HOW DOES HE STAY SO YOUNG?

WELL... HE TAKES HIS VITAMINS,

TIME FOR MAMAS LIL HELPER

SORRY, NOT TONITE DEAR, I'M BUSHED.

HE GETS PLENTY OF REST,

HE WATCHES WHAT HE EATS,

HE WATCHES AS INNOCENT KIDS COWER IN FEAR AS THEY AWAIT THEIR GRISLY FATE

FOR THE MOST IMPORTANT PART OF DICKS REGIMEN IS DEVOURING FRESH PITUITARY GLANDS

HE PICKS HIS TEETH WITH ONE OF THE HUNDREDS OF TINY BONES THAT MAKE UP THE HUMAN HAND.

MISSING
HAVE YOU SEEN ME?
MILK

OH YEAH... AND HE DRINKS PLENTY OF MILK TOO.

the abbreviated PICTORIAL BIOGRAPHY of BABY X

EXECUTED BY D. KIRK

THE PARENTS OF BABY X, AFTER THE WAR, BEGAN THEIR COURTSHIP IN A SPIRIT OF FRENZIED ABANDON.

CONCEPTION WAS UNPREMEDITATED, GROWTH INEXORABLE.

DOMESTIC BLISS WAS PREFIGURED IN THE FORM OF A NEW HOME.

LIFE THERE WAS NOT ALWAYS TRANQUIL.

MERCIFULLY, THE HAPPY MOMENT SOON ARRIVED, AND BABY X WAS DELIVERED INTO THE WORLD.

CONTINUED...

# AXIS SALLY

*by Rob Weisberg*

Out of twelve Americans indicted for treason following World War II, all but five were radio broadcasters—a fact all of us at FMU can be proud of. One of the most notorious to be convicted was Mildred Gillars, or "Axis Sally," as she was known to the GIs who heard the Radio Berlin broadcasts.

A graduate of Hunter College in New York, Gillars went to France to study music in 1929 after failing as an actress. By 1934 she was in Germany, where she fell for former Hunter professor Max Otto Koischewitz.

Koischewitz became Radio Berlin's Program Director, and Gillars became his star propaganda broadcaster. Typically, she did a DJ program—breaking up the music with anti-Semitic raps. "Damn Roosevelt! Damn Churchill!" went one of her tirades. "Damn all the Jews who made this war possible. I love America, but I do not love Roosevelt and all his kike boyfriends."

"Axis Sally" also liked to air messages from American POWs. Telling the POWs she visited that she was a Red Cross representative, she enticed them to send happy messages to suggest that living under the Nazis, even in POW camps, was a good thing. Once on the air, she would inter-cut POWs' messages with propaganda despite having promised the prisoners not to do so.

Despite all her other antics, "Axis Sally" was convicted on the basis of just one broadcast, a radio drama called "Vision of Invasion" that, on the eve of D-Day, sought to scare GIs out of invading occupied Europe. In the play, the mother of an Ohio soldier sees her son in a dream. He tells her that he's already dead, his ship destroyed mid-invasion by Germans. GIs can be heard sobbing and shrieking in the background, and the effect of the broadcast is said to have been chilling.

Gillars tried several tactics in court, but ultimately claimed, unsuccessfully, that her love for Koischewitz had motivated her. Her lawyers argued that Koischewitz had a Svengali-like grip over her; she was his puppet.

# DAVE RABBIT

*by James Marshall*

Little is known about the charismatic Mr. Rabbit, but at some point in the late '60s he began his pirate (or, as he called them, underground) FM broadcasts out of Saigon. "Radio Fist Termer," which appeared at 69 MHz on the FM dial, bombarded GIs with "the hard-assed sound of hard acid-rock music, the sound of today's American youth."

In addition to treating stoned grunts, maggots, and first-termers to the far-out sounds of Bloodrock, Hendrix, Steppenwolf, and Iron Butterfly, he gave news reports: "We have just gotten word that a new Korean massage house is open in the Saigon area: available are steam bath, back massage, hand job and blow jobs..."; helpful hints: "If you're going by the Carousel Club tonight, stay away from the Korean at the door; he's pushing some bad H..."; and spread his good vibes in a way Bob Hope never could. He would break into the middle of an Iron Butterfly opus to heavy-osity: "This is one long mother-fucker, think I'll go down the hall and take a shit, smoke a joint, and get blown..." and share his psychedelic experiences with his listeners (over the opening bars of "Eight Miles High"): "This goes out to me and my comrade, Pete. We're tripping..."

I don't know how long Radio First Termer lasted (and it was pretty blatant, for a pirate, giving out the phone number and frequencies) or whatever became of Dave Rabbit, his engineer/sidekick Pete, or his sulky-voiced newslady, Nugent. But the surviving aircheck I own assures them all a place in the broadcasting hall of fame.

LENNIE MACE

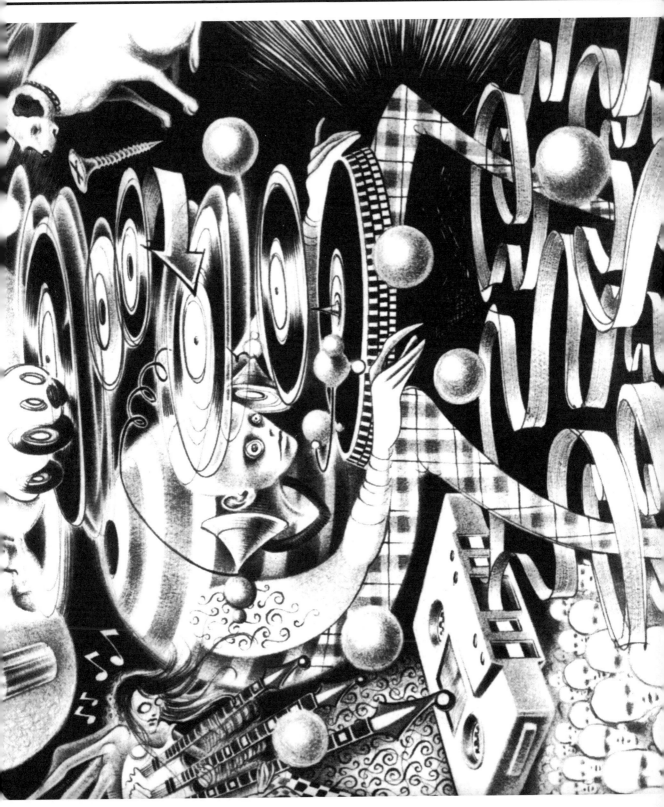

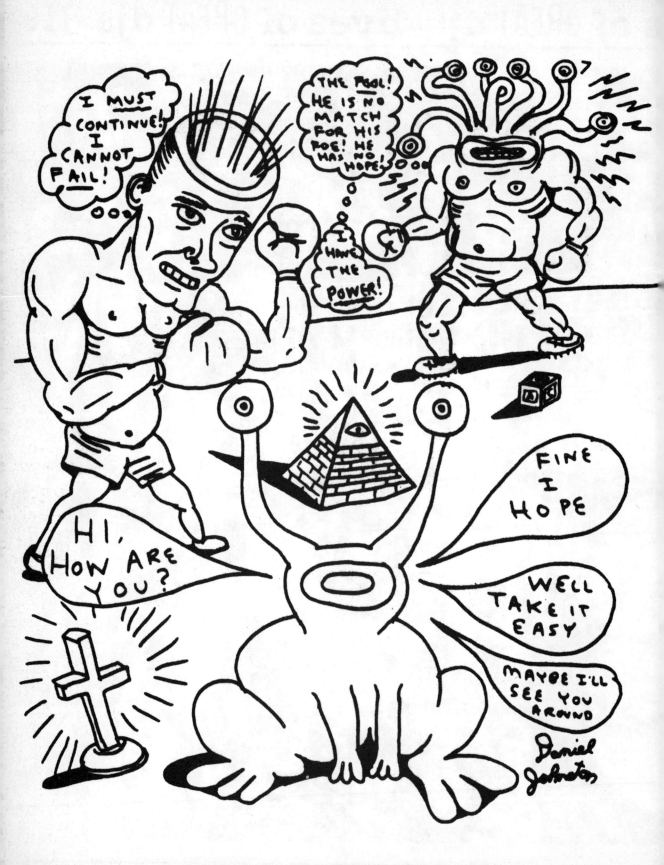

# TRUCK STOP TEA PARTY

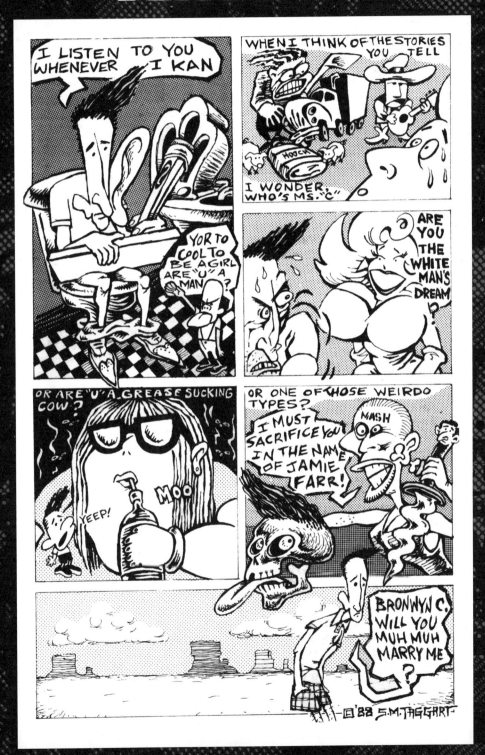

# Jai le Rockin Pneumonia et la Boogie Woogie Flu

*by Elisabeth Vincentelli | Illustrations by Carol Tyler*

In these troubled, cynical times, WFMU can rely on two surefire topics to elicit laughs from their jaded listeners: show tunes and French music. (French musicals, like *Les Misérables* or *Miss Saigon* being, of course, The Antichrist.) Since I confess to being partial to both genres, it's a wonder I haven't been driven out of the station in tar and feathers. But I'm still here, and I will use my allotted time to dwell on a fairly obscure subject related to French rock: the 1960s craze for French adaptations of American songs. We French have always had a love/hate relationship with the United States. We like to scream about "cultural imperialism" while buying American products by the truckloads.

During the 1960s, this ambivalence was illustrated by the juxtaposition of several musical trends: there was the birth of modern French pop, exemplified by brilliant song-writers (Serge Gainsbourg, Françoise Hardy, the Jacques Dutronc/Jacques Lanzmann team) and inspired arrangers (Michel Legrand, Michel Colombier); there were the "yé-yé girls" (Sheila, Sylvie Vartan); and there were the

"rockers" (Johnny Hallyday, Eddy Mitchell). All but a few did, at one point or another, adapt American songs into French.

Many opted for American-sounding monikers: Claude Piron became Danny Boy; Claude Moine, better known as Eddy Mitchell, did "Johnny B. Goode" as "Eddie Sois Bon"; Claude Benzaquen, Hervé Fornieri, and Norbert Blancke turned into Frankie Jordan, Dick Rivers, and Burt Blanca overnight, while Jacques Dautriche called himself Sullivan, in an attempt to cash in on Donovan's success, no doubt.

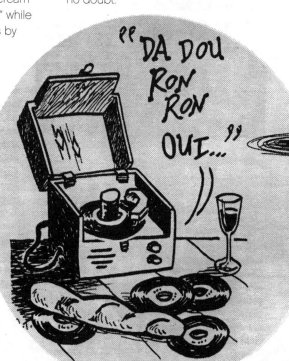

## Things got hairier when French performers tackled Bob Dylan.

Meanwhile, the French charts were invaded by "Three Cool Cats," "Twisting The Night Away," "Friday On My Mind," and "Ain't That Loving You," except that they were known as "Nouvelle Vague," "Laissez Nous Twister," "Vendredi M'Obsède," and "Quel Merveilleux Souvenir Johnny," respectively.

How did they turn a bona fide Yankee song into something French? Some, like "Da Doo Ron Ron," were easy enough: as "Da Dou Ron Ron," and with identical arrangements, it was a hit for Jean-Philippe Smet, er, Johnny Hallyday. Others didn't have ono-matopoeia for titles and were more problematic. Since many of those responsible for the French lyrics didn't actually speak English, they came up with lines they thought fit the musical mood of the song. The results ranged from more or less faithful to completely different altogether. "I Only Want To Be With You," popularized in England by Dusty Springfield, became Richard Anthony's "À Présent Tu Peux T'en Aller," which literally means, "you can leave now." Another surrealistic result was Les Pirates' "Je Bois Du Lait" ("I drink milk"), an adaptation of a Jerry Lee Lewis song called "Let's Talk About Us." Chuck Berry's "Thirty Days" shrank considerably in Johnny Hallyday's "Rien Que 8 Jours" ("only eight days"), while "He Was A Friend Of Mine" became "Toi Qui M'as Fait Pleurer" ("you who made me cry"). It's also doubtful Chuck Berry's "Rock 'n' Roll" would have been as self-reverential as Johnny Hallyday's version, which includes the lines

"Qu'elle m'empêche d'écouter Chuck Berry / Entre elle et moi, tout serait bien fini" ("if she keeps me from listening to Chuck Berry / it's over between us").

Things got even wackier when some English-speaking artists actually got careers in France by singing in French, which included things like "Ya Ya Twist" and "Hello Dolly." Cleveland-born Nancy Holloway covered Burt Bacharach's "Don't Make Me Over" as "T'en Vas Pas Comme Ça," while New Zealander Graeme Allwright performed protest songs in French.

While it didn't matter that much if the poetry of "Da Doo Ron Ron" didn't survive the translation, things got hairier when French performers tackled Bob Dylan. Hugues Aufray jump-started his career by record-ing an album titled *Aufray Chante Dylan*, with twelve Dylan songs done in French. One of the adapt-ers, Pierre Delanoë, boasted at the time that they hadn't translated but "adapted" the songs, often com-pletely changing the lyrics.

Other esoteric covers includ-ed two different versions of Ray Charles's "What'd I Say?" ("Est-ce Que Tu Le Sais?") though only Eddy Mitchell's, recorded in London in 1965, can boast Jimmy Page on

guitar. Equally worth looking for are Brigitte Bardot and Sacha Distel (a jazz guitarist turned crooner) dueting on "Tu Es Le Soleil De Ma Vie" (Stevie Wonder's "You Are The Sunshine Of My Life"), Annie Cordy's "Docteur Miracle" ("Witch Doctor"), and Richard Anthony's "Itsy Bitsy Petit Bikini" (need you ask?).

Unfortunately, French singers don't translate American and English songs as much as they used to. Now they do them in their original language, which isn't nearly as fun. A recent exception was "Paris, Le Flore," Étienne Daho's hit version of Stuart Moxham's "Love At First Sight." At least Daho had the sense to completely alter the lyrics, keeping a great tradition alive and well.

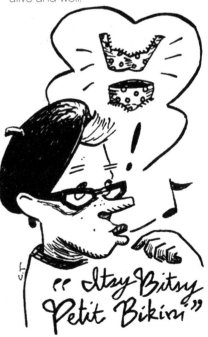

"Itsy Bitsy Petit Bikini"

MARK BEYER

# 555

## OR, MY PHONE NUMBER'S LIFE ON THE BIG SCREEN

*by Andy Breckman*
*Illustrations by Wayno*

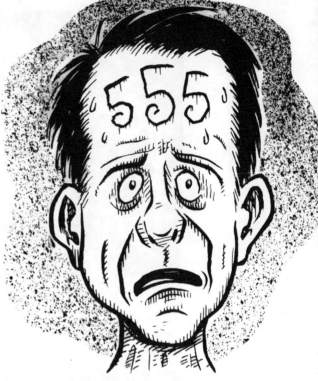

This is a true story about the movie business. Specifically, about *phone numbers* that appear in the movies.

You know how, in the movies, phone numbers always start with "555"? Even in good movies. You're watching the film. You're really into it. Then Robert DeNiro turns to Jessica Lange and says: "Call me. My number is 555-4512." And—instantly—you're jolted back to reality. Because everybody knows it's a phony phone number.

And Jessica Lange should know it, too. I always half-expect the Jessica Lange character to get pissed off and snap: "Do you think I'm an idiot? I know this isn't a real number! Fuck you!"

You might wonder: why don't they just use a *real number*? What would happen? Who would call? Well, since you asked...

I write for the movies. The first script I wrote was a comedy called *Moving*, which, inexplicably, got made. It starred Richard Pryor.

While they were making it, Stuart Cornfeld, the producer, called me and said they needed a phone number in the next scene. He didn't want to use an "obviously fake 555 number." That's the kind of producer Stuart Cornfeld was. He was a visionary.

He asked permission to use my office number, including the area code. "Don't worry," he said, "it'll be in the background. It'll be on a Real Estate sign. No one will see it."

I said okay, and forgot all about it. The movie opened. The movie sucked. The movie lost twenty million dollars. No one called. I went on with my life...

Then, a few months later, the movie came out on *video cassette*. On video, people could glimpse the number...then rewind...and freeze the frame! That afternoon, my office phone rang.

ME: Hello?
CALLER: Yeah. Uh. Who's this?
ME: Who's *this*?
CALLER: Uh, did you know your phone number's in a movie?
ME: *My* phone number—?
CALLER: Yeah. It's a Richard Pryor movie. It's called *Moving*. Man, you should sue them or something..."

It had begun. That first night, I got ten other calls.

I could gauge how well the movie was renting by how many calls I got. The first week, I averaged ten calls a night. The second week, it fell to five or six. More on weekends.

I stopped answering my office line and let the answering machine get it. For a whole year, I dreaded hitting the MESSAGES button.

I got about 150 calls. All guys. No women. To my relief, they never associated me with the movie. They just figured my number was somehow chosen at random.

What type of individual would pause a video tape, then call a number they glimpsed on a TV screen? Well, assholes. In fact, they fell into *six distinct sub-species of assholes*:

### THE BUDDIES:

About half the callers were genuinely trying to be helpful. They wanted me to know my phone number was in a movie. They thought I'd find it amusing. "Uh, I just thought you should know your number's in a movie. It's called *Moving*. It's on a For Sale sign, about halfway through..."

### THE LEGAL EAGLES:

A few calls had an angry, revolutionary tone. They thought I was being exploited, and recommended legal action. "This number is your private property, man! Warner Brothers has no right to use it! Sue the bastards! Suck 'em dry. They can afford it!"

### THE COMEDIANS: About

20% of the callers tried to be funny. They were almost always drunk. And had southern accents. I could hear their moron friends in the background, howling.

They'd say things like, "Hi, is Richard Pryor there?" or, "Yeah, I'm calling about the house for sale? Uh...does it have a jacuzzi?" Then they'd laugh and hang up.

Sometimes, these masters of comedy would think of something hysterical to add, and call back. How I miss them.

### THE BULLIES: Then I got

the ranting psychotics. They would actually threaten me. Over the phone. "Hey, I saw your number in the fuckin' movie. You fuckin' asshole. I'll fuckin' rip you apart!"

### THE LONELY HEARTS:

One out of every ten callers were pathetic. They really wanted to meet me. Some of them called back two or three times. A few left me *their* name and number.

I guess they thought Warner Brothers was sponsoring some sort of big-screen bulletin board: "Hi? My name is Dale Butterworth. I'm calling from Buzz Creek, Colorado. I saw your number in the Richard Pryor movie. So, where am I calling? 201? What is that—New Jersey? Anyway, I'd love to say hi. My number is 659-7487. I'm home every night after nine, except Monday..."

### THE CREEPS: The scariest

callers were the Conspiracy Creeps. They acted like they had deciphered some sort of *secret code*.

They always whispered. And they had an excited, expectant tone in their voice, like they were calling CIA headquarters to get instructions: "...I'm calling about the number...in the movie? It was on the sign?...so...I'll call back tomorrow about the same time..."

Finally the calls tapered off. There was a brief resurgence when the movie was shown on HBO. Then it died down again.

**I GOT A MILLION OTHER STORIES. YOU WANT TO HEAR THEM? GIVE ME A CALL. MY NUMBER IS *555-3473*.**

# Covers

DREW FRIEDMAN

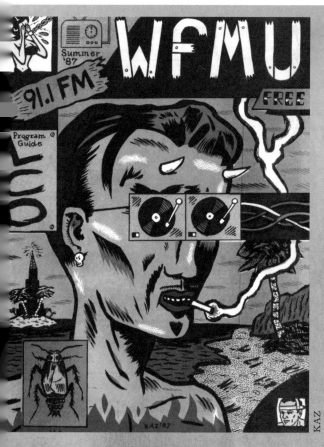

KAZ

DANIEL KIRK

49

JONATHAN ROSEN

ALEXANDER ROSS

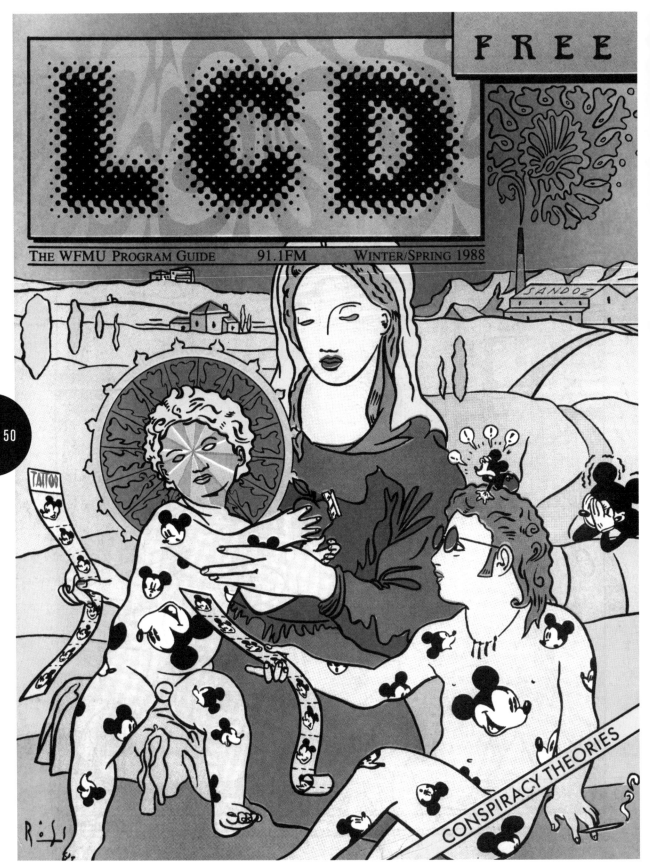

FREE

# LCD

The WFMU Program Guide     91.1FM     Winter/Spring 1988

CONSPIRACY THEORIES

50

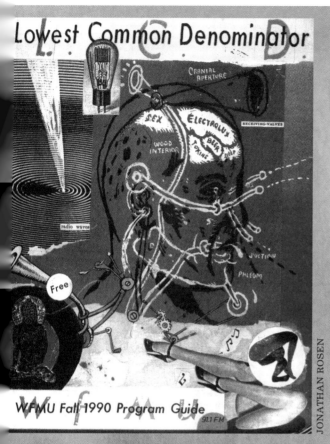

Lowest Common Denominator

WFMU Fall 1990 Program Guide 91.1 FM

JONATHAN ROSEN

LENNIE MACE

51

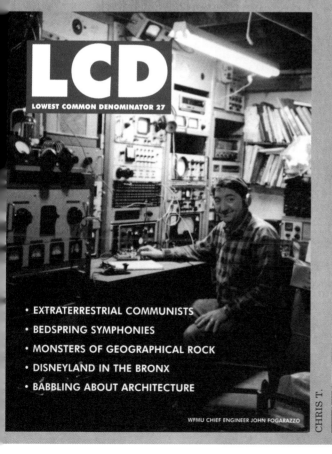

# LCD
LOWEST COMMON DENOMINATOR 27

- EXTRATERRESTRIAL COMMUNISTS
- BEDSPRING SYMPHONIES
- MONSTERS OF GEOGRAPHICAL ROCK
- DISNEYLAND IN THE BRONX
- BABBLING ABOUT ARCHITECTURE

WFMU CHIEF ENGINEER JOHN FOGARAZZO

CHRIS T.

FAll '86 LOWEST COMMON WFMU DENOMINATOR FREE 91.1FM

RADIO

BRUNO RICHARD

PETER BAGGE

53

ROBERT ARMSTRONG

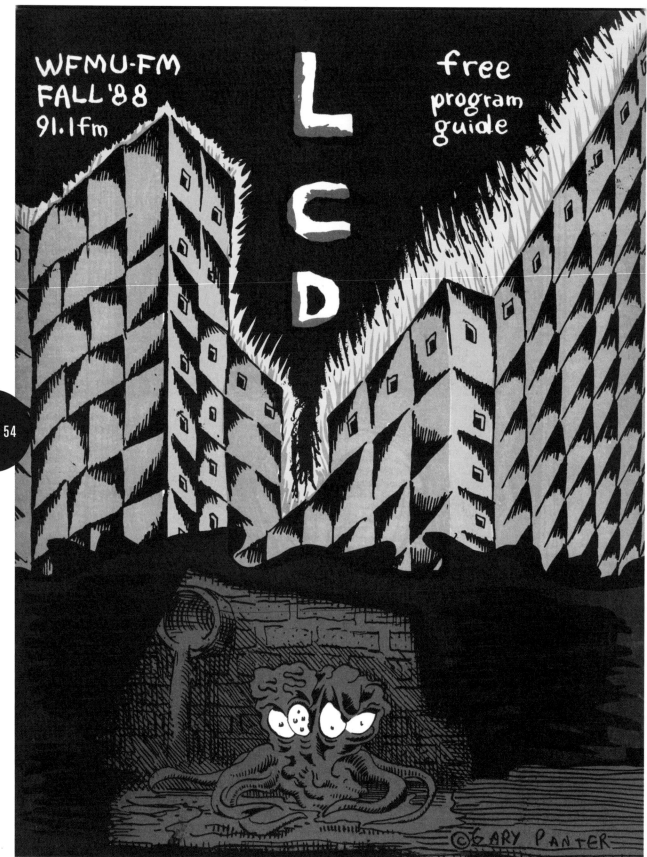

GARY PANTER

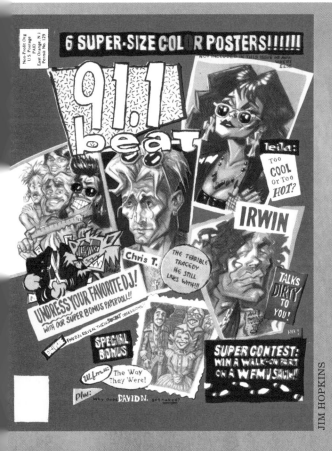

JIM HOPKINS

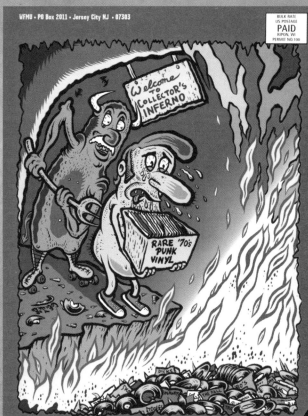

ROY TOMPKINS

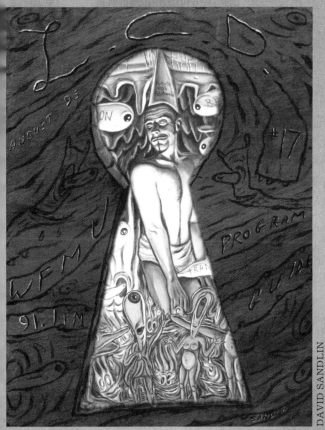

DAVID SANDLIN

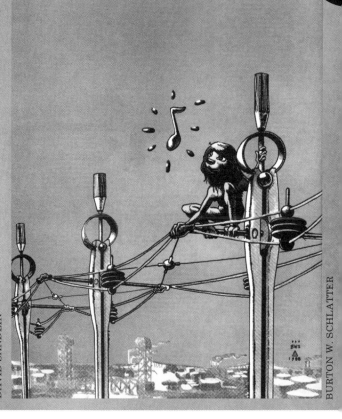

BURTON W. SCHLATTER

JIM WOODRING

artwork©1997 by Jonathon Rosen

wfmu 90.1 fm / 91.1 fm radio
## lowest common denominator 21
WFMU Fall 1997 Listener's Guide    http://www.wfmu.org

JONATHAN ROSEN

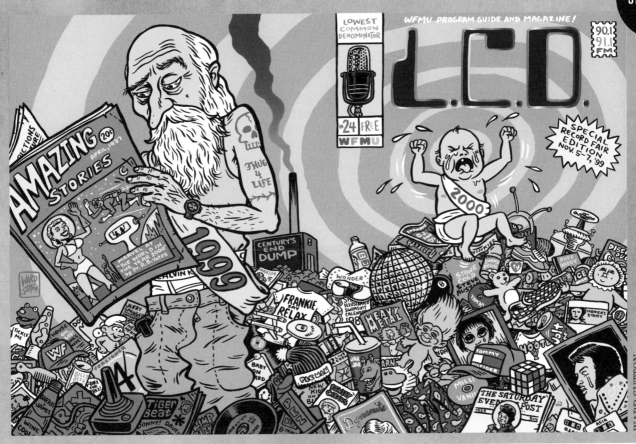

WARD SUTTON

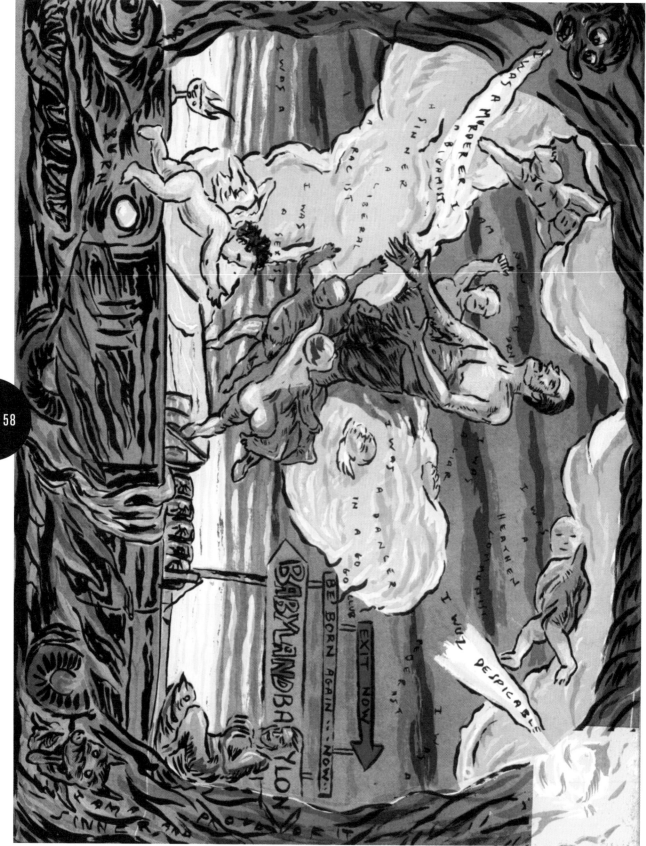

58

DAVID SANDLIN

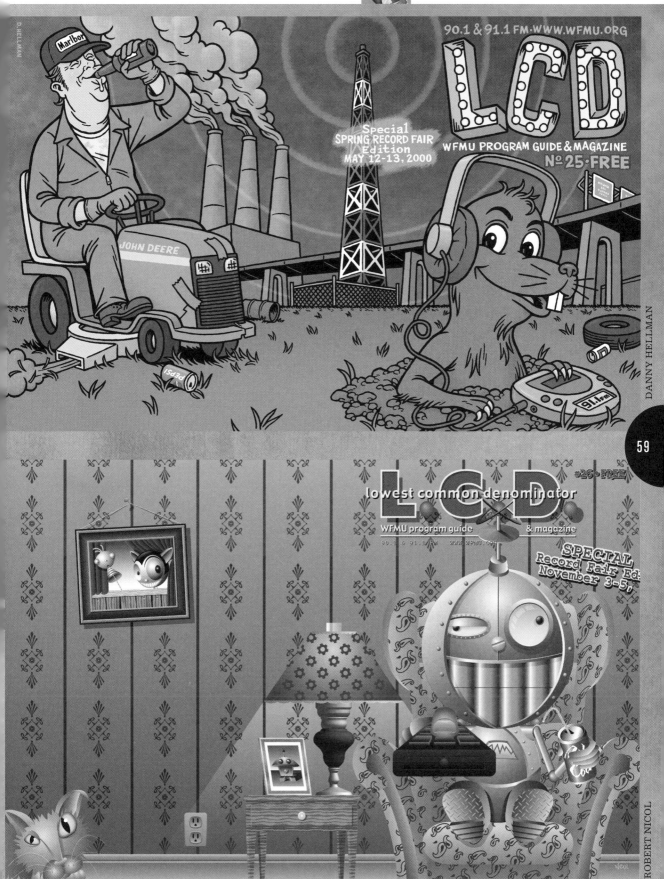

# L.C.D.

## LOWEST COMMON DENOMINATOR

### WFMU MAGAZINE AND LISTENER'S GUIDE

$3.95

NUMBER NINETEEN

HARVEY PEKAR ON JOE MANERI

NERVOUS NORVUS

URINE THERAPY

JUGZ

JOSH ALAN FRIEDMAN ON THE WINEDALE BAR

COLLABORATIVE COMICS
FEATURING DAN CLOWES, GARY LEIB, CHRIS WARE, TERRY LABAN, AND DOUG ALLEN

RICK ALTERGOTT EXPOSES MURRY WILSON

FEAST FOR THE EYES BY NICK TOSCHES

CHIP WASS

hicvue

CHIP WASS

May
1994

No.
16

WFMU 91.1 FM PROGRAM GUIDE

MARK LANDMAN

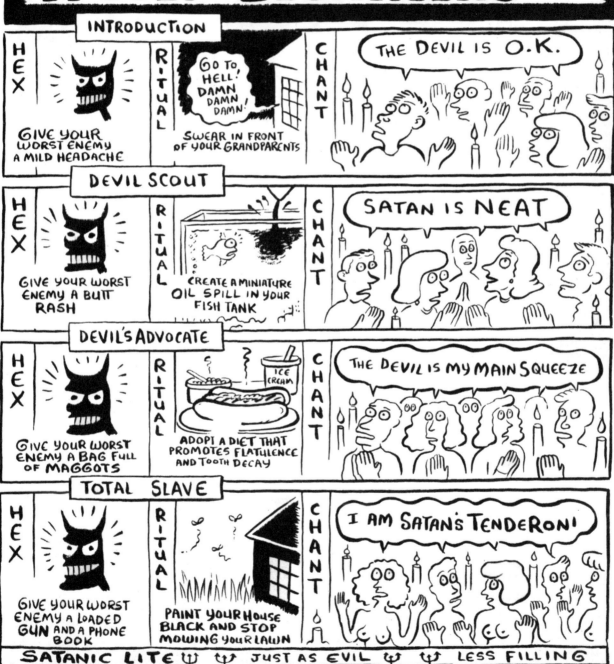

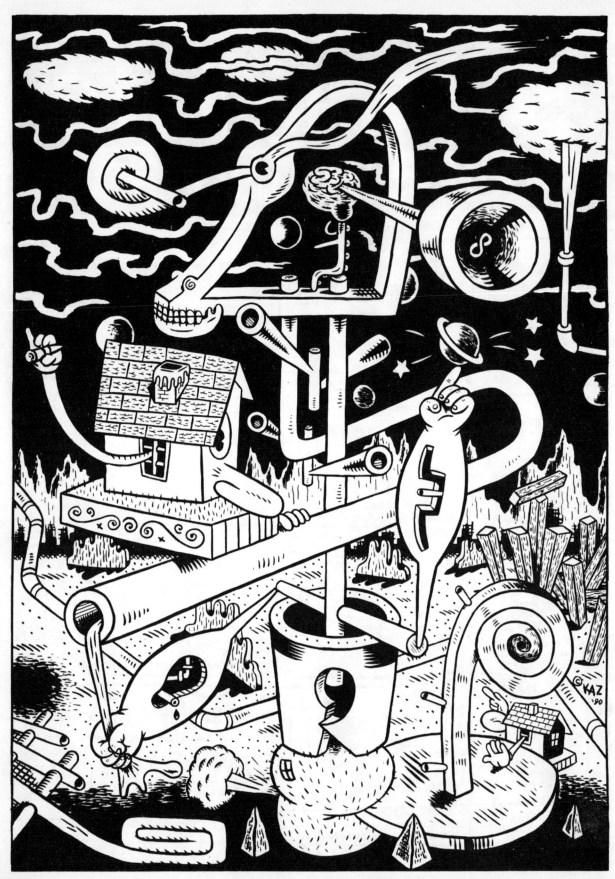

I'VE GOT IT ALL UNDER CONTROL

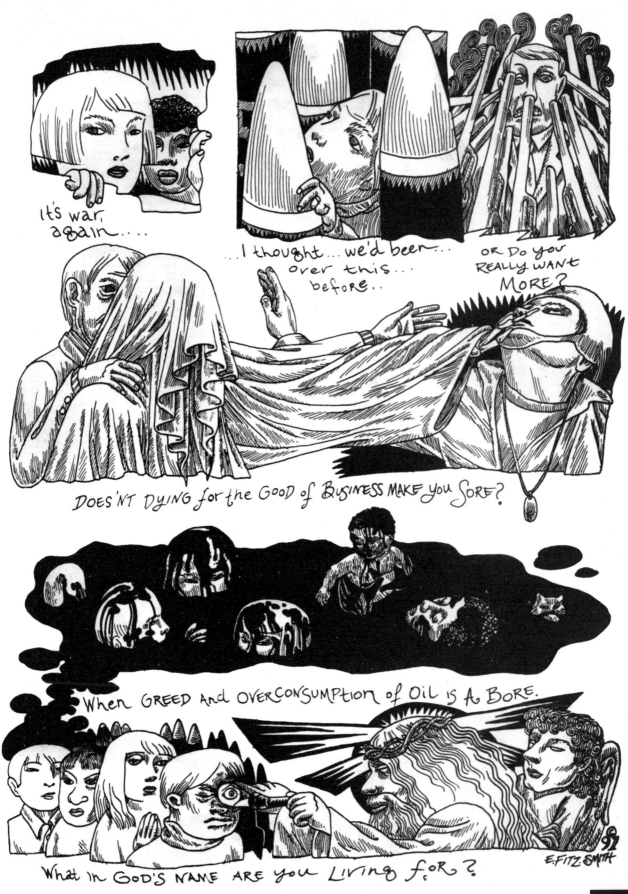

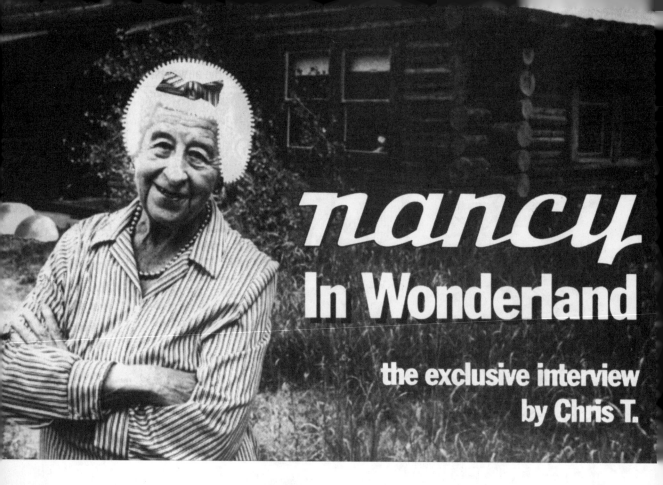

# nancy
# In Wonderland

## the exclusive interview
## by Chris T.

**L**ewis Carroll created a fantastic world peopled with strange inhabitants and sent a little girl named Alice down a rabbit hole into its midst. Many of us are surprised when we discover there was an actual Alice, and Carroll created the Wonderland stories for her and her young friends' amusement.

The South Bronx is a long way from Victorian England, but for cartoonist Ernie Bushmiller the distance was not so great. Though his drawing style is now considered a classic expression of form following function, it was Carroll's intricate illustrations for "Alice" that convinced Bushmiller to become an artist. In the mid '20s he went searching for a young girl around whom he could build another strange world and he found her—Nancy Carbonaro of 137th Street.

Her story has remained untold—until now.

Through the diligent efforts of cartoonist Mark Newgarden, the real Nancy has been found. Nestled in the wilderness of Wappingers Falls, New York, she passes her remaining days quietly unaware of the cult status her cartoon counterpart has achieved. She granted *LCD* a brief interview on one condition: her age or birthdate not be revealed.

*LCD:* How did you meet Ernie Bushmiller?

**NANCY:** He had an interest in my older sister. He was soft on her. She was quite attractive, but not interested in him. She thought he was silly.

*LCD:* So he would come over the house? Did he ask her out?

**NANCY:** Oh no, no. Back then you didn't ask a girl out. You courted her, and always in the presence of a parent or chaperone. The furthest he ever got in my house was the foyer. My father refused to have him inside.

*LCD:* Why was that?

**NANCY:** He didn't think that anyone who drew cartoons for a living could ever support himself, never mind a wife and family. He didn't want to encourage anything between my sister and Mr. Bushmiller.

*LCD:* How did you and Ernie come to be friends?

**NANCY:** He was trying to get information out of me—about my sister, find out if any of the neighborhood boys were interested in her or if she gave a fig about him. I told him I'd tell him for an ice cream sundae, so he took me to Jahn's for the Kitchen Sink.

*LCD:* I'm assuming Jahn's was an ice-cream parlor but what was the Kitchen Sink?

**NANCY:** It was a huge bowl filled with every kind of ice cream, every kind of syrup, every kind of topping you can imagine. It was meant for four people but I wanted it for myself. It cost nearly three dollars! I can still remember Mr. Bushmiller's face when they set it down in front of me. He said, "You can't eat that all," and I said, "I can and I shall." And I did. I was a fat little girl.

**LCD:** What about the hairdo and the bow? Was that yours or did Ernie come up with that?

**NANCY:** No, that was my hair. That still is my hair. It's always been curly and unruly. The bow was my mother's attempt at making me more feminine. I was a tomboy.

**LCD:** Did Ernie tell you he wanted to make you a cartoon character?

**NANCY:** Not as such. He had a notebook with him all the time and he was always writing down things I'd say. He was writing a comic strip called *Fritzi Ritz* and it was about the romantic misadventures of a young woman and there was a character in there called "Phil Fumble"...

**LCD:** Wasn't "Phil Fumble" actually Ernie?

**NANCY:** Yes, he was. He was a suitor, and if I can recall correctly, an unsuccessful one. Then later on Nancy appeared as Fritzi's niece. I didn't like that.

**LCD:** Why?

**NANCY:** Because I felt like Mr. Bushmiller was making fun of me somehow. I felt he was holding me up to public ridicule. He could've changed my name—I mean the cartoon character's name—but he didn't.

**LCD:** Did you ever ask him why he didn't use another name?

**NANCY:** Yes, I did. He said he wanted to impress my father, show him that he was a success. It didn't work, though. My father disliked him even more and forbid me to see him. We used to go to Jahn's every Sunday and Mr. Bushmiller would ask me about my week and take notes and I could order anything I cared to.

## "It was a huge bowl, full of every kind of ice cream..."

**LCD:** And he would use events from your life in the comic strip?

**NANCY:** Yes. Constantly.

**LCD:** Can you recall any specific examples?

**NANCY:** There was one or two about Modern Art that came out many years after we were no longer speaking. That was based on a trip to the 1939 World's Fair with my parents. They had one building and the outside was designed by that Salvador Dali fellow. I hated it. It made me nauseous. I spoke to Mr. Bushmiller about it and he took some of my comments and used them.

**LCD:** Did he ever speak to you about compensation of any kind?

**NANCY:** Not to me but to my father. He tried writing a letter, but my father tore it into pieces. The subject never came up again. Once when I was in college he made quite a sizeable payment on my tuition without my knowledge. I didn't know who the anonymous benefactor was for years. I suspected, though.

**LCD:** What about Sluggo? Was there a real Sluggo?

**NANCY:** No. I was far too young to be seeing anyone. I was a shy child with no friends. Sluggo was Nancy with no hair and a different nose. I think Sluggo was based on Mr. Bushmiller more than anyone else. At a certain point, after I had become a woman, he developed a crush on me—Mr. Bushmiller, not Sluggo. I think Sluggo was his way of having a relationship with me because I wasn't interested in him. He was much older than me.

**LCD:** When was the last time you spoke to Ernie?

**NANCY:** He phoned me a few months before he died in 1984. He called me his "Alice." It wasn't until a few years ago I realized what he meant. I thought he was talking about "Alice" the waitress on that TV show.

**LCD:** Thank you so much.

**NANCY:** Thank you. Goodbye.

1953: Gumby debuts

March 3, 1873: U.S. Congress adopts Federal Anti-Obscenity Act, banning from the mails "every obscene, lewd, lascivious or filthy book, pamphlet, picture, paper, letter writing, print or other publication of indecent character."

WRITTEN BY **EL BRENDEL**

# THE SCALE OF FUNNY

**REALLY FUNNY** ............ Steve Allen

Dick Butkis—the funniest name in sports

............ Earth Shoes

**ALWAYS GOOD FOR A LAUGH**
... James Earl Jones doing anything

............ Animals in human clothing

... Mt. Rushmore

......... 1920's Football Helmets

.... Davy Jones ............ Hindenburg Disaster

......... Fluids up the nose ............ Fart Noises **BRAP**

**COULD GO EITHER WAY**

............ Wedgies

......... Jandek ......... Nancy Walker

......... Parrot Jungle

**PLAYED-OUT PLATEAU**
... Leslie Nielson

......... Spinal Tap Jokes **Spinal Tap** ™

**NOT REALLY THAT FUNNY**

......... Plate Jugglers

......... Comic Strips in Village Voice

... Subway Ads (Except Dr. Tushe which is always good for a laugh)

......... Hand Buzzers

......... Cher

... Pantomine Horses

COPYRIGHT 1993
MATT GROENING

... Zappa ............ The Scale of Funny

... Woody Guthrie

......... Flying Saucer Records (i.e.: "Mr. Jaws," "Watergate," etc.)

**PAINFUL SUB-SCALE**
... Senor Wences

......... Bongwater

**WORSE THAN ZIGGY**

......... Bob Hope

**UNFUNNY** ......... Keith Haring

......... Steve Allen

ART BY **SCOTT MACNEILL**

69

# RRREAL KILLER, MONSTER PUNK GARAGE MUSIC

*by Bill Kelly*

"...MAH BABY DOES the ◎*@ ⊗✴★:⦂"

LVS 93

Everybody out there in radio land with WFMU (World's Finest Musical Underground) punched in on the car's dashboard has probably realized by now that I'm more than just a fan of KILLER, MONSTER PUNK GARAGE MUSIC from the hoary 1960s. In any event, I'd be willing to bet that there is more than just ephemeral interest in some of you big shooters regarding which classic punkers made wavy gravy on the Billboard charts back then. At least I've deluded myself into thinking that. This treatise is an attempt to define what exactly constitutes killer, monster punk garage music from the golden age of rrreal rock & roll.

First of all, *killer punk only came out between 1964 and 1967*. Once the Summer of Love had addled the minds of America's youth with psychedelic visions of utopia, punk garage music was having its death gurgle. By 1968, even late 1967, I'm hard pressed to find a rrreally snotty rekkid that could be legitimately classified as punk rock.

Secondly, I'm gleefully discarding most of what came out of England, except those cave dwelling Troggs. Let's face it, *the Brits just never got with the punk program*. They were too busy patting themselves on the back for their imagined superior musicianship. If it were not for that talented satanic weenie Jimmy Page, this misnomer would certainly have been seen for the ruse it most certainly was, since Page played lead guitar in the studio for just about every English band with a drum

set. Rightly so. The guy can flat out play. Forget the droning Led Zep crap we are all so hideously bored of. Jimmy Page is a guitar genius. But getting back to gleefully chucking the invasion bands, I'm sad to say that even the wonderful Kinks (Page played lead on their early hits), magnificent Animals (more Page leads), and the sacred early Rolling Brian Jones are being excluded. They are forever classified as British invasion, er...intrusion bands, not killer, monster punk, even if they may have been.

All of the great surf and hot rod music is being canned. That's a separate sub-group of rrreal rock & roll unto itself. *As perfect as the Byrds were*, I'm eliminating them as well since they fall into my definitions as a folk rock band, a genre they defined.

Now which American bands are killer, monster punk bands? Paul Revere & the Raiders? Nah! *Killer, monster punk rock was never recorded by guys in cute little tights*. I will make an exception with one or two of their rekkids, since every American band from L.A. to P-Town copied them. By the time "Kicks" came out, they were teeny bopper heart throbs, not punks. The Strawberry Alarm Clock? Maybe! Killer, monster punk bands are not usually named after gaily colored fruits. This was a tough call but "Incense & Peppermints" is a great rekkid, tainted by its having come out after the goofy Summer of Love and being the only rrreally cool song these guys ever made. Tommy James? Uh uh. If they

were really punks they would have sung "My baby does the sucky fucky." *Punks don't play kissy face with their dates.* They get tossed in jail on morals charges. How about the Beau Brummels? I love them as much as I love chocolate, but are they a punk band? I think not. This was a tough call as well, since I'd like to include them. They just were not grungy enough. The Boxtops? They hit the charts in late '67 with "The Letter" but made the mistake of using violins in its production. Real punks can't even spell violin. Sorry, Alex. The Vanilla Fudge Packers? You answer that one. The Soul Survivors? I say nay. *The Jefferson Airplane? Dirty hippies get beaten up by rrreal punks.* Gary Lewis? He's no more of a punk than Shari Lewis. Sam the Sham? Not by the hair of my chinny chin chin. The Ohio Express? Actually, I consider their first hit to be bona fide punk. It was all that other "Yummy Yummy," "Chewy Chewy" bubblegum crap that they'll be remembered for, though. Mitch Ryder? The only thing he ever did right was cover the Kingsmen. The Music Explosion? They were a punk band but "Little Bit of Soul" wasn't a punk rekkid. Call it Blue Eyed Soul, just like the Young Rascals's vinyl offerings. The Outsiders? They had a horn section, which is anathema to all self-respecting punks. Their lead singer, Sonny Geraci, later sang one of the wimpiest rekkids of all time, "Precious and Few" by Climax. I get hysterical blindness any time I even see it in an oldies store. The Grass Roots? Eat me. *The Turtles? Don't make me puke.* Enjoyable bands, not punk. The Five Americans? Yeah to their early releases. "Western Union," though, is no more of a punk rekkid than "Afternoon Delight" by the Starland Vocal Band. *The Human Beinz? No no no no no no no no no no no no no no no no no no no no no no no no no no no no.* How about the mysterious You Know Who Group? I know nothing of their origins. They may even be from England. I'm going to include them anyway, though, since they wore masks. After recording, it enabled them to knock off gas stations if they so desired. Now that's punk! And what about Them? I never considered them to be an English band, for good reason. They were from Ireland. Any nincompoop knows that Ireland is not a part of England, so I'll include them here.

In any case, my list of the top 91 killer, monster punk rekkids from those halcyon days of rrreal rock & roll is highly subjective and amorphous, but, hey, I've wasted over twenty five years thinking about this, so I like to presume that I know what I'm talking about. Either that, or I've become more delusional than usual.

# THE TOP 91 KILLER, MONSTER PUNK REKKIDS OF THE 1960S (ACCORDING TO BILLBOARD):

1. "Wild Thing"—The Troggs
2. "Incense & Peppermints"—The Strawberry Alarm Clock
3. "96 Tears"—? And the Mysterians
4. "Hang On Sloopy"—The McCoys
5. "Louie Louie"—The Kingsmen
6. "Surfin' Bird"—The Trashmen
7. "The Jolly Green Giant"—The Kingsmen
8. "We Ain't Got Nothin' Yet"—The Blues Magoos
9. "Psychotic Reaction"—Count Five
10. "Money"—The Kingsmen
11. "Fever"—The McCoys
12. "Little Girl"—The Syndicate Of Sound
13. "I Fought the Law"—The Bobby Fuller Four
14. "Gloria"—The Shadows of Knight
15. "Dirty Water"—The Standells
16. "Just Like Me"—Paul Revere & The Raiders
17. "I Had Too Much To Dream"—The Electric Prunes
18. "I Want Candy"—The Strangeloves
19. "Liar Liar"—The Castaways
20. "Let It All Hang Out"—The Hombres
21. "She's About A Mover"—The Sir Douglas Quintet
22. "Talk Talk"—The Music Machine
23. "Journey To The Center Of Your Mind"—The Amboy Dukes
24. "Double Shot Of My Baby's Love"—The Swingin' Medallions
25. "Little Latin Lupe Lu"—Mitch Ryder & The Detroit Wheels
26. "Farmer John"—The Premiers
27. "Lies"—The Knickerbockers
28. "I Need Somebody"—? And The Mysterians
29. "Shakin' All Over"—Chad Allen & The Expressions (A.K.A. The Guess Who)
30. "Come On, Let's Go"—The McCoys
31. "Here Comes The Night"—Them
32. "I See The Light"—The Five Americans
33. "Love's Made A Fool Of You"—The Bobby Fuller Four
34. "Get Me To The World On Time"—The Electric Prunes
35. "With A Girl Like You"—The Troggs
36. "Beg, Borrow And Steal"—The Ohio Express
37. "Land Of 1,000 Dances"—Cannibal & The Head Hunters
38. "Night Time"—The Strangeloves
39. "Bird Dance Beat"—The Trashmen
40. "The Rains Came"—The Sir Douglas Quintet
41. "Hey Joe"—The Leaves
42. "7 And 7 Is"—Love
43. "Mystic Eyes"—Them
44. "She's The One"—The Chartbusters
45. "Pushin' Too Hard"—The Seeds
46. "A Question Of Temperature"—The Balloon Farm
47. "Oh Yeah"—The Shadows Of Night
48. "Cara-Lin"—The Strangeloves
49. "Can't Seem To Make Up My Mind"—The Seeds
50. "Death Of An Angel"—The Kingsmen
51. "Roses Are Red My Love"—The You Know Who Group
52. "Sometimes Good Guys Don't Wear White"—The Standells
53. "I Can't Control Myself"—The Troggs
54. "Run Run Run"—The Gestures
55. "Little Latin Lupe Lu"—The Kingsmen
56. "Steppin' Out"—Paul Revere And The Raiders
57. "Shake"—The Shadows Of Knight
58. "One Track Mind"—The Knickerbockers
59. "Up And Down"—The McCoys
60. "Annie Fanny"—The Kingsmen
61. "Sugar And Spice"—The Cryan Shames
62. "My Little Red Book"—Love
63. "Evol, Not Love"—The Five Americans
64. "You Make Me Feel So Good"—The McCoys
65. "Why Pick On Me"—The Standells
666. "You're Going To Miss Me"—The 13th Floor Elevators
67. "Rumors"—The Syndicate Of Sound
68. "Are You A Boy Or Are You A Girl"—The Barbarians
69. "Can't Get Enough Of You Baby"—? And The Mysterians
70. "Pipe Dream"—The Blues Magoos
71. "Sunshine Games"—The Music Explosion
72. "The Climb"—The Kingsmen
73. "The People In Me"—The Music Machine
74. "Not Too Long Ago"—The Uniques
75. "Don't Worry Mother, You Son's Heart Is Pure"—The McCoys
76. "It's Cold Outside"—The Choir
77. "I Got To Go Back"—The McCoys
78. "Gloria"—Them
79. "Wait A Minute"—Tim Tam And The Turn-Ons
80. "She Drives Me Out Of My Mind"—The Swingin' Medallions
81. "Little Miss Sad"—The Five Emprees
82. "A Thousand Shadows"—The Seeds
83. "Killer Joe"—The Kingsmen
84. "Can't Help But Love You"—The Standells
85. "Stop And Get A Ticket"—The Clefs Of Lavender Hill
86. "I Confess"—The New Colony Six
87. "I Still Love You"—The Vejtables
88. "The Little Black Egg"—The Nightcrawlers
89. "I Wanna Meet You"—The Cryan Shames
90. "Mr. Farmer"—The Seeds
91. "Omaha"—The Moby Grape

## WHAT IS NEW JERSEY'S WORST FEAR?

HERE WE GO WITH OUR FIRST (AND LAST)
# L.C.D. FOLD-IN
People in different areas of the country have
different natural disasters to worry about:
floods, earthquakes, hurricanes, tornadoes, etc.
To find out what's disturbing Garden Staters,
fold in the page as shown.

**FOLD LIKE SO**

FOLD SO "A" MEETS "B"   A▶                                        ◀B

DESPITE ANY AND ALL POSSIBLE PRECAUTIONS, BAD
THINGS HAPPEN EVERYWHERE, EVERY DAY.
AFTERWARDS, WE ALL MUST REBUILD AND REPAIR

ARTIST & WRITER:
WAYNO

A▶                                                      ◀B

May 28, 1959: U.S. Army launches monkeys Able and Baker into space.

Here's another true story from my pathetic show business career. This one is about Don McLean. You know, the "American Pie" guy. And why I think he's an asshole. And why you should, too.

I started out as a folkie. I thought I was Bob Dylan. None of my so-called friends had the fucking courtesy to tell me I wasn't Bob Dylan. Anyway, I figured what I needed was a big-time show biz manager, so I sent out a bunch of demo tapes. And it worked—I got a call from a guy named Herb Gart.

Herb was well-known in folk circles. He used to manage a bunch of big-name acts, like the Youngbloods and Janis Ian. But everyone gradually left him. When I signed with him in 1979, he had only one semi-famous star left in his roster: Don McLean.

GARY LEIB

# Why I Don't Play "American Pie" on My Show
### by Andy Breckman

Don McLean was already old news here in the States. But they still loved him in Norway. Go figure. And Israel. And Canada. In the spring of 1980, McLean was scheduled to do a ten-city tour of western Canada. Herb arranged for me to go along as the opening act.

On tour with Don McLean! It was the biggest thing that ever happened to me. I fantasized about hanging out with him. And co-writing with him. And becoming sort of his protégé.

But my dream tour was a disaster and I'll tell you why: Don McLean—Mr. "Starry Starry Night"—Mr. "And I Love Her So"—turned out to be the most bitter, petty, insecure scumbag I ever met.

The tour started like this: we were on the plane. McLean glanced out the window. He said he saw a shooting star. I said make a wish. He said "I did, but it didn't work. You're still here."

It was downhill from there. During the day, McLean complained constantly. He humiliated Ray, our tour manager. He mocked "lesser" singer-songwriters, like Bob Dylan and Bruce Springsteen. At night, he picked up young, woeful-looking Canadian folk groupies and brought them back to his room for what he called "dick autographs."

He wasn't just bitter. He was nuts. I mean certifiable. For example, he had a lame movie idea. He wanted to play a singing cowboy, like a modern-day Roy Rogers. And he would fight crime.

Then he remembered something. He had recently done the music for a movie called *Fraternity Row*. While he was on the set, he had met John Ritter and mentioned his "singing cowboy" idea. McLean became obsessed: what if Ritter stole the idea?

For two days, it was all he talked about. John Ritter stealing his stupid idea. Should he have a lawyer write Ritter a threatening letter? Is there a way to backdate a copyright? It was spooky. His obsession wasn't based on anything. He had only met Mr. Ritter once. And Ritter never expressed any interest in the idea. I was on tour with Norman Bates's older brother.

The nightmare continued. One morning in Calgary, I met McLean in the lobby of our hotel. He had bought a local paper, and was reading a review

of our show. But he wouldn't let me see it. All he said was, "Well, they hated us." Then he crumpled up the newspaper and threw it away.

After he left, I fished the paper out of the garbage. It's true, the reviewer did hate McLean. He called McLean pompous and out of touch. But the reviewer LOVED the opening act! It was one of the first rave reviews I'd ever gotten, and McLean didn't want me to see it.

Every night, during my set, as a joke, I sang a couple of verses of "American Pie." Then I said, "Gosh, I hope Don hadn't planned on singing that one." It always got a huge laugh. I asked Don if he minded the joke. He said he didn't.

But I guess he did. On the last show of the tour, I was introduced as "Don's special guest." I came out. I did my set, including my little "American Pie" joke. Then McLean came out. I sat in the back of the auditorium and watched. McLean ended the show by saying, "Thank you. I'll be back next year. And I won't be bringing my special guest."

The crowd gasped. Try to imagine it: the headliner at a folk concert—for no apparent reason—putting down his opening act from the stage!

I was devastated. I confronted McLean backstage. Why would he say such a thing? He just snapped, "You play with me, you play with fire—and you just got burned." Then he walked away. I still don't know what the hell he meant.

The tour ended. After that, I avoided ol' Don like the plague. In the '80s, the music community mounted a string of mega-concerts for various causes—*Live Aid*, *We Are The World*, etc. Herb Gart put out the word: Don McLean was available. But the phone never rang. Herb and Don couldn't understand it. But I did. It was the Asshole Factor. Nobody could stand the guy.

I know what you're thinking: "Okay. I'm convinced. Don McLean's a one-hit schmuck. What am I supposed to do about it?" Well, you can't kill him. That would be wrong. And expensive. But you can spread the word. So the next time you're playing Trivial Pursuit—the "Special Has-Been Edition"—and Don McLean's name is mentioned, do me a favor. Say, as authoritatively as you can,
"I heard he's an asshole."
I'd appreciate it.

The preceding article was taken from *LCD*, issue number 16, May 1994.

In May 2004, Don McLean asked us to post this response:

## My Belated Response to Andy Breckman's article: "WHY I DON'T PLAY AMERICAN PIE IN MY SHOW"

I only saw this stupid piece by Mr. Breckman last week, but I guess it's been around for quite some time. I hope this will follow it wherever it goes in the future, in order to assure that certain factual errors do not become urban legend.

First: I never met John Ritter in my life. I enjoyed his comedy, loved his father's films and was shocked at his premature death.

Second: I have never put down Bob Dylan. I have followed Dylan's career since I first saw him at Carnegie Hall in 1962 and have always found him to be an inspiration.

Third: My career has been a wonderful gift which has lasted 35 years and counting. If Mr. Breckman wishes to get those facts straight he can find out whatever he needs to know by looking me up in "Who's Who in America" or "Who's Who in the World." Mr. Breckman's name will not be found there.

Finally: I need to set the record straight about how Andy got on my shows in Canada all those years ago. Mr. Gart (a very ex-manager) did not "arrange" to have him open my shows, although that was what he was told. I was played a tape of Breckman's songs and thought they were brilliant. I could feel the comic talent he had and the wit. I knew Andy came to Gart's office because he admired me and I wanted to give him a break by letting him open.

Nobody opens my show without my permission but it goes farther. I did not need an opening act who was a complete unknown and never sold a ticket. In order to put him on my show he had to be paid out of MY FEE. I wonder if Andy Breckman realizes that any time he was on my show it was because I wanted it and often took a fee reduction in order to make it happen. Little did I realize until I got around this guy a little bit that he was a thin-skinned egomaniac and a dreadful stage performer. Maybe he could have had a career in Winnipeg where they liked him.

Anyway, things went downhill, and I disliked Breckman for precisely the type of low blow remarks in this piece. It's like I have my own Mark David Chapman but without the balls, since it took scared little Andy seventeen years to get up the nerve for character assassination. There's something very tattle-tale about all this, but he still seems to be what I thought he was, a dufus.

A dufus is very high school, just like Andy. So let's all hope that cowardly little Andy Breckman will save all his T.V. money and invest it in a good therapist to help him get over the realization that even when people admire his talent, they will secretly think he's "such a dufus."

SINCERELY, DON McLEAN

December 3, 1901: Walt Disney born

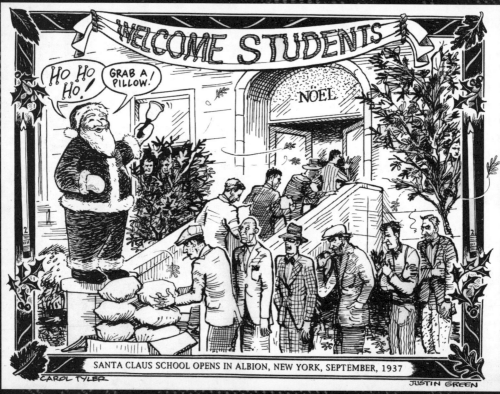

1937: School for Santa Clauses opens in Albion, New York

by Chris T.

*Illustrations by Jim Blanchard*

## ALAN BERG

On June 18, 1984, radio talk-show host Alan Berg was machine-gunned into infamy in the driveway of his suburban Denver townhouse. Berg, whose life and violent death inspired Eric Bogosian's play (and Oliver Stone's ham-fisted movie) *Talk Radio*, was verging on national prominence, having recently been profiled on *60 Minutes* and selected by his employer, KOA-AM, to cover the Democratic National Convention in San Francisco.

A self-proclaimed "Wild Man of the Airwaves," the controversial, belligerent Berg managed to enrage, abuse, provoke and fascinate—insulting and cutting off his callers while carrying on irreverent and frank discussions about oral sex, Christianity, racial intolerance, gun control, and any other topic his angry, abrasive tongue could wag about.

KOA's powerful signal, capable of reaching thirty-eight states in the evening hours, meant Berg's blitzkrieg was pissing off a lot of people. In 1979 while working at KWBZ, a listener named Fred Wilkins, a local head of the KKK, stormed into the air studio and told Berg to prepare to die. Berg informed his listening audience that Wilkins had pointed a gun at him, but Wilkins—arrested and charged with felony menacing—claimed Berg was just trying to up his ratings.

Also trying to up their "ratings" and come to national prominence were the members of "The Order," a virulent white power/Aryan Resistance movement ranging throughout Colorado and the Pacific Northwest and affiliated with the Aryan Nations. Created and led by separatist/survivalist Robert Jay Matthews,

"The Order" took as its blueprint and manifesto William Pierce's *The Turner Diaries* and had assembled a "hate list" of those who were deemed to be threatening the existence of the white race and worthy targets for assassination. Among them were Henry Kissinger, David Rockefeller, Fred Silverman—and Alan Berg. Berg's assassination was a carefully planned, paramilitary operation funded with bank robbery proceeds. "The Order" self-destructed after coming up against a much more powerful military operation, the FBI.

Alan Berg

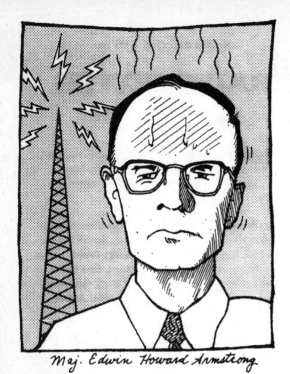

Maj. Edwin Howard Armstrong

# MAJOR EDWIN HOWARD ARMSTRONG

If you head north on Route 9W to the Cresskill/Dumont line you'll see, rising four hundred feet above the Palisades of Alpine, Major Edwin Howard Armstrong's grave marker. It is the antenna tower of the first-ever FM station, W2XMNF, erected in 1936 and now crowded with satellite dishes and aerials receiving and relaying all manner of television, cellular, and microwave signals. And a lone FM station, WFDU, out of Farleigh Dickenson University.

It was in the basement of another university, Columbia, that Maj. Armstrong (he served in the newly formed Signal Corps in World War I) pioneered an entirely new form of broadcasting: static-free, crystal clear, high-fidelity Frequency Modulation. It was the crowning achievement in a life devoted to radio and broadcasting. He single-handedly wrenched radio out of the crystal-set/headphone era with his discovery of regeneration and super-regeneration—principles which utilize feedback to amplify and strengthen weak signals. He developed the superheterodyne—an incredibly sensitive and selective type of receiver—for the Army. He fought lengthy,

expensive patent battles over most of his invention against those hoping to discredit him and profit from his genius. And there was FM.

It should have made him incredibly wealthy, it should have eradicated AM and become the broadcasting medium. It should have made him a household name like Edison. But Armstrong hadn't counted on corporate greed, the profit motive, and the Radio Corporation of America. RCA, a corporation engineered by the government for the purpose of developing the fledgling U.S. broadcast industry (then at the mercy of foreign concerns, like the British Marconi Co. and others) by pooling the important patents of AT&T, Westinghouse, and General Electric, was not about to turn its attention away from its new infant—television. David Sarnoff, a twenty-five-year friend of Armstrong's and the president of RCA, cut Armstrong off from the only company large enough to give FM the send-up it needed. And then the real troubles began.

Plagued by endless patent suits, struggling to keep FM alive, Armstrong began pouring his own money into research, development, and refinement. He put the Alpine station on the air. He presented speeches and prepared papers for assorted engineering and broadcasting societies. He sat before numerous government hearings, bought many a lawyer's summer home and continued his obsessive quest to bring FM to the people, through a second World War and into the postwar years. He waited patiently for what should have been the explosion of FM but for one thing—the FCC. One of their engineers, and Alexander Ring, recommended a frequency shift for FM to "protect" it from sunspot interference. He incorrectly predicted it would become a problem every eleven years or so. On the flimsiest of pretexts the whole FM band was ordered to move "upstairs" from 42 to 50 MHz (its home of more than ten years) to its current position of 88-108 MHz. This had the effect of nearly killing the new industry, making fifty or so transmitters and 500,000 radio sets obsolete overnight. It was just one more blow for the clear-thinking, logical, and soon-to-be-destitute Armstrong.

Twenty-three years to the day after patenting FM, Maj. Armstrong put on his hat, coat, scarf, and gloves, and walked out his apartment window, thirteen floors to his death.

# UPSIDE DOWN & DIZZY

PART II

© 90 MICHAEL DOUGAN

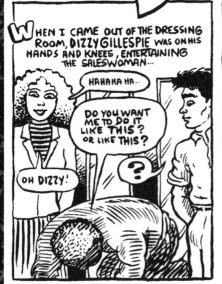

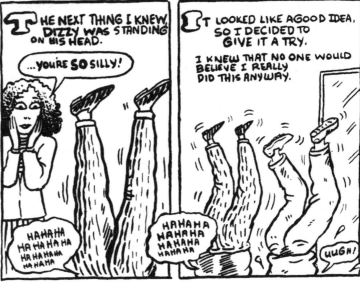

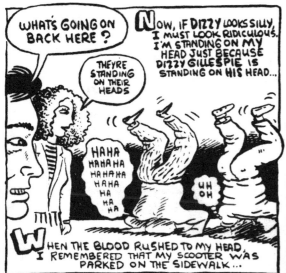

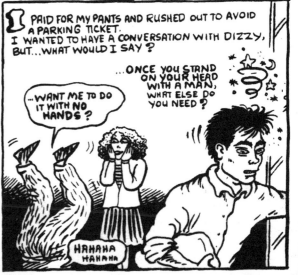

# The Laws of Unemployment

*by Bronwyn Carlton*

Like most DJs at WFMU, I'm usually unemployed. I just spent two years without a job, and it wasn't easy. I'm bright, likable, talented—people were *always* offering me work. But like the Eddy Lawrence song says, "I'm not looking for work, I'm looking for money." Over the years I've developed a nearly foolproof system that keeps me at leisure for months at a time.

I discovered the Laws of Unemployment when I first graduated from college. I'd been a DJ on our school's 10-watt (smaller than a lightbulb!) station for three weeks; I played nothing but bagpipe music and because record albums all have that blank space between cuts, I thought the idea was to leave some dead air between each song. After my third show the station manger made me news director to get me off the air. (As news director, I mostly worked with my cartoonist boyfriend to paint a mural of Aztecs pulling snakes out of buckets on the wall of the station manager's office.) At the time I graduated, there were approximately twelve openings in the entire country for beginners in broadcast journalism, and about 126,590 applicants for each job. These were the jobs I went after, a perfect example of both RULE NO. 1: APPLY ONLY FOR JOBS FOR WHICH YOU ARE NOT QUALIFIED and CORROLLARY A: APPLY ONLY FOR JOBS IN OVER-CROWDED FIELDS.

My closest brush with employment came when I responded to a newspaper ad placed by a radio station in Klamath Falls, Oregon. After a couple of weeks the station manager called me up and had me make an audition tape over the phone. He asked me to talk about what I was wearing, and he taped me, and then he said he figured I should come down from Portland for an interview. It cost $27.70 for a round-trip bus ticket to Klamath Falls. I estimated the cost of a motel room, taxis, and food for two days to be about $40. The next day I took sixty of my last seventy dollars in the world and left town. I got into Klamath Falls at midnight.

People who have never been to Klamath Falls probably will find it hard to imagine what it's like. I didn't see any taxis when I got off the bus, so I just started walking around with my suitcase. There was a big hotel about five blocks from the depot, and the door was unlocked so I went inside. It was completely deserted, which I guess explained why none of the lights were on. I started feeling creepy, so I headed back to the bus depot. Just outside the entrance, I was accosted by a horribly disfigured woman. Her face looked as if it had melted in a fire.

"Are you the girl who was looking for a taxi?" she leered.

"Uh, no," I said. "That wasn't me."

"Well, I'm the taxi driver," she announced, waving a scar-encrusted flipper at a yellow cab idling at the curb. "You'd better come with me. You're not safe out here by yourself."

I didn't know what else to do, so I threw my suitcase into the back seat and climbed in.

"I don't know where you're going to stay tonight," Mrs. Scarface muttered as we cruised by the big abandoned hotel. I told her I'd gone into the hotel and had been surprised to find it deserted. She braked the car in the middle of the street and turned to stare at me. "You went *in* there?" she gasped. I said yes, and she just looked at me. Finally we started back down the street.

There are a number of hotels in Klamath Falls, none of which answer their night bell after 10:00 PM. As we drove from place to place, looking for a room for me to rest up for my important morning interview, Mrs. S asked me about myself, where I was from, what I was doing there. Several times she alluded to "trouble" in town, but I never did find out what she meant. Finally, when we tried every

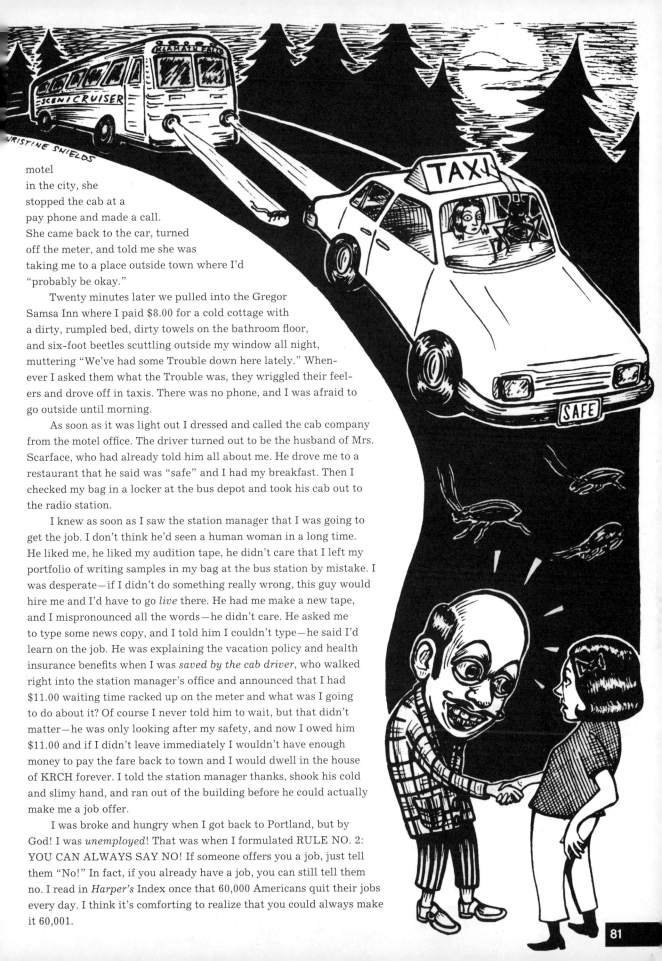

motel
in the city, she
stopped the cab at a
pay phone and made a call.
She came back to the car, turned
off the meter, and told me she was
taking me to a place outside town where I'd
"probably be okay."

Twenty minutes later we pulled into the Gregor
Samsa Inn where I paid $8.00 for a cold cottage with
a dirty, rumpled bed, dirty towels on the bathroom floor,
and six-foot beetles scuttling outside my window all night,
muttering "We've had some Trouble down here lately." When-
ever I asked them what the Trouble was, they wriggled their feel-
ers and drove off in taxis. There was no phone, and I was afraid to
go outside until morning.

As soon as it was light out I dressed and called the cab company
from the motel office. The driver turned out to be the husband of Mrs.
Scarface, who had already told him all about me. He drove me to a
restaurant that he said was "safe" and I had my breakfast. Then I
checked my bag in a locker at the bus depot and took his cab out to
the radio station.

I knew as soon as I saw the station manager that I was going to
get the job. I don't think he'd seen a human woman in a long time.
He liked me, he liked my audition tape, he didn't care that I left my
portfolio of writing samples in my bag at the bus station by mistake. I
was desperate—if I didn't do something really wrong, this guy would
hire me and I'd have to go *live* there. He had me make a new tape,
and I mispronounced all the words—he didn't care. He asked me
to type some news copy, and I told him I couldn't type—he said I'd
learn on the job. He was explaining the vacation policy and health
insurance benefits when I was *saved by the cab driver*, who walked
right into the station manager's office and announced that I had
$11.00 waiting time racked up on the meter and what was I going
to do about it? Of course I never told him to wait, but that didn't
matter—he was only looking after my safety, and now I owed him
$11.00 and if I didn't leave immediately I wouldn't have enough
money to pay the fare back to town and I would dwell in the house
of KRCH forever. I told the station manager thanks, shook his cold
and slimy hand, and ran out of the building before he could actually
make me a job offer.

I was broke and hungry when I got back to Portland, but by
God! I was *unemployed*! That was when I formulated RULE NO. 2:
YOU CAN ALWAYS SAY NO! If someone offers you a job, just tell
them "No!" In fact, if you already have a job, you can still tell them
no. I read in *Harper's* Index once that 60,000 Americans quit their jobs
every day. I think it's comforting to realize that you could always make
it 60,001.

81

June 10, 1946: Bikini introduced.

MICHAEL MCMAHON, TEXT BY DOUG SCHULKIND

January 11, 1964: Go-go culture is born as Whiskey A Go-Go opens.

LYNNE VON SCHLICTING, TEXT BY DOUG SCHULKIND

# THE MYSTERY is SOLVED!

## WHO REALLY KILLED J.F.K?

©THE Feinberg CONSPIRACY THINK TANK INC.

SINCE THAT TRAGIC DALLAS DAY IN NOVEMBER 1963, MANY CONSPIRACY THEORIES HAVE CIRCULATED ABOUT PRESIDENT KENNEDY'S TRUE KILLERS...

I NEED THIS TRIP LIKE I NEED A HOLE IN THE HEAD...

## THE MOB

DIS'LL TEACH HIM AN' HIS NOSY LITTLE BRUDDA TA POKE AROUND IN OUR BIZNIZ...

## THE CIA &/OR FBI

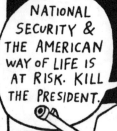

NATIONAL SECURITY & THE AMERICAN WAY OF LIFE IS AT RISK. KILL THE PRESIDENT.

...DAMN PLAY BOY

## CASTRO & THE COMMIES

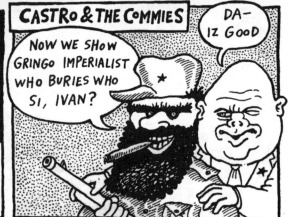

NOW WE SHOW GRINGO IMPERIALIST WHO BURIES WHO SI, IVAN?

DA-IZ GOOD

## L.B.J.

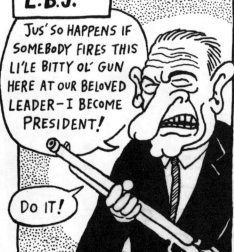

JUS' SO HAPPENS IF SOMEBODY FIRES THIS LI'LE BITTY OL' GUN HERE AT OUR BELOVED LEADER—I BECOME PRESIDENT!

DO IT!

## The SHOCKING TRUTH:

BY PUBLICLY FORSAKING TRADITIONAL MENS' HEADWEAR, THE TREND-SETTING YOUNG PRESIDENT CAVALIERLY INCURRED THE WRATH OF THE POWERFUL HAT INDUSTRY, WHOSE SALES PLUMMETED AS AMERICAN MEN ADOPTED KENNEDY'S CHAPEAU-LESS STYLE... THE HAT LOBBY'S BRUTAL SOLUTION TO THE CRISIS: **ASSASSINATION!**

1,000 STAMPS

JOHN F. KENNEDY

OBVIOUSLY, THE HABERDASHER'S EVIL SCHEME TO REVERSE FASHION HISTORY FAILED MISERABLY, LEAVING BEHIND ONLY A BEWILDERED NATION OF SILLY BASEBALL HAT WEARERS (WHICH DON'T COUNT AS **REAL** HATS.)

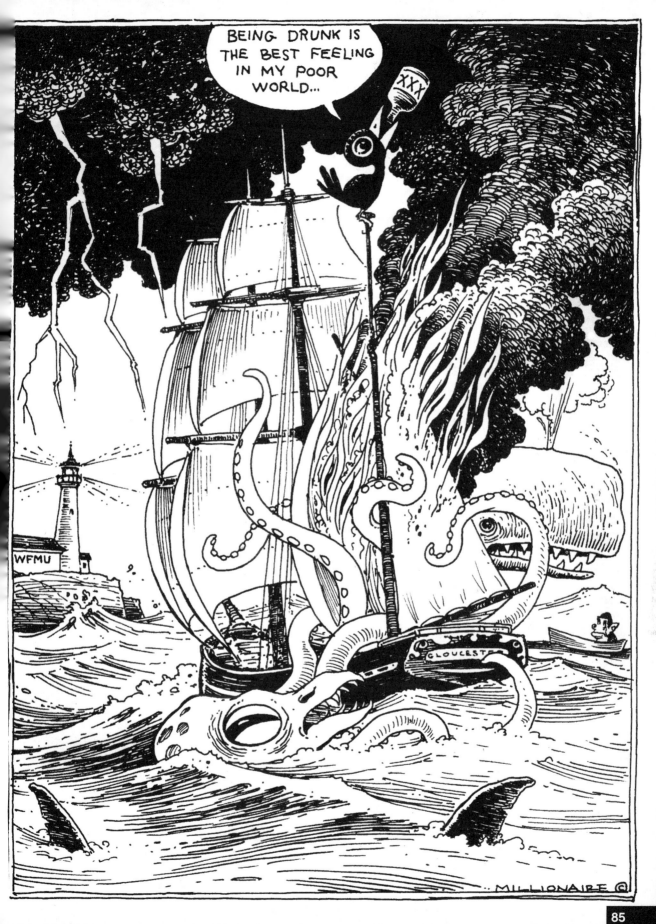

# And Now...

## Our Future Presentation

*Illustrations by Ned Sonntag*

**Luc Sante — The Cinema of Tomorrow!**

**Surveillance camera videos** of famous people in their own homes will be sold by the millions on the black market.

There will be an unexpected revival of **sing-along shorts** preceding the main feature; urban audiences will trill with particular vigor.

In big cities **there will be theaters that specialize in showing movies backwards**, speeded up, blurred, or upside-down. They will win a small but devoted cult following.

**A religion will arise** that will treat the contents of all Hollywood musicals as literal truth.

**Urban centers** will be so clogged with buildings that midtown hotels will dispense with windows altogether, replacing them with continuous videos of idyllic landscape in every room.

People will become **connoisseurs of end credits** and will avidly discuss the shifting careers of their favorite best-boy grips and optical-printing technicians.

Alternative film industries will spring up all over the place, especially in Middle America, where **right-wing Christian studios** will turn out features largely for Third World distribution.

Movies of **strictly local significance** will be made in waysides all over America, so that, for example, a heroic fiction loosely based on the life of Joe Doakes, mayor of Frog Flats, will be a hit within a twenty-mile radius of the county seat and completely unknown anywhere else.

It will be illegal to show weapons on the screen, and during fight scenes in movies, combatants will slug each other with foam-rubber bats.

**Powerful projectors** will be employed to show movies on low cloud cover as a public service. There will be a Fauve school of movie-makers who will deliberately use the "wrong" colors in their prints. They will also discard continuity, and they will issue manifestos.

**Condensed versions** of popular films will be made especially for the harried business-man market; they will gain a following among schoolchildren, who will view them in lieu of the full-length versions as a shortcut on homework.

Someone will successfully revive the doctors and nurses genre.

**Very short movies** will become popular again, and theaters will program stacks of two reelers for the first time since the early 1920s. Ticket prices will vary according to time consumed: spectators will be given stamped chits upon entering and, as in parking garages, will be charged, say, $5 for the first hour and $1.50 per additional thirty minutes.

The most widely popular movies will feature casts of **domestic animals dressed as humans.**

**Plot will be considered a highbrow affectation,** and the mass audience will revel in two-hour spectacles of people eating potato salad and comparing their operation scars.

**Entrepreneurs** will buy the rights to old movies, and re-release them with "bridging scenes" featuring hit tunes, late-model cars, and dialogue concerning laudable hygiene practices, for contemporary relevance.

**A neo-neo-Realist movement,** which will take hold in Europe and spread to the United States, will consider it de rigueur to show booms, stands, flags, clappers, cords, and suchlike in every frame. Movies will go the way of the steam engine and the clothes ringer, and in theaters the light from the projectors will be used for hand shadow displays.

Whole movies will be made in which everyone **talks in rhyme.**

**Bootleg versions** of Hollywood movies will circulate that will be cobbled to-gether from unused takes and will feature slipshod acting and equipment lapses. They will win an eager market.

**Movies will mysteriously appear** that have no credits at all, and people will feel strangely compelled to see them over and over again.

**Leading roles in Hollywood productions will be sold to the highest bidder,** and movie after movie will be released featuring hith-erto unknown real estate speculators and food substitute magnates limping and gag-ging their way through their scenes.

Slide inserts will be available for automobile headlights so that the beams will project alluring pinups onto the nocturnal landscape.

87

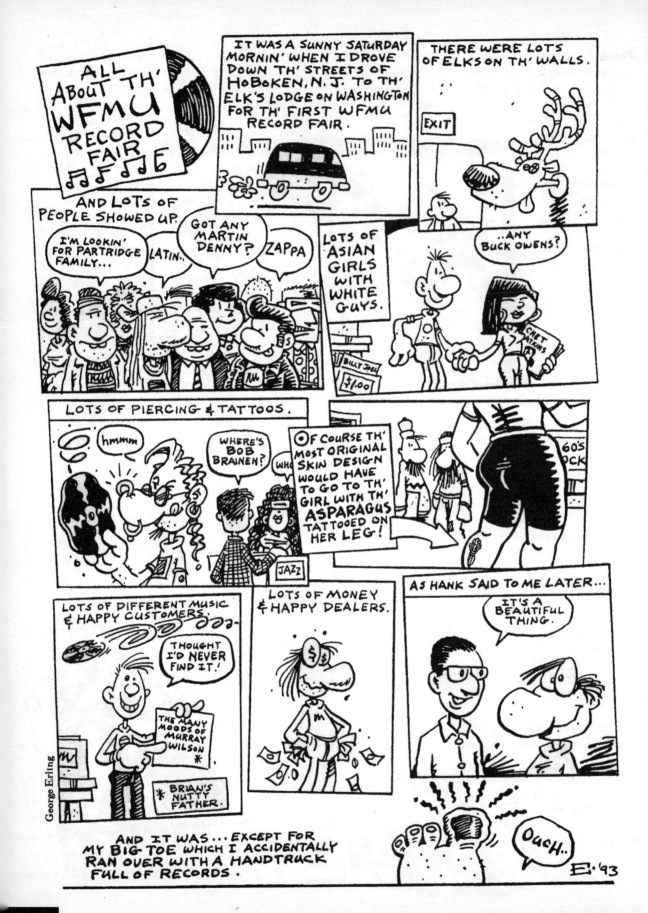

December 25, 1924: TV Pioneer Rod Serling submits himself for your approval.

January 13, 1962: TV comedy pioneer Ernie Kovacs totals Corvair and himself.

*by Kenny G.*

# May We Graft Chicken Wings to Your Head In The Interest of Aviation?

## The insane (but hilarious) minds of Coyle & Sharpe

James P. Coyle and Mal Sharpe hit the streets—and local radio—of San Francisco in the fall of 1963. Dressed as clean-cut, IBM-executive types, they lugged around one of those clunky "portable" reel-to-reel tape players and inflicted a hilarious brand of man-on-the-street interviews on an unsuspecting public. Their straight appearance a ruse, they would pull in unwitting passers-by to answer their ultimately absurd questions, often con-vincing the victim to do something as outrageous as agreeing to commit murder or rob a bank.

It's incredible now to hear the gullibility of these people—you think, it just couldn't happen today; people are too cynical and paranoid. But it was a different time in America: the post-Eisenhower/pre-Vietnam Cold War period. At that time, the only really "alternative" thing the media was picking up on was the Beats; the hippies were still several years away. Coyle and Sharpe were not hanging on the Beat Scene; rather they lived in a residence house on Russian Hill where they met in 1960, and spent their days doing recorded put-ons that verged on conceptual performance art. In a sense, what they were doing was a dark and twisted audio version of *Candid Camera*.

James Coyle was a professional con man who had, according to Mal Sharpe, talked his way into 160 jobs by the time he was twenty-four and taken none of them; the simple act of getting the job was enough. Mal Sharpe had arrived in San Francisco from Boston, a communications major bumming around the Bay Area, when he fell under Jim's persuasive spell. Soon enough, they were out on

the streets with a hidden microphone honing what was to become a paying gig. In 1963 they were contracted by radio station KGO to come up with three hours of material five days a week to be broadcast that very same night. The result was spontaneous radio, the likes of which is unknown today. Each morning they would meet at a coffee shop and brainstorm the day's ideas. They would look at everyday objects around them and invent absurd situations: a lamp would become "a human lamp post," a chicken wing on a plate would become something grafted to a person's head "in the interest of aviation," and so on, until they were ready to go out on the streets seeking their "victims." (Jim's widow, Naomi, has told me that their victims were carefully selected—usually by their shoes!) At the end of the day, they would turn their tapes into the station where they would be broadcast that evening up and down the West Coast.

Admittedly, a lot of what they did was sheer hassle for hassle's sake. They spent their days roaming the city, looking for people to bother wherever they went. There is one interview in which they approach a gentleman sitting leisurely under the shade of a tree on a lovely fall afternoon. As the leaves begin to fall from the tree, they accuse the man of being anti-arboreal and an enemy of nature, a claim that he adamantly denies. More arguing ensues and in his characteristically brilliant manner, James Coyle forces the conversation to the point where the man has been accused, tried, and found guilty of arboricide. His sentence is to have to endure the

abrasiveness of Coyle and Sharpe. In another situation, they walked onto a construction site and with no idea in mind, found a carpenter eating a sandwich for lunch—whereupon they insisted that the man give them a bite of his sandwich. Surprisingly enough, the confrontations rarely came to blows, as Coyle and Sharp would defuse the interview by saying, "May we tell you something? This is all in the interest of humor!" whereupon all would laugh and recall what was going through their minds during the interview as if they were old friends.

Sometimes the work is chilling. In one scene, they try to convince a passer-by to make a phone call for them and say, "We have little Jimmy Jones here with us and we'd like to arrange a meeting..." There is a lot of work involving cults, conspiracy theory and political revolution that all too unfortunately came to pass in the following quarter of a century.

In addition to street interviews, Coyle and Sharpe also did several studio pieces, small bits of Dadaist/Surrealist humor that went over everybody's heads. (Listening to them today, they strike me like sound poems/Zen *koans*; I can't imagine what the average AM listener made of them thirty years ago!) Over the course of time, they developed threads running through the work that evolved into elaborate political conspiracy theories and included and cast of characters such as: Mayor Harry Kodiak, his arch nemesis Chancellor Eric Argyle, Repugno and his child the filthy Baby Rasputin. These imaginary beings were involved in a series of kidnappings, murders, political upheavals and power struggles centering around the L.A. Invasion (a fictitious war between San Francisco and Los Angeles led by Field Marshal Coyle and Field Marshal Sharpe.) Of course, the average citizen on the streets of San Francisco became involved in the struggle and was asked to take sides and perform absurd tasks for the cause. Much of this work predated and influenced Bay Area artists like Negativland and Survival Research Laboratories, as well as The Firesign Theater. It is also possible to see their influence in David Letterman's humor as well as (for better or worse) the Jerky Boys.

Things started to pick up for Coyle and Sharpe around 1964. Their radio show was gaining national attention to the point where they were featured in a *Newsweek* article. Then came the recording offers—they released two albums for Warner Bros., *The Absurd Imposters* and *The Insane But Hilarious Minds of Coyle and Sharpe*. Following a move to Los Angeles, the duo made a television pilot called "The Imposters": a series of street interviews and set-up situations where they busted people's balls (tennis great Pancho Gonzales being one of them). However, these guys were essentially artists and they resented the influence and control that the "Hollywood Mafia" wanted to assert on their work—and to be honest, Hollywood wasn't exactly crazy for them either; they were too "weird." One day Jim Coyle just up and split. No one knew where he went and even Mal Sharpe was not to find out what happened until fifteen years later when they finally spoke. Hollywood was nauseating Jim, so he and his wife moved to New York where they waited for his father to die so they could inherit some money. After this happened, they moved to Austria and finally settled in Cambridge, England, where they lived quietly for years reading the classics and listening to Wagner, Mahler, and Bach. Jim died in 1992 of complications arising from diabetes. Mal Sharpe stayed in Los Angeles and began a career in radio, which he continues to this day. He moved back to San Francisco and found an interest in Tibetan Buddhism. Mal has continued his man-on-the-street work, often with a more humorous, philosophical, and gentle bent.

Listening to Coyle and Sharpe is a bit like traveling to a foreign land—suddenly everything you know is wrong, and it's up to you to question and reinvent attitudes you have, complacently, long taken for granted. A mirror is held up to our seemingly random and absurd societal conventions; they make us question what we call "common sense" and "everydayness" in a way that "high" art, cinema, and literature are capable of. In their unsuspecting victims, we squirm in sympathy as we see more than a bit of ourselves reflected, uncomfortably laughing along, of course, "all in the interest of humor."

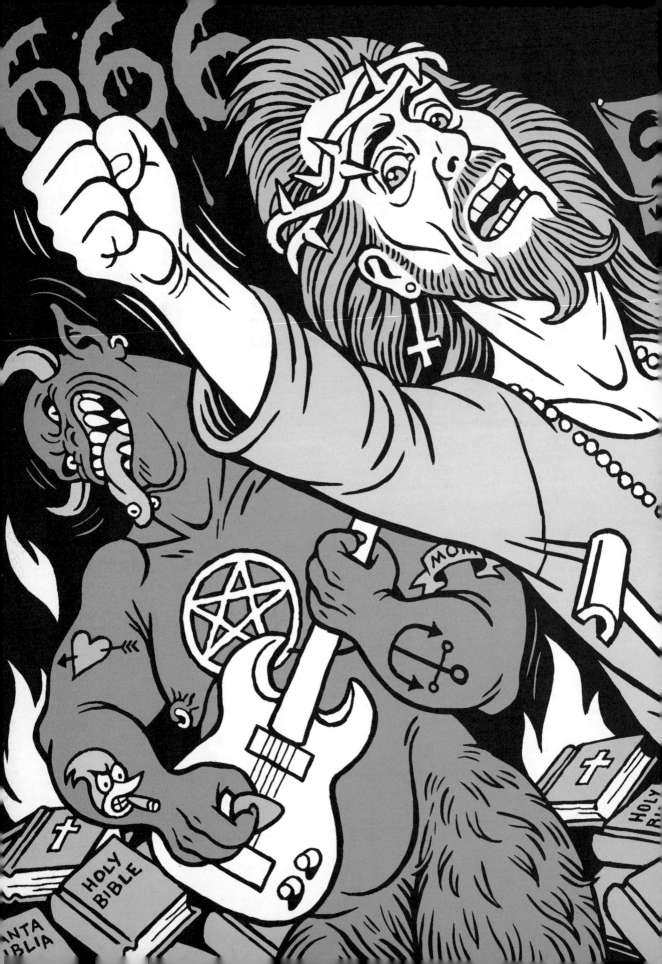

# Christ, Communists, & Rock 'n' Roll:
## Anti-Rock 'n' Roll Books 1966–1987

*by John Marr | Illustrations by Danny Hellman*

In the realm of crackpot literature, few sub-genres surpass anti–rock 'n' roll literature in sheer quality. Like the finest fringe literature, they are suffused with paranoia, rabid passion, and a refreshingly original take on conventional logic. Their philosophy combines the best elements of fundamentalist zealotry, Communist conspiracy, and bizarre pseudo science…

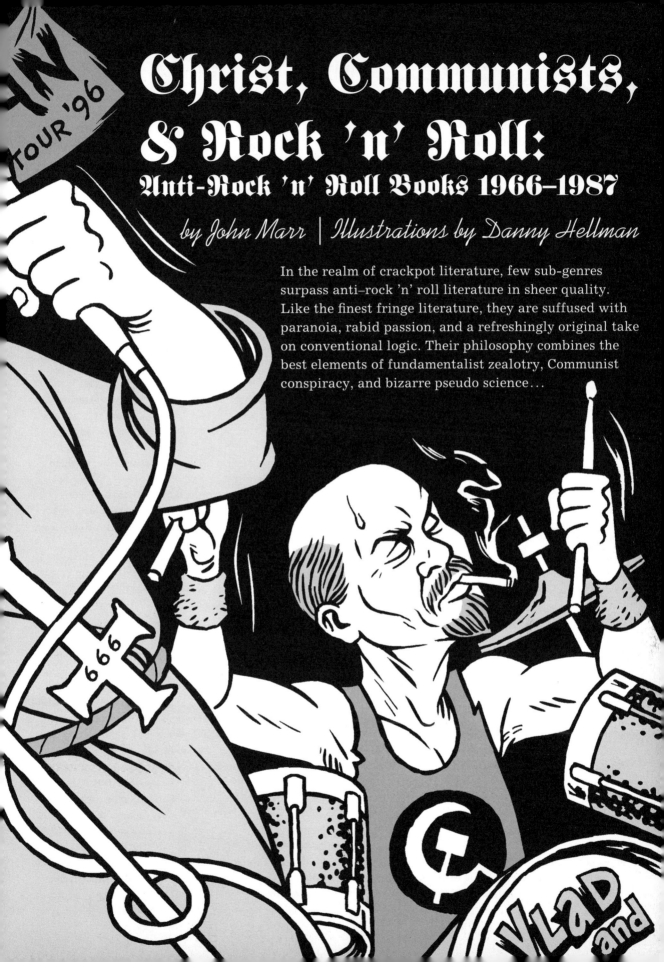

they are completely accessible to the average reader. Most other breeds of kooks require extensive background knowledge to be fully appreciated. Try plowing through a JFK conspiracy book without knowing your Zapruder and grassy knoll, for example. On the other hand, the only prerequisite for anti-rock appreciation is a passing familiarity with "Classic Rock" radio.

Anti-rock books give you more of what you read crackpot literature for.

The opposition to rock 'n' roll has a long history, probably started with the first hit. But it took **THE BEATLES**, especially John Lennon's ill-advised Jesus comparison, to really crystallize the opposition. And leading the charge was David Noebel. The crusty old professor of the anti-rock school, Noebel was one of the few to inject something other than extensive knowledge of the Old Testament into his attacks on rock 'n' roll. Starting in 1966 with his first book, *Rhythm, Riots, and Revolution*, he utilized scholarly footnotes, Aristotle quotes, and elaborate pseudo-science in his battle against the backbeat. Virtually every anti-rock writer since owes him a heavy debt, directly or indirectly.

Noebel sees rock music as a subversive Communist plot. He accuses the Soviets of using "an elaborate calculated scientific technique aimed at rendering a generation of American youth neurotic through nerve-jamming, mental deterioration, and retardation." The method is the widespread broadcasting of music with a steady, primitive beat synchronized with the body's natural rhythms literally hypnotizes the unsuspecting listener. Rock 'n' roll, with a voodoo inspired "jungle beat," fits the bill. He writes "**THE BEATLES**, or **THE MINDBENDERS**, for example, need only mass hypnotize thousands of American youth, condition their emotions through the beat of the 'music' and then have someone give the word for riot and revolt...If the following scientific program is not exposed, degenerated Americans will indeed raise the Communist flag over their own nation."

Noebel proves this "power" of music by showing parallels between Communist brainwashing techniques in Korea and Pavlov's work with conditioned reflexes. Not only was Pavlov Russian, he was also a big pal of Lenin's!

The conclusion is obvious. For the unconvinced, Noebel delves still deeper, unmasking in the classic McCarthy fashion dozens of "Communists" in the rock, folk, and children's (!) recording industry. But the real clincher is that rock 'n' roll is banned in the **USSR**! Obviously, they know something we don't about the "constant, destructive noises called '**BEATLE** music.'"

Noebel continues fighting the Red Rock Menace in 1973's *The Marxist Minstrels*. He emphasizes that things are still going to plan—so much so that he feels confident reprinting verbatim chapters from *Rhythm, Riots, and Revolution* warning of the imminent peril of folk rock. He gleefully points out that drugs are a standard Communist tool for debauching youth and fingers a few more pinko **A&R men**. Noebel appears to be expecting to see the Russians in Jersey, or at least on Bandstand, any day.

In 1967, Noebel was joined in attacking rock by Bob Larson, the first of several rock musicians turned minister. Not only did Larson's first book, *Rock and Roll: The Devil's Diversion*, introduce the devil to the anti-rock genre, but it started the career of rock's most durable opponent. Larson continues to go on strong today, via books, television, and a syndicated radio show.

Forget Pavlov. Forget the Russians. In *The Devil's Diversion*, Bob points straight at the Horned One, writing, "Rock and roll is a part of this plan [Satan's] to achieve a world-wide moral decay." Drawing on Noebel, Larson warns of the power of The Beat. It's the devil's beat, borrowed from primitive, heathen rituals, which whips dancers into a frenzy. It's the beat, throbbing in sync with the body's natural rhythms, that hypnotizes kids, triggers riots, and leaves them incapable of making sound moral decisions after the dance. But it comes from a source far more evil than the Kremlin.

For once the kids are safely hypnotized and aroused, the music hits them with a **MESSAGE OF IMMORALITY** while they're helpless to resist! According to Larson, "Lyrics of today's rock songs are a large part of the tidal wave of promiscuity, illegitimate births, and political upheaval that have swept our country."

Larson revised *The Devil's Diversion* in 1968 and 1970 to document the increasing degeneration of youth music. Drugs, heathen cults, immorality, and other portents of moral Armageddon—all were on the upswing. But even worse—perfectly innocent Christian teenagers were not only listening to rock but liking and even (gasp!) playing it, calling it "Christian Rock."

Larson exposed this insidious new threat in 1971 with *Rock and The Church*. His message: **NO! BLASPHEMY!** The only true Christian music is sung by born-again Christians who only associate and play for other born-again Christians, and heaven help them if they're not born-again enough! The devil's beat is no medium for a religious message. As Larson warns these misguided adolescents, "When used excessively, under proper circumstances, the beat of rock is a force

accommodating demonic possession and therefore is not worthy as a vehicle to communicate the gospel."

Larson's books have since mellowed, although listeners to his radio show may beg to differ. In *Rock*, which first came out in 1980 (later revised and re-titled as *Larson's Book of Rock*), the warnings about the devil's beat have disappeared. Suddenly, Larson only worries about immorality and occultism in the musicians' lyrics and lifestyles.

He still admits to his rock 'n' roll roots — "but that was in the 'Happy Days' of white bucks and Fats Domino." Today, rock is playing a different and sinister tune. "When the lyrics explore the obscene and profane, when the entertainers glorify the perverse and forbidden, and when the beat borders on the erotic, that's where I say 𝕹𝕺!"

Larson plays on parents' fears that there's something wrong with the incomprehensible noise Junior calls "music." He tells them to trust their parental instincts. It's not just wrong, it's dangerous! Where do kids get all those ideas about sex, drugs, and Eastern religions? 𝕽𝕺𝕮𝕶 '𝕹' 𝕽𝕺𝕷𝕷!!

There may not be a devilish beat, but he reassures parents that rock music causes drug addiction, promiscuity, suicide, and homosexuality.

In Larson's eyes, the interviews in *Hit Parader* and *CIRCUS* are philosophical manifestos for the American youth, and virtually every lyric is loaded with un-Christian messages, carefully hidden from adult eyes via slang and innuendo. He warns, "Some top hits are so lewd that the lyrics can't be printed for fear of having this book classified as pornography."

If they're not explicit, he demonstrates a Freudian ability to read sex, drug, and occult "messages" into every song. In this, he's helped by unique interpretations of teen slang: "funky" always means sexual odors, "groovy" is a sexual position, and "gigs" are sex orgies.

To protect kids, Larson doesn't advocate force — just gentle Christian persuasion. He cautions parents to set a good example themselves by nixing soap operas and country. It's not easy. Parents are up against peer pressure and an "addicting" (but in itself harmless) beat. But there is hope. Larson points to the shining example of one fine lad who wrote him, telling how he broke all his records when "I began to notice myself accepting more tolerant attitudes towards sex and God."

Fortunately, now there is an alternative: Christian Rock. Larson now loves C-Rock, describing it as the younger generation's way of praising God. As long as one sticks to "real" Christian performers who sing uplifting

songs with a gospel message and live the true Christian lifestyle, everything will be fine. Even if it has a back beat.

Following closely in Larson's footsteps are Dan and Steve Peters, AKA the Peters Brothers. This duo of incorrigible publicity hounds don't move a muscle until the cameras show up. They started in Minnesota in 1979 with a well-publicized record burning, and have since flooded the market with books, tapes, slide shows, TV appearances, and even a traveling anti-rock seminar/ circus in defense of American youth. Fortunately for readers on a limited budget, originality is not their forte. Their books are very repetitive; to read one is to read all. All save the most serious students should be satisfied with one, such as The Peters Brothers Hit Rock's Bottom.

Philosophically, the Peters Brothers are Bob Larson (whom they consider "authoritative") taken one step further. They have the same complaints, but what Larson calls bad, they say worse. And whatever Larson OKs, they fall over themselves in the eagerness to promote it.

Echoing Larson's current position, they have no problems with the beat. They even think it's kind of catchy! Their problems are with what they see as the basic themes of rock culture: nihilism, humanism, hedonism, rebellion, occultism, and drugs. 𝕷𝕴𝖁𝕰 𝕬𝕴𝕯 didn't fool them for a minute: "Many of the stars of 𝕷𝕴𝖁𝕰 𝕬𝕴𝕯 got there by helping destroy the moral fiber of America's youth."

The teen suicide "epidemic" is their favorite warhorse. In every book, they drag out the same stories about happy, well-adjusted middle class white boys who suddenly fall under the spell of rock 'n' roll. Six months later, mom and dad come home and find Junior dangling from the rafters with 𝕬𝕮/𝕯𝕮 or 𝕺𝖅𝖅𝖞 𝕺𝕾𝕭𝕺𝖀𝕽𝕹𝕰 blasting on the stereo. Guess who's to blame?

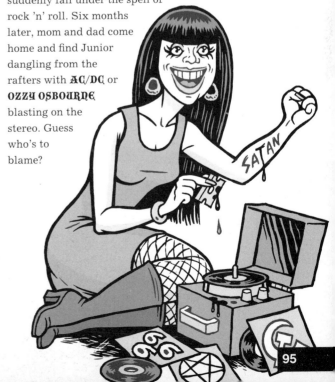

Yet not all these tales end so tragically. They proudly tell of one teen, John Tanner, who swallowed a shotgun after one too many **BLACK SABBATH** albums.

Happily, he survived, finding Christ as he lay on the floor in a pool of his own blood. He's a happy young man today, albeit without much of a face, doing the Lord's work by playing the rock 'n' roll analog of the reformed heroin addict in the Peters's road show.

The Peterses do the usual griping about obscene lyrics and immoral rock stars. But they think the threat is far more insidious. The real danger is what you can't hear. The dark forces behind the music are attacking the listener's subconscious with subliminal and backward-masked messages.

Subliminal messages are virtually inaudible vocals that somehow your subconscious can pick up. Backward-masked lyrics say something when played backwards. Sometimes, they're recorded that way—forwards, gobble-dygook; backwards, clear as a bell. But usually, they are perfectly clear forwards but say something completely different (usually sinister) when played backwards. And it isn't necessary to master the intricacies of reverse threading a tape deck to hear the hidden message.

The Peterses think these play a vital part in driving the six evil themes home. Somehow, your subconscious can interpret backward messages saying "Satan, he is God" (**BLACK OAK ARKANSAS**), "Here's to my sweet Satan" (**LED ZEPPELIN**) or "Decide to smoke marijuana" (**QUEEN**). The Peterses don't think musicians put the messages there deliberately. It's just the anti-Christ speaking through rock stars, his unwitting agents, via their **EVIL** music. The only way this can be stopped is through rating all records, printing lyrics on all sleeves, and, just to be safe, frequent record burning.

Happily, there is an alternative for upright Christian teens yearning for kick-ass music that won't steal their souls. "Is Christian contemporary music a ravenous wolf in disguise?" the Peterses ask, and answer with a resounding no! As long as the lyrics and the performers' lifestyles check out with the Bible, it's great! Worried parents are reassured that "There is nothing inherently evil with the

color black, with leather, with earrings, with spiked arm bands—they are simply fashions." So crank up those **STRYPER** and **U2** albums and make a joyous noise unto the Lord!

The Peters's books are distinct in their endless, unabashed self promotion. They proudly refer to themselves as "dedicated to exposing the **TRUTH** about rock" and continually congratulate themselves for their courage and resolve.

They boldly meet the enemy face to face—interviewing Gene Simmons of **KISS**, and reprinting the transcripts. They load their books with ads, references, and plugs for their other books and tapes. They even request readers who've gotten the message to stop—don't burn those records. Send them to the Peterses for "research" and they'll burn them after copying all the "questionable" lyrics and photographing the "obscene" cover art.

Further out on the fringe is Jacob Aranza, author of *Backward Masking Unmasked* (1983) and *More Rock, Country, and Backward Masking Unmasked* (1985). With an inimitable style that removes any doubt of a ghostwriter, "one of the outstanding young ministers of America" handily out-paranoids Larson and the Peterses combined.

Despite the titles, his sketchy shallow books don't delve deeply into backward masking. *BMU* is just the standard sketchy, shallow mishmash of evil lyrics on evil records by evil stars in evil record jackets spiced up with a few **LED ZEPPELIN** records being played backwards. Nonetheless, the man is scared. He solemnly warns, "75% of the rock and roll today (top 10 stuff!) deals with sex, evil, drugs, and the occult."

The real fun comes in *MBMU*, when Aranza reveals who's behind all this evil music (three guesses) and boldly exposes "Satan's Agenda"—a musical 4-step plan for the complete and utter corruption of American youth by the forces of darkness. Step One ran from 1955 through 1965, pushing sex and setting the stage for the sexual revolution. Step Two (1965–1970) tossed in drugs, rebellion, and anti-establishment attitudes. Step Three's (1970–1980) goal was to popularize music, having an "addicting sound with loud, violent tones" and lay the groundwork for the

final step. Step Four, scheduled for the 1980s, will have promoters "pronounce rock stars as messiahs." No gig would be complete without a full-blown satanic service's kids lining up to sell their soul to the devil.

And what sort of Satanic plotter would spill the beans? Aranza got the dope from an anonymous evangelist friend of his who sat next to an equally nameless rock manager on a plane. In the course of a casual conversation, said manager told all. Left unsaid is Satan's reaction to this casual betrayal.

Aranza does approve of C-Rock, although he is shocked that some C-Rockers actually listen to secular rock for ideas. C-Rock could be the one thing to save youth from the rock 'n' roll satanic religion. But he advises caution: "If the music you're listening to doesn't come from the heart of a spiritual Christian artist, you are opening the door to carnality, humanism, and demonic forces." In Aranza's mind, music either promotes God or Satan.

There is no such thing as "neutral" music.

As strange as Aranza gets, things only become stranger with Jeff Godwin. As the main rock 'n' roll hatchet man for Jack Chick (the comic-book tract guy), Godwin neither asks nor takes any quarter. His books are crudely written ranting and raving screeds in the best tradition of hate literature. You can easily picture him frothing at the mouth as he penned such classics as *The Devil's Disciples* (1985) and *Dancing With Demons* (1988). He makes groundless accusations, leaps to the broadest conclusions from the flimsiest evidence, and meanders from point to point for no apparent reason. He's the lunatic fringe of the anti-rock movement, and probably proud of it. From his perspective, the Peterses, Larson, and the other anti-rock writers are closet 𝕾𝕷𝕬𝖄𝕰𝕽 fans, if not outright devil worshipers.

And that's who Godwin says is behind all rock: 𝕾𝕬𝕿𝕬𝕹! To Godwin, Satan is not only alive and well and living on planet earth, but as real as his next-door neighbor. He sees Satan's hand everywhere: lyrics, album covers, concerts, even in the groups themselves.

## 𝔜𝔢𝔰, "𝔗𝔥𝔢 𝔏𝔬𝔯𝔡 𝔥𝔞𝔰 𝔞𝔩𝔰𝔬 𝔯𝔢𝔳𝔢𝔞𝔩𝔢𝔡 𝔱𝔬 𝔰𝔬𝔪𝔢 𝔆𝔥𝔯𝔦𝔰𝔱𝔦𝔞𝔫𝔰 𝔱𝔥𝔞𝔱 𝔦𝔫𝔠𝔞𝔯𝔫𝔞𝔱𝔢 𝔡𝔢𝔪𝔬𝔫𝔰 𝔣𝔯𝔬𝔪 𝔱𝔥𝔢 𝔫𝔢𝔱𝔥𝔢𝔯𝔴𝔬𝔯𝔩𝔡 𝔞𝔠𝔱𝔲𝔞𝔩𝔩𝔶 𝔞𝔯𝔢 𝔪𝔢𝔪𝔟𝔢𝔯𝔰 𝔬𝔣 𝔰𝔬𝔪𝔢 𝔬𝔣 𝔱𝔥𝔢 𝔪𝔬𝔰𝔱 𝔭𝔬𝔭𝔲𝔩𝔞𝔯 𝔟𝔞𝔫𝔡𝔰..."

Of course, Godwin wasn't born this way. He spent ten years as a rock fan and musician, even allegedly surviving 𝕿𝕳𝕰 𝖂𝕳𝕺 "stampede" show in Cincinnati.

Then he discovered Jesus Christ. A sample of his theology: "Why should we fear God? 𝕭𝕰𝕮𝕬𝖀𝕾𝕰 𝕳𝕰 𝕳𝕬𝕾

𝕿𝕳𝕰 𝕻𝕺𝖂𝕰𝕽 𝕿𝕺 𝖀𝕿𝕿𝕰𝕽𝕷𝖄 𝕯𝕰𝕾𝕿𝕽𝕺𝖄 𝖀𝕾, 𝕬𝕹𝕯 𝕿𝕳𝕬𝕿 𝕴𝕾 𝕬𝕷𝕷 𝖂𝕰 𝕯𝕰𝕾𝕰𝕽𝖁𝕰!!" One can only assume he had a hell of a bonfire.

Reaching back to the '60s, Godwin revives the voodoo beat theory. The rock beat has the same time signature as the human heart. Obviously, this hypnotizes and brainwashes listeners into accepting Satan's message. And the message is so evil that it could only be Satan's.

The music encourages the use of "mind decaying, death-dealing drugs," frequently couched in slang only understood by teens. Not only is promiscuous sex promoted, but also abnormal sex as epitomized by 𝕯𝕬𝖁𝕴𝕯 𝕭𝕺𝖂𝕴𝕰, the "limp-wristed king of the abnormal world of Homo Rock." Godwin claims that all screamed rock vocals are actually inspired by the sound of the "homosexual penetration of the male" and whip crack drum beats are the first step on the path that leads directly to steamy homosexual 𝕾&𝕸.

Naturally, Godwin is a believer in backward masking. He explains it by describing how rock stars invoke (literally!) demons at recording sessions to ensure hit records. The back masked messages are the imp's calling cards. He warns, "I believe that even now Satan and his demons are blaspheming and insulting God and the Lamb with their horrible rock record covers and backmasked broadcasts from Hell."

And the demons just don't hang around the studio. Merely playing a rock record can call them up ready to snag the nearest available adolescent soul.

After all, as Godwin points out, "addiction to rock 'n' roll is a form of demonic possession."

It's important to realize that Godwin isn't just talking about pentacle-encrusted heavy metal bands. Satan lurks

behind the bright tempo of the most innocent bubblegum pop ditty. "Virtually nothing in popular music today is worth your support…NO ONE makes it big in secular music without selling out to Satan," he writes as he lambastes HALL & OATES for their "homosexuality and Satanism." And "We Are the World" with its message of "Love is all we need" is wrong because "Jesus Christ is what this world needs!"

Not even Christian rock is safe. The C-Rock that Larson and the Peterses praise isn't sufficiently Christian for Godwin's taste. He thinks that most "Christian" artists are really dupes for Satan, if not closeted devil-worshippers themselves. He singles out STRYPER for especial wickedness evidenced by their satanic "777" symbol and *To Hell With The Devil* album.

Godwin believes this really means "To Hell WITH the Devil," the fate of all STRYPER fans. Only gospel and hymns are safe. His advice to parents? "The purpose of rock music is to split, splinter, and destroy your home." He urges them to burn everything relating to rock in their homes immediately—all records, tapes, books, clothes, posters, even jewelry—and double their daily prayer time. Only through these extreme measures can a home be secured from demons during the last days.

Fortunately, the anti-rock genre apparently peaked (along with the Parents Music Resource Center [PMRC]) in the mid-'80s. It has since fallen by the wayside, displaced by such less metaphysical debates as gangsta rap lyrics and the V-chip. But the books are still out there, and keep coming out. These are just some of the highlights awaiting the diligent connoisseur of crackpots.

But they all share one miraculous power: they leave the reader with an irresistible urge to listen to OZZY OSBOURNE's "Suicide Solution" while screaming

# "Rock On!"

# SELECTED BIBLIOGRAPHY:

## Rev. David Noebel
*Rhythm, Riots, and Revolution* (1966)
*The Marxist Minstrels* (1973)

## Bob Larson
*Rock & Roll: The Devil's Diversion* (1967, 1968, 1970)
*Rock & the Church* (1971)
*Rock* (1980, 1982)
*Larson's Book of Rock* (1987)

## Dan & Steve Peters
*Hit Rock's Bottom* (1984, 1986), with Cheryl Miller
*Why Knock Rock?* (1984)
*Rock's Hidden Persuader: The Truth About Backmasking* (1985)
*What About Christian Rock?* (1986)

## Jacob Aranza
*Backward Masking Unmasked* (1983)
*More Rock, Country, and Backward Masking Unmasked* (1985)

## Jeff Godwin
*The Devil's Disciples* (1985)
*Dancing With Demons* (1988)

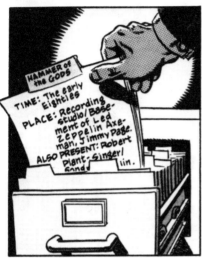

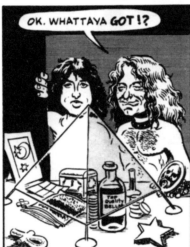

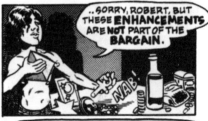

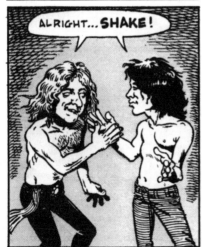

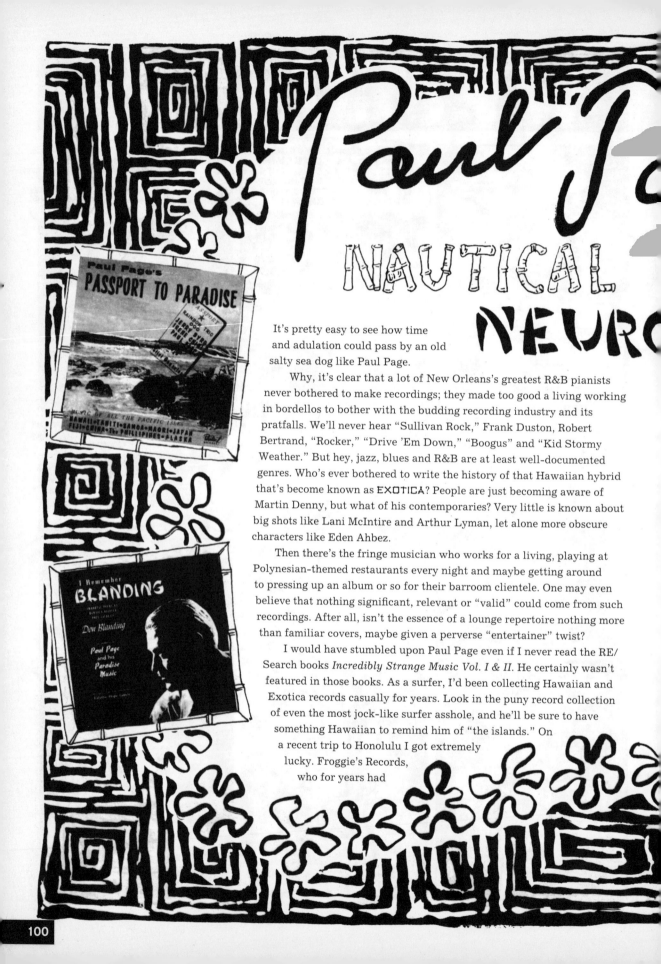

# Paul Page: NAUTICAL NEURO

It's pretty easy to see how time and adulation could pass by an old salty sea dog like Paul Page.

Why, it's clear that a lot of New Orleans's greatest R&B pianists never bothered to make recordings; they made too good a living working in bordellos to bother with the budding recording industry and its pratfalls. We'll never hear "Sullivan Rock," Frank Duston, Robert Bertrand, "Rocker," "Drive 'Em Down," "Boogus" and "Kid Stormy Weather." But hey, jazz, blues and R&B are at least well-documented genres. Who's ever bothered to write the history of that Hawaiian hybrid that's become known as EXOTICA? People are just becoming aware of Martin Denny, but what of his contemporaries? Very little is known about big shots like Lani McIntire and Arthur Lyman, let alone more obscure characters like Eden Ahbez.

Then there's the fringe musician who works for a living, playing at Polynesian-themed restaurants every night and maybe getting around to pressing up an album or so for their barroom clientele. One may even believe that nothing significant, relevant or "valid" could come from such recordings. After all, isn't the essence of a lounge repertoire nothing more than familiar covers, maybe given a perverse "entertainer" twist?

I would have stumbled upon Paul Page even if I never read the RE/Search books *Incredibly Strange Music Vol. I & II*. He certainly wasn't featured in those books. As a surfer, I'd been collecting Hawaiian and Exotica records casually for years. Look in the puny record collection of even the most jock-like surfer asshole, and he'll be sure to have something Hawaiian to remind him of "the islands." On a recent trip to Honolulu I got extremely lucky. Froggie's Records, who for years had

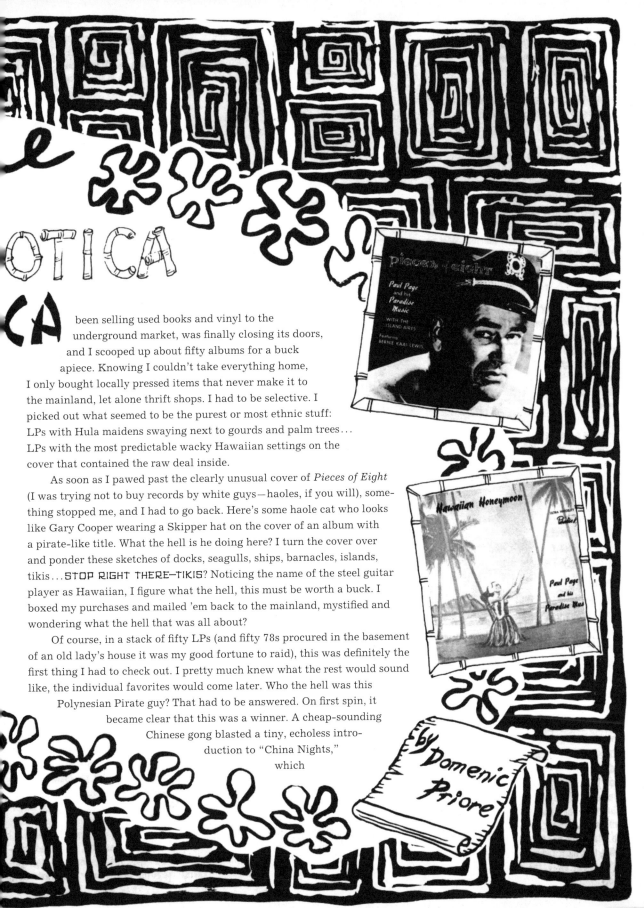

**OTICA**

**CA**

been selling used books and vinyl to the underground market, was finally closing its doors, and I scooped up about fifty albums for a buck apiece. Knowing I couldn't take everything home, I only bought locally pressed items that never make it to the mainland, let alone thrift shops. I had to be selective. I picked out what seemed to be the purest or most ethnic stuff: LPs with Hula maidens swaying next to gourds and palm trees... LPs with the most predictable wacky Hawaiian settings on the cover that contained the raw deal inside.

As soon as I pawed past the clearly unusual cover of *Pieces of Eight* (I was trying not to buy records by white guys—haoles, if you will—something stopped me, and I had to go back. Here's some haole cat who looks like Gary Cooper wearing a Skipper hat on the cover of an album with a pirate-like title. What the hell is he doing here? I turn the cover over and ponder these sketches of docks, seagulls, ships, barnacles, islands, tikis... **STOP RIGHT THERE—TIKIS**? Noticing the name of the steel guitar player as Hawaiian, I figure what the hell, this must be worth a buck. I boxed my purchases and mailed 'em back to the mainland, mystified and wondering what the hell that was all about?

Of course, in a stack of fifty LPs (and fifty 78s procured in the basement of an old lady's house it was my good fortune to raid), this was definitely the first thing I had to check out. I pretty much knew what the rest would sound like, the individual favorites would come later. Who the hell was this Polynesian Pirate guy? That had to be answered. On first spin, it became clear that this was a winner. A cheap-sounding Chinese gong blasted a tiny, echoless introduction to "China Nights," which

by Domenic Priore

apparently had been a good place for Page's backing group, the Island-Aires, to "live and love." So it's the decadence of the wandering seaman we're dealing with already. Next up, it's as flipped as it's ever gonna get, as we are introduced to Paul Page…*narrating* "When Sam Comes Back to Samoa." (Can this guy actually *sing*, or is this just a put on?):

NOW SAM'S BEEN GONE FOR A LONG, LONG TIME
WHILE HE'S BEEN AWAY
ROCK 'N' ROLL HAS COME & GONE
AND JAZZ IS HERE TO STAY!
WHEN SAM GOES BACK TO SAMOA
HE'LL HAVE TO CHANGE ALL HIS WICKY-WACKY-
    WU [HARDLY ACTUAL SAMOAN LANGUAGE,
    FRIENDS]
FOR TO SWING AND SWAY, THE ISLAND WAY
MEANS ROCK-A-HULA BABY, I LOVE YOU
ROCK-A-HULA HONEY, I LOVE YOU

It's pretty clear from this statement that the album came out sometime after the release of the Elvis Presley film *Blue Hawaii* and before February 7, 1964.

Page comes off like a gracious host on the entire LP. The Island-Aires sing a few genius numbers ("Ports O' Call," "Matey," and the peppy "Let's Have a Luau"), Bernie Kaii Lewis plays some splendid steel guitar solos on "Beyond the Reef" and "Sweet Someone," and Page lays down some fine benedictions himself. Most of the tunes included are origi-nals, and some lines, perhaps, only Page can sing in his own inimitable style:

IT DOESN'T COST A CENT FOR HER UPKEEP
FOR THERE'S NOTHING THAT SHE NEEDS!
ALL SHE WEARS IS A GREAT BIG SMILE
AND A LITTLE STRING OF BEADS
("MY FIJI ISLAND QUEEN")

Then there's the big emotional number, "Castaway." Backed by Bernie Kaii Lewis's sad steel guitar, a despondent Page slowly repeats, "Castaway. Castaway. Castaway. Castaway…" in such a reflective tone

that it's obvious he's adrift, and a dreamlike state takes hold:

ONCE I HAD MY LOVE BESIDE ME
IN A HARBOR CALLED HOME
AND NOW WITHOUT MY LOVE TO GUIDE ME
I'M JUST A DERELICT ON THE FOAM

The album ends with the "Pacific Farewell Medley" represent-ing New Zealand's Maori ("Now Is The Hour"), The Philippines ("Philip-pine Farewell"), Japan ("Sayanara"), Tahiti ("E Maururu A Vaai) and Hawaii ("Aloha Oe"). Over Bernie's steel guitar, Page recites a descriptive Don Blanding poem called "Aloha Oe" that echoes this most famous melody of the islands. You're swept away, the masterpiece is in the bag, and you wonder "where is this guy, and what the hell is he doing now?"

I caught up with Paul Page through ASCAP, whose logo is proudly emblazoned on the back cover of every Paul Page album I've seen. In fact, one of the oddball things about Page's liner notes is the way he boasts about his membership in the song publishing organization. He's eighty five years old now, and the rough life of a seafaring beach-comber has caught up with him. His hearing is almost gone, and in the past two years it's been getting tough for him to remember all the details of his illustrious, exotic career. Once a male model who auditioned for a part against a young John Wayne, Page now fittingly wears an eye patch. The ravages of hard drinking and wild women in various ports have taken their toll. The guy in an Old Spice commercial plays a role; Paul Page lived it and wrote songs to tell the tale.

"I was quite a rounder in my day…there's too much to tell. I was busy modeling for photographers and working on radio. I knew so many women in my modeling days, I must've gone to bed with over four hundred women. Isn't that awful?

Terrible…and I never once ever had any kind of disease. I'm clean."

Page was reared in Indiana, and by the time he was in high school became "the youngest commercial newspaper editor in the United States," he brags. "Walter Winchell once called me the multiple man, because I had so many amazing talents…at least a dozen of 'em that I made money on." Shortly after gradu-ation he relocated to Juneau, Alaska, and got a job with a small newspaper. He also kick-started his music career, playing live on the local airwaves. "I had a radio program up in Alaska for the O.C. Smith Typewriter Company, and one day I looked over in the control room and there sat Will Rogers. He comes out and says, 'You're good, kid. You ain't gonna stay up here in Alaska, are ya?' I says, 'I ain't?' Well, he says 'Maybe ain't ain't right, but I know a lot of people who ain't sayin' ain't, they ain't ain'tin. Think about it…'"

With this wisdom and encour-agement from an American folk hero of such magnitude, Page took his Alaskan experience and brought it back home to nearby Chicago. "I always liked Hawaiian music. 'Pages of Memory' was the name of my radio show on the NBC network, and I had fan clubs all over North America. We did a program every morning at the head of 'The Breakfast Club.' I just played and sang on piano and organ, all by myself, and I wrote the script. I did 'My Isle of Golden Dream,' which was written by the composer of 'The Breakfast Club' theme, Walter Blaufuss. So I got this Hawaiian band together and Art Reams became my manager. We toured the country, and an NBC producer came into the nightclub to hear me sing and play. That night they hired me, offering me a ten-year contract on NBC. This all happened around Pearl Harbor Day, December 7th, 1942."

It was during these radio broadcasts that Page began to incorporate the element of Polynesian poetry. He was especially inspired by Don Blanding, the "Poet Laureate" of Hawaii whose 1928 book *Vagabond's House* featured the verse of a drifting beachcomber and cameo-styled illustrations of island scenery. Paul guitarist reputed to have inspired both bottleneck/slide blues musicians and country artists in the development of the pedal steel guitar. Hoopi also headed up a booking agency in Hollywood—the industry relied on him to provide dark-skinned Hawaiians as extras in both the popular Polynesian films of the era, Hawaiian Islands made the city a mecca for the Hawaiian music craze of the 1920s, and clubs like The Hula Hutt, The Singapore Spa, Hawaiian Village and Hawaiian Paradise sprang up to accommodate the action. Even Clifton's Cafeteria downtown became a neon-tropic-art-deco paradise. Paul Page eased

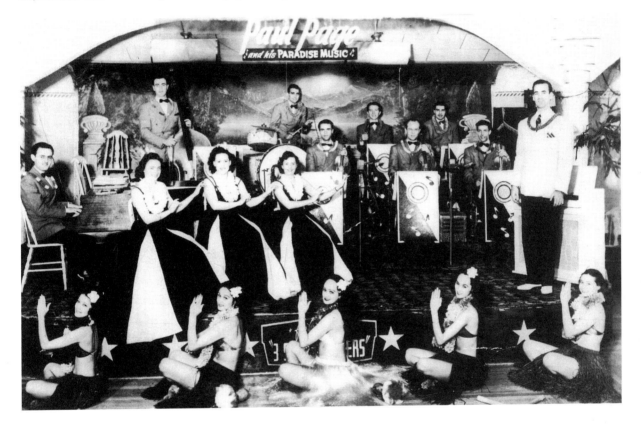

Page would soon adapt Blanding's art style to the Exotica environment, but initially Page concentrated on Blanding's poetic dream world to conjure up a floor show atmosphere unique in its time (and non-existent today).

When Page came in off the road, he developed modeling as a sideline income. "I was a very popular photographer's model for magazines. About that time I auditioned for a part in a movie with John Wayne. He was the same size I was." On the West Coast trip Page made contact with Sol Hoopi, the legendary lap steel

such as Bing Crosby's *Waikiki Wedding*, and in Westerns, where the kanakas and wahines came in handy as Native Americans. Hoopi's connections eventually lured Paul Page to Los Angeles.

"I worked at The Seven Seas in Hollywood with Sol Hoopi, the nightclub across from Grauman's Chinese Theater. I played Hammond organ and MC'd the floor shows with Lulu Mansfield." The Seven Seas was indeed a glamorous night spot during the glory days of Hollywood's Dream Factory era. L.A.'s proximity to the

into this scenario in the early 1940s: "I moved my radio program to the NBC studios at Sunset and Vine, and then I'd go over and do The Seven Seas. I had my fun at the nightclub...that was my job as an entertainer." When asked what he did on his day off, his answer was simple enough: "Slept."

At the advent of the television era in 1949, Page hosted the very first Polynesian T.V. show, which was an extension of his radio show and his floor show at The Seven Seas. "I had the Starr sisters in my band, a vocal

trio. Kay Starr was one of 'em. She became famous on her own, and I had five hula gals in my big band. Five hula gals and three caucasian sisters. They were all good." However, an accident soon forced Page off the air for a while, and he had to start all over when he got well.

In the meantime, the Exotica craze began to kick in hard in the Los Angeles area. Don the Beachcomber's became the hip Hollywood haunt where Clark Gable and his pals hung out. Martin Denny was playing in the bar while proprietor Donn Beach was busy inventing the Mai Tai and a slew of now-famous tropical drinks. Trader Vic's became San Francisco's answer to the reverie, and The Luau in Beverly Hills became a swanky alternative for the posh set. Tiki became the God of Recreation as soldiers continued to return to the Port of Los Angeles at San Pedro. James Michener's *South Pacific* was a Broadway smash, and Thor Heyerdahl's adventure book *Kon-Tiki* set the tone of Los Angeles during the Truman era. Soon the area was over-whelmed with tiki apartment complexes, a surfing craze and knock-off tiki restaurants by the dozens. Paul Page had little trouble finding work.

"I played at a restaurant called Pago Pago off and on for ten years. A columnist in Van Nuys said I was the most popular entertainer in the San Fernando Valley...that's a big valley, you know." Coincidentally, one of Page's best tunes was titled "Pago Pago," kicking off a personal trend wherein Paul Page songs (and LPs) would be named after tiki restaurants in the Greater Los Angeles area. Page worked at the Pieces of Eight in Marina Del Rey and sure enough, a great tune and an entire LP bore that name. Then there was the Castaway in Glendale, which was another great song and LP title. Finally, there was

the Ports of Call in San Pedro, and of course Page did not miss the opportunity to name a cool song after this establishment, and follow it up with an LP bearing the moniker. "Down there, south of Los Angeles, I used to have an office right near the Port of Los Angeles. That album sold well in San Pedro..." Sheesh! Page went so far as to use the actual logos of these restaurants on the album covers. Exploitation of the best kind, indeed.

While all this was happening, Page began to pursue his art career as well. "I sold some paintings for $4,000 to $5,000 and had a couple of art exhibits. One was at the Hollywood Musicians Union and another one was at Barker Brothers department store in Los Angeles. Don Blanding introduced me to the public...I loved him, and he loved me. He used to come in and see me all the time when I played at the Roosevelt Hotel in Hollywood. I did an album of his poetry after he passed away called *I Remember Blanding*." Blanding provided Page with inspiration on the canvas and in verse, and this album was really over the top. Bernie Kaii Lewis provided ethereal steel guitar backdrop to Page's loving narration of Blanding's best work, and in turn the LP holds up as an intense artistic departure for Page as well; it's his *Pet Sounds*, his "Gates of Eden," it's the *Forever Changes* of the Paul Page catalog.

Keep in mind that Paul Page was pretty much making a living off a Los Angeles trend in the restaurant business. He'd make a nightly wage as a performer, a few dollars off of the D.I.Y. albums he was producing, and some dough perhaps from a modeling gig here and there. To bring in extra cash, Page indulged in two areas that can now be seen as ex-tremely hip and ahead of their time.

"I wrote songs for amateur song-writers in Hollywood for a song shark company. They'd send in their lyrics, and I'd write the music and record 'em (the songs). Magazine ads, you know, for songwriters." Hmmmnnnn...Paul Page also shared two vocations with recent phenome-non Harvey Sid Fisher: modeling and astrology songs. Some three decades before the unintentional novelty success of the bewildered Harvey Sid, Paul Page released twelve 45 RPM singles, years before any hippie astrology trend. One side featured an astrological analysis, and the flip had a song representing the month. He set up a separate record label for these ditties called, you guessed it, *Astrology Records*.

Page was beginning to turn out albums at a consistent rate too, and the quality never suffered. He used the best talent around, which is odd for such independent releases, but Page certainly had the respect of the Hawaiian music community. "I worked with Jerry Byrd. He's the greatest steel guitarist in the business. Bernie Kaii Lewis was actually the greatest of them all, but he died too soon. He was good, I recorded with him a lot. He could play anything...he did 'Lover' on solo steel guitar—imagine that? You could play it on piano, but nobody could play it on steel guitar—it's too difficult. He could, though. I know all those Hawaiians; used to speak the language. Dick McIntire, Lani McIntire, Ray Kinney, Alfred Apa-ka...all of 'em. Even Harry Owens."

Paul Page sounded like none of them. What he accomplished in these individualistic recordings was unique. Completely based in a Hawaiian sound, his songs end up sounding like Polynesian sea shanties, with spoken word dramatics coloring the dynamic mix. By the time Page

was making records, Martin Denny had become popular with "Quiet Village," so in turn, Paul Page included an insane, diffused combination of tropical sound effects. He didn't bother to have his musicians shout out bird calls in time with the music, however. On his masterful *Hawaiian Honeymoon* album, the sound effects are somewhat arbitrarily laid on. They don't match the rhythm of the songs, but after repeated listening you get accustomed to what is initially scary stuff. One especially chilling moment is the chant tune "Au-we Wahine," where the jungle drums clash with the teeth of some god-forsaken jungle animal that I won't attempt to identify. Then there's his "Big Island concept album" called *The Big Island Says Aloha*, where Page has deftly chosen all tunes featuring references to Big Island locales. It's true genius to sit back and revel in tunes like "Akaka Falls," "Hilo March," "Chicken Kona Kaii" and "Little Grass Shack in Kealakelua, Hawaii."

By this time, Page had made his exit from Los Angeles to the island of Hawaii. "I played the Kona Coast, and was the best known entertainer on the Big Island. I worked for the Kona Steak House and I wrote for the Kona Hilton Hotel. I played all over the islands, and knew Martin Denny well. I'd been out to his house many times in Honolulu, and he used to come and see me when I played." Paul Page became so firmly entrenched in the culture that he became the president of the Hawaiian Professional Songwriters Society. For their newspaper, he penned a cartoon column as "Chief Wahanui." His love for the music had consumed his being. On his first LP recorded in Hawaii (*Passport to Paradise*) Page even showed a social consciousness in his lyrics:

ACROSS THE WATER SEE HOW THEY RISE
CONCRETE TO THE SKIES
TALL TIKI TOWERS REMINDING ME, HAWAII'S ON THE GO
AND THIS I KNOW
*AU E MAU KE EA O KAINA I KAPONO*
JUST AS TRUE AS IN KAMEHAMEHA'S DAY
AND THE BLUE ISLAND SKY WILL REFLECT IN THE WATER
IF WE ALL TRY TO KEEP IT THAT WAY
("ALA WAI BLUES")

He'd definitely flipped—big time. So firmly entrenched in the home of his first love, *Passport to Paradise* includes perhaps the greatest tribute to Hawaiian music ever recorded, "The Big Luau in the Sky." When I brought this song up, it didn't take long for the withered memory of Paul Page to strike up the words off the top of this head. "Oh yeah, that was one of my favorites. There's a narrated verse where I mention practically every important Hawaiian musician of this century—you name 'em, I mention 'em all." And then Paul Page, on the telephone from Arizona to San Francisco, bursts out into song:

**DOMENIC PRIORE IS THE AUTHOR OF** *LOOK, LISTEN VIBRATE, SMILE* (LAST GASP).

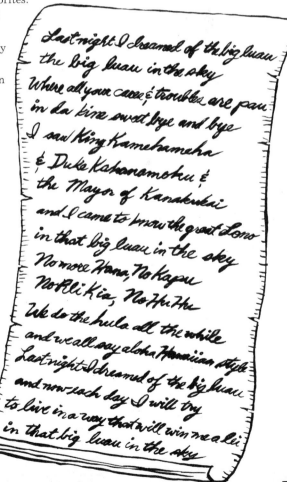

Last night I dreamed of the big luau
the big luau in the sky
Where all your cares & troubles are pau
in da kine sweet bye and bye
I saw King Kamehameha
& Duke Kahanamoku &
the Mayor of Kanakukai
and I came to know the great Lono
in that big luau in the sky
No more Hana, No Kapu
No Pilikia, No Huhu
We do the hula all the while
and we all say aloha Hawaiian style
Last night I dreamed of the big luau
and now each day I will try
to live in a way that will win me a lei
in that big luau in the sky

OCT. 15TH, 1994 - SIDESHOW ATTRACTION "THE HUMAN BLOCKHEAD" RECEIVES LIFE IN PRISON FOR ARRANGING MURDER OF HIS CLAWHANDED STEPFATHER, "LOBSTER BOY."

(TO INMATES: PLEASE TAKE IT EASY ON THE HUMAN BLOCKHEAD — PAT MORIARITY '95)

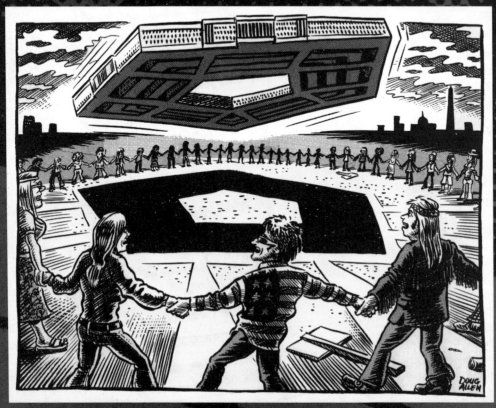

October 21, 1967: Yippies exorcise evil spirits from Pentagon, causing it to levitate.

WAY BACK IN THE EARLY NINETIES, I LIVED IN CHICAGO, AND IN THE OLDE DAYS (90-92) ON THURSDAY NIGHTS THE ZANIEST DOODLERS IN CARTOONS, MID-WESTERN DIVISION, WOULD GATHER AT A COFFEE HOUSE CALLED EARWAX. THE USUAL BUNCH OF IDIOTS INCLUDED: ME, DAN CLOWES, TERRY LABAN, CHRIS WARE AND ARCHER PREWITT, WITH GUEST APPEARANCES BY DOUG ALLEN AND DAVID GREENBERGER & JESSICA ABEL. WE'D GATHER AT 8:00 p.m. AND GRAB A BUNCH OF XEROX FLYERS THAT PILED UP IN THE FRONT OF THE JOINT AND ALTERNATE PANELS ON THE BACK OF EM, MAKIN SOME OF THE MOST VULGAR, POINTLESS COMICS EVER. HERE PRESENTED FOR THE FIRST TIME IN LCD IS THE RESULT OF OUR NERVOUS COFFEE SCRIBBLES, LOADED WITH ALL THE LAFFS, LOVE AND PENIS DRAWINGS WE COULD COMMIT TO PAPER. ENJOY!

GARY LEIB

The Mini-Comics Jam Archive contains of hundreds of spicy 8-pagers, with more created every time we get together. The cast now includes left-coasters Richard Sala, Lloyd Dangle, Adrian Tomine. Big-time publishers can contact me in NYC to plan the Boxed Set Release and Multimedia Options. —GARY LEIB

# A FEAST FOR THE EYES

## by Nick Tosches

Please feel free to move more closely to the stage

Be neither ashamed for my sake nor afraid for your own to look on me, for beneath this mortal shell lie heart and soul just like your own

I refuse to live on charity or secluded from society, and I receive no money for my appearance here

My sole income is derived from the sale of these miniature Bibles, which though barely larger than a matchbox contain every word of Old and New

A quarter, four bits, a dollar bill, let the wise man's words guide your giving: here but for the grace of God go you.

I have seven perfectly formed brothers and sisters

In fact unlike the others with whom I share this stage I was not born to life this way

Until the age of seven the sun did smile down upon me as upon all others

That was the age when I entered this very room beneath the crossroads of the world

It was my dear father who took me here, for edification, enlightenment, amusement, those same eternal enticements that bring you yourselves to stand before me on this day

We saw the doc's trained fleas and the elephant-skinned lady, Karl the Frog-boy, the man from World War Three, John Dillinger's death-mask, the Lord's Prayer on the head of a pin, and more.

art © 1996
Richard Sala

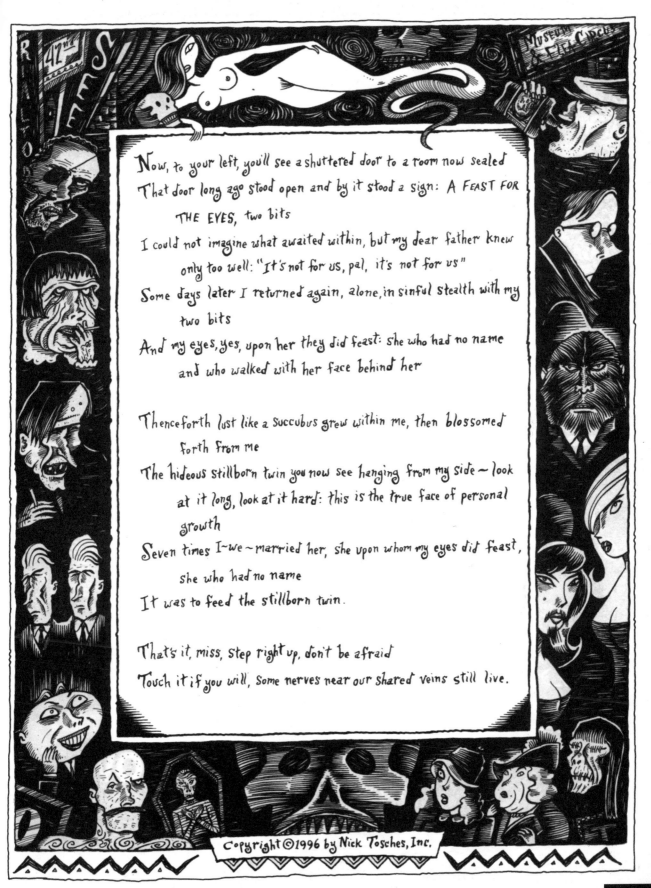

Now, to your left, you'll see a shuttered door to a room now sealed

That door long ago stood open and by it stood a sign: A FEAST FOR THE EYES, two bits

I could not imagine what awaited within, but my dear father knew only too well: "It's not for us, pal, it's not for us"

Some days later I returned again, alone, in sinful stealth with my two bits

And my eyes, yes, upon her they did feast: she who had no name and who walked with her face behind her

Thenceforth lust like a succubus grew within me, then blossomed forth from me

The hideous stillborn twin you now see hanging from my side ~ look at it long, look at it hard: this is the true face of personal growth

Seven times I~we~married her, she upon whom my eyes did feast, she who had no name

It was to feed the stillborn twin.

That's it, miss, step right up, don't be afraid

Touch it if you will, some nerves near our shared veins still live.

February 19, 1924: Lee Marvin is born!

August 9, 1948: Hank and Audrey Williams' first divorce annulled, legitimizing Hank Jr.

Ephemera

FALL 1987 DJ SCHEDULE

DON TYWONIW

by David Sandlin

Terence McKenna
by Kaz

Dolly Dimples
by Ned Sonntag

Al Goldstein
by Peter Bagge

Forrest J. Ackerman
*by Gary Panter*

Emma Goldman
*by Diane Noomin*

Tex Avery
*by John Schnall*

St. John the Baptist
*by Joe Coleman*

Jimmy Piersall
*by Daniel Clowes*

Leon Theremin
*by Archer Prewitt*

William S. Burroughs
*by Charles Burns*

G. Gordon Liddy
*by Jim Blanchard*

Charlie Starkweather
*by Glenn Head*

Harvey Kurtzman
*by Jay Lynch*

Spike Jones
*by Drew Friedman*

Zora Neale Hurston
*by Mary Fleener*

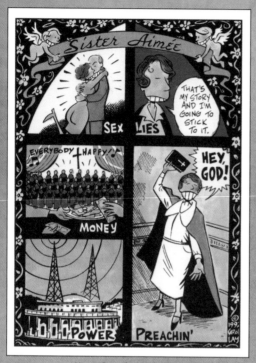

Aimee Semple McPherson
by Carol Lay

Captain Beefheart
by Steven Cerio

D. G. Rempel
© Mark Newgarden

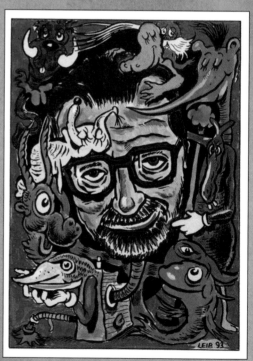

Dr. Seuss
by Gary Leib

Rush Limbaugh
*by Justin Green*

William Randolph Hearst
*by Bill Griffith*

Lenny Bruce
*by J. D. King*

St. John the Divine
*by Jonathan Rosen*

Raymond Scott
*by Hank Arakelian*

Sun Ra
*by Robert Armstrong*

Esquivel
*by Wayno*

Rev. George Went Hensley
*by Mack White*

Lizzie Borden
*by Mark Beyer*

Dan Ashwander
*by Mark Martin*

Florence Foster Jenkins
*by Alison Mork*

The Legendary Stardust Cowboy
*by J. R. Williams*

Marcus Garvey
*by Ben Katchor*

John Waters
*by Mark Landman*

Marion Williams
*by Stephen Kroninger*

Sergei Nechaev
*by Spain*

Jesse Helms
*by Roy Tompkins*

Rasputin
*by Richard Sala*

Emile Cohl
*by Chris Ware*

Szukalski
*by Jim Woodring*

Ernie Kovacs
*by R. Sikoryak*

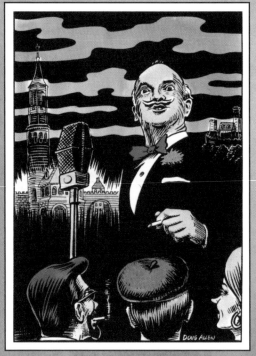

Lord Buckley
*by Doug Allen*

Sarah Winchester
*by Carol Tyler*

Nikola Tesla
*by Sean Taggart*

**STUFF**

WFMU nightlight
*by Jerry Todd*

WFMU tattoos
*by Kaz*

Back montage from WFMU Airwave Idol cards
*by Dr. PhrankenShop*

GARY PANTER

J.D. KING

LENNIE MACE

DAVID SANDLIN

# MAGNETS

WFMU
91.1
EAST ORANGE, NEW JERSEY
201-266-7900

WILLIAM GRAEF

91.1 FM

KAZ

FREEFORM 91.1 FM
wfmu
90.1 FM • wfmu.org

DR. PHRANKENSHOP

WFMU
PO BOX 2011
JERSEY CITY NJ
07303-2011
wfmu.org
90.1
91.1
GLEIB

GARY LEIB

Artwork by Wayno

# SPADE COOLEY

by Michael McMahon

**1935** — OKLAHOMA BORN DONNELL CLYDE COOLEY, EXPERT AT POKER & FIDDLIN', ARRIVES IN HOLLYWOOD AT AGE 25; BECOMES FRIEND & MOVIE STAND-IN TO ROY ROGERS

**1943** — RISES FROM FIDDLER TO LEADER OF JIMMY WAKELY'S WESTERN OUTFIT, SOON AFTER BESTS BOB WILLS IN "BATTLE OF THE BANDS" AT VENICE BALLROOM

"THE KING OF WESTERN SWING!"

"'TIL DEATH DO US PART"

**1945** — WEDS BAND MEMBER ELLA MAE EVANS AS RECORDING DEBUT "SHAME ON YOU" CLIMBS TO #1

"A RAISE ?! GET THE HELL OUT OF HERE !"

**1946** — FIRES POPULAR LEAD SINGER TEX WILLIAMS; ASSEMBLES INNOVATIVE 20-PIECE BAND

"AND THE STAR OF THE HOFFMAN HAYRIDE..." KTLA

**1949** — POPULARITY PEAKS IN FEATURE FILMS AND A WEEKLY HOLLYWOOD TELEVISION SHOW STILL HIGHEST RATED OF ALL-TIME

"IT'S TIME FOR THE CHAMPAGNE BUBBLE MUSIC MAN HIMSELF..."

**1956** — HEART ATTACKS, HEAVY DRINKING & TELEVISION NEMESIS LAWRENCE WELK HASTEN END OF MUSIC CAREER

"YOU'RE GONNA WATCH ME KILL HER !"

**1961** — FIRST TORTURES, THEN BEATS & KICKS WIFE TO DEATH, FORCING DAUGHTER TO WATCH; SENTENCED TO LIFE IN PRISON

**1969** — AWAITING PAROLE, DIES OF HEART ATTACK AT AGE 59 MOMENTS AFTER PERFORMING AT A SHERIFF'S BENEFIT

# KING OF WESTERN SWING

September 17, 1991: Rob Tyner, MC5 lead singer, flunks CPR exam. (age 46)

September 20, 1911: Frank De Vol, TV & film composer and bandleader born.

November 30, 1936: Yippie prankster Abbie Hoffman born

This news item ran in the *Los Angeles Times* on December 16, 1974.

## Rodney Eskelin was my father.

I was recently at the New York Public Library and decided to search the records for any mention of this event. I had always suspected that there would be and here it was. I was familiar with the circumstances of his death but was shocked by the bold matter-of-fact delivery and yet, strange as it sounds, able to draw a certain amount of strength and comfort from the reality of it. Sometimes I feel that my father probably had a more profound effect on my life than anyone I've ever met. It's quite a legacy, especially given the fact that I had almost no direct contact with him before he either accidentally or intentionally left this world.

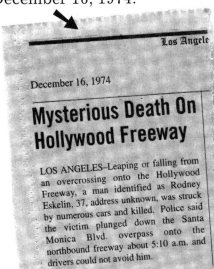

Los Angele

December 16, 1974

### Mysterious Death On Hollywood Freeway

LOS ANGELES—Leaping or falling from an overcrossing onto the Hollywood Freeway, a man identified as Rodney Eskelin, 37, address unknown, was struck by numerous cars and killed. Police said the victim plunged down the Santa Monica Blvd. overpass onto the northbound freeway about 5:10 a.m. and drivers could not avoid him.

# ✸ RODD KEITH *Revealed*

A pioneer in the "song poem" industry, Rodd Keith recorded hundreds of demos for aspiring songwriters. Several of his more bizarre creations can be heard on *Beat of the Traps*, *The Makers of Smooth Music*, **and** *I Died Today*

by **Ellery Eskelin**

**Rodney Keith Eskelin** (or "Rodd" as he spelled his name) was considered a musical genius by every person that I've ever spoken to who knew him. For most of my life this story would remain a deeply private one, difficult to gain a perspective on let alone try to relate and share with others. In 1994, however, that all changed. I discovered that my father Rodd Keith (as he was known in the music business) had himself been discovered by an intrepid record collector and was now gaining cult status for his work in the "song poem" industry. "Song poem" music refers to those "send us your lyrics" ads that you've probably seen in magazines. Rodd was one of the people who set those words to music and recorded the songs which were then "sent around" as promotion on behalf of the client. A strange process that produced even stranger results. This is Rodd's (and my) story.

Rodd's musical beginnings centered largely around the church. His father found religion in mid-life, became a minister and took his wife and three sons into the heartland of America to preach the Gospel. A very musical family, the Eskelins formed a singing group and traveled throughout the Midwest performing for revivals and even cutting a few 78s along the way. At an early age Rodd showed great musical prowess playing a variety of instruments and writing choir and instrumental arrangements for various church groups. After finishing his religious schooling in Florida, Rodd was assigned to a church in Baltimore to handle the music program. It was here that he met my mother Roberta (also a musician), married her and took to the road, traveling across the country playing music while looking for a place to settle. "Rodd and Bobbie" were a two-keyboard team playing piano and organ. They eventually wound up doing a weekly live television program in Wichita, Kansas, in the late '50s called

**Rodd, the early years, circa 1964**

"Just a Song at Twilight." It was here that I was born in 1959. By this time, however, Rodd's ties to the church and religion were becoming tenuous. He had always been something of the charming eccentric (part of what made him attractive to my mother in the first place), yet it soon became apparent that Rodd had his own way of looking at the world and that it was not always compatible with the practicalities of family life. They made it as far as California before things took a turn for the worse. Out of work, roaming the streets of Los Angeles, child in tow and their few possessions piled in a little red wagon, Rodd's detachment and nonchalance in the face of potential homelessness proved too much for my mother. She decided that this was no life for a family and returned to Baltimore with me in 1961. I was eighteen months old.

Growing up in Baltimore wasn't so bad. It's an insular sort of place that begins to take on a surreal quality the longer you stay. In my case, it was a long way from Los Angeles and any conception of my unknown father was somewhat vague at best. All in all though I was pretty happy. After all, I was new to the world and had yet to realize my family situation was rather unusual. My mother continued to play Hammond B3 organ and performed all over town with her own group. I got to hear a lot of music at an early age and was inspired myself to take up the tenor saxophone in 1969. I was ten years old and within a few weeks I announced that I was going to become a jazz musician. I actually knew this the first day we brought the horn home but I waited a while to say it since I was very serious and didn't want anyone to think that this was simply the impetuousness of youth talking.

Stories of my father's musical prowess inspired me. "He could play any instrument he picked up," my mother told me. He drove her crazy by always waiting until the last possible moment to write new arrangements for their show, coming up with fantastic music right off the top of his head and expecting her to sight-read on live television. This was all very effortless for him and he didn't seem to understand her consternation. Rodd loved "progressive" jazz and played

Live TV, Wichita, KA, 1959

his favorite records in my room when I was a child. He was sure that it would have a beneficial effect on me someday. Maybe that explains a lot about how I turned out!?! My mother was afraid that Rodd's far out taste in music would scare a young child.

In any event, Rodd's predilection for modern harmony was beginning to get him into a little trouble at church where his improvisations at the organ were met with

some disapproval. Churchgoers complained about the "sick cow" sounds that Rodd was making out of their precious hymns. Back at home Rodd and his father-in-law (a fine guitarist) played "what chord am I playing?" games, each trying to stump the other by grabbing a handful of notes on the organ and defying the other to figure out what the hell it was.

Stories of Rodd's eccentricities were equally intriguing. He apparently had little regard for the conventions of practical life. He was a pretty laid back guy but was intense about his beliefs and had to argue everything. In a good-natured way, he loved to mess with people's minds and see if he could get a rise out of someone. A very bright guy, he loved to talk and make up outlandish stories. The weirder the better. He could go on endlessly and if my mother protested, she was admonished with the advice that she just needed more discipline. Occasionally his imagination would get the better of her, from his calm and serious explanation that those strange middle-of-the-night sounds on the roof were definitely demons, to his alarmingly casual comments about potential "lifestyle arrangements" where their marriage was concerned. Even more shocking was his rationalization of why it was okay for him to have loaded up the trunk of the car with stolen instruments from the local music store (where they worked) to sell as they traveled the country looking for work. She always stressed though that Rodd was a loving person whom everyone liked a lot and who got along well with everyone he met. He never seemed to get upset and had a live and let live attitude about life that was

actually very inspiring to her and the people they knew. It was this liberal attitude toward life that led to recommendations from their friends that they might like to live in California.

Maybe it's a strange sort of story for a young kid to hear about his dad but I was very, very impressed. We didn't have much contact from Rodd's side of the family after the split. Then around 1973 we started getting letters from Rodd's mother. The whole family was now in Los Angeles and she gave us the run down on everyone's activities. She mentioned that Rodd was now in the recording business. "People from all over the country send him either poems or words and music and Rodd makes records from them. He can just read through the poem for a few minutes and then make up the music and immediately sing and play it," she wrote. I'd never heard of anything like that before, sort of an odd line of work it seemed to me. I guess it didn't really impress me as being a very big deal and after a while it sort of slipped my mind. She ended her letter by inviting me to come visit them and meet my father. My mother thought that perhaps I was now old enough to handle Rodd's "unusualness" and was planning to send me to Los Angeles the next summer. Unfortunately that meeting would never take place. The next letter we got was an account of Rodd's death and the circumstances that led up to it. Rodd had become involved with drugs.

My initial reaction was rather calm, which surprised me a little. Having no working recollection of this man made it all seem a little academic at first. It took a little while for it to hit me but then it became all too real. The shock of realizing that I'd never get to know that man who had so inspired my imagination became immense. I was fifteen.

Over the years, I began seeking out people who knew him. The responses were uncannily similar as if these people, many

of whom did not know each other, were all speaking from the same script. "Your father was a musical genius" are usually the first words out of their mouths. The stories of his drug use and odd behavior were startling. Here was a guy that liked to walk on high balconies just for fun. At least that's what a couple people seem to remember his doing once before he died. No one knows whether Rodd's death was intentional or an accident. I've met people who feel strongly one way or another but most don't really know. The older I get the more acutely I feel this loss. It doesn't get any easier. It just gets harder.

PREVIEW RECORDS INC.

#1009-B
2:45

Arthur Music
A.S.C.A.P.

## I DIED TODAY
(A. E. Lawson-R. Keith)

### RODD KEITH

In 1976 I flew to Los Angeles to meet the Eskelin family. It was a wonderful time. I remembered the letter my grandmother had written in which she mentioned Rodd's work. Were there any recordings of him playing I wondered? After all these years I was absolutely desperate to hear anything that might exist. My grandparents had some records stored away and promised to make a tape of them and send it to me in Baltimore. Some months later it arrived. My mother was just as anxious as I was to hear it. We sat in the living room and put the cassette on. The sound quality was pretty poor, kind of hard to make out. "Is that Rodd singing?" my mother asked. It sounded like a pop thing, kind of commercial. We looked at

each other. I didn't want to say anything but this really sounded terrible. My mother said that this was not at all what Rodd was capable of. We were both disappointed. So this was to be the legacy I thought. A talented guy who got involved with drugs and died way too early.

I felt destined to have to go through life unable to truly relate my feelings about it to any one else. Rodd had, however, remarried and had a daughter, which meant I had a sister, although her whereabouts were unknown. My grandmother said that Rodd's second wife left California and they didn't know where they went. After many years they finally got in touch and I met my sister Stacey for the first time in 1986. We hit it off immediately. Stacey had little recollection of Rodd either due to the fact that he and her mother also split up early. Because of that, Stacey and I share a deep bond where our father is concerned. Here was someone who knew what I felt.

I recently made another trip to California to visit the family. My uncle Jerry brought out a big box of records that he had been keeping. There were all recordings of Rodd. There seemed to be at least two hundred records there. Thinking back to my first experience with Rodd's music freaked me out a little. I didn't want to hear this stuff. I was desperate to have anything that Rodd may have recorded that would have indicated the kind of genius that everybody spoke of, but I wasn't eager to sift through a pile of what I thought was probably junk. My uncle even offered to give me any of the records I wanted. I passed and said thanks but maybe another time although I did glance through the pile. Most of them were under the name Rodd Keith but there were a few under the name Rod Rogers. I learned that Rodd sometimes used that name to record under, a curious fact that didn't mean much at the time and might have been totally forgotten had it not been for...you guessed it, WFMU freeform radio.

I'd become a huge fan of WFMU not long before that trip and had even gotten to know some of the staff. They had been playing some of my records on the air and I'd even played live on Doug Schulkind's show. One day a catalog from the station arrived in the mail. I was leafing through the pages and happened across a record called *Beat of the Traps*. The description of this "send us your lyrics" music sounded very much like the type of work Rodd did. It reminded me of an interview I heard on the station with someone who collected this kind of music. I only caught the very end of it but it made me think of Rodd. I wondered if they had any of his records though I sort of doubted it. I almost turned the page when I noticed the cover of the record. "MSR Madness featuring...ROD ROGERS." My jaw hit the floor. Could it be? No way, I thought. I held the page in front of me for a long time, my mouth still hanging open. Who else could it be?! I had to find out. 'FMU would be having a record fair the next week so maybe I could get it directly. I called the station and spoke to Doug about it. "I think I might know the identity of Rod Rogers," I told him cryptically. I put the date of the fair on my calendar. There was no way I was going to miss this. The day arrived and I made my way downtown to Mary Help of Christians Church, the scene of the fair, and found the WFMU table.

There was the record. I still wasn't sure if this was Rodd so I bought the LP and quickly left to listen to it at home. While waiting for the bus I took the record out and began reading the liner notes. Tom Ardolino (drummer for NRBQ) had been collecting "song poem" music for over twenty years and this collection was his cream of the crop. Towards the end of the notes he mentions that Rod Rogers turns up on a lot of these records also under the name Rodd Keith. SHIT, THIS WAS IT!! He had even been searching for information about Rodd and called one of the record companies that put his music out. The guy who answered the phone told him that Rodd had died and then said, "Yep, he was a keyboard genius." UNFUCKING-BELIEVABLE!! Not only was there interest in Rodd's stuff but he was considered some sort of exalted visionary of a new

genre of music. AND they were calling him a genius to boot! I quickly returned to the fair to buy another copy of the record and drop the bomb on everyone that Ellery Eskelin is the son of Rod Rogers. I met Byron Coley (who put the record out on his label, Carnage Press). He was polite but I could tell that the thought that I might be some sort of delusional nutcase was not far from his mind. I still remember the incredulous look on David Newgarden's face as he walked past me muttering, "I can't believe that Rod Rogers is your father."

A sign of the times, Rodd, circa 1972

The best was yet to come. I got home and put the record on. It was bizarre. My mind stopped working. It was clearly some sort of attempt at pop music but, man, was it strange. It was like nothing I had ever heard and I loved it. The words were rather odd and the music was blatantly fucked up but it was also really charming. Rodd's cuts really sparkled. He sang and played with a zest and enthusiasm that turned each twisted song into a gem. Compared to the stuff I heard as a kid, this was something else altogether. My mother enjoyed it a lot even though she said that it still didn't show what Rodd could really do. He was "just playing around" but his personality came through strongly she thought. Considering the title cut "Beat of the Traps," Rodd's borderline psychotic (drug induced?) rant about the drums, I realized that his personality must have been something far beyond my wildest imagination. Needless to say, I got my ass right back to L.A. and got ahold of all those records.

Since then, Phil Milstein (coproducer of *Beat of the Traps* and *The Makers of Smooth Music*) and I have been busily researching song poem music. Here's how it works. Companies like MSR Records, Preview, and Film City would take out ads in magazines soliciting the public for lyrics. The companies then paid someone like Rodd to set them to music and record them. The records would serve as a demo for the customer. Fame and big bucks were just around the corner. For a fee of course. It was called "song-sharking" and was just this side of a scam. Rodd did this type of work for easy money on and off from the mid-'60s up until his death in 1974. In the beginning he applied the Chamberlain, an early keyboard sampler. A predecessor to the more well-known Mellotron used by the Moody Blues and the Beatles, the Chamberlain used actual tape loops of a variety of instruments and even voices. Rodd was one of the first to master the instrument and I still don't think anyone has ever exploited it to the degree that he did. Check out the song "Little Rug Bug" from *Beat of the Traps*. It's done entirely on the Chamberlain. Later on Rodd hired studio musicians from the L.A. scene, continuing his habit of waiting to the last minute to come up with great arrangements right off the top of this head, going straight to music paper sometimes while eating lunch and holding a conversation at the same time.

Often the results were good by any standards, other times it seemed like all hell had broken loose, probably the result of too many thirty song a day, unrehearsed, drug-fueled sessions. The combination of what were usually pretty strange but sincere lyrics from "amateurs" and cut-rate production values make this the last place anyone might expect to find "works of art" but there they are. Even Rodd considered what he was doing to be a form of prostitution, calling it "commercial crap." He knew he was capable of much more but he threw himself into it nonetheless. He took pride in his work, trying to do each job better than the last, even if it was sometimes a bit tongue in cheek. That's what made it work though. Running through this work so fast that he didn't have time to worry too much about aesthetic issues forced him into a place

in which conviction was everything. Rodd had a way of making the most out of a very limited set of circumstances, which is a quality that I hold in high regard in music generally. Since there was no time for rehearsal or second takes, whatever you played the first time was IT! If one person in the group took a wrong turn everyone had to figure out how to go with them in order to save the track. It's just like improvising. When mistakes get made that's where the music starts. That's been a valuable lesson to me as a musician. As the jazz world becomes ever more conservative and boring I'm more and more attracted to those players who are not afraid to make mistakes, players who make the absolute most of what they've got, be they "virtuosos" or not.

Unfortunately for Rodd, more "legitimate" work was elusive. He seemed not to know how to focus his talents, his difficulties exacerbated by drug use and a growing disinterest in the "real" world. Stories of Rodd's drug use are harrowing. His personality seemed to be a natural for hallucinogens and he took to them with an almost religious fervor. Going in cycles, Rodd would be productive for a time then stop working completely, losing touch with day-to-day reality. During these times he forgot to pay his bills and would sometimes even lose his apartment. Debbie Davies (one time guitarist with Albert Collins and leader of her own band) was Rodd's girlfriend at the time of his death. She remembers Rodd and his friend Conrad (someone I'd love to find) brewing PCP-laced tea, spending their days drinking and talking, creating a strange world and language that she could no longer enter into. Rodd's second wife Joni remembers being called by the police one night to come get Rodd. Apparently he left his apartment one night high on

LSD wearing only a raincoat. He liked to be naked at home so he didn't feel the need to get completely dressed since he was only going out for a pack of cigarettes. Rodd caused quite a sensation on Sunset Boulevard as he somehow managed to catch the raincoat on fire and was forced to rip the burning coat off, resulting in his arrest. She also told me stories about his apartment (in which he painted one room entirely black and decorated the walls with yellow garbage bag twist ties), his arrest record for shoplifting, and the time he almost ruined her hearing by firing a gun in the car. It was also suspected that Rodd may have even been living on the street for a brief period. If this paints a frightening picture, I must temper it with just as many stories of a bright, loving, easygoing man who charmed everyone around him and loved his family as much as they loved him. It may well be, as Debbie now feels, that Rodd was manic depressive. Swinging in and out of functional life, taking LSD every day just to cope, Rodd seemed less and less interested in reality and slowly created a world of his own. His predilection for word play and storytelling took on alarming proportions. He learned to talk backwards.

He saw profound meaning in seemingly nonsensical word play. He talked endlessly but no one could understand him.

One story has survived though. Rodd spoke of making a movie. It was said that he liked to take pictures and had bought one of the first video-type cameras available. Rodd described how the main character in this movie would jump to his death from a freeway overpass. Nobody thought much about it at the time. Two weeks later Rodd either jumped or fell to his own death in much the same way he described. Some of his friends thought he was depressed, perhaps the result of something in his childhood. Others swear that Rodd could have never taken his life intentionally. He certainly wasn't happy having spent so many years doing demos. There's a rumor going around that Rodd actually had his death leap filmed. It's probably a distortion of Rodd's movie story. Still, it's telling that no one that I've talked to dismissed it as being totally ridiculous, as if it were actually within his character to have done so. All in all, there are just as many compelling reasons to think that Rodd's death was indeed an accident. I like to think that he had a lot to live for.

At the time of this writing I am almost at the age that Rodd was when he died. My sister Stacey is expecting her first child. Rodd would have been a grandfather. I did have one indirect contact with Rodd through a letter to my grandmother. I was about fourteen and I described for her my ambitions in music. She showed the letter to Rodd. He said that I had good taste in music and that he was proud of my talent in the music field. Thanks Dad.

Ellery Eskelin
New York City, 1996

*Ellery Eskelin plays tenor saxophone in New York and around the world. He produced a collection of his father's recordings titled* **I DIED TODAY—MUSIC OF RODD KEITH**, *for the Tzadik label's "Lunatic Fringe" series.*

# 9 SPOT ILLUSTRATIONS FOR
## THE
## NEW YORKER
## (REJECTED)

TULI KUPFERBERG

# Anatomy of a Bomb

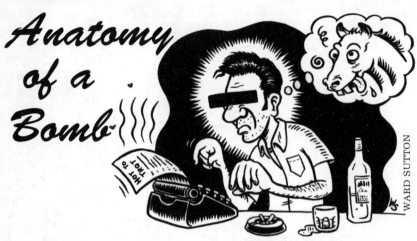

WARD SUTTON

So, if a scene went like this:

**Bobcat**: Five grand? We'll never raise that much money!

**Talking Horse**: Sure we can. I have an idea.

**Bobcat**: Uh-oh.

**Talking Horse**: I could enter the Kentucky Derby and win.

**Bobcat**: Forget it, Albett. I've seen you race. I'm surprised you weren't arrested for loitering!

*Here's what I had to work with:*

**Bobcat**: Five grand? We'll never raise that much money!

**Talking Horse**:...

**Bobcat**: Uh-oh.

**Talking Horse**:...

**Bobcat**: Forget it, Albett. I've seen you race. I'm surprised you weren't arrested for loitering!

It wasn't writing. It was more like solving one of those Chinese box puzzles. You try it, Mr. Smartypants. Fill-in the blanks. Make that fuckin' scene funnier.

Anyway, I was a good comedy soldier. I did my best. I slogged through the movie, filling in the blanks, one by one. Finally, I handed in my rewrite. Later, I heard that John Candy was hired to replace Elliot Gould as the voice of the horse, and that he had thrown out the script and ad-libbed the entire part.

The movie was released. I was going to say it "sank like the Titanic," but the Titanic managed to actually stay afloat for 45 minutes.

This is a true story: the movie came and went so fast I didn't get a chance to see it in Jersey. I had to go into the city to see it. It was playing at the 8th Street Playhouse. I stepped up to the box office and said, "One, please." The Box Office Lady looked up. She was genuinely puzzled. She said, "You know it's *Hot to Trot*?"

I know how you nutty FMU hipsters love to hear juicy inside stories about your favorite Hollywood movies. Well, tough titties. I can't help you. I never worked on any of your favorite movies. But I did do a rewrite on *Hot to Trot*. Remember that one? Sure you do. It starred Bobcat Goldthwait? About the talking horse? Remember? *Hot to Trot*?

I think my *Hot to Trot* story is worth telling for two reasons: one, it was, without question, the most bizarre rewrite assignment in Hollywood history; and two, they already commissioned the artwork for this article.

It was the late '80s (not exactly the Golden Age of American Comedy). In those days, I was under contract at Warner Brothers. I was sort of their comedy foot soldier: I wrote my own crap or rewrote other people's crap. I was the crap guy.

In 1988, they produced *Hot to Trot*. You won't find *Hot to Trot* in the "Classics" section of your video store. Technically, it doesn't even belong in the "Comedy" section. This film deserves its own section. Its own special rack. The UNWATCHABLE LAUGH-FREE DREK rack.

As I said, it's about a talking horse. It was originally supposed to star Joan Rivers. But then Joan's new TV talk show bombed, so Joan was out and "The Bobcat" was in. By the way, kids, that's the sign of a well-executed professional movie script: a leading role that can be played by either Joan Rivers or Bobcat Goldthwait.

Elliot Gould played the voice of the horse. Imagine that—Elliot Gould was

available! They tested the film in front of an audience and this, more or less, is what the audience said: "It sucks." "It's not funny." "Don't make me watch it again." I think that somebody at the screening yelled, "Unfocus!"

What could they do? The movie was "locked." It was over. They had a disaster on their hands. Then some young turk executive at the studio had a brainstorm. Wait, he said, we're not dead yet! We can still change the horse's dialogue!

He was right. This was 1988, before "Babe," before talking movies used high-tech computer imaging. In those days, Hollywood was still using the old hands-on "Mr. Ed" technique: when an animal had to "talk" they yanked violently on a wire attached to its lips or jammed a carrot up its ass. The animal's lips didn't actually form words; it just winced in pain and bared its teeth.

So, the Comedy Brain Trust figured the horse is just opening and closing its mouth, right? Nobody knows what it's saying. We can go back and "loop in" different, funnier, better lines for the horse to say! It was a brilliant plan. Foolproof. All they needed was a hapless asshole who would agree to write the new equine dialogue.

I said, "I'm on my way!"

I thought it would be a quick, painless paycheck...but soon I realized it was a nightmare assignment. I could only rewrite half the dialogue. I could change the horse's lines, but all of the other lines were locked in!

# Out of Williamsburg

STORY BY HARVEY PEKAR; ART BY JOE SACCO; COPYRIGHT © 1995 BY HARVEY PEKAR

LET ME INTRODUCE JOE MANERI, A GUY WHO 35 YEARS AGO, MAYBE EARLIER, WAS PLAYING LIKE THE NEW MUSICIANS OF TODAY. A GREAT ARTIST, A SCHOOL OF MUSIC UNTO HIMSELF, WHO, UNFORTUNATELY IS VIRTUALLY UNKNOWN, ALTHOUGH PEOPLE LIKE PAUL BLEY AND GEORGE RUSSELL HAVE CALLED HIM A "GENIUS."

AT THE AGE OF 68, JOE'S JUST RELEASED HIS FIRST CD, 'GET READY TO RECEIVE YOURSELF' (LEO LAB).

JOE WAS RAISED IN WILLIAMSBURG, BROOKLYN. HIS PARENTS WERE FROM PALERMO. AS A KID HE LEARNED HOW TO PLAY CLARINET FROM, AMONG OTHERS, A SHOE REPAIRMAN AND A FURNITURE MAKER.

YOU PLAY GOOD, JOE, BUT YOU GOTTA LEARN SOLFEGGIO.

AT 15 JOE BECAME A FULL-TIME MUSICIAN, TRAVELING AND PLAYING GIN MILLS AND CHEAP HOTELS, WHERE HE WAS EXPOSED TO AMERICA AT ITS SLEAZIEST.

BY 19 HE'D DEVELOPED AN INTEREST IN AVANT-GARDE CLASSICAL MUSIC, AND FROM 1947-57 HE STUDIED COMPOSITION AND THEORY WITH JOSEF SCHMID, A STUDENT OF ALBAN BERG'S.

HOWEVER, JOE LOVED IMPROVISATION, AND WAS SIMULTANEOUSLY PLAYING JAZZ GIGS AS WELL AS ETHNIC WEDDINGS, WHERE HE PERFORMED JEWISH, GREEK AND ARABIC MUSIC AND DEVELOPED AN INTEREST IN MICROTONALITY.

IN 1959, JOE WAS COMMISSIONED BY ERIC LEINSDORF TO WRITE A PIANO CONCERTO FOR THE BOSTON SYMPHONY. IT WAS NEVER PERFORMED, BUT IT BROUGHT HIM TO THE ATTENTION OF GUNTHER SCHULLER, WHO, IMPRESSED BY JOE, SET UP A QUARTET JAZZ RECORDING SESSION FOR HIM ON ATLANTIC IN 1962.

THE '62 RECORDINGS HAVE NOT BEEN RELEASED, BUT, AS A RESULT OF REVIEWING HIS CD THIS YEAR, I GOT TO KNOW JOE, WHO SENT THEM TO ME ON A CASSETTE. THEY'RE AMAZING. HIS BAND IS USING ODD, FOR THAT ERA, METERS: 7/8 AND 9/8. JOE'S TENOR SAX AND CLARINET WORK IS ASTONISHING. HIS IMPROVISATION IS FREE, NOT BASED ON PRESET CHORD CHANGES. HE USES MICROTONES AND MULTIPHONICS AND DEVELOPS MOTIVES VERY SKILLFULLY. ONE OF HIS COMPOSITIONS IS A 12-TONE PIECE, AND ON IT HE IMPROVISES ATONALLY. RHYTHMICALLY, TOO, HE'S ADVANCED, OFTEN PLAYING AGAINST THE BEAT INSTEAD OF SWINGING CONVENTIONALLY.

I'VE PLAYED THIS TAPE FOR SOME OUTSTANDING MUSICIANS, WHO WERE ASTONISHED BY IT.

JOE WENT THROUGH SOME ROUGH TIMES IN THE 1960'S, BUT SCHULLER GOT HIM A JOB AT THE NEW ENGLAND CONSERVATORY OF MUSIC IN 1970, WHERE HE'S BEEN EVER SINCE. HE PLAYED SOME OF HIS RECORDED IMPROVISATION TO FACULTY MEMBERS, WHO PROBABLY DIDN'T KNOW WHAT TO MAKE OF IT.

WHADJA THINK?

HMM... YES, VERY NICE. THANK YOU FOR SHARING IT WITH ME.

BECAUSE OF THIS COLD RESPONSE, JOE GOT DISCOURAGED AND GAVE UP ON IMPROVISING. HOWEVER, DURING THE BEGINNING OF THE KLEZMER REVIVAL, HANKUS NETSKY, WHO FOUNDED THE KLEZMER CONSERVATORY BAND AT THE N.E.C., BECAME AWARE OF JOE'S KLEZMER AND GREEK CLARINET WORK AND TOLD ME HE WAS KNOCKED OUT BY IT.

HE BRINGS TO HIS VERY SPIRITUAL APPROACH A GREAT KNOWLEDGE OF MUSIC, FROM BACH AND SCHOENBERG TO GREEK AND JEWISH STYLES TO JAZZ.

RIGHT ON, HANKUS! JOE CREATED INDEPENDENTLY OF ORNETTE COLEMAN AND JOHN COLTRANE, WHO HE WASN'T AWARE OF IN THE EARLY 1960'S, A STYLE OF IMPROVISATION THAT INCORPORATED FREE JAZZ, MODERN CLASSICAL, BALKAN AND NEAR EASTERN ELEMENTS. DEPENDING ON THE CONTEXT, HIS PLAYING MAY HAVE MORE IN COMMON WITH JAZZ OR CLASSICAL OR GREEK OR KLEZMER MUSIC. BUT VERY OFTEN ALL OF THESE FORMS ARE PRESENT IN HIS SOLOS IN VARIOUS DEGREES. WHAT HE'S REALLY PLAYING IS "JOE MANERI MUSIC."

IN THE MID-1980'S JOE'S STUDENTS URGED HIM TO START PLAYING PROFESSIONALLY AGAIN, WHICH HE DID IN CLUBS WITH HIS SON MATT, A FINE VIOLINIST. THIS LED TO A 1992 MONTREAL JAZZ FESTIVAL APPEARANCE WITH BLEY, WHICH WAS HIGHLY PRAISED, AND TO THE MAKING OF HIS CD.

GRADUALLY HE'S GETTING SOME ATTENTION. HIS CD HAS BEEN VERY WELL RECEIVED, AND HE JUST PLAYED A JEWISH ART FESTIVAL IN TORONTO IN EARLY JULY. I'D CALLED AND TOLD DAVID BUCHBINDER OF THE FLYING BULGAR BAND, BASED IN TORONTO, WHO BOOKED THE FESTIVAL, TO HIRE JOE. HE'D ALREADY HEARD ONE OF JOE'S TAPES, SO HE WAS EASY TO CONVINCE.

JOE'S ACHIEVEMENTS ARE SO AMAZING... YOU GOTTA CHECK HIM OUT.

PLUS HE'S A WONDERFUL PERSON, A REAL WARM-HEARTED GUY, ONE OF THE GREATEST MEN TO EVER COME OUT OF WILLIAMSBURG.

END

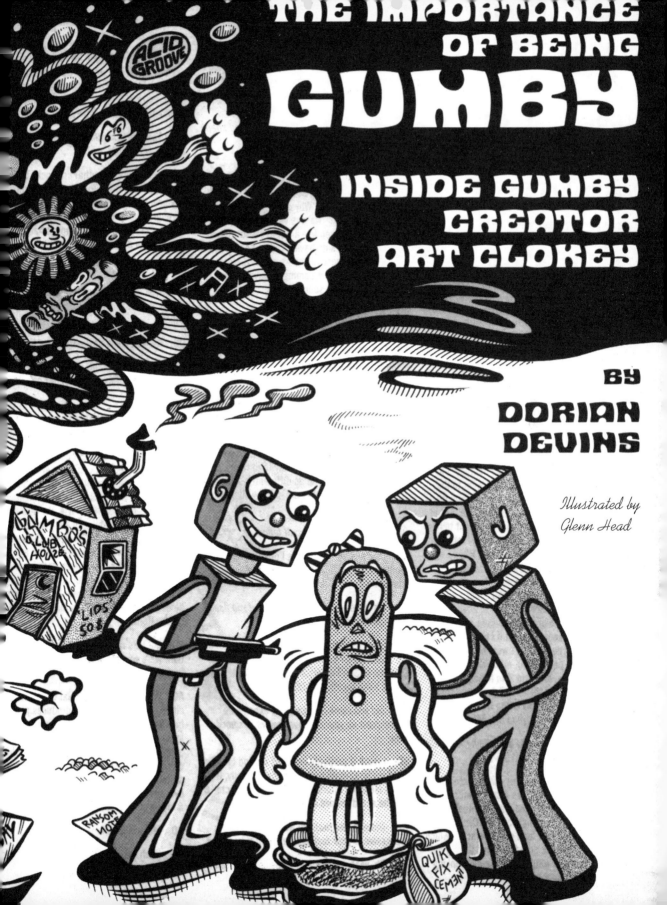

# Watch *Gumby* today and it still seems more like the surreal vision of a tripping acid-head than a kid's show.

Not surprising, really; Gumby creator Art Clokey has experimented with many things in his life including theology, film-making, and yes, psychedelic drugs.

Forced to live in what Clokey describes as "almost slum living" in his early years, little Art was willingly given up for adoption by his widowed mother and stepfather. Taken in by Joseph W. Clokey, who would eventually serve as Dean of Fine Arts at Miami University at Oxford, Ohio, Art was exposed to his new father's passions, including oil painting, motion pictures, photography, and opera. The road to Gumby would soon follow.

After a stint in the Air Force's Photo Intelligence detachment during WWII, Clokey entered the Graduate Program in Cinema at USC where he studied under Slavko Borkevich, a well known Yugoslavian montage artist and the then head of the Cinema Department. Inspired by Borkevich, and with a new knowledge of the power of cinema, Art Clokey set off on his new career. And, as for many of us who grew up watching him on TV, Gumby seems to be much more than a toy for Art Clokey—he's a philosophy.

Recently, Art Clokey paid a visit to WFMU and shared his views on Gumby, his guru, and yes, psychedelic drugs.

**AC:** I'm inclined to believe that this whole reality is a giant person, you might say. As Paul Tillich (a German philosopher) would say, a "ground of being." Initially, I

was interested in the ministry, so after graduating I went to the Hartford Seminary, which was interdenominational. It was a great experience in tolerance. But at the end of the year I decided I didn't want to be a minister, I just wanted to make films. Probably religious films, but it didn't happen. When I went to Hollywood I couldn't get a job because I wasn't a member of the union, so I started my own little production company with fifty bucks and made a little film which I showed to advertising agencies. The head of the Coca-Cola agency in L.A. was so amazed, he asked if I could put Coke bottles in the spot. So I went back (he gave me $110 out of petty cash), made the same spot with Coke bottles, and sent it to headquarters in Atlanta. I worked for them for three years and then Budweiser put me to work doing Bud spots for about two years. That was good discipline.

**LCD:** So you sort of fell into advertising, then did *Gumbasia*?

**AC:** Right. When I had a three- or four-week break, I made *Gumbasia*, which was a sort of music video with jazz in animated clay, and that was what persuaded Sam Engle at Twentieth Century Fox to finance a pilot film for a clay character, which I would have to think up. I fashioned Gumby out of clay. It was just a functional figure, thinking of the medium and its requirements. It had to be practical for a series—easily duplicated and so on, because we used hundreds of figures for each episode. Engle was very philanthropic; he really wanted to improve the quality of television for children. This was not just making money—he wasn't thinking of money. Gumby had a noble grandfather!

**LCD:** I read somewhere that Gumby's head shape was inspired by your father?

**AC:** Right, my father in Detroit. There was a picture of him from when he graduated from high school. I looked up at it (I was about four or five years old) and asked, "Why does Daddy have a bump on his head?" He was very proud of this huge curl that looked like a bump on the side of his head. A lot of kids have it today. People ask me where I get these ideas. I say, "They're given to me."

It's just like dreaming or daydreaming. They come into your subconscious.

**LCD:** You also did *Davey and Goliath*?

**AC:** The Lutheran Church saw Gumby on NBC and flew out to see us. They wanted to do educational films for television using our techniques. We were doing both series simultaneously.

**LCD:** Wasn't that difficult?

**AC:** Well, fortunately, the Lutheran Church didn't let me write any of the scripts, except maybe a couple, I think. Because of my own upbringing, mine had less piety than theirs. Many, of course, I would do differently—put more drama in them—but they did pretty well on television.

**LCD:** They actually had a cult following.

**AC:** That's right. Every time I did a lecture on Gumby, during the Q&A period invariably someone would ask about *Davey and Goliath*.

**LCD:** We talked a little before about if you used psychedelic drugs.

**AC:** From 1955 through 1966–67, I didn't touch the stuff. Then I got caught up with the Flower Children in San Francisco. I met Alan Watts—we smoked hash together in Japan!

**LCD:** Did you think that the drug experience would open up your creative powers in some way?

**AC:** I think it probably loosened up and broadened my imaginative inclinations. Actually, it made me more interested in how Gumby acted, how he acted toward other people.

**LCD:** Did you think that you were somewhat repressive of your feelings before that?

**AC:** Oh, yeah, absolutely! I was so repressed of my feelings, I didn't know other people had feelings.

**LCD:** You were then able to work from a different vantage point, I guess?

**AC:** Oh, yes, with more awareness. I was able to exert more control when it was needed. I didn't get wild. I know some of these kids we hire now as animators, they're really wild. If I let them go, they'd distort Gumby into a real weirdo!

**LCD:** You pretty much always retained complete control of Gumby?

**AC:** Yeah. What was that channel—the Playboy Channel? They did a three-minute Gumby episode. It was just on the verge of being a little pornographic. It had a clay, perfect Gumby, a father, Pokey, his parents, and it had Hugh Hefner! You didn't see it?

**LCD:** No! Well, I don't get the Playboy Channel.

**AC:** Well, it had Hefner giving Gumby and Pokey a psychedelic drink and they go on a trip, a sex trip!

**LCD:** Did you know they were going to do this?

**AC:** No, no I didn't. My attorneys wrote them a letter and told them they'd better not show it again!

**LCD:** I understand you have a guru in India. Does he influence your work at all?

**AC:** Yes, well I suppose it does, but subconsciously. I looked back on some of my work—it's amazing that some of it's prophetic. Some of it describes a current situation of civilization and so on. Especially in the movie, the new movie that hasn't been produced yet. [The guru] you're talking about is Sathya Sai Baba, the avatar. He's recognized as the avatar of the age. We went to India to see if he was genuine and he's unlike any of the other gurus. He doesn't come outside of India to raise money for any-thing, and he doesn't allow his followers to raise money [for him].

**LCD:** So, he's real, not a money-making corporation. Were you introduced to him through friends?

**AC:** Well, yes. We have a Sai Center now in most cities in the country that intro-duces people to him and what he's doing. We sort of play down a lot of aspects

of his life because we don't want people to get the idea that he's establishing a cult, which he isn't. He believes in the unity of all religions. The basic religion is love. We went over there to see if he was genuine; we had seen a movie of him materializing things.

**LCD:** Materializing?

**AC:** Yeah, out of nothing. Like what they do in Las Vegas. So we went over to see if he was actually authentic, and he does actually materialize things right out of space. I saw it myself. I sat about one foot from him and saw stuff coming out of his hand!

**LCD:** That's like watching a Gumby episode.

**AC:** He materialized a solid gold image. He pulled it right out of the sand, actually.

**LCD:** When you found him was it a big revelation in your life?

**AC:** Well, I was looking for the Second Coming. I'd read the Bible over and over again. I would go to see every guru in the country to see if they were true and see if they were the Second Coming because some of them would do amazing things. But they were lim-ited. Then I went over to India and I saw Sai Baba and he's unlimited! He can turn a mountain into a piece of sugar. He's done that—he's turned rocks into sugar right in front of a geologist's eyes, just by blowing on it.

**LCD:** But do you believe in science, pure science and all that?

**AC:** Oh, yeah, I majored in geology, I studied chemistry and physics and all that.

**LCD:** Being as Gumby's made out of clay…

**AC:** It's interesting. The kids are attracted by clay, they like the clay, because clay I guess has been in our collective subconscious for thousands of years. We've been making figures of gods and so on through the centuries. So, Gumby is green. Why, they always ask me? And I tell them I always liked

Walt Whitman's poem "Leaves of Grass." Grass is green.

**LCD:** What about Pokey?

**AC:** Pokey is more of an earth color. The original color of Pokey wasn't cardinal red, it was a kind of brick color. He has four feet on the ground. He's down to earth, and he's kind of the foil for Gumby when Gumby gets his head in the clouds.

**LCD:** And the Blockheads?

**AC:** Well, that's an interesting phenom-enon, too. People are what we call "bad" because they're blocked in one way or another. They're mischievous because they're blocked. They are ignorant, and a lot of their instincts are blocked by emotional traumas and childhood and so on. And mistreatment.

**LCD:** And the "G" and "J" on the sides of the Blockheads' heads?

**AC:** That was for no hidden reason—they looked a little like ears.

**LCD:** Just stylistic. So you yourself could say that you were a Blockhead until you opened up and became a Gumby?

**AC:** Yeah. I think everyone can identify with Blockheads—we're all Blockheads—we're all imperfect because we're blocked by what happens to us in the world.

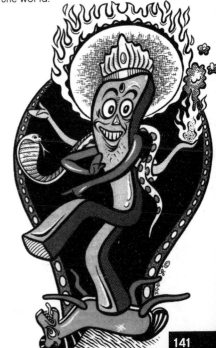

# W.F.M.U.

## presents: "I KNOW BRIAN'S DAD!"

BY REX DOANE AND RICK ALTERGOTT

ONE OF THE MUSIC WORLD'S MOST ECCENTRIC FIGURES IS KNOWN NOT AS A PERFORMER HIMSELF, BUT MORE FOR HIS ROLE AS THE FATHER/MANAGER OF THE WILDLY SUCCESSFUL ROCK GROUP, "THE BEACH BOYS"!

"IT IS SAID THAT THE ACORN FALLS NEAR THE OAK. A VICTIM OF ABUSE HIMSELF AT THE HAND OF HIS OWN FATHER, MURRY WILSON PASSED THE LEGACY ONTO HIS SONS, BRIAN, CARL AND DENNIS."

"EARLY IN HIS ADULT LIFE, MURRY LOST HIS LEFT EYE IN A FACTORY ACCIDENT"

"LATER, HE WOULD DELIGHT IN HIS SON'S HORROR AS HE POPPED HIS GLASS EYE FROM ITS SOCKET WINKING AT THEM THROUGH THE EMPTY EYEHOLE!"

"AT A LITTLE LEAGUE GAME, MURRY HIT BRIAN OVER THE HEAD WITH A BAT, POSSIBLY MAKING HIM RESPONSIBLE FOR BRIAN'S DEBILITATING HEARING LOSS IN HIS RIGHT EAR"

"BRIAN ALSO SUFFERED THE INDIGNITY OF BEING FORCED TO TAKE A SHIT ON A DINNER PLATE IN FRONT OF THE WHOLE WILSON FAMILY, A PSYCHE SHATTERING EXERCISE IN HUMILIATION."

"BROTHER DENNIS RECEIVED HIS PUNISHMENT IN THE FAMILY'S BATHTUB, SO AS TO PREVENT HIM FROM DAMAGING ANY FURNITURE IN HIS STRUGGLES TO ESCAPE!"

"DURING THE BRITISH INVASION, WHEN THE BEATLES' POPULARITY THREATENED THE BEACH BOYS' OWN ON THE AIRWAVES, MURRY HATCHED A SCHEME; PRINTING AND CIRCULATING BUTTONS THAT READ: 'I KNOW BRIAN'S DAD!'"

"PREDICTABLY, THIS WEIRD PROMOTION WAS DOOMED TO FAILURE."

AFTER HIS OUSTER AS THE BOYS' MANAGER, IT WAS LEARNED THAT MURRY HAD NEGOTIATED A $700,000 CASH SETTLEMENT FOR THE RIGHTS TO THE EARLY, CLASSIC BEACH BOYS CATALOG -- WHICH WOULD BE APPRAISED IN LATER YEARS AT A VALUE OF AROUND $25 MILLION!!

WHAT AN ASSHOLE, THIS GUY, EH!?

end.

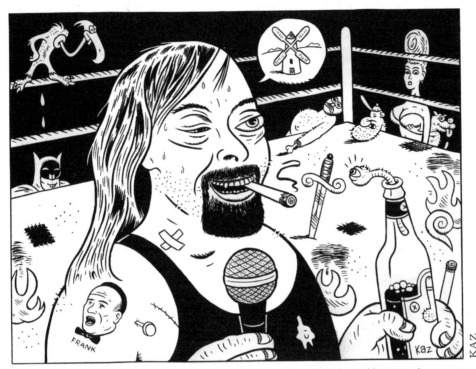

February 23, 1976: Glen Jones makes radio debut as co-host of Wide World of Wrestling,
WHBI-FM, Newark, New Jersey

June 3, 1959: First radio signal bounced off the moon (recorded message from President Eisenhower
to Canadian Prime Minister Diefenbaker).

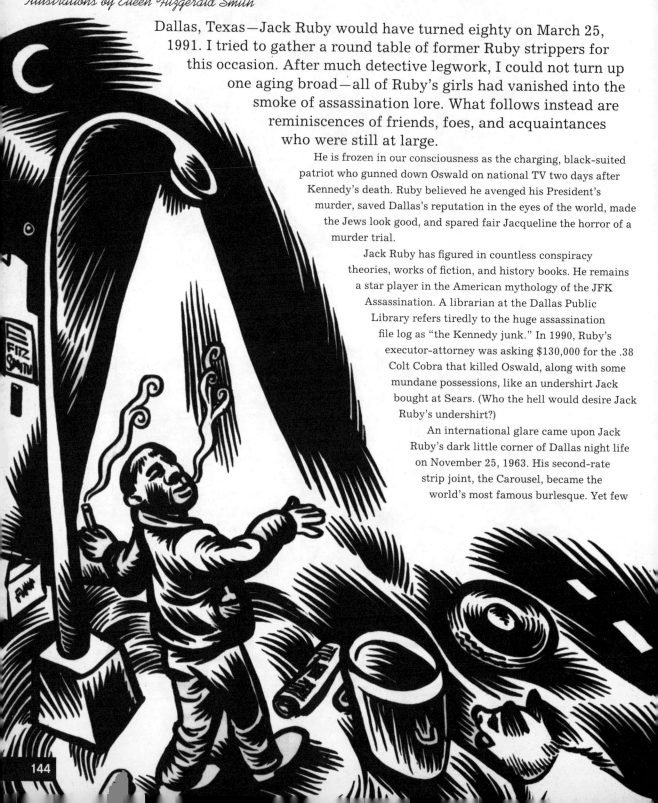

# Jack Ruby: *Dallas's Original J.R.*

by Josh Alan Friedman
Illustrations by Eileen Fitzgerald Smith

Dallas, Texas—Jack Ruby would have turned eighty on March 25, 1991. I tried to gather a round table of former Ruby strippers for this occasion. After much detective legwork, I could not turn up one aging broad—all of Ruby's girls had vanished into the smoke of assassination lore. What follows instead are reminiscences of friends, foes, and acquaintances who were still at large.

He is frozen in our consciousness as the charging, black-suited patriot who gunned down Oswald on national TV two days after Kennedy's death. Ruby believed he avenged his President's murder, saved Dallas's reputation in the eyes of the world, made the Jews look good, and spared fair Jacqueline the horror of a murder trial.

Jack Ruby has figured in countless conspiracy theories, works of fiction, and history books. He remains a star player in the American mythology of the JFK Assassination. A librarian at the Dallas Public Library refers tiredly to the huge assassination file log as "the Kennedy junk." In 1990, Ruby's executor-attorney was asking $130,000 for the .38 Colt Cobra that killed Oswald, along with some mundane possessions, like an undershirt Jack bought at Sears. (Who the hell would desire Jack Ruby's undershirt?)

An international glare came upon Jack Ruby's dark little corner of Dallas night life on November 25, 1963. His second-rate strip joint, the Carousel, became the world's most famous burlesque. Yet few

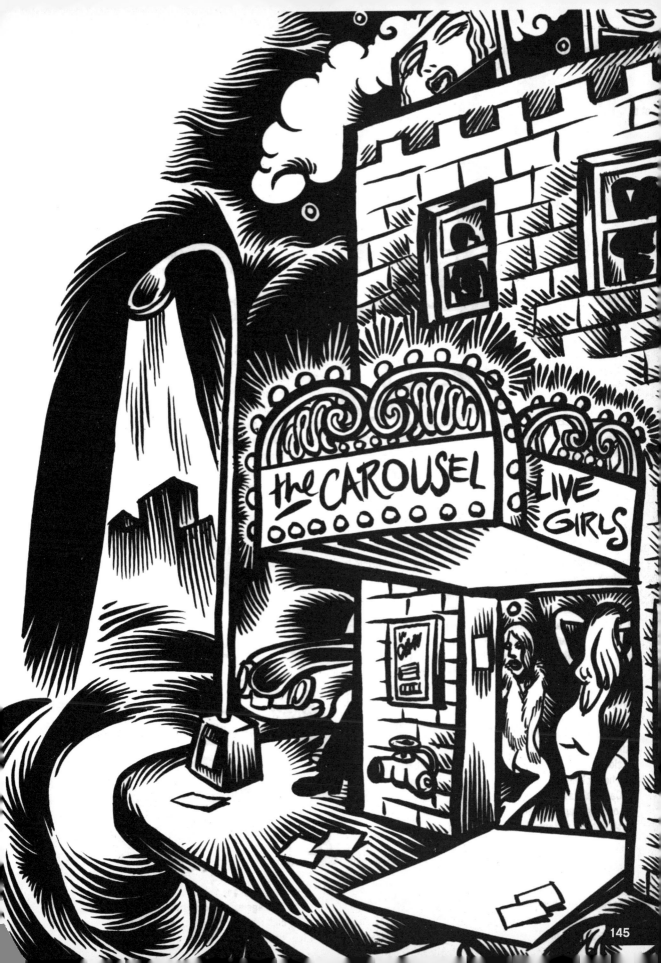

145

customers ventured in after Ruby hit the front pages.

"Anybody coulda killed Oswald, the way people's feelings was running at that time—it didn't surprise me it was Jack," says Dallas Deputy Sheriff Lynn Burk, who knew Ruby well and was present when Oswald was captured at the Texas Theater. "I'm surprised some policeman didn't kill Oswald first."

"He stuck by what he did," says Captain Ray Abner, who was Ruby's personal jail guard. "He said he loved Kennedy and that he was glad he did it. But I believe Jack just intended to wound Oswald. Spend a couple years in prison, sell a book and movie rights. He was a small figure who came up from the Chicago underworld. He was a guy who wanted to be a big-shot."

On Ruby's last day as a free citizen that November morning in '63, he was a paunchy, balding, 52-year-old burly-Q operator. He had oily, slicked-back black hair, a cleft in his chin, five o'clock jowl shadow, and he wore cuff links, a tie stickpin, and diamond pinkie rings. The Carousel was located on Commerce Street, one flight up, between a parking garage and a short-order restaurant. Strippers' 8x10s hung over the entrance. A $2 cover allowed horny patrons entrance to a square, barn-like room with dark-red carpeting and booths of black plastic. Jack Ruby's stage was the size of a boxing ring, with a five-piece bump-and-grind orchestra, but no dancing.

The bar was boomerang-shaped, finished in gold-plated plastic and gaudy gold-mesh drapes. The black barkeep, Andy Armstrong, was Ruby's right-hand man. Overhead hung a gold-framed painting of a stallion, which Ruby believed had "real class."

Obsessed with "class," he operated from a dingy little office in the back with a gray metal desk and small safe.

Terre' Tale, a Dallas strip queen of the '60s, had a dozen routines. The crowd favorite was an Uncle Sam act in which her boobs marched in time with a hup-two-three-four soundtrack. She met Ruby when innocently answering a Carousel newspaper ad for a cocktail waitress: "The black bartender told me to come back with the sexiest outfit I had. When I came back, they sat me down next to a guy with more arms than an octopus. I didn't even know the Carousel had strippers. I'd never seen a strip. The girls laughed at my reaction. 'When Jack sees you, he'll have you on amateur night this Friday.' But Jack Ruby was nice to me. 'Does your body look as good as your face?' he said. 'No, I have two kids,' I told him. Then he told me he could make me a star, put me in an apartment, send me to the beauty parlor every day."

Terre' Tale refused Ruby's offer, but a few years later she was headlining the Colony Club, two doors down from Ruby at 1322 Commerce. Abe Weinstein's Colony Club was Dallas's most reputable burlesque from 1939 to 1973. Ruby envied this deco cabaret, which seemed to possess the elusive class he so craved.

"My club was a nightclub," says retired owner, Abe Weinstein, now 83. "His was just a joint. I had big names; he had nobody. When he came from Chicago to Dallas in

'47, he came up to my club right away. He was told there's a Jew runs a club, that's how I met him."

Ruby, whose God-given name was Rubenstein, ran a few music spots before opening the Carousel right next to Abe in 1960. Ruby was a tremendous pain in the ass, bottom-feeding off the Colony's action for three years. "My relationship with Jack was bad," says Weinstein. "He threatened to kill me one week before he killed Oswald. I'd had him barred from the club. He tried to hire away my waitresses and employees. Here's my opinion: Jack Ruby killed Oswald because he wanted to be world-famous. If he'd have killed Oswald before the police got Oswald, he would have been a hero. But it was no great thing to get him in the police station."

Ruby was particularly jealous of amateur night at the Colony and the lines it drew. There was no such thing as jail bait—girls in their mid-teens could hop onstage and strip.

"I started when I was 15," recalls former stripper Bubbles Cash in her North Dallas jewelry-pawn shop, Top Cash. "If you were married in Texas, you could do anything your husband said you could do. I married at 13. I told my husband I wanted to be a dancer and take Candy Barr's place as a star in downtown Dallas. The ladies were like movie stars,

glamorous, classy. The first time I took my clothes off onstage was great. I wore a red, white, and blue dress, and when I unzipped, everyone went crazy, and my husband was proud. It was amateur night."

Eventually Ruby ripped off the amateur-night idea, sweet-talking local secretaries who'd never gotten naked before an audience onto the Carousel stage.

Bubbles recoils at the mention of Ruby, whom she never worked for: "I was told by Abe don't even go near his place. The Carousel had a bad connotation; the girls weren't on their best behavior. They did some hookin' outta there."

Weinstein, who lives alone with his memories, has almost no contact today with any of the strippers who graced his establishment. "I had the biggest stripper, Candy Barr," boasts Weinstein. She was another figure associated in myth with Ruby. Abe pronounces her name with the same emphasis one would use for a Milky Way candy bar. "I named her, started her in the business, managed her. She packed the house every night."

Abe claims Barr never worked for Ruby or had anything to do with him. But according to sax player Joe Johnson, Candy Barr came after hours to Ruby's Vegas Club, in the late '50s, to strip. "All the girls came over to the Vegas to strip," says Johnson, who led a five-piece R&B group there. Johnson worked for Ruby six years, starting in 1957. His trademark was belting out sax solos as he walked along the bar top. "I was part of a family. Ruby was the best boss I had in Dallas. After he shot Oswald, the FBI followed me everywhere I'd play. I got six pages in the Warren Report."

Legendary Dallas-born Big Texas Tenor, David "Fathead"

Newman, took hometown gigs at Ruby's Vegas and Silver Spur dives, when on leave from Ray Charles. "The thing I remember most about Jack Ruby," chuckles Newman, "were the stag parties in his clubs. Whenever the striptease dancers came out, he'd want the musicians to turn our backs, 'cause these were white ladies. He'd say, 'Now, you guys turn your

backs so you can't see this.' But the strippers would insist that the drummer watch them so he could catch their bumps and grinds. So, Jack says, 'Well, the drummer can look, but the rest of you guys, you turn your backs on the bandstand.'"

Ruby's penchant for barroom brawls kept him in minor scrapes with Texas law. Deputy Sheriff Lynn Burk, a dapper 67, remembers the frontier days of Naughty Dallas. He was a frequent lunch mate of Ruby's, and still has Jack's Riverside phone number in his phone book. Burk ironed out some of Ruby's barroom troubles.

He first entered Ruby's music joint, the Silver Spur, in 1953: "Jack was stayin' open late; there was suspicion he was serving liquor after hours." Working undercover, Burk

visited the club with a pint of whiskey and poured himself a shot, in the wee hours. Ruby politely told him to take it outside, thus abiding by the law. Burk was impressed.

Pre-Kennedy Assassination Dallas had small-town camaraderie, whereby the Texas Liquor Control Board supervisor could meet for lunch with a burlesque owner. Ruby often brought sandwiches by the dozen up to police headquarters. Free drinks went to servicemen, even reporters, who Ruby ingratiated himself with. That's why he wasn't seen as out of place in the basement where Oswald was transferred.

Burk says he enjoyed Jack's stories about a fighting childhood on the East Side of Chicago. Ruby had been a Chicago ticket scalper, then sold tip sheets at a California racetrack. He came to Big D after the army discharged him in '47 with a good-conduct medal and sharpshooter's rating.

Burk recalls that Ruby was a good fighter who lifted weights and sparred with former lightweight champ Barney Ross who appeared as a character witness in Ruby's murder trial.

"When I was assistant supervisor of the Liquor Board in Dallas, a man called one day, wanted to know what we did to proprietors who beat up customers. I said you come to my office, and if we prove a breach of the peace, we can suspend his license.

"So this great, big man, well dressed, comes in, some executive with LTV. Said he was down at the Carousel, he'd gotten separated from some friends. He thought they might have entered the Carousel; so he went up and paid admission, walked around, didn't see 'em; so he asked for his money back before leaving. They said no, wouldn't give him his money back. He said, "Well, I'm not

staying.' They said, 'Well, we're not giving your money back.' Then he said the proprietor knocked him down. He got up, and the proprietor knocked him down again.

"I said, 'I'll get Jack Ruby down here; you identify him.' I called Jack. I said, 'Come on down, and come to my office first, you understand?' Because the complainant and the supervisor were sitting in the other office.

"I said, 'Jack, there's a man in the next room you beat up at the Carousel.' He remembered. I said, 'We're goin' in there, and you be the most humble damn man ever walked into that damn office.' So we go in, and I say, 'Mr. Smith, this is Jack Ruby.' Jack said, 'The first thing I wanna do is apologize.' The man said, 'Why did you knock me down the second time?' Jack said, 'You're a lot bigger than I am,' and described a fight where he knocked a man down once who got up and bit his finger off. Ruby showed his missing finger. He said that was the reason he always hits a man a second time. He said, 'You can bring your whole office to my club; I'll feed them and give them drinks—I'm just sorry for what happened.' The man dropped the complaint."

Abe Weinstein tells this anecdote about Ruby's temperament: "There was a famous Dallas society doctor that lived in Highland Park. He was a good customer of mine, never bothered anybody or fooled with the girls. For years, every time his wife left town, he'd come up to the Colony. Then a month passed, two months, I never saw him. I called a meeting with the girls, but nobody seen him. One day I'm walking by the Adolphus

on Commerce, and I ran into Dr. Ross. He told me there'd been a doctors' convention in town. A colleague from Los Angeles stayed with him, and Dr. Ross showed him the city. Took him up to Ruby's place first, and he didn't like the show. Dr. Ross walked down the steps and said he'd take the guy next door for a real show. Jack Ruby happened to be standing behind and

heard the remark. When they got to the bottom of the steps, Ruby grabbed Ross by the neck and knocked out all his teeth. He couldn't report it to the police because he was a Highland Park society doctor—what was he doin' in this joint?

"But that's Jack Ruby, Dr. Jekyll and Mr. Hyde. If you went into his club, he'd never seen you before, and said, 'Jack I'm hungry; I don't have a place to sleep,' he would feed you and give you a place to sleep. But if he didn't like you, he'd stab you in the back."

Virtually all the strippers who worked for Jack Ruby have evaporated from the city of Dallas. Just try searching for a Double Delite in the phone directory. "I didn't live 47 years by talking about it," spat one

ex-husband of a Ruby stripper, who hung up.

"You're talking three generations of strippers back," explains Shane Bondurant, a 1960s burlesque star who now preaches at the Rock of Ages church. Ms. Bondurant once twirled a ten-gallon Stetson hat from one boob to the next, whilst spinning two pistols at the hips. She used 24 live snakes in her act, and made headlines when one of the two lions she kept in her trailer park bit her leg.

Like Bubbles Cash, Terre' Tale, and Abe Weinstein, Ms. Bondurant knows the whereabouts of not one single Ruby girl: "I would figure most became prostitutes, addicts, or died. A stripper's career is ten years, and the few who survive afterward must be quite strong and pull their lives together."

Ruby's girls were not that strong. There were suicides that became part of the conspiracy lore. Baby LeGrand, whom Ruby wired money minutes before killing Oswald, was found hanging by her toreador pants in an Oklahoma City holding cell in 1965. Arrested on prostitution charges, her death was ruled a suicide.

Tuesday Nite was another suicide. And in August 1990, worldwide interest was stirred by the latest conspiracy theory: the son of a Dallas cop claimed his father shot JFK and presented a plausible scenario of evidence. His mother had worked at the Carousel, overhearing Ruby and her husband discussing the planned assassination. She was then given shock treatments and is now allegedly too ill to speak to reporters.

Certain Ruby girls showed great devotion for their boss. Little Lynn liked Ruby enough to show up at the

jail crying after Ruby was imprisoned. The 19-year-old, blue-eyed stripper carried a Beretta pistol in her scarf to give him. She was arrested at the entrance.

Shari Angel, once billed as "Dallas's own Gypsy," also kept a candle burning for Jack Ruby. In a 1986 *Dallas Times Herald* interview, the former Carousel headliner tried to raise money for "a medal or monument for Jack. He was a wonderful man." Angel described him as a mother hen to the girls, who took them to dinner and bowling. She married the Carousel emcee, Wally Weston, who later died of lung cancer. After years in an alcoholic haze, she found Jesus and pulled herself together. "You know," she told the Herald, "I've seen [Ruby] hit a man— I mean a real hard shot—and then pick him up and feed him for a week. He was big-hearted. If I could just get a monument to him, then maybe we could finally lay him to rest."

Angel once again relates Ruby's attack-repent ritual of belting some guy out, only to turn around and "feed" him. A little-known literary gem, *Jack Ruby's Girls*, was published in 1970 by Genesis Press in Atlanta. "In Loving Memory of Jack Ruby," read the dedication by Diana Hunter and Alice Anderson. "Our raging boss, our faithful friend, the kindest hearted sonuvabitch we ever knew." This reflected the love-hate relationship of a half-dozen strippers profiled within.

There was Tawny Angel, who Ruby fell "insanely in love with," tripping over his speech. Until her, say the authors, Jack Ruby–style sex encompassed only superficial one-nighters with "bus-station girls, trollops, and promiscuous dancers."

"Jack Ruby's Carousel Club was in the heart of a city that never took the Carousel to its heart," wrote the authors. "Dumping" champagne was a Carousel ritual. Girls accidentally spilled bottles of the rotgut stuff, marked up to $17.50 from a $1.60 wholesale price. Jack Ruby beer went for 60¢ a glass, and it was shit. He encouraged the bar girls not to drink it, just to waste it when sitting with suckers in the booths. Ruby didn't allow hooking, claimed the authors, just the false promise of sex so they could hustle champagne.

Jack chiseled money from customers, yet loaned money to friends. He beat, pistol-whipped, and blackjacked unruly patrons down the stairs. Spend money or get out—that was the attitude of the man who avenged President Kennedy's death.

"I never believed there was a conspiracy between Jack and anyone," states Deputy Sheriff Burk, never before interviewed about Ruby, "because Jack Ruby had two dogs he thought more of than anybody. If he had any idea he was gonna kill Oswald, he woulda arranged for those dogs. It was a spontaneous outburst—he was over at the Western Union when they moved Oswald. It was timing."

Not many folks came to visit Ruby in jail, according to Ray Abner. Immediately following the arrest, Abner was assigned to guard Ruby's jail cell for over a year. He kept an ear on phone calls, listened to the arguments between Ruby and his sister Eva, watched him shower, heard him break mighty wind, even must have smelled it.

Ruby's cell was isolated from the rest of the prisoners, near the chief's office, with full-time security. "Jack liked special attention," says Abner. "He felt like they oughta prepare meals the way he wanted 'em. I ate strictly jail food, same as the prisoners, and I insisted he do the same. None of the girls came to see him. Just his lawyers, his sister Eva, and his brother Earl. I couldn't help but overhear his conversations; so I'm pretty sure he wasn't involved in any conspiracy."

Ruby was riding high in the months after he shot Oswald. He doted over his daily shipment of fan mail, over fifty letters a day congratulating him, calling him a hero. "But after a while," Abner remembers, "the fan mail dropped off, and he got depressed."

Ruby was convicted, and he died of cancer in January 1967 while he was awaiting a retrial. In the meantime, those who made their living in his champagne-hustle world had to go elsewhere for work. *Jack Ruby's Girls* documents the pilgrimage of two strippers after the Carousel closed: Lacy and Sue Ann applied for jobs at Madame De Luce's upscale whorehouse in the Turtle Creek area of Dallas. But Madame believed Ruby "ruined" women as potential prostitutes. All tease, promise, but no fuck is what Ruby taught them. The reputation as a Ruby Girl was a stigma for those who tried to become hookers.

Jack Ruby didn't allow that type of hanky-panky in the Carousel. "This is a fuckin' high-class place!" he would remind any doubting Tom, Dick, or Harry, as he kicked them down the stairs.

JOSH ALAN FRIEDMAN IS A DALLAS ROUSTABOUT, FORTY-DEUCE ALUMNUS, AND THE AUTHOR OF *TALES OF TIMES SQUARE*. THIS ARTICLE ORIGINALLY APPEARED, IN SLIGHTLY MODIFIED FORM, IN *HUSTLER* MAGAZINE.

THANKS, MR. FLYNT!

WFMU Presents

# I, Rebel!

## The Phil Spector story
### by Rex Doane & Alex Wald

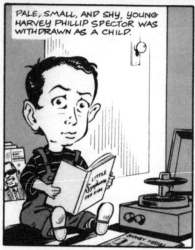

PALE, SMALL, AND SHY, YOUNG HARVEY PHILLIP SPECTOR WAS WITHDRAWN AS A CHILD.

LITTLE PHIL WAS DRIVEN FURTHER INTO SOLITUDE WHEN HIS BELOVED FATHER UNEXPECTEDLY COMMITTED SUICIDE.

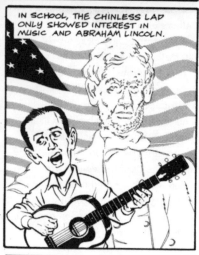

IN SCHOOL, THE CHINLESS LAD ONLY SHOWED INTEREST IN MUSIC AND ABRAHAM LINCOLN.

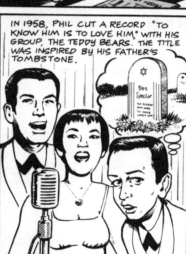

IN 1958, PHIL CUT A RECORD "TO KNOW HIM IS TO LOVE HIM" WITH HIS GROUP, THE TEDDY BEARS. THE TITLE WAS INSPIRED BY HIS FATHER'S TOMBSTONE.

SUCCESS CAME EARLY AND OFTEN TO PHIL IN THE ROLE OF PRODUCER.

AT AN IMPROMPTU ORGY, PHIL ABANDONED TWO EAGER NYMPHOS TO COMPOSE "SPANISH HARLEM."

...I HAVE TO BEG YOUR PARDON...

PHIL BEGAN TO RELY HEAVILY ON THE ADVICE OF DR. KAPLAN, HIS PSYCHIATRIST.

AS A SPOOF SPECTOR RELEASED "DR. KAPLAN'S OFFICE" ON THE B-SIDE OF A BOB B. SOXX 45.

PHIL GAINED A REPUTATION FOR BIZARRE BEHAVIOR AND WILD AND GARISH OUTFITS.

BY THE LATE 60s, HIS STATUS AS A ROCK 'N' ROLL PSYCHOPATH WAS SECURE.

NEXT: GUN-TOTIN' PHIL GETS DEEP WITH JOHN AND YOKO AND WIGS-OUT THE RAMONES!

SEAN TAGGART, TEXT BY BRONWYN CARLTON

726 AD: Byzantine ruler Leo III forbids the worship of icons.
"Iconoclasm-mania" sweeps Constantinople.

J. R. WILLIAMS, TEXT BY CHRIS T.

360 AD: Julian, Rome's last pagan emperor, drinks Celtic beer while in France and slags it in a satirical poem, harping on the flatulence. Which he lights.

# LIVES OF THE HIPSTER SAINTS:
# JAZZBO...
## ON THE RADIO *by Gene Sculatti*

*It's late. In the background, a piano plays a drowsy blues. Then a voice:*

"People ask me what it looks like down in the Grotto, and I haven't really said too much about it lately, I guess, but one of the main things is that in order to get here you've got to come down a long kind of underground tube that leads in from street level. At Forty-Second and Third. You crawl in on a tube over which there's a burlap sack hanging down. That's to keep the wind and cold air from blowing in. And then you are immediately in the main cave room, which is hemispherical and looks almost vaulted at the highest point...about twenty feet above the Grotto floor, which is flat and dry.

"And the Big Ben stalactite, which is the largest one of several, comes down fifteen feet from the ceiling. And then there are smaller ones growing up from the floor of the Grotto (and one is about five feet, six feet high) and those are stalagmites. If they ever connect, they're called columns, and we have three of these, where a stalactite and a stalagmite have...grown together. It's very rare, but we have 'em."

The piano shimmers. The voice resumes. "And at the top of the Grotto it's very dark purple, almost black. And then it starts getting progressively light as it goes down the side, [piano] getting into the various shades of purple, mauve, magenta, taupe, and all those. And then if you look over to the left side you will see a mushroom patch growing there of the "Purpulus grottus" variety, and they're about four feet in diameter. They're huge. And that's where I got the idea to have Purple Grotto-burgers. I was gonna have a series around town underneath the ground where you go in and have a Grotto-burger. 'Cause mushrooms...are very much like steak (filet mignon)...if you get a good mushroom. And these are the best...

"Over on the extreme right there's a pit of fluid that's almost like a small lake. And it's a fluid that has not been analyzed as yet. It's thick, and we've plumbed the depths to about two hundred fifty, three hundred feet with lead weights and wire, and there's no sounding the bottom. So that's one of the reasons no people are allowed down in the Grotto. I just can't get insurance for a place like this..."

What? Where are we? For all the sense it's making, it might as well be Mars in 2856, or maybe 7680. But we're in New York City, in 1982. It's four in the morning; we're tuned to radio station WNEW, and the piano, the voice, and the way-out word "jazz" belong to Al "Jazzbo" Collins (or "Jazzbeaux," depending on how whimsical he feels)...

Cool may not even be the word for Collins. He's of it, inside it, beyond cool. Just ask the Jazzbo multitudes, Al's Pals (they must number in the hundreds of thousands by now) gathered around radios in San Francisco, Salt Lake, and L.A., where they're waiting for him to return, as if to ask, "Did it really happen?" It did. It does, weeknightly, midnight to 5:30 a.m. now in New York, just as it did from 1950 to 1960.

Back then they turned to Jazzbo for jazz. He was in the clubs, at Birdland and the Hickory House, down at the downbeat office, digging, and he was on the air laying a taste on the ears (Dizzy Gillespie, Charlie Parker, Sinatra and Shearing and Peggy Lee, and Slim Gaillard doing that whole "mello-roony" rap about "Ce-ment mixer, putty putty").

But if it's music that brought 'em in, it was Jazzbo who kept them coming back, with an announcing style so laid back it was four winks west of Sominex, but so hip. Snooze and you lose, 'cause what he's saying at that crazy half-speed is twice as gone as any other disc jockey you've ever heard.

It all started at the University of Miami in 1941 with the line "What's new at the 'U'? This is Al Collins, and here's Professor Hoo-ha." Subbing for a fellow student, Collins made his radio debut on the college station by accident. No matter. After reading the line, standing for the first time in the studio control room "with the lights, the 'On the air' signals, the engineer,

the mike, the drama of the thing hit me with a bursting brilliance. And I said to myself, 'Hey. Whew! What a scene. I think I would like to do this.'"

At Chicago's WIND a few years later, his engineer suggested Collins use something with the word jazz to title his program, which was, after all, a jazz show. A product of the day, a clip-on bow tie called Jazzbows, did the trick. "I went on the air that night," Collins remembers, "and said, 'Hi, this is Jazzbo here with some really fine music.' And the phones started ringing and everybody wanted to know 'Who's Jazzbo?' I said, 'Heck, it's a really good handle.'"

The handle helped get Collins to WNEW in 1950. He recalls a night there, too:

"I started my broadcast in Studio One which was painted all kinds of tints and shades of purple on huge polycylindricals which were vertically placed around the walls of the room to deflect the sound. It just happened to be that way. And with the turntables and desk and console and the lights turned down low, it had a very cavelike appearance to my imagination. So I got on the air, and the first thing I said was, 'Hi, it's Jazzbo in the Purple Grotto.' You never know where your thoughts are coming from, but the way it came out was that I was in a grotto, in this atmosphere with stalactites and a lake and no telephones. I was using Nat Cole underneath me with 'Easy Listening Blues' playing piano in the background."

For fun, Collins gave the Grotto its own bestiary—Harrison the Tasmanian Owl, who dug Paul Desmond and Brubeck; Jukes, a female chameleon who went for swing; Clyde, a Dixieland-digging crow; and a flamingo named Leah, who, Jazzbo told his listeners, liked "music to fly by."

The combination hit hip Manhattanites like a saucer from the spheres; within days, fans began showing up at 'NEW demanding to be taken downstairs to the Purple Grotto.

Collins capitalized on his radio fame in 1954, cutting a series of "Great Moments in Hipstery" bop-talk records for Capitol. *Little Red Riding Hood* was his hit, but *Discovery of America* had some choice lines. On Columbus, "hanging out at the royal court in Spain": "Chris has been on the scene for months and there's one thing on his mind: boats. It was then that he met Queen Isabella, who had

only one thing on her mind: (ahem). In short, she had bulging eyes for our man. In fact, she was verily flipping her coronet for Mr. C..."

Jazzbo split for San Francisco in 1960 (where he was to stay until 1969). He kicked things off at KSFO there with the *Collins on a Cloud* show. To the accompaniment of dreamy harp music, Collins "floated" over the city, looking down and grooving on the bridges, ships, and scenes.

From '60 to '62 he had his own TV show on the local ABC affiliate, mornings at 8:30 right after the *Crusader Rabbit* cartoons and before Jack LaLanne's warm-ups. Many viewers (this one included) couldn't quite believe their eyes or ears. Here was Collins, in sky-blue jumpsuits, interviewing celebrities, politicians, sheiks, musicians, and Third Street bums as they sat in a barber chair. Here were impromptu studio performances by the entire Count Basie Band, Louis Prima, Jackie Mason, and others.

"The producer of the show and I would drive down the street in San Francisco. If we saw anybody that looked like a character—or anybody that looked different from everybody else—we'd yell at them,

# JAZZBO!

'Seven o'clock tomorrow morning at Channel Seven. Be there!' We got great guests—one pirate-looking guy with a wooden leg who walked around like Captain Hook."

A central part of the TV program was the (sometimes multiple) screening(s) of the scene from *Treasure of the Sierra Madre* where Mexican actor Alfonso Bedoya tells Bogart, "Badges? [pronounced "botches"] I don't have to show you any stinking badges!" The line has delighted Collins for twenty years. He liked it so much, in fact, that in 1970, while in Los Angeles's KFI, he convinced city fathers in suburban Sierra Madre to help him stage a festival for the faithful. Twenty-five thousand showed up to nosh with their hero, attend art exhibits, and enjoy round-the-clock showings of the movie at the town's Humphrey Bogart Theatre.

Late in 1981, Jazzbo left Frisco's KGO to return to 'NEW. Re-ensconced in the Purple Grotto, he's once again mild and woolly in New York—fading out a Coleman Hawkins side to deliver an impromptu dissertation on the virtues of egg-drop soup ("A lot of people misunderstand it. It's best when it gets into a gelatinous kind of feeling, if you know what I mean."), plugging a small-press poetry mag, inviting character-callers like the Baron of Bleecker Street to phone in.

The Baron is the head of Società Mangione ("the society of people who love to eat"), the first New York chapter of Al's Pals, more than three hundred individual special interest clubs formed by Jazzbo buffs across the country.

"That whole thing started in San Francisco," says Al. "We were having a bad drought, and one night this lady called up the show. Her name was Olga, and she talked like Zsa Zsa Gabor. She was off the wall, to put it mildly. She'd go out in the morning in Bodega Bay, where she lived, and greet the tide with a sign that said, 'Welcome In, Tide,' and she'd perfume some of the flowers that had no original scent. She went out with a pitch pipe and gave the hummingbirds the right note so they wouldn't be out of tune. So she called one night and said, 'Jazzbo dahling, if you want to have water, you must have frogs. Everybody knows that where frogs are, there's water, so if everybody gets a pair of frogs and puts them in their back yards, soon we'll have water.'

"So, I said, 'Gee, that's a great idea, Olga.' And I hung up. About ten minutes later a guy named Mike calls and says, 'Al, I have an albino frog with pink eyes, and I'd like to be a member of the frog club.' So I said, 'Listen, Mike, if you've got a pink frog with red eyes or whatever, I think you should be the president of the Frogonians.' He agreed. I gave his address, and in a week he had about forty-five letters from people. And today it's still going and he's got over ten thousand registered members."

Jazzbo seems pleased just to keep it all spinning, from behind his pickle barrel in the Grotto. The calibrated candle's white and purple rings tick off the minutes in a slow burn beneath Forty-Second and Third. On the turntable something cool from the West Coast spins. The lights dim.

"...And then there are three lesser caves that you can see in the background if you look straight ahead in the Grotto. These are occupied by Doctors Hunyati, Cherumbolo, and Caligari. As a matter of fact, Caligari is up tonight, sanding down some of the small cabinets he's making. Dr. Hunyati, of course, is the famous piano tuner who developed that pinkie cream for pianists, and Dr. Victor T. Cherumbolo you know as the fellow who helps out at the planetarium...and shows people where the different planets are, 'cause he's from there."

*POSTSCRIPT:* At the end of the '80s, Jazzbo left New York to return to the Bay Area. As if in a dream, California members of the Collins cargo cult—who'd despaired of ever grokking the Grotto again—awoke one morning (May 1990) to find A.C. on the a.m. (KAPX, Marin County). He was as good as they'd remembered: kibitzing on the phone with anyone who called (to a local chef: "Yeah, I wanna get the recipe to that special meat sauce. Let me find a pencil and we'll take it from the top"), spinning choice sounds ("Man, can we ever have too much Erroll Garner?").

By 1993, Jazzbo had moved to KCSM, the jazz station at the College Of San Mateo ('60s comic-prankster Mal Sharpe also does a show there), where he's been ever since: Saturdays, from 9 p.m. to midnight. If you're in Frisco, loose your lobes on him (FM 91).

GENE SCULATTI FOLLOWED *THE CATALOG OF COOL* WITH "THE COOL AND THE CRAZY" RADIO SERIES, WHICH HE CO-HOSTED AND PRODUCED WITH RONN SPENCER, OVER SANTA MONICA'S (CALIF.) KCRW-FM FROM 1984 TO 1987. IN 1993, ST. MARTIN'S PRESS PUBLISHED HIS SEQUEL TO THE CATALOG, *TOO COOL.*

# VANILLA Ghost
by JAMES KOCHALKA

THE END

The Mini-Comics Jam Archive contains of hundreds of spicy 8-pagers, with more created every time we get together. The cast now includes left-coasters Richard Sala, Lloyd Dangle, Adrian Tomine. —GARY LEIB

# Once they roamed the earth, proud and free.

**Mighty herds of Moose and Elk, great flocks of Eagles, pride after pride of Lions. But finest of all were the Shriners. Romping and gamboling and driving miniature cars in precision formation, the gold-and-rhinestone trim on their bright red fezzes sparkling in the sun; truly, they were the most playful of all**

# fraternal organizations!

While they're not yet extinct, these days the Shriners could be called an endangered species. At the turn of the century, millions of men— possibly one out of every five adult males in the United States—belonged to one or more fraternal lodges. But as times and attitudes change, these all-male social organizations are literally dying out. "The Black Camel is advancing on us," say the Shriners, who have lost over one-third of their membership since 1980. And it's hard to see where they'll find

young replacements for the members who leave in a hearse. It never occurs to most of us nowadays to belong to a lodge. When was the last time one of your buddies turned to you and said, "Dude, next week I'm joining the Kiwanis"?

Apparently, fraternal organizations offer things that nobody wants any more: buddy-buddy fellowship, mumbo-jumbo rituals, and frequent mandatory meetings. But even though we may not want to join them, it's still possible to admire them from a certain (ironic) distance. It's a bit like watching the last of the dinosaurs thunder off into the sunset, doomed but glorious. We know the world may never see their likes again. The Shriners, the boldest and most in-your-face of all the fraternal organizations, hold a special fascination for me and many others.

Most of us couldn't tell an Elk from a Rotarian from an Odd Fellow, but we all know at least something about the Shriners: that they wear those funny hats, that they support a network of charity hospitals for children, that they've organized themselves around a hokey Arabian Nights theme. And most of all, we know them from their

public appearances in parades and such, dressed as clowns, or teetering on tiny mini-bikes, or tooling around in go-karts decked out as miniature cars or trucks (or even, in the case of a Kansas crew called the "Wheat-wackers", mini-threshing machines.) To a person with a post-modern sensibility, red-fezzed Shriners present an irresistible retro image. They're like walking, talking clip-art!

trappings of pyramids, camels, palm trees, and scimitars. Dressed in Bedouin robes, new Nobles are initiated in a symbolic journey across a desert's burning sands to an oasis, where thirsts are quenched with free-flowing wine. While real Moslems shun alcohol, the play-Arabs of the Shrine have a reputation as party-hearty drinkers. The Shrine's annual conventions are famous for bringing together

handshakes, all based on legendary stonemasons who supposedly built medieval cathedrals and Old Testament temples. (For this reason, Masonic symbols include builders' tools like the compass, the square, and the trowel.)

With members as illustrious as George Washington, Winston Churchill, Mozart, Ty Cobb, and Roy Rogers, you'd think the Masons

# LOOKING under the FEZ

by Candi Strecker | Illustrations by Wayno

Though most of us have some idea what they look like, not many know what the Shriners actually are. Officially, they're the Ancient Arabic Order of the Nobles of the Mystic Shrine (A.A.O.N.M.S.), founded in 1872 as a fun-loving recreational super-fraternity. A colorful Near East theme runs through everything they do. Their 191 chapters, or "Temples," bear names like Sahara, Tangier, Damascus, Mecca, and Nile. They surround themselves with Ali Baba

thousands of jolly, tipsy, boys-will-be-boys carousers for a week of good-natured minor mayhem.

But rearrange the letters A.A.O.N.M.S. and they spell "A MASON," a not-so-subtle clue that one must first be "a Mason" in order to become a Shriner. If you're seeking a dark side to the Shriners' frisky tomfoolery, here's where to look, because the Masons (or Freemasons) are an older, larger, and much more mysterious group. For centuries, outsiders have speculated about the Masons' secret oaths, rituals, and

would be above reproach. But their secrecy and claims of ancient wisdom make them a magnet for every paranoid theorist. Masons are lumped in with the Trilateralists, the Bavarian Illuminati, the New World Order, and all those other bogeymen who are supposedly pulling our strings from behind the curtain. A recent episode of "The Simpsons" perfectly captured these fears, as the secret society of "Stonecutters" gathered to gloat over their octopus-like reach into every aspect of life:

*Who controls the British crown?*
*Who keeps the metric system*
*down?*
*Who robs cave fish of their sight?*
*Who rigs every Oscar night?*
*We do! We doooooooo.*

When you become a Shriner-watcher, you inevitably have to confront the question of whether the Freemasons are a shadowy cabal of masterminds or a sociable bunch of fuddy-duddy insurance salesmen. It's fun to indulge in paranoia, and I'm as fond as the next guy of Pynchon and Robert Anton Wilson and Smoking Man episodes of "The X-Files." But I also try to look at the Shriners the way I do professional wrestlers: drawing a line between Entertainment and Reality. And I just can't believe these fraternal organizations are anything but a bunch of harmless old coots who like to dress up and chant some ritual claptrap. A little voice in the back of my mind pipes up "Sure, that's what they WANT you to believe." But common sense suggests that if these groups really had any powerful secrets, they'd have waiting lists of people eager to join, instead of plummeting membership rosters.

The one power that Masons and Shriners do control is the ability to keep women outside their Temples' doors. And this seems to be at the heart of both their former appeal and their current decline. It's as if men once deeply craved opportunities to withdraw from the fearful presence of women. Nowadays, despite the occasional noise about men-from-Mars-women-from-Venus, we just don't have that anxious need to escape from each other. Men and women don't inhabit separate spheres in the modern world. We bump up against each other all day long, at work and at play, and we don't seem

to have a big problem with that. Whenever possible, men and women choose to be together, whether it's in co-ed dormitories or on co-ed softball teams. Sure, we sneak out for the occasional boys' night out or all-girl-evening to bitch and blow off a little steam. But we don't require formal clubs with frequent meetings and robes and regalia to do so.*

Another conflict that keeps modern men out of the fraternal life is society's demands on our time. We've all heard that life was harder back in Great-Grandpa's day, but he did seem to have plenty of leisure time to spend down at the lodge. Today we're busy with our careers, busy with our families, and when we want entertainment, we've got TV and videos and the internet right in our homes. After days full of packed schedules and time conflicts, the last thing we want is the Lions Club or the Shriners making more irritating demands on our time.

Still, there are a few ways in which hip postmodern people can relate to the Shriners. One of these is the appeal of Exotica. The Shriners adore wrapping everything into a fancy package of Orientalia, a fantasy world of camels and oases, turbans and fezzes, Poo-bahs and Rajahs, and Most High Imperial Potentates. We are suckers (in an ironic, tongue-in-cheek way) for Exotica from the really, really Far East: bamboo-trimmed tiki bars, pineapple-garnished cocktails, and the birdcall-laced sounds of Martin Denny.

The rituals of every fraternal organization are laced with grandiose speechifying about returning to lost, mysterious, ancient truths. We've read that kind of stuff before: on the backs of our collectible '50s record albums, the ones with names like *Taboo* and *Primitiva*.

And we can certainly sympathize with the Shriners' urge to escape every once in a while into an evening of costumed role-playing. The Shriners play at being Sheiks and Nobles of a loyal, royal Desert Brotherhood. We want to pretend to be what the Shriners themselves were. We put on their cast-off fezzes (picked up at a yard sale or thrift store) and dress in sharkskin suits or cocktail dresses, put some Mancini or Dean Martin on the stereo, and sample a cigar or a martini. And just for one night, we transform ourselves into…confident, prosperous, Cadillac-driving aluminum-siding salesmen, without a serious thought in our heads except having a serious good time. And to our surprise, it feels pretty darn good.

It's a crazy, mixed-up, one-step-removed way of being a Shriner, but it's probably as near as most members of our generation are ever going to get.

CANDI STRECKER OCCASIONALLY PUBLISHES HER POP-CULTURE JOURNAL, *SIDNEY SUPPY'S QUARTERLY* AND *CONFUSED PET MONTHLY* (P.O. BOX 515, BRISBANE, CA 94005-0515). SHE LIVES WITH HER HUSBAND AND DAUGHTER NICOLA (YES, AFTER TESLA) IN A HOUSE FULL OF ANTIQUE TRANSISTOR RADIOS.

*Or do we?* One historian draws an interesting parallel between traditional fraternal organizations and the recent "men's movement," in which guys go off in the woods where women can't watch them, and get in touch with their "primitive selves" by wearing paint and feathers and beating on ritual drums. See Mark Carnes's "Iron John in the Gilded Age," *American Heritage*, September 1993.

# AMONG THE VINYL PEOPLE — by Jim Ryan

Last summer I worked at an outdoor record stall right next to a photo postcard stand

The postcard place attracted boatloads of model-gorgeous women, while the used vinyl aura of our side repelled them like a force field (as it exerted a magnetic pull on homely guys)

I tried not to dwell on the implications of this.

HEY, WAIT! I'M OVER HERE!

I was too busy observing the ways of record collectors:

Verbatim → OF COURSE I DON'T LISTEN TO THEM! I WRAP 'EM IN ONIONSKIN AND STORE THEM IN A VAULT!

1st Pressings

ELVIS

...A GEEKDOM UNTO THEMSELVES.

POOR TOILET TRAINING?... BRAIN DAMAGE?

OOH! IT'S A WHITE LABEL PROMO!

...Obsessive, covetous and 99% male.

The Classicist

I'D BUY THE VIVALDI TOO, BUT THEN I'D BE BAROQUE!

Chortle

THE SHOW TUNE fan

SIGH! POOR JUDY!

Mr. Colored Radio

NAAH, THEY LIFTED THAT TUNE FROM SLEEPY BLIND LUTHER "FATBACK" JOHNSON

...AND WHILE IT WOULD BE A STRETCH TO SAY I CAME TO LOVE THEM, I DID GROW TO APPRECIATE THEIR PLACE IN THE GRAND SCHEME.

IF EVERYONE WAS LIKE THAT WOMAN, ALL OF ROBERT JOHNSON'S RECORDS WOULD HAVE MOULDERED AWAY IN ATTICS BY NOW.

...BUT EVERYONE WOULD HAVE A NICE ASS.

The "Spirit of '66"er

...AND I OWN 400 DIFFERENT VERSIONS OF "WOOLY BULLY"!

The Jazz Afficianado

...BEFORE THIS JUNE 9th SESSION, "PREZ" ATE A BIG LUNCH- CHICKEN SALAD, I BELIEVE...

The 'FMU D.J.

"JACK LA LANE IN HI-FI"! I'VE BEEN LOOKING FOR THIS!

So now when I hear some fascinating old tune on the radio, I silently thank the obsessive guy who rescued it from yard sale oblivion.

...AND THANK GOD I DON'T HAVE TO WAIT ON HIM.

January 12, 1912: Jackson Pollock born

March 21, 2288: Capt. James T. Kirk born in unnamed Iowa town

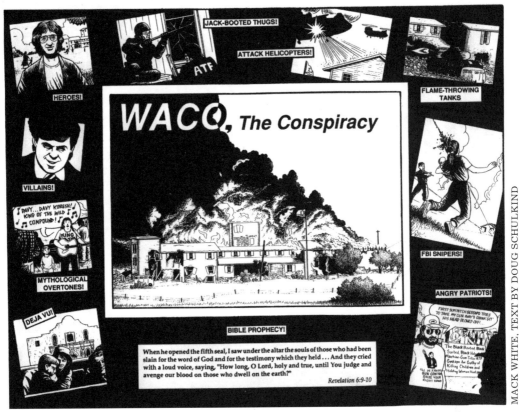

April 19, 1993: David Koresh successfully goads U.S. Dept. of Justice into provoking immolation of himself and 85 others.

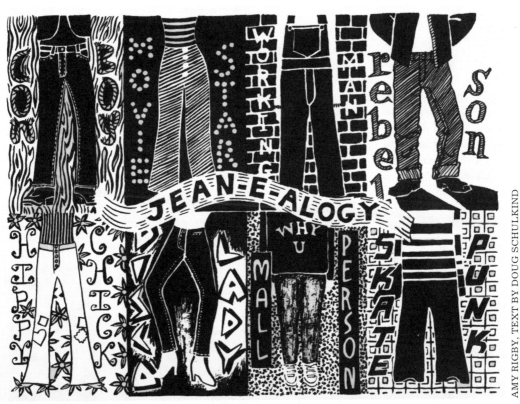

May 20, 1873: Levi Strauss and Jacob Davis receive patent for denim trousers with rivet-enforced pockets.

# Laughs, Love and Life

## with *Neil Hamburger*

by *Tom Scharpling*

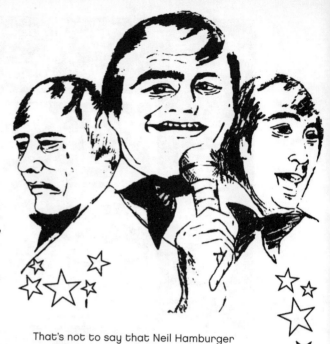

*Nothing of Gods, nothing of Fate. Weighty affairs will just have to wait. Nothing that's formal, nothing that's normal, no recitations to recite! Tragedy tomorrow, comedy tonight!*
—Stephen Sondheim, from *Comedy Tonight*

*What's this world need but a good laugh—agreed? Don't you think we need it? Well, that's my job—going around making people laugh. That's what I enjoy doing—what's wrong with that?*
—Neil Hamburger, Introduction to *America's Funnyman* LP

If laughter is good medicine, then stand-up comedians are travelling doctors, roaming from town to town, dispensing their comedic cures. Metaphor firmly in place, that means performers like Jerry Seinfeld and Bill Maher are highly skilled specialists. Conversely, a comedian like Neil Hamburger is the guy who checks your blood pressure at Pathmark.

Armed with just his wit and an old-fashioned entertainment aesthetic, Mr. Hamburger plays 350-plus engagements a year at clubs, lounges and pizza parlors across America (not necessarily in that order). While he might be hanging for dear life onto the lowest rung of the showbiz ladder, his dedication to the profession is absolute.

His comedy might not be as perfect as that of the Jay Lenos and Tim Allens of the world. They've got their acts down to a well-timed science, drawing laughs at precise moments. Neil's jokes are more like low-grade fireworks—just as likely to draw groans as applause (and possibly take a finger). His act is of the "warts and all" variety—never perfect, but always real.

That's not to say that Neil Hamburger lives in the ghetto of Outsider Art—he is not "the Jad Fair of comedy." While the Elite dig Mr. Fair's intentions, you'd be hard pressed to get Joe Lunchpail to put on *Music To Strip By* after a hard day in the factory. Neil doesn't play to a specific scene. While his records are released by "indie rock" record labels, his goal is to have his comedy heard by all people. Like the title of his most recent album states, he does indeed strive to be "America's Funnyman."

(THE FOLLOWING INTERVIEW WAS CONDUCTED VIA PAY TELEPHONE AS MR. HAMBURGER WAS IN THE MIDDLE OF A U.S. TOUR.)

## ☆ *Neil on . . .* **The Formative Years**

**LCD:** Tell me about your early stand-up experiences.

**Neil:** Lots of open mikes, birthday parties, that sort of thing. There was a bit more "blue" material. That's what people wanted, and I had a real sense of desperation in those days to get the career going. Now the tides are turning again, and we may add that sort of material to the set once again.

**LCD:** What comedians influenced you when you were starting out?

**Neil:** Rich Little is great, of course…Tim Conway, Jonathan Winters. A lot of the TV sitcoms are pretty funny and have been a big influence—any of them that you can name have been a big influence on the comedy of Neil Hamburger.

**One of Neil's many homes away from home**

## ☆ Neil on... Life on the Road

**LCD:** Describe a typical day in the life of Neil Hamburger.

**Neil:** Well, we have a show to do, so there's no time for a "typical day." Tonight we're in Carson City, which is nice. It's a big show, that's the capital of Nevada. A lot of times we take the smaller shows though, in the smaller towns. You have dinner, then you do the show, and that's pretty much it.

**LCD:** What is the easiest type of crowd to please, and what is the hardest type to please?

**Neil:** I'd say the smaller crowds are generally easier, because they can't make as much noise and try to drown you out during your routine. I like playing the nightclubs and the comedy clubs as opposed to these pizza parlors where they don't have a stage per se—you're just kinda stuck in the corner. But you never know what'll happen. It's been a great career overall.

## ☆ Neil on... Laughter and Inspiration

**LCD:** It's your job to make all of us laugh. Where do you turn when it's time for you to laugh?

**Neil:** Hmmm...have you ever seen *Dorf On Golf*? Tim Conway—he's real funny—I always try and keep up on his current releases. Rich Little has been an influence. Yakov Smirnoff is quite funny. And especially all of the current comedians out there. I can't keep track of their specific names because they're all so good that they're nearly interchangeable.

**LCD:** What is it that allows you to take things from everyday life and make them funny?

**Neil:** Well, you keep up on things. Whether it's current news events, or current slang—"lingo" as they call it—the movies...I try to see as many movies as I can. Performing as often as I do, which is about 350 shows a year, I rarely get the chance to work out any bugs that might hamper a routine, which means I always keep a bottle of insect repellant alongside my gin and tonic.

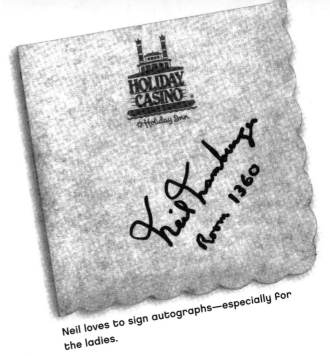

Neil loves to sign autographs—especially for the ladies.

**LCD:** What's the most recent movie you've seen, and did you create any new material from the experience?

**Neil:** Oh yes. I saw one, the new one, oh, what is it called. Very, very exciting. And I think there could be some Oscars, the acting was tremendous. But I can't remember the name. It'll come back to me. Well, it's so popular right now, you probably know what I'm talking about...but yes, I think I'll end up with some new material from it. It's always good to keep current, on top of things.

## ☆ Neil on... The Business End of "The Business"

**LCD:** How did you get the title "America's Funnyman"?

**Neil:** The public never actually voted on it. That was actually more of a management decision—a gimmick if you will. I think it's great though. I'm gonna keep using it. But basically it's just a gimmick. My manager has spoken to the copyright office about setting it up as a legal thing, but we haven't heard back from them.

### NEIL HAMBURGER FAN CLUB

This card certifies that the person named below is a member of the Neil Hamburger Fan Club. Bearer of this card is legally entitled to LAUGH THEIR HEADS OFF whenever NEIL comes to their town!!!

Tom Scharpling

Neil Hamburger, America's Funnyman

A cherished tchotchke.

**LCD:** Based on the content of your album *America's Funnyman*, your life seemed to be bottoming out around the time it was recorded. What was going on and how are you doing now?

**Neil:** You know, that album was taken from a handful of shows during a winter tour last year, and though it is very representative of my routine last year, I think the people that produced it must've used some of the more depressing segments purposely, because I get asked that question a lot. Yes, things were tough. I was going through a painful divorce, and quite frankly, attendance at a lot of the shows was not what it could've been. But I've always been gifted with laughter, and that has seen me through some rough times. Right now I'm doing what I always do—taking the jokes out on the road and performing almost nightly. Some of the problems in my personal situation have not yet been resolved.

**LCD:** Why do your records come out on "indie rock" labels?

**Neil:** I don't really know why. But I'm glad they do, so that they can put their whole promotions department to work on just one comedian. If they had all sorts of comedians on the label, they probably wouldn't have as much time for me, or as much loyalty. This way they can really do a bang-up job. Great people.

But I like a lot of the new music. Of course, my personal taste is for country and western, like Kenny Rogers, Lionel Richie, Neil Diamond, those guys, that sort of thing. But I don't mind Kenny G. or some of the other new music either. Have you heard that song "Smooth Operator"? That's the sort of newer thing that I hope catches on more as a trend. I don't know who it is. And Jimmy Buffett, I guess that's not strictly "indie rock," but he's done some great records over the years. I have his cassette.

**LCD:** The "Top 10" list on the *America's Funnyman* album was censored. Why?

**Neil:** Right. Well, we were going for a certain audience with that record. I didn't make the decision—that was a management decision. Actually, the people who put together the record, because I just do the shows, and then other people take the tapes and edit them together, and you never know what they're gonna do.

But now if you've seen the show lately, you'll see that we let fly with an occasional R-rated zinger now and again. It just depends on where the show is. Yesterday we had an afternoon show at a junior high school assembly, so there you're gonna keep it clean—you stick to the political material or sight gags. You don't talk about personal problems or impotence or whatever it might be.

**LCD:** I heard a rumor that there is a Neil Hamburger television special in the works. Could you tell us more?

**Neil:** It was wonderful. We actually produced an hour-long TV special for national syndication. The show had all kinds of guest stars—it was kind of an old-time variety show starring myself. It was an introduction to the public what I'm about. It featured songs and skits and routines, all kinds of things.

Unfortunately, the company in Taiwan that we contracted out to make the half-inch or three-quarter inch masters for the syndication company went bankrupt, and our master tape was taken by the Taiwanese government and sold by the bank that seized all their holdings. So we don't know where it ended up. All we know is that the show was aired in India and South Korea.

So what we're trying to do is reconstruct the show using the outtakes and the early edits, but this is difficult, so we may have to film again from scratch. We still have a good script, but a lot of money was put into this and with the tape being lost, the investors are a little reluctant to do it again.

**LCD:** Tell me about the competitiveness of the comedy business.

**Neil:** Well, let me state right off that I love today's comedians. Funny, funny stuff. They're a great bunch of people, too. Very talented. But yes, sometimes you get into a situation where they will try to take your bookings. You're booked at a club or pizza parlor, you drive 400 miles to get there, and you're off the bill because some comedian with stars in his eyes has slipped the owner a fifty dollar bill for your slot. It can happen.

☆ *Neil on ...* **Comedy**

**LCD:** You utilize many different styles of comedy in your act (jokes, social commentary, physical humor). What are the talents required to master each of these brands of humor, and how did you develop the skills?

**Neil:** You learn by doing. That's the only way. There are bound to be some bad shows along the way, until you perfect the craft. Physical humor is especially difficult to master. I've been getting more and more interested in it lately, as today's

audiences seem too sophisticated sometimes for the simple joke, it just doesn't get them laughing. So you have to try something else. Pull out the eggs and the balloon animals, or whatever you come up with.

*LCD:* Regarding social commentary, what boundaries do you set for yourself?

**Neil:** The only boundary is my own lack of knowledge regarding current affairs. I'm always willing to offer social commentary if it will get a laugh.

*LCD:* Where do you see the future of comedy heading? Will computers be involved in comedy's future?

**Neil:** I hope not. If I can quote the Constitution here, I think comedy is of the people, for the people, by the people. Computers will never be able to make people laugh—they don't have the timing. I don't know. Can they program in the timing? Or the passion a comedian has for his own material? Maybe it could happen. But it shouldn't. I'd be out of a job.

 *Neil on . . .* **Showbiz**

*LCD:* How did you meet up with Art Huckman, your manager?

**Neil:** Huckman approached me after a show in Needles, California, and offered his services. He's Hollywood all the way. Art has worked with a lot of the greats—maybe it will rub off! He was semi-retired from the business after losing a couple of lawsuits, but he saw something in me and I am grateful. He is behind my career 100% for now. He's been my manager for two years now, which must be some sort of a record! Sometimes he seems a little tired.

*LCD:* Which performers do you consider your peers? Any "showbiz secrets" you can disclose to us about your celebrity friends?

**Neil:** Well, I don't like to discriminate—they're all my peers. So much great entertainment, so many comedians out there. I love playing the same club with a big-name act, like Cook E. Jarr, who I did a show with in Las Vegas, or Lorna Luft, whose act I've always admired.

Lately though, I've been playing a lot of the smaller clubs, outside of the big cities, which is fine, but it makes it hard to get the "showbiz secrets." But I'll tell you what: Jerry Van Dyke, Dick's brother, is supposed to be a great guy with a heart of gold. And here's a great story—Bert Convy, before he passed away, was known to make secret runs in the middle of the night to get chocolate shakes at McDonald's.

Never even told the wife, just slipped out the back door. Wonderful!

Art Huckman met Freddie Prinze, the comedian from *Chico and the Man* just a couple of days before he died. He talked to him at a Vons Market in Century City, he was in line behind him. He called the police after the suicide, with his inside story, offered to testify. But then Art has a lot of great stories of working with celebrities, lots of secrets. Lots of secrets. For instance, he did some work for Rich Little years ago, in the '60s. He's been to Rich's house, that sort of thing. He said it was very tidy.

Then there's Richard Hatch, from *Battlestar Galactica*, who I met at a self-help seminar, and he was a very, very nice man. This is a great business. I have to admit, I wish my career was headed more on an uphill slope though.

*LCD:* Finally, to anybody starting out in the comedy business, do you have any advice?

**Neil:** Please don't steal any more of my bookings. That is getting to be a real problem. Some of these new comedians are ruthless.

**Neil can still find time in his busy schedule to unwind at home.**

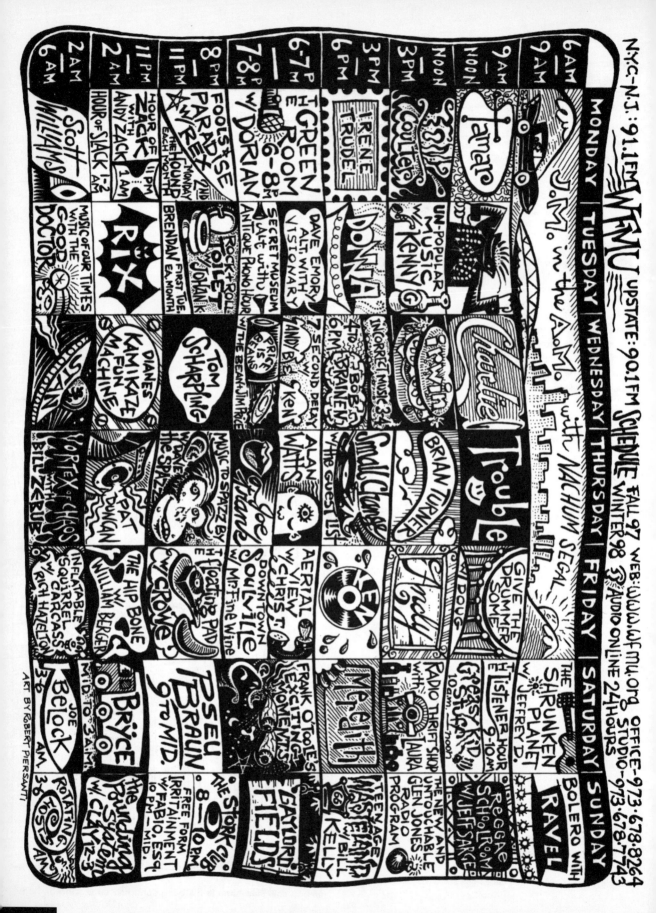

# Carnival NYC

By Celia Bullwinkel

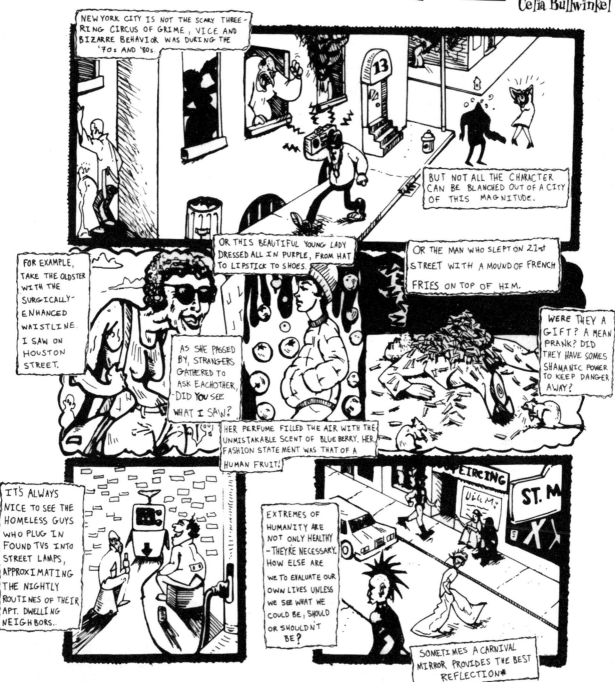

NEW YORK CITY IS NOT THE SCARY THREE-RING CIRCUS OF GRIME, VICE AND BIZARRE BEHAVIOR WAS DURING THE '70s AND '80s.

BUT NOT ALL THE CHARACTER CAN BE BLANCHED OUT OF A CITY OF THIS MAGNITUDE.

FOR EXAMPLE, TAKE THE OLDSTER WITH THE SURGICALLY-ENHANCED WAISTLINE. I SAW ON HOUSTON STREET.

OR THIS BEAUTIFUL YOUNG LADY DRESSED ALL IN PURPLE, FROM HAT TO LIPSTICK TO SHOES.

OR THE MAN WHO SLEPT ON 21st STREET WITH A MOUND OF FRENCH FRIES ON TOP OF HIM.

AS SHE PASSED BY, STRANGERS GATHERED TO ASK EACHOTHER, DID YOU SEE WHAT I SAW?

WERE THEY A GIFT? A MEAN PRANK? DID THEY HAVE SOMES SHAMANIC POWER TO KEEP DANGER AWAY?

HER PERFUME FILLED THE AIR WITH THE UNMISTAKABLE SCENT OF BLUEBERRY. HER FASHION STATEMENT WAS THAT OF A HUMAN FRUIT!

IT'S ALWAYS NICE TO SEE THE HOMELESS GUYS WHO PLUG IN FOUND TVS INTO STREET LAMPS, APPROXIMATING THE NIGHTLY ROUTINES OF THEIR APT. DWELLING NEIGHBORS.

EXTREMES OF HUMANITY ARE NOT ONLY HEALTHY – THEY'RE NECESSARY. HOW ELSE ARE WE TO EVALUATE OUR OWN LIVES UNLESS WE SEE WHAT WE COULD BE, SHOULD OR SHOULDN'T BE?

SOMETIMES A CARNIVAL MIRROR PROVIDES THE BEST REFLECTION*

# Flabby Preludes for a Dog: Erik Satie Primer

*by Kenny G.*

In the midst of an art opening at a Paris gallery in 1902, Ambient Music was born. Erik Satie and his cronies, after begging everyone in the gallery to ignore them, broke out into what they called Furniture Music—that is, background music—music as wallpaper, music to be purposely not listened to. The patrons of the gallery, thrilled to see musicians performing in their midst, ceased talking and politely watched, despite Satie's frantic efforts to get them to pay no attention.

Today, Furniture Music is unavoidable. Nowhere are we free from the tyranny of it; we can't walk into a store or deli without hearing the generally dreadful stuff drifting through the environment. As a matter of fact, people buy Ambient music to fill up the space, to make it easier to work in, to make love in, to relax in; today, there's a goddamned Furniture Music industry. When was the last time you were at a dinner party where there was no Furniture Music tinkling away in the background?

Over the years, a number of extraordinary musicians have paid tribute to Erik Satie: Brian Eno's made some pretty damn good Furniture Music and Richard James, a.k.a. Aphex Twin, is an acknowledged master of the genre. Indeed, the entire Muzak phenomenon—not to mention LiteFM—owes a debt to The Velvet Gentleman.

But it's not only the Ambient folks that claim Satie as patriarch; just about every radical musical movement in this century can trace its roots back to Satie. Take John Cage, for example. His entire career—and, as a result, the course of music in the twentieth century—took a turn after being exposed to a strange little three-minute piece of Satie's called Vexations. It's only a single page of music but it has the instructions "to be repeated 840 times" scrawled on it. For years it had been written off as a musical joke—a performance of the piece would take approximately twenty hours—an impossible, not to

mention tediously boring, task. John Cage, however, took it seriously and gave Vexations its first performance in New York in 1963. Ten pianists working in two hour shifts conquered the piece, which lasted eighteen hours and forty minutes. Cage later explained how performing Vexations severely affected him: "In other words, I had changed, and the world had changed...It wasn't an experience I alone had, but other people who had been in it wrote to me or called me up and said that they had had the same experience." Other people in Cage's circle at the time who might have shared the Vexations experience included La Monte Young, who went on to create his own consciousness-altering time-based environments, and Yoko Ono, who gained fame with such Satiesque performances as Bed Piece with John Lennon, in which the couple stayed in bed for a week to protest the Vietnam War.

The religious vibe that many people have gotten from Vexations is no coincidence. Satie, naturally drawn to strange religions, was a Rosicrucian for a while in the 1890s. It was here that he was introduced to the mystical strains of Gregorian and Plainsong chant—music that would influence everything Satie would do for the rest of his career. The ethereal, aloof, and impersonal music went against everything Wagnerian, the rage of the moment in Paris. As a matter of fact, Satie composed his most famous works, the Gymnopédies, while under the spell of the Rosicrucians.

However he quickly grew disillusioned with the Rose+Croix and, having acquired an even stronger appetite for ritualistic music and quasi-religious ceremony, went on to form his own short-lived church, L'Eglise Métropolitaine d'Art de Jésus Conducteur. The scope of Satie's church was classic Outsider—almost something out of Adolf Wölfli.

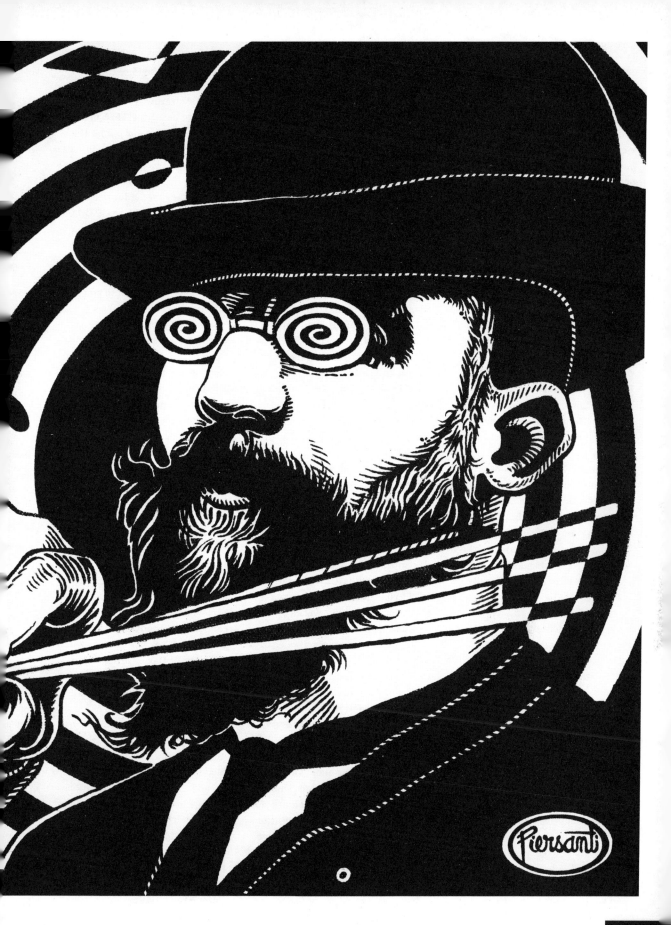

Satie envisioned 1,600,000,000 converts dressed in black robes and gray hoods defending the Church against attack with armaments consisting of oversized battle swords and medieval lances that were five meters in length. He also self-published an "official" church journal whose sole function was to give Satie a soapbox upon which to rant against music critics hostile to his work. Obviously, the church had only one member.

Satie supported the church (as well as his musical aspirations) by playing piano in a famous Montmartre cabaret, the Chat Noir. During his tenure there, Satie knocked out a number of stunning bawdy cabaret tunes as well as impressing a young composer, Claude Debussy, who hung out at the place. Debussy immediately recognized the genius in Satie and fell under his influence. Not too long afterwards, Debussy and his friend Maurice Ravel began writing Satie-inspired pared down music that soon snowballed into the world-famous movement known as French Impressionism. Satie, ever the oddball, was left in the dust and it wasn't until Debussy and Ravel were firmly established many years later that they finally fessed up to Satie's influence.

While Debussy and Ravel were getting rich and famous, Satie remained dirt poor—so poor, in fact, that he was given the title "Monsieur le Pauvre" by his friends. In 1898, he moved from Montmartre to a cheap industrial suburb of Paris, Arcueil, where he would spend the rest of his life. No one ever set foot in Satie's room until his death some quarter century later. Around this time he began wearing his famous gray velvet suits—twelve identical ones—earning himself the name "The Velvet Gentleman." He continued to commute by foot several miles each day to Montmartre to play at the cabarets and walked back home to the 'burbs every night with a hammer in his pocket for protection.

As he settled into Arcueil, his behavior became more eccentric. He detested the sun, wrote an enormous number of letters to himself reminding him of his appointments, and refused to wash his hands with soap, favoring pumice stone instead. However, his most extreme behavior was his eating. In his book *Memoirs of An Amnesiac*, Satie described his eating habits: "My only nourishment consists of food that is white: eggs, sugar, shredded bones, the fat of dead animals, veal, salt, coconuts, chicken cooked in white water, moldy fruit, rice, turnips, sausages in camphor, pastry, cheese (white varieties), cotton salad, and certain kinds of fish (without their skin). I boil my wine and drink it cold mixed with the juice of the Fuchsia. I have a good appetite, but never talk when eating for fear of strangling myself."

In 1905, at the age of forty, after having been kicked around by critics and his peers, Satie decided to go back to school to study the "proper" classical techniques of counterpoint and theory. He sat in classes with students half his age, honed his skills, and graduated four years later with flying colors. While he composed some "serious" works after graduating, his music continued to become more bizarre. He began scribbling mysterious directions all over his scores and gave a running commentary of dialogue, puns, and absurdities: to be jealous of one's playmate who has a big head, the war song of the King of Beans, canine song, to profit by the corns on his feet to grab his hoop, and indoors voice. The titles, too, were remarkable: Veritable Flabby Preludes (for a Dog), Sketches and Exasperations of A Big Boob Made of Wood, Five Grins or Mona Lisa's Moustache, Menus for Childish Purposes, and Dessicated Embryos, just to name a few.

Much of the music, to my ears, is pop; the tunes are knowable and hummable. For the most part, it's upbeat stuff: rowdy and really funny. And quite beautiful. Most of Satie's work was written for piano. His Trois Gymnopédies, a tinkling piano suite that you would immediately recognize if you heard it, has been abused in the media for decades as "soft, sentimental" Muzak. On the other hand, his *Parade* (1917), a collaboration with Jean Cocteau, Picasso, and Serge Diaghilev, rocks and rolls for twenty minutes and was the first classical work to employ a battery of sirens, car horns, typewriters, guns, and blasting percussion. The piece outraged so many people that there was a riot the first night it opened, and the collaborators were smeared all over the Parisian press, turning the fifty-one-year-old Satie into a star overnight. In its experimentation, *Parade* opened the doors for all types of mechanical music to come later this century; musique concrete, techno, and industrial music all trace their lineage back to *Parade*.

From *Parade* until his death in 1925, Satie lived the life of a celebrity. He found himself surrounded by a group of young followers, Les Six, who revered the old man and carried out his advances to radical extremes. It's worth checking-out the work of Darius Milhaud, the most prominent of Les Six who uses a slew of jazz, mechanical, and world music devices in his compositions. As a result of the World War II diaspora, Satie's influence manifested itself in completely unexpected ways: Milhaud found himself teaching at Mills College in Oakland, the American postwar experimental music hotbed. Among Milhaud's students were Morton Subotnick, Robert Ashley, Pauline Oliveros, and Phil Lesh; there's a direct connection from *Parade* to Dark Star.

Following Cage's premiere of Vexations, a flood of previously unavailable recordings appeared on the market to slake the '60s experimentalists' thirst. Today there remains an enormous number of records around, both in print and used. The best place to start is with Aldo Ciccolini's definitive set of Satie's complete piano works, *Piano Music of Erik Satie, Vols. 1–6*, on EMI Angel. Ciccolini's sound is warm and fresh, the playing magnificent, and, in doing Satie's entire piano repertoire, many of the pieces make their first recorded appearances on these discs. (Warning: stick to the LPs and avoid the CD versions which were re-recorded later and have no punch).

Once you're hooked on the piano works, there's a bunch of great orchestral pieces to check out. Pick up any recording of Gymnopédies Nos. 1 & 3, which were orchestrated by Debussy. These hackneyed pieces, heard ad infinitum, sound incredibly fresh when re-heard in an orchestral framework; their beauty is restored once again. The same goes for *Parade*—it's hard to make a lousy version of it. I prefer the vintage recordings to the newer digital ones—the new recordings are too slick—the sirens are too modern, and the typewriters sound more like word processors. John Oswald, a.k.a. Plunderphonic, recently did an incredible cut-up version of *Parade* that appears on a RecRec sampler.

Like John Oswald, a lot of musicians have gotten juiced on Satie's eccentricity and freedom. In the '60s, there were some pretty strange attempts to imitate the wackiness of Erik Satie, the grooviest being *The Electronic Spirit of Erik Satie Featuring the Moog Synthesizer with the Camarata Contemporary Chamber Orchestra* (London/Deram XDES 18066, LP). The record is essentially a seance performed by a bunch of stoned hippies to try to invoke the spirit of Satie from the grave through the medium of the Moog Synthesizer. Oddball pieces such as *Sports et Divertissements* (1914) are hepped up to sound like a cross between Perrey & Kingsley, Cheech & Chong, and *After Bathing At Baxter's*.

My favorite Satie record is *Erik Satie: Selected Works* (Erato MHS 4700W, LP) performed by the Ars Nova Ensemble with Marius Constant conducting. The record is packed with historical gems and contains the only recorded version of Furniture Music that I know of. The piece consists of three movements: Curtain of a Voting Booth, Tapestry of Wrought Iron, and Phonic Tiles— may be performed at a luncheon, each more repetitive and banal than the next; Satie makes Eno's *Music for Airports* seem exciting by comparison. The LP also contains a prescient Minimalist piece from 1924, Relâche, which was the score for a collaboration Satie did with Marcel Duchamp and Francis Picabia. Eleven repetitions (thirteen minutes) of Vexations finish out this disc, and, while there have been many attempts to record Vexations over the years, most of them have proven fruitless: one LP I own contains a number of repetitions whereby the last chord of the final repetition ends with a lock groove,

to suggest infinite playing time (ah, vinyl...). However, with the advent of the CD, it is possible to listen to all eighteen hours and forty minutes of Vexations using the repeat function on CD players.

Finally, there seems to be a booming Erik Satie industry thanks to Trip Hop and Ambient music; as folks gravitate to a more laid-back dreamy state, Satie makes more and more sense. Last year Folk Implosion based a noir Trip Hop piece, Wet Stuff, on the opening notes of Satie's Trois Gnossiennes, and a few years ago, Malcolm McLaren used the same riff throughout his entire disc *Paris*. DJ Spooky cites Satie as a major influence in many of his diatribes as well as incorporating Satie samples into his mixes.

However, there's one recent use of Erik Satie that proves once and for all that his time has finally come: Brian Eno's Windows '95 Startup Sound. In my opinion, Eno has written a pocket symphony to rival (and could not exist without) Vexations. Both are concentrated miniatures, both are resistant to familiarity, and both stand up to countless repetitions. The only difference is that Satie never got a million bucks to write his.

# TROUBLETOWN

By LLOYD DANGLE

THAT'S ALL FOR TONIGHT'S REGULAR, OBJECTIVE NEWS. NOW, FOR SOME SENSIBLE HOMESPUN COMMENTARY, HERE'S AN ESSAY BY HENRY HUBBINS.

EXPLODING BREAST IMPLANTS
©1992

Y'KNOW, OUT HERE IN MONTANA I'VE BEEN HEARING A LOT OF CONSPIRACY THEORIES LATELY. FROM AIDS AS A LABORATORY CREATION, TO KENNEDY— EVEN DOUBTS THAT ZACHARY TAYLOR REALLY CHOKED TO DEATH ON A RASPBERRY SEED!

PAT PAT PAT o

IF YOU ASK ME, PUBLIC MASTURBATORS LIKE OLIVER STONE COLLECT TEENY BITS OF MEANINGLESS INFORMATION LIKE SQUIRRELS EXPECTING AN EARLY THAW...

THEN THEY FORMULATE THEIR HARE-BRAINED THEORIES IN ORDER TO FILL UP A GIANT HOLE IN THEIR LIVES!

THEY OUGHTA TRY CHOPPING SOME WOOD,

CONSPIRACY THEORISTS ARE REALLY JUST A SAD BUNCH OF LOSERS WHO CRAVE PUBLIC ATTENTION.

AND EVEN MY DOG CHESTER KNOWS GARBAGE WHEN HE SMELLS IT. FROM MONTANA, I'M HENRY HUBBINS.

OFF THE AIR:

OKAY, WE'VE PLANTED OUR MESSAGE ON EVERY NETWORK AND NEWS ORGANIZATION, HUGH. WHAT'S NEXT?

PROCEED WITH THE SUBLIMINAL MISINFORMATION CAMPAIGN ON BOTTLE TOPS AND CHOCOLATE BON-BONS.

GOTCHA

GENERAL ELECTRIC    Coke    TIME-WARNER    PEPSI

May 6, 1937: The NBC Blue Network airs the first soundbite in history: announcer Herbert Morrison's weepy on-the-scene report of the Hindenburg crash.

NED SONNTAG

174

# more Ephemera

Leon Theremin
*by Sam Henderson*

George Leigh-Mallory
*by Sam Henderson*

The Carol A. Deering
*by Sam Henderson*

Charlie Chaplin's Body
*by Sam Henderson*

176

Count St. Germain
by Kaz

Eva Peron's Body
by Mack White

Peking Man
by William Graef

Helen Brach
by Diane Farris

Frank Sinatra Jr.
*by Dorian Devins*

Jimmy Hoffa
*by Robert Armstrong*

Amelia Earhart
*by Justin Green*

Louis Aime Augustin le Prince
*by Chris Ware*

# MUSIC/ART CONVERGENCE
## MAY 26—30, 1992

W F M U
91.1 FM

# SILENT AND LIVE AUCTIONS

# VE BROADCASTS AND PERFORMANCES
# RMANS VAN ECK GALLERY 420 W. BROADWAY, NYC

179

**WFMU** Catalog of Curiosities

1997 Heaven's Gate Edition

CDs
Books
Videos
Comics
&
Stuff
You
Need

Over 180 New Items!
Krautschlock!
Calls to Oakies!
Theremins Galore!
Blowin' Thru Yokohama!
Sex & Broadcasting!

GREG CARTER

WFMU CATALOG OF CURIOSITIES

LCD SPECIAL EDITION    SUMMER 1995    WFMU 91.1 FM

RECORDS, CDs, BOOKS, VIDEOS, COMICS
• SPACE AGE BACHELOR PAD MUSIC
• STUPID OLD ROCK and ROLL
• CONSPIRACY THEORIES
• SLEAZE, RADIO, MENTAL ILLNESS and MORE

@WAYNO 94

WAYNO

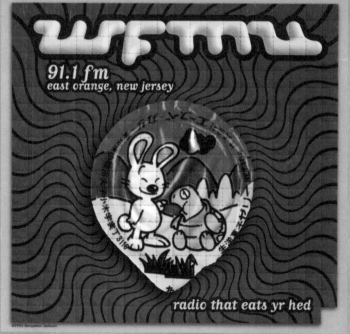

WFMU

91.1 fm
east orange, new jersey

radio that eats yr hed

BENJAMIN JACKSON

 STICKERS

SEAN TAGGART

WILLIAM GRAEF

DR. PHRANKENSHOP

181

DR. PHRANKENSHOP

WFMU
91.1/90.1 FM • WFMU.ORG

WFMU
91.1 FM

2
© 1996 M. MORAN
EL DIABLITO

21
LA MANO

14
LA MUERTE

27
EL CORAZON

37
91.1
FM
EL MUNDO

GREETINGS FROM WFMU
91.1 FM
HOME OF FREEFORM RADIO
M. MORAN '93

MARK MORAN

J.D. KING

183

"ENTER THE AUDIO HUSSY."

NICK BERTOZZI

 **T-SHIRTS**

SKO

INVESTIGATE FISH FARM

STEVEN KEENE

185

KAZ

RODNEY ALAN GREENBLATT

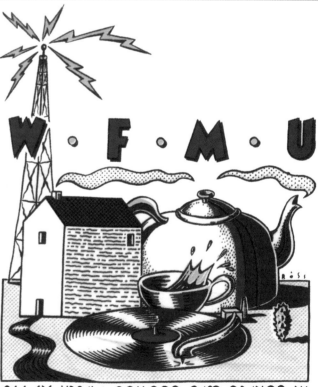

MARK ZINGARELLI

TAKESHI TADATSU

CHRIS WARE

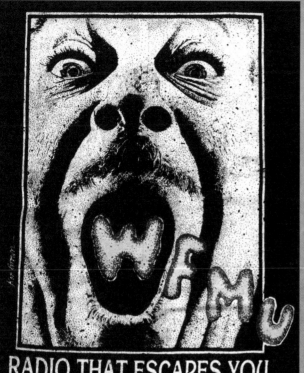

RADIO THAT ESCAPES YOU
91.1 FM UPSALA COLLEGE E. ORANGE NJ

KEN BROWN

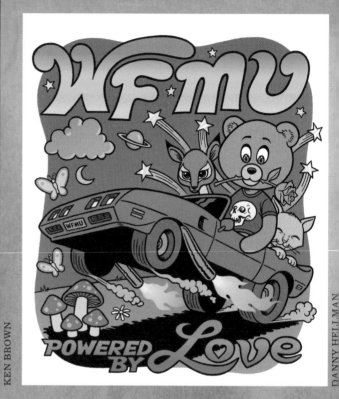

POWERED BY Love

DANNY HELLMAN

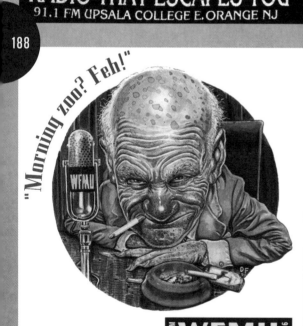

"Morning zoo? Feh!"

WFMU
91.1FM  90.1NJ

DREW FRIEDMAN

WFMU

91.1/90.1 FM
wfmu.org

GREGORY JACOBSEN

188

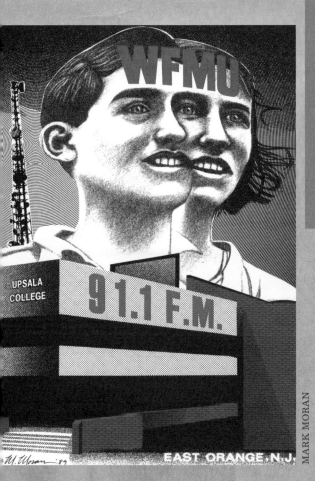

GARY TAXALI

THE MONKEY BRAIN TONIC

PAUL LEIBOW

189

JIM FLORA ART LLC

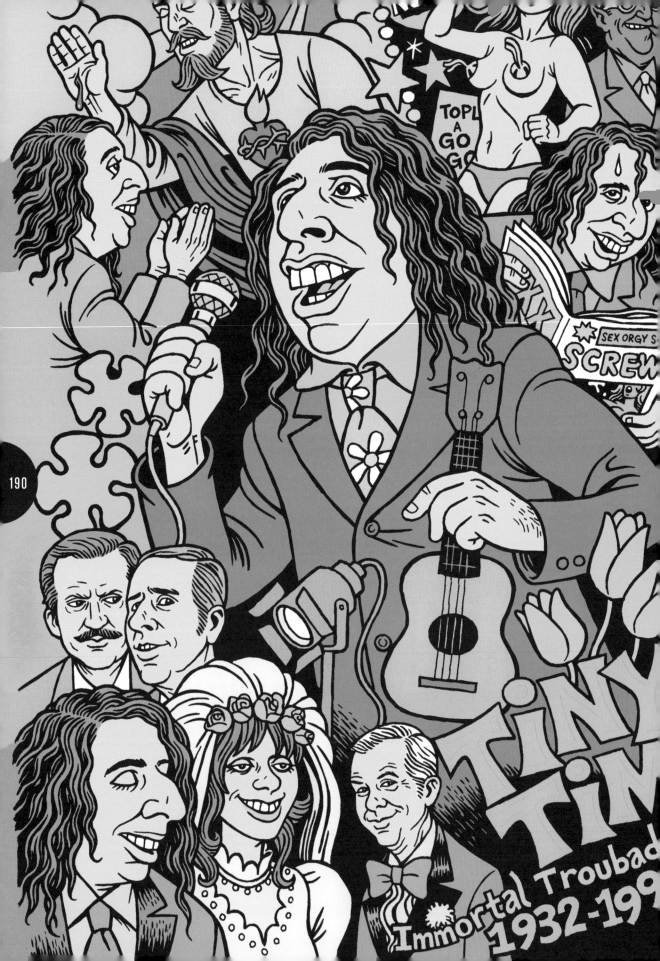

Wade (center) with the original Rhythm Rockers

**Wade Curtiss spent his life in a wheelchair rolling over every square in his path. That translates into one tall stack of knock-down, lame-ass, no-go hodads, my friends, all of them expendable and despicable for their lackluster ways.**

Crippled from birth, Wade (born Duane Theodore De Santo, July 6, 1943, in Fort Wayne, Indiana) was never able to walk. The use of his hands and arms was severely challenged by a congenital "club" deformity which caused his stub arms to turn inward and backward. Mom De Santo shuffled the kids (sisters Helen and Lorraine and Baby Duane, nicknamed "Teddy") north to Canada in January 1944, where the family was able to get the best medical attention and public education they could for their boy. Despite his physical handicaps, Duane was smart as a whip and determined to have a blast. He shared a wicked sense of humor with his mom, and early on began tape recording mock celebrity interviews and prank phone calls with her. An avid radio fan with clear signals beaming twixt the Great Lakes, Duane rode the dial between Toronto's behemoth CHUM, Detroit's CKLW, and Buffalo's WJJW, catching the bug for country/western, rhythm & blues, and, most especially, rock 'n' roll. He was a sharp-dressing cat with a cool record collection and a yen for electronics by the time Mom De Santo schlepped her brood back Stateside in 1957.

# THE FABULOUS FLIPPED-OUT WORLD OF THE ORIGINAL BUFFALO BOP-KAT WADE CURTISS

*King of Rock & Roll*

*by Miriam Linna*

Thank you, Charles Atlas. A young Dixie Dee flexes for the camera.

Wade was obsessed with the idea of becoming a rock 'n' roll guitar slinger himself, but was momentarily stumped by the obvious problems posed by a regular git fiddle. Ever the logical thinker, he rigged a steel guitar with four E-strings and one banjo string, which he felt, properly tuned, sounded close enough to a traditional guitar. With short steel rods in each hand, he was able to play some of the meanest guitar ever, and certainly created a unique sound! Wade also messed a bit with piano and drums, but the guitar was his passion. Despite the physical limitations, Wade never considered himself handicapped. He was driven to write songs and perform before a live audience and did exactly that. Using the stage name Ted Russell, Wade formed his first teenage combo, the Rhythm Rockers, when he was just fifteen. Primarily an instrumental combo, Wade (Ted) led the group, playing lead and bass guitar with his steel guitar rig. Tom Kasper and John Lindler were early rhythm guitar guys, and the drum duties went swiftly from Mike Petrie to Jack Clarke.

Ted Russell And His Rhythm Rockers became local celebs with their own fan club and a pair of insanely wild 45s under their collective belt, starting with the two-sided instro whomper "Terock" (which drives along with alternating sax, piano, and accordion solos!) b/w the screamin' sax 'n' piano stomper "The Slide." Issued on Huntington, Long Island's independent Golden Crest label, "Terock" opened doors for the double R's at Aubrey Cagle's Glee label back in Wade's home state of

Indiana. Glee soon thereafter issued the Rhythm Rockers' sophomore sensation "Real Cool" b/w "Brang," again, two killer instros featuring Wade's echophonic guitar excellence. The magnificence of these sides can't be overemphasized. They are the golden cream of raw echo-swamped guitar instrumentals with a scary, forbidding undercurrent that truly sets them apart from professional hit instro fodder.

Wade was, like most boys in Buffalo at the time, crazy for wrestling. Of the local wrestlers, his favorites were Don Beitelman (Don Curtis) and Mark Lewin. As fate would have it, he was to soon team up musically with another young grappler by the name of Dick Derwald.

Buffalo's own Dixie Dee was born Richard Derwald on February 15, 1935, and as a boy was very thin and frail. He was the quintessential sand-in-the-face 98 pound weakling until he witnessed his first wrestling match, when he followed some school buddies to the Buffalo Arena to witness Gorgeous George vs. Ray Villmer. "I was thrilled," recalls Mr. D, "I knew right then that I wanted to wrestle.

"I had no idea how to go about it. I was so small, and had no muscles at all. That summer, my family went on vacation and rented a cottage, and somebody who had rented the place before us left behind a part of a Charles Atlas course. I was twelve years old, and I thought if they can do it, so can I. I started reading Bernarr Macfadden's magazines and got to work with the pushups and all. By the time I was fifteen or sixteen, I had gotten pretty big. Back in Buffalo at that time, there was no place to buy

exercise equipment. There were no commercial gyms at all. I had to mail order for the weights. I still remember the delivery guy being pretty mad at me!"

Richard was boyhood pals with fellow wrestling fan Ted Lewin (author of *I Was A Teenage Professional Wrestler* and now a professional artist), whose big brothers Donn and Mark would soon find worldwide fame as mat men. Ted himself was, true to his autobiography, a teenage wrestler, tag-teaming with his big brothers. All the while, Ted was sketching the big men in the ring, eventually painting his experiences on canvas in oils. As kids, Richard, Ted, and Mark took their cues from ex-Marine Donn, who was a star in local physique exhibitions and a favorite in the squared circle.

"In the early '50s then and there was no rock 'n' roll, per se. It was rhythm and blues, and the only one playing the stuff was George 'Hound Dog' Lorenz on WKBW. He had a show on Saturday mornings after Rambling Lou, a country guy. He'd play rhythm and blues from eleven AM 'til one in the afternoon, and I liked that. I'd listen to him while I lifted weights! My dad worked Saturdays, so I'd put a blanket out in the front room and listen to the Hound Dog and lift."

Richard graduated high school in 1953 and began wrestling in earnest as Dick Derwald (still later as Dick Daniels), with his first bouts at a most colorful venue: "Ray Matty's place was a little bar in the front. In back, there was a little auditorium set up with a ring and bleachers. It was great. I

Wade as Master Curtiss with the Pink Panthers, circa '78

went on to wrestle in Toronto at Maple Leaf Gardens, in Rochester, in Syracuse. I wrestled Yukon Eric and I wrestled Fritz Von Erich, and I wrestled the Mighty Atlas on Cleveland TV.

"Buffalo had a million strip clubs back then," Richard recalls with a laugh, "and countless bars, clubs, restaurants, venues. There was plenty to do. We used to go to a place called the Kitty Kat Club and I would sing what was like bluesy rockin' rollin' stuff with the group there, the Vibraharps. Donnie Elbert was their original lead singer, and when he quit, a guy named Danny took over. They made a record without me called 'Walk Beside Me' b/w 'Cozy with Rosy' for the Beech label.

"I wrote 'Voodoo Mama' and 'Urang-utang' to sing with the band. I'm a big movie nut—that old Universal stuff is my favorite. I'm not big on musicals, but that horror stuff, oh you can't beat it. Anyway, we went in and made a demo on a four-track at Howell Studio over on Delaware near Kenmore. It was all done live, no tape-overs, nothing like that. I brought the record to George Lorenz, who was making big waves at WBKW, and he said, okay, you press it and I'll play it. It came out on Fine Records out of Rochester. George told us if we came up with some cash, he could get it to Alan Freed. I didn't do it. I wish I had. It's a strong record, and I think it could have done something.

"Anyway, I was still wrestling, but I wanted to sing real bad, too. I was hoping to combine it—sing during interviews and stuff! I was working everyday as a filing clerk, and wrestling evenings. One night, Pedro Martinez (local booking agent) called me to wrestle a guy at the Rochester Arena, where Frank Sexton was on against Yukon Eric in the main event. We went out and started wrestling, and after about fifteen minutes he started clamping down on me, and I thought, hey, this guy's really trying to hurt me. So, I tried to move way from him and the crowd started cheering for me. I could see this guy's veins coming out of his head. So the bell went off and it was over. I was in the dressing room when Pedro walked in and threw his cigar against the wall and he called me a lot of profanity and he says, 'This is the guy's home town, what the hell is the matter with you?!' I knew I was in trouble. So a couple of days later he calls and says, 'Dick, you're gonna go wrestle Fred Atkins on Cleveland televi-

sion.' Now, Atkins was a guy who broke guys' arms and legs and really hurt people real bad, and I knew there was some kind of vendetta going on. I knew they were gonna bust me up. I called the guy up and told him I had the flu and I couldn't make it. Really, that was, in a way, the end.

"But for a period of four or five months there, I was doing it all. I would drive home from a gig, put my bass away, pick up my wrestling gear, get back in my car, and drive to Cleveland (at that time, Lord Layton was the TV wrestling announcer there—he was real big). It was a five hour drive! I'd wrestle Illio Dipaulo or the Mighty Atlas, drive home, get an hour's sleep, and then go play again!

"I was Dick Derwald in the ring, and Dixie Dee with the band. 'Dixie' was for southern rock, like Jerry Lee Lewis, and 'Dee' was like easy to remember, and beside, there were all those Dee's out there. I had picked up a cheap bass guitar and learned to play, so I was playing and singing now with my own band of guys, the Rhythm Rockers. We had put up a sign with our name at the Knickerbocker over on Niagara Street, and I get this call. Apparently this guy Wade [Curtiss] had called the bar and said, 'Hey, you're using my name, that's the name of our group.' Well, as it happens, I had been dating the sister of my piano player and we were breaking up, so that was causing a little grief in the band. So, I quit the other band and figured I'd join up with Wade.

"The first time I met him, I walked into the room, and there he was, and he says, 'I didn't tell you I was in a wheel-chair, did I?' I mean, I guess I was kind of taken aback. I couldn't understand how he could play a guitar—I mean, his arms were severely malformed, his fingers faced up and away from his body, and the upper part of his arms, from the shoulder to the elbow, was very short. Then I saw he had a steel, or what you call a Hawaiian, guitar, that he played for a regular guitar and also as a bass! Wade was an amazing guy. He never received disability from the government because he refused to label himself as disabled. So anyway, I quit my other band—they were moving into more progressive stuff like George Shearing, and I didn't like that. It gave me a headache. I thought, hey, I really love rock 'n' roll, and with Wade I knew I could be up front and center, and that's where I wanted to be."

**Backstage with Wade...**

Wade Curtiss and Dixie Dee may have been an odd pair physically, but their sensibilities were identical. Both loved rock 'n' roll and wrestling; both were determined to be their very best. Together, they made some of the most frantic recorded mayhem ever. Dixie made his first appearance on the B-side of the third Rhythm Rockers' 45 with the legendary "Bright Lights," which he co-wrote with Wade. The A-side was an instro, the RR's version of Cozy Eggleston's "Big Heavy," which was disc jockey George "Hound Dog" Lorenz's theme song. The rhythm-laden seven incher was pressed on Wade's own Terock label, and oddly, "Bright Lights" managed to find its way onto England's Starlite label EP Twist On! just a couple of years later. It also appeared at that time as the A-side of a Belgian 45 on the NewTone label, backed with "Night Stroll" by Harry Lewis.

By this time, the Rhythm Rockers were a fixture in Buffalo nighteries and at record hops. Wade's infirmity was rarely a problem, although one regular gig had a drawback: "Dellwood Ballroom was upstairs—we had to get him and the wheelchair up about forty steep stairs. But once we got him up there, nobody really paid attention to the fact he was onstage in a wheelchair, even if we had to wheel him onto the stage when there wasn't a curtain."

They soon went back into Howell Studios, which was just around the corner from Wade's apartment. Richard recalls:

"In one night we knocked off a remake of 'Voodoo Mama,' 'Bright Lights,' 'Maxene,' and I think 'Real Cool,' all at Howell. The guy who ran the studio was an older man. I don't think he had any idea what we were doing, which probably helped with the sound, ha ha! Back then, EQ's and multiple balance—none of that was even heard of! They'd just turn on the microphones and turn on the amps and away you went!

"Wade's sound was unique, driving. That sound came about because of his physical limitation. Because he couldn't play traditionally, didn't have the dexterity, he developed his own sound."

Wade had been messing with home recordings back in Canada with hilarious radio skits starring his mother as Zsa Zsa Gabor, and now with his own combo, he began taping radio shows, band rehearsals, and live shows, providing a fascinating document of Buffalo teen nightlife.

"Man, we had some crazy times," laughs Dixie Dee, recalling life in show-biz with Wade Curtiss: "We were booked at Crystal Beach at the Ontario Hotel one night, and Wade insisted

**Staunch Wade fan Link Wray picks up some tips from The Master.**

on driving. He picked me up in his convertible, and we were whipping down the highway at about sixty miles an hour and a bee stung him on the back of the neck! He could not reach back to swat it because his arms really couldn't reach back there and he started screaming and jumping around and I didn't see that he had a bee on his neck—I didn't know what was wrong!

"Another time, Wade took a job with a big black radio station and we did one of their dances, and we were trying to fit in and were just about to go into a popular song at that time, 'Pretty Blue Eyes,' and I didn't even think, I just dedicated it to all the girls in the audience. Everybody was

laughing and of course there wasn't a blue eye in the place.

"I always wore a black tee shirt, tight pants; I had a lot of muscle, even though I wasn't wrestling professionally anymore. The band would usually start with an instrumental, then I would come out. I loved to finish with 'Ain't Got No Home.' I'd do both voices. One time we played a Lancaster Moose Club hop for a deejay named Freddie Claustine. There were always two bands at a big hop: a band at eight and a band at ten. The band at ten would finish the hop. When they finished, the hop was over. They wouldn't play any more records. Well, that night they brought

in an out-of-town band to finish the hop, and when we got there, Freddie comes over to me and says he heard the band run through their stuff at four, and he was worried because they just weren't any good. He was making a lot of money on these hops—he was getting over three hundred people in the Moose Club! So he says, 'Can you guys just hang around, I'll put these guys on first. I'll tell them I want to get them on the road earlier or something.' They went on, it was okay. Nobody went crazy or anything. Then we played and blew the place away. Well, we found out later, the guy was Frankie Avalon. Bobby, Fabian—all from Philadelphia, all terrible!

I mean, a lot of the white singers—Jerry Lee, Elvis—they may have copied the black artists, but they had soul. These guys had nothing! When all that 'whitebread' stuff started to happen, the Rhythm Rockers started to slip out of vogue. People viewed us as just, well, not hep."

The end of the Rhythm Rockers came suddenly in 1961. "We were playing at a place in Riverside called the Club Bar, where we had built up a cult following. The place was packed every Friday and Saturday night. It was a blue-collar neighborhood, and our kind of music was really going over there really, really well. So one night, we're playing there and Wade tells me, 'I'm going to Nashville' and I said, 'When!?' and he says 'Monday'! And he tells me I should come too! I told him I couldn't just pick up and leave, that I had a job. He just... left. He told us on that Saturday night—we had to cancel all our shows. We were booked weekends indefinitely, and suddenly, it was all over."

That particular Monday morning in 1961, Wade loaded up his car with his guitar, a new Silvertone tape recorder that he'd special-ordered from Sears, and a modicum of necessities, and headed for Music City, USA. His doings over the next dozen years, however, are sketchy at best. We know that he was involved in a fake Trashmen band during the mid-sixties, and thankfully, the tape of his frantic answer song to "Surfin Bird," titled "Puddy Cat (Mama-Meow-Mow)," has survived. In 1969, he recorded and released the astonishing "Electrics Theme," a crazed instrumental (originally titled "Steel Rocket") on which Wade plays both lead guitar and bass on his steel git setup. It ranks with the most atmospherically demented hunks of wax ever made,

reminiscent of a sonic steel cage match between T. Valentine, Jerry McCain, and Joe Meek. He also started up his Record Masters business as a sideline, which he used to license his own and local yokels' material, as well as rare tracks from his personal record collection. He took over the defunct label name Aaron, on which Hank Swatley's legendary "Oakie Boogie" was issued, thus drawing the attention of various record mavens worldwide. His reissue of "Real Cool" on the Aaron label bore the mysterious credit of "Duane De Santo, Guitar Man," no doubt confusing collectors. Oddly enough, Wade also connected with fellow wild man Hasil Adkins and, in fact, can be credited for getting Hasil into a professional recording studio for the first time. Hasil had sent Wade a demo and Wade had jumped at the opportunity to record the "Hunch Man" for Aaron. "Duane was a nice guy," recalls Hasil, "but there was something weird going on. Somebody was after him or what all. I don't know. Duane got me set up in the studio and all, but he disappeared or somethin'. I made that 'Blue Star' and 'He's Just Telling You That' and 'I'm In Misery,' when he got me up there, but then it never came out on Aaron like he said it would. I don't know what happened to that guy. One thing I can say about him though; he knew a good record when he heard it."

Wade met the love of his life, Susan Neal, at a wrestling match at Nashville Fairgrounds, and the couple married in 1974, settling in Madison, Tennessee. Wade's life took a new turn which drew largely on the experience of his early years in Buffalo: he entered the fabulous world of wrestling, adopting the tyrannical alter egos of the terrible Master Curtiss (who would chase opponents around in his motorized wheelchair and handcuff them to the turnbuckle) and the rich and evil Doctor Master Canada. His valet was the enigmatic Miss Candy, whose face was totally concealed by an impenetrable veil. Wade got into the game by running ads locally promoting his shoestring operation, SIU (Sports International Unlimited), and calling for willing, unfettered grapplers to come forward. His stable came to include masked tag teams the Interns, the Pink Panthers, and the Canadian Blues, and assorted bad guys such as the masked

Vicious Victor, Hillbilly Herb, Hillbilly William, Rockin' Midnight Special #1 (and #2!), Super Destroyer, and Nightstalker. There was also the ever-popular Ladies' League with Rockin' Eva, Princess Myra, Saphire [sic], Denise Black, and "Big" Mary G. All the while, Wade was paying the bills working by day as a draftsman for Metro Water and Sewer in Nashville, but having the time of his life in the wild world of wrestling by night. Susan, his widow, recalls, "Wade was always a bad guy. He'd say 'I just don't give a damn.' One night in Gallatin there was a woman who thought her baby face wrestler son was getting hurt in the ring by Vicious Victor, I think it was. She had a small handgun in her purse and was about to shoot Wade, who was pulling

**Thanks again, Charles Atlas. Dixie Dee today.**

his usual nasty tricks ringside. He had a completely split personality. He was one way—mean and evil—in public, and totally another behind closed doors. He always felt you had to be one way for the people. He liked Don Green and Bearcat Wright and Ho Jo (the judo chop guy), Mark Lewin, the Von Erichs, Don Curtis." Wade hobnobbed with the cream of the crop in every field of entertainment. Susan adds, "He had first met Link Wray I think in the late '50s, because when they met up again in 1979, they were talking about playing together twenty years before. They were really good friends. Also Little Richard played a gig with him once. I got to meet him once when he was still pretty straight!"

"In December of 1979, Wade went into the hospital with cellulitis in his legs. Since he couldn't bend them up at all, fluid collected in his legs. They wanted to amputate, but he did not want that. He did not want to be treated as a cripple, and if they took off his legs, he wouldn't be able to get in and out of the car and go places. He didn't want to be left in a corner somewhere. He managed to do just about everything. He could type, he could write his signature and autographs, and he made a special hand control for his car so he could drive. He tried to put a patent on that invention, but the attorney told him it would cost a thousand dollars just to start the paperwork. He wanted the WWF and WCW to come and check him out and get him into their federations, but they must've been afraid that he'd get hurt or something. He was the only one in the world who had the idea to be a mean manager in a wheelchair. When they were doing the wrestling dolls, they could've made a Wade Curtiss doll with a motorized wheelchair with a remote control. It's too bad."

Susan describes what she calls Wade's "behind closed doors" persona: "Wade loved baseball—the Dodgers were his team. He kept calling Dodger Stadium and finally got through to Tommy Lasorda, and they met when Tommy came to Nashville, and became friends. Wade was a Republican; he wanted to be President, of the United States. He loved shrimp, deep fried. He drank black coffee, five or six cups a day. He loved Carl Perkins, Jerry Lee Lewis, Link Wray, and he loved Nancy Sinatra's 'These Boots Are Made For Walking.' He loved fancy shirts with After Six ruffles down the front. Also, his hair had to be perfect; he sometimes spent up to eight hours on his hair. He did not like hippies. Beards irritated him. He didn't like panhandlers. They'd come up to him for a handout and he'd just say 'Just don't even bother me.' He had no use for people who wouldn't better themselves. He had an attitude. He had that attitude in real life, at ringside, everywhere he went. People would stop and look and he'd yell 'What are you lookin' at!?' He suffered with terrible pain in his legs and took Percodan for it. He missed a lot of wrestling matches because either the pain was so bad or he couldn't drive with the Percodan."

Master Duane Theodore Canada Russell Wade Curtiss De Santo expired on August 7, 1993, from congestive heart failure brought on by cellulitis in his extremities. His bones may rest in scenic sojourn in Nashville's Woodlawn Cemetery where a stone marks the spot, but you can bet your bottom dollar he's elsewhere boomin' the big beat and whackin' pretty boys on the noggin with the crook end of a jewel-encrusted cane, far beyond the shadow of sorrow and the valley of pain.

**Epilogue:** Dixie Dee reverted back to Richard Derwald, family man/good citizen, and seemingly left his former glories behind. Then one day a dozen years later, he looked in the mirror and decided that he didn't like the changes that the years had brought on. He went back into the gym and not only regained his old physique but his old confidence, once again. He returned to wrestling, bought a ring of his own, and began booking wrestling locally. For a while, he tag teamed with his son Ritchie, and is documented as the inventor of the wrestling action figure doll. Today, Richard Derwald is a nationally known expert on men's image enhancement. He is the author of the acclaimed book *For Men Only* and owner of Dorian Cosmetics for Men, based in Lantana, Florida. He has appeared on numerous television programs and operates a flagship unisex salon in Buffalo, New York.

# WADE CURTISS/DIXIE DEE DISCOGRAPHY

## 45 RPM

### 1958
**DICK DERWALD & THE VIBRAHARPS**—"Urangutang"/ "Voodoo Mama" (Fine)

### 1959
**TED RUSSELL & THE RHYTHM ROCKERS**—"Terock"/"The Slide" (Golden Crest)

### 1960
**TED RUSSELL (& HIS) RHYTHM ROCKERS**—"Real Cool"/ "Brang" (Glee)

### 1960
**DIXIE DEE WITH TED RUSSELL (& HIS) RHYTHM ROCKERS**— "Bright Lights"/Ted Russell (& His) Rhythm Rockers— "Big Heavy" (Terock)

### 1962
**TWIST ON! EP** includes "Bright Lights" plus cuts by Percy & The Rockin' Aces, Mighty Trojans, and Dee-Dee Gaudet (Starlite) UK

### 1962
**DIXIE DEE (& HIS) RHYTHM ROCKERS**—"Bright Lights"/ Harry Lewis—"Night Stroll" (NewTone) Belgium

### 1969
**THE ELECTRIC EXPERIENCE**—"Electrics Theme"/The Duke of Earl & The Electric Experience—"I Found Love" (Hop-Town)

### 1972
**WADE CURTISS**—"Big Ol' Dan And The Hitch Hiker"/ "Made The Front Page Again" (Aaron)

### 1973
**Duane De Santo (Guitar Man)**—"Real Cool"/Curt Flemons With Ricky & The Ricardos—"Born To Bum Around" (Aaron)

### 1980
**DIXIE DEE WITH WADE CURTISS & THE RHYTHM ROCKERS**— "Bright Lights" (alt. version)/"Maxene" (Terock)

### 1996 WADE CURTISS & THE RHYTHM ROCKERS—
"Puddy Cat (Mama-Meow-Mow)"/"Real Cool" (Norton)

### 1997 WADE CURTISS & THE RHYTHM ROCKERS
FEATURING DIXIE DEE—"Bright Lights"/"Hurricane" (Norton)

## CD

### 1997 WADE CURTISS & THE RHYTHM ROCKERS
FEATURING DIXIE DEE—"Bright Lights" (Norton)

HE FORMED THE CONNECTICUT YANKEES IN JANUARY OF 1928 AND CUT HIS FIRST RECORD IN AUGUST. BY '29 VALLEE HAD AN AUTOBIOGRAPHY AND STARRED AS HIMSELF IN A FULL-LENGTH TALKIE.

HE DESIGNED A MEGAPHONE TO AMPLIFY HIS MODEST VOICE. HE LATER PATENTED IT AND SOLD IT.

_Heigh-Ho, Everybody!_

HIS CATCHPHRASE, "HEIGH-HO, EVERYBODY," WAS THE "WHERE'S THE BEEF?" OF 1928.

NOTORIOUS PARTY SCHOOL, THE UNIVERSITY OF MAINE HAD THE DUBIOUS DISTINCTION OF HAVING A DRINKING SONG, "THE STEIN SONG," AS ITS OFFICIAL THEME.

WE RAISE A GLASS TO DEAR OLD MAINE

VALLEE'S VERSION WAS SO POPULAR A BAND RECORDED A HIT "ANSWER" TUNE.

♫ I'D LIKE TO FIND THE GUY WHO WROTE "THE STEIN SONG." ♫

HE WASN'T DUBBED "THE VAGABOND LOVER" FOR NOTHING. IN AN ERA BEFORE THE PILL, VALLEE PROBABLY SLEPT WITH MORE WOMEN THAN ANYONE BESIDES JOHN HOLMES OR WILT CHAMBERLAIN.

UPON SELLING HIS PERSONAL EFFECTS THE ELDERLY CROONER SHOCKED ARCHIVISTS AND HIS CURRENT WIFE BY LOUDLY RECOUNTING SOME OF HIS CARNAL EXPLOITS.

I REMEMBER ALICE FAYE USED TO LOVE IT WHEN I'D SNEAK UP BEHIND HER AND SLIP IT IN...

AS TIME WENT BY HIS VOICE GOT THINNER AND HIS SANITY SHAKIER, BUT HIS EGO WAS UNDIMINISHED. WHEN ASKED IF HIS EARLY '70S GIGS WERE A "COMEBACK" THE SEPTUAGENARIAN INSISTED THAT HE WAS AS BIG A STAR AS EVER.

I'LL BE FRONT PAGE NEWS UNTIL THE DAY I DIE.

HE ALSO TRIED TO CHANGE THE NAME OF HIS STREET IN THE HOLLYWOOD HILLS TO _RUE DE VALLEE._

BUNCH OF PATHETIC PUKES!

NEIGHBORS COMPLAINED AND THE CITY COUNCIL REJECTED THE PROPOSAL.

IN THE 1968 HIPPIE COMEDY _I LOVE YOU, ALICE B. TOKLAS_, POSTERS OF RUDY VALLEE AND HO CHIH MINH HANG TOGETHER ON A WALL DURING AN ORGY SCENE.

HEIGH HO

HI RUDY

FORTY YEARS LATER HIS FAME LIVED ON.

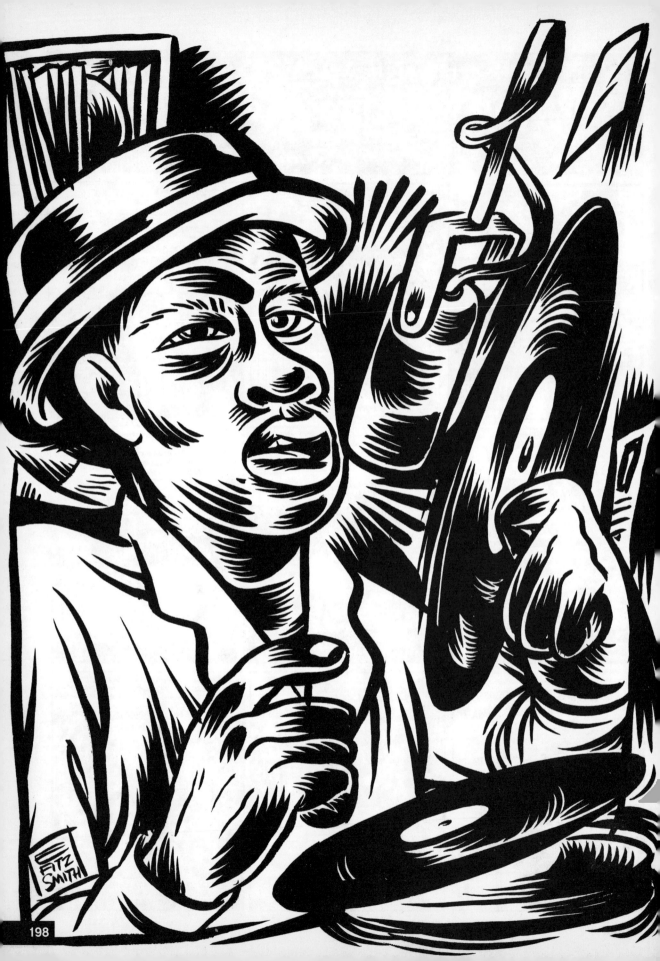

Okay kats and kittens get on your boppin' mittens! Here's some hip babble for you rabble. I'm gonna freak and squeak 'til I crack my beak! One...two...three...BLAST OFF!

Yeah, well, that was then. Today, excepting a few hipster freaks and some black rap jocks, the airwaves have about as much personality as a damp chicken. Clueless niceguys and constipated academics reign supreme in the Land of the Bland.

When Rock 'n' Roll first hit—with all the force of a screaming howitzer—people were stunned. At first nobody, including the few early black jocks who'd copped the mellotoned, yoghurt-smooth patter of their white confreres, knew how to sell it. Eventually though, platter pushers began getting real gone, tossing black jive, then teen slang and finally speed rap in between plays. But ah, who were these original napalm-lunged men of steel and How Did They Come To Be? Good question, Sherman. To pinpoint their origin we step into the Way Back Machine and set the dial for 1946 Nashville, Tennessee.

Businessman Randy Wood buys a home appliance repair shop in nearby Gallatin. The back storeroom has a stash of about two thousand 78s of "race" artists—that meant black in them days. He wants to dump 'em, doesn't know how. Somebody intro's him to Gene Nobles, an ex-carny and local dee jay. Nobles recalls how old time minstrel shows were always popular with white audiences. Maybe his listeners might dig a shellac version of same. Hell, they might even buy 'em as a novelty since with isolated exceptions down

# Dee Jay Jive -O- Rama

## by Dick Blackburn

*Illustrated by Eileen Fitzgerald Smith*

home blues, R&B—dirty stuff—isn't on the air. Only recently a few black servicemen had paid a call to ask if the station might play "their music." They had brought with them records similar to the ones Wood has.

Nobles is on WLAC, a 50,000 watt station beaming up to Montreal, over to El Paso and even down to Jamaica. Wood and Nobles buy a one-minute spot to peddle their shellac at six for a dollar. Nada. They ante up for fifteen minutes. Still zero response. They're about to pack it in when on the third or fourth Monday they get hit by a veritable tsunami of mail. Gallatin no longer has a 3rd Class post office.

Under the strains of Albert Ammons's "Swanee River Boogie," Nobles's sly double entendres ushered in a new sound. The word had spread, to bored white collegians always looking for a new kick and to the huge untapped black audience that dug tuning in their main kick. Right away WLAC's ofay jocks went the sepia route. Bill "Hoss" Allen was a Gallatin native— a town with more blacks than whites. His deep southern drawl plus hipness to black culture/slang made him sound like a brother. "I used to say it was 'get down time.' That's what pimps called the hour they put their girls out on the street. My opening was always 'The Hossman's down for Royal Cream (a hairdressing) and Randy's Record Mart. The world's largest mail order record store. In the business of sending out those phonograph records to you my friends, by mail C.O.D., guaranteed safe delivery no matter where you be. Just pay Uncle Sam and he'll lay it on you man!'"

Unlike Allen, John Richbourg— "John R. way down in Dixie"—was a soap opera announcer from New

York who had to learn the lingo from scratch. He did and began breaking new discs on his one to three in the A.M. spot. The Randy's Record Mart Show became so hot that indie promo men took to sending in an acetate along with a Franklin to insure some spins. If after ten days the major distribution centers in New Orleans and Charlotte hadn't placed any orders, the acetate would be tossed before ever being pressed.

Now the hip audience for all this, although dominant and able to turn others on, was still a minority. In '51, Alan Freed—a classical dee jay in Cleveland—noticed white kids in a local record shop grooving on greasy raucous R&B. Freed had a streak of volkspirit. Although sympathetic to the progressive jazz jocks' constant programming battles with square pop radio management, he felt bop was too cerebral, too elitist, too—hell you just couldn't dance to it!—but this honkin' noise was a stone groove. He talked the shop's owner into sponsoring him before hitting up WJW with a new concept, viz.: the epochal Moondog Show on which he was to popularize the hallowed phrase "rock 'n' roll." His theme song, "Hand Clappin'" by Red Prysock— full of booting tenor and repetitive clapping—became a herald of the new music and a Teenage Call To Arms. A show just for them hosted by some wigged adult who dug as they did. Party down!

Finally known as Moondog's Rock 'N' Roll Party, the late night show rocketed to success, making Freed one of the nation's biggest dance promoters and sending him off first to WINS in New York (he eventually gained enough power to be allowed to broadcast out of his own house!) and thence to Hollywood where he appeared as himself in a few exploito flix before things started to go very wrong.

First he was denied national TV exposure when black teen idol Frankie Lymon danced with a white gal on his Dance Party on WNEW. Soon after he was accused of not only starting a riot but inciting anarchy during a Beantown R'n'R concert. Getting the charges dropped nearly broke him. He quit WINS whom he felt hadn't given enough support and switched to WABC. In '59, the payola scandals broke. He became their major casualty.

He surfaced briefly in Miami, and again in LA, as an oldies show host—tiny stopgaps on a downward slide. To the last he claimed with characteristic egotism—and no truth—to have coined the term "rock and roll." When he died, a penniless dipso in January '65, nobody gave a damn. The squalling baby he'd helped midwife was, in large part, becoming too sophisticated to be reminded of its back o' town beginnings.

Today, the '50s have been so thoroughly deballed by dat ol' debil Mass Media it's hard for younguns to grok just what all the ancient hubbub was about. Yet for a while Freed seemed to be opening doors to a veritable Host of Demonic Furies. Early R'n'R was scary stuff to the Eisenhower greysuits—hell, some of it still is! And A.F. wasn't just some lone nut. He soon had lotsa company.

Over at WAOK in Atlanta, Zenas Sears was promoting Piano Red, Chuck Willis, and—gulp!— Little Richard.

Out on the West Coast—arguably the true birthplace of R&B— "Jumpin'" George Oxford broadcasted over KSAN in San Francisco and Oakland. In between plugs for E-Z credit furniture stores, his juicy ham actor tones sounded as if he was about to do a dirty old man on the young chicks whose squeals punctuated his spiels ("Ole jumpin' daddy you make me want to shout!").

In LA—on Harlem Matinee and Huntin' with Hunter—infallible hit picker Hunter Hancock chuckled like some maniacally square Babbitt, his high-pitched voice cracking countless cornball jokes.

New Orleans boasted white slurred-voice maestros Poppa Stoppa and Jack the Cat—both fiercely loyal to their local artists. However, Vernon Winslow, the guy who originated and wrote The Poppa Stoppa Show, was black. When he finally got on the air himself—as the suave Doctor Daddy-O— he had to broadcast out of Cosimo's Recording Studio because the hotel which housed the radio station wasn't integrated. Years later they relented—only to make him ride up in the freight elevator.

Soon the trickle of black dee jays became a flood, as Bugs Scrugs from Memphis, Sugar Daddy Birmingham from Winston-Salem, Jockey Jack Gibson in Atlanta, and Professor Bop in Shreveport played sounds as funky as their soubriquets. They became real powers in the biz

and were diligently courted by artists and prexies alike. When Bobby Robinson, owner of NYC's Fury label, sent Chicago's Big Bill Hill a copy of "Kansas City" by Wilbert Harrison he included a case of the WOPA jock's fave scotch. Big Bill rode the disc until it broke out all over the Midwest like an epidemic of German Measles.

Over in Memphis Town, WDIA became the first black-owned radio station. There, young Elvis P. heard blues 78s by Sonny Boy Williamson and Howlin' Wolf played by tyro dee jay B.B. King. Elv was to have his first waxing aired on WHBQ in July of '54 by the burg's most happening dee jay. That the man was white is really incidental—he could've been purple with green polka dots.

Dewey Phillips was the craziest hick to ever hit King Cotton. About his sponsor Falstaff Beer: "If you can't drink it, freeze it and eat it. Open up a rib and pour it in." A fractured pill head, he held manic four-way conversations with himself, mangled words, shouted over his records, even ripped 'em off the turntable if he didn't dig 'em, and he had such power that a phrase leaping from his Sizzlean brain to his motor-mouth and into the mike was often established street lingo next day. On a local TV show he created even more mayhem with the help of art director Harry Fritzius, whose zany Ernie Kovacs–like genius complemented Daddio D to a T. The man's aural crazy quilt is available on CD from Memphis Archives. Buy it, dig it, and pick up on Robert Gordon's *It Came From Memphis* (Faber & Faber) which has a whole chapter on Messrs. Dewey and Fritzius.

Most really mind-boggling dee jays, however, were black. Dr. Hepcat (nee Lavada Durst) blew a few minds around Austin, Texas, with the bop chatter he'd developed announcing black baseball games. His version of the Lord's Prayer is

still a classic: "I stash me down to cop a nod. If I am lame I'm not to blame—the stem is hard. If I am skull orchard bound don't clip my wings no matter how I sound. If I should cop a drear before the early bright—when Gabe makes his toot—I'll chill my chat, fall out like mad with everything allroot."

The "stem" is the street. Now let me carve your knob further. For instance, the Doc might say that if he had a pony to ride, he could domino the nabbers, cop some presidents, gas his moss, and get togged with some beastly ground smashers. Translation: If he had a job, he could avoid the police, make some money, get his hair conked, and buy some new shoes. Then he'd be mellow to puff down the stroll where he'd motivate his piechopper to latch onto a fly delosis. Or, in layman's parlance, he'd be in the right mental state to ride down the street where he'd affect an introduction to a good-looking girl. (N.B. copies of Durst's righteous booklet *The Jives Of Dr. Hepcat* can be purchased from Antone's Records, 2928 Guadalupe, Austin, Texas 78705 Tel: 512-322-0660).

Still, all this mind-twisting argot had a fairly rational delivery. To really get down in the surreal alley we flip to Louisiana and a very esoteric jockey indeed. Like all great rap artists his contributions lose something when transformed into cold print but what the hey. It's the mid '50s. A gospel record has just ended.

"A-men an' don' forget to write me a cahd or lettuh to Groover Boy KWK Shreveport 2, Loose Bananas. Well—we'll sanomorebaybeh. Gonna get right on ahead wif' de music 'cause we know we got one right chere dat everyone want to heah. I got about fifty ree-quests for dis an' don't has tahm to read 'em all but ANYHOW HERE'S DE REK-KID BY JOE LIGGINS AND HIS ORCHISTRA titled "oooOOOOOHH-HHWHUUUUU! HOW I MISS YA!"

In those days when White Citizens' Councils were worrying about their children being mongrelized by "screaming moronic nigger music," ol' Groover Boy must've wiped 'em out big time. 'Specially when he'd throw an orgasmic fit in the middle of a farting sax solo. His approach to sponsors was nonetheless, uh… idiosyncratic.

"Dis is de KWK tahm on amerigofutenam (?). Feeuuuuuum! A man full—of mud—in Shreveport. Ya know—I like to get serious for just a minute chere baybeh. By de thousands people are turnin' to da rich foamy mellocutions of Palmer's Skin Success Soap. Ya whips up ya soothin' foamy mellocution an' allows it to remain on an' luxurize three minutes. Now…here's what dis gentle foamy mellocutions do: ONE: it relieves de irritations of upset… skin, blackheads, rashes and pimples. TWO: it act as a deodarant removin' de skin back-teh-rye-uh chief cause of ah-ffensive puhspuhration odor, an' THREE: it hygenically cleanses luv-ly complexions an' soothes with its lano-lin! Toooo-day! Only twenny five cents at drug and toiletrie counters! An' now Big Joe Turner! 'Cherry Red'!" (plays record) "Rock me mama in your big Hollywood bed 'til my face turns cherry red!"

Yes kids, it was leer-ics like these that riled far less extreme groups than the KKK.

Chief Offender here was Cincinnati's King Records who issued the infamous "Annie" songs by Hank Ballard and The Midnighters. In "Work With Me Annie," Hank encourages the title character to give him "all my meat." Subsequently, Annie has a baby and "can't work no more." This was temporary, for in later release they're doin' it "in the halls, on the wall." To further increase the demand for these records, it would seem entire convents were warned not to buy them. Ha!

Other bawdy sagas followed: Bullmoose Jackson had his "Big 10 Inch." The Swallows replied, "It Ain't The Meat But The Motion," and Todd Rhodes offered the gals a ride on his "Rocket 69" while Wynonie Harris had to say "Good Mornin' Judge" after dating a white cop's sixteen-year-old daughter!

Although these were just updates of party records blacks had enjoyed since the '20s, it was their exposure over America's airwaves that fried the bluenose's bacon. Who cared if drugged-crazed, sexed-up coons listened to such filth in their living rooms?

Now all of white womanhood with the flick of a knob could hear how Dinah Washington's dentist "Long John" filled her "cavity" with his "drill" and then felt her "whole inside!" The hounds of decency began to froth and snap.

BMI, the publishers of most race ditties, came under hornet-like attack as did the dee jays themselves. Of course, the majors tried squashing the indies by covering black raunch with white, lust-drained versions. Answering Hank B., Etta James asked Richard Berry to "Roll With Me Henry" engendering the coy "Dance With Me Henry" by Her Nibs Miss Georgia Gibbs.

In "Shake Rattle & Roll," Big Joe Turner gazes upon voluptuous semi-nudity in disbelief—"You wear those dresses the sun comes shining through/Can't believe my eyes all that mess that belongs to you" and then gives out with the poetic genital confrontation, "I'm just like a one-eyed cat peepin' in a seafood store." Later, achieving greater intimacy, he groans, "You make me roll my eyes and then you make me grit my teeth." When Bill Haley sang about the same hoyden on Decca, home of Der Bingle, the poor guy didn't even get a buss on the cheek.

'Course even the indies couldn't get too far out on the rim. Little Richard's "Tutti Frutti" on Specialty was an obscene song he'd performed in black drag bars like New Orleans' Club Tijuana and The Dew Drop Inn. Dorothy La Bostrie was called in at the last minute to de-X-rate the words at a failing recording session and—bingo—a star was born.

White rockers were as swiftly gagged as black ones. Gene Vincent, already on shit lists for pronouncin' "huggin'" in "Woman Love" on Capitol with more of a "f" than an "h," couldn't garner much airplay with the indefatigable "Rollin' Danny" who "lined six chicks up against the wall and pulled 'em all." He was told to clean up his act. He did, much to his artistic misfortune.

Not all dee jays and their music became defanged overnight. As a Detroit teen, I tolerated Bobbin' With Robin with Robin Seymour on WKMH. He played black and white R'n'R but his rapport with the stuff was minimal. The rawest it got was Brenda Lee's "Dum Dum." But late at night, under the blankets, clutching my trusty Japanese pocket transistor, I'd really groove to WJLB's rhymin' Frantic Ernie Durham: "Only one lean green to make the scene down at the Greystone Ballroom. An' when ya go tell 'em that ERNIE HIPPED YA SO! Let's can the chatter an' get to a platter. We're gonnascratchsome coolwax! Gonnagiveya thatrealgoodfeelin'! Gonnabe climbin'alloverthe ceiling. Little Richard 'Ain'twhatchadoit'stheway thatchadoit (Ain'twhatchaeatit 'sthewaythatchachewit)!'"

I only saw The Frantic One once. My date and I were, predictably, just about the only whites at a huge P.M. jazz and R&B concert in the late '50s. All of Black Society was there, togged out, coiffed to the max, when the Prophet Jones entered, prancing gay and flanked by two bodyguards. As always, he

was clad only in green—the color of money. Black women shivered. The proph was heavy business. Ebony had reported how he'd foretold the coming of the Atom Bomb after seeing a puff of white smoke escape from a fried chicken leg on his plate during a church social. He swept into his seat, the lights went down, the spot came up and the MC walked out. Lo!—It was Frantic Ernie. Years later, I called him on the phone for an interview. He was into his rhymin' spiel before I'd even got my name out.

Ernie was an exception. As the '50s wound down, the majority of jocks came on like second-rate hucksters snaring teens with every tired con known. A few were genuinely clever. WIL in St. Louis became famous due to Jack Carney, who came on like a games director at Camp Neverwazza. He personally drove the winners of his contests to school for a week in rented stretch limos.

Once, Jack announced that a mystery phone number was hidden somewhere in the city. Whoever found it and called in would get five grand. For days he teased his eager listeners, withholding the Big Clue until they were about ready to blow. Then at rush hour he confessed: the digits were in a pill box taped inside a car's radiator cap. Carney set up a ticking metronome. If the number wasn't found in three minutes the dough would be forfeited. After the last agonizing second had passed, an engineer happened into the studio and casually asked what it was he was "supposed to have done with that pill box." End of bit. Fine. But outside the whole city had gone into monstro-gridlock. Every motorist had jammed on his breaks, hoisted his hood and unscrewed his cap.

Another audience grabber was the stay-awake-marathon. Peter Tripp, NYC's "Curly-Haired Boy in the Third Row," staged one in

an empty recruiting office in Times Square. For five whole days and nights he stared back sleepless at the freaks who made faces at him through the plate glass. Finally, his rap began to disintegrate. His face turned white. His lips went blue. Forgetting to put out his cigarette, he set his sport jacket on fire.

Up in Buffalo on WRBW, Dick Biondi "the old spaghetti slurper" typified the MOR teen-slanted jock with his wiseguy slickness, forced laugh, and obviously manufactured excitement. But then it was becoming difficult for anyone with a brain to become turned on by the formulaic "Philadelphia Sound" Dick Clark had hatched in '57 with Danny & the Juniors' "At the Hop"—perhaps the best of the genre.

My vote for greatest teen jock goes to another Philly resident: Joe Niagra of WBIG—"Wibbageland." An early rhymer—"hear the word from this rockin' bird"—Niagra earned listeners by never letting his speech become predictable drone or babble. He had a knack for the odd pause or unexpected, but perfect, emphasis that gave the impression he was not only gassed about a single's success but actually proud to serve his listenership. "I predicted this would make it big and you proved me right!"

Besides being a super salesperson, Niagra may have also invented payola. Philly was then the largest center for indies who, having less clout than the majors, incessantly had to grease the wheels.

One day in the early '50s, when Joe was still a faceless pop dee jay, he dined with Harry Finfer, an indie record producer. Harry asked Joe to spin a new single. Joe agreed. Harry picked up the lunch tab—somewhere around three bucks. Outside the beanery, Joe, who was

making maybe sixty a week, sees a hundred dollar suit in a store window and flips over it. Next day the suit arrives at the studio addressed to Niagra from Harry with a note requesting more plays of his records. Joe was like a kid at Xmas. He rides the hell out of anything Harry sends him from then on. Glockenspiel medleys, singing canaries, whatever. Payola is born.

"The indies tried to get the dee jays boozed, fed and laid," says Oaky Miller, a former Philly jock of the late '50s. He maintains, as so many others do, that he accepted gifts but only played the records if he thought they were good. Miller, now a comedian and actor, follows in the tradition of Steve Allen, Jack Paar, Ernie Kovacs, Garry Moore, Bob & Ray, Jonathan Winters, and Soupy Heinz (later Sales), all platter pushers before they were funnymen. Miller, typically, got his start through sheer chutzpah.

In the summer of '57, he was on the Atlantic City boardwalk looking for a slave before the fall semester. A young dee jay in the window of a dance emporium was broadcasting over loudspeakers to rope in a tip—of which there were, so far, only six. Oaky strode in and buttonholed Frankie, the owner. When he heard the kid's pay was twenty-five beans a week he was shook. "Hey," he said, "I can pull in more people than this lame you got.

Walk me down the boardwalk. If a hundred kids don't stop me to say hello, forget I asked."

It was a calculated move. Oaky had been a bigtime athlete at a humungous Philly high school. Atlantic City was where all the city's teens came for summer fun (cf. one of the Royal Teens to Dick Clark on American Bandstand: "Well we wuh at the beach, y'know? An I sawr this gurl wearin' shawt shawts, etc.")

Without knowing an A from a B side, he scored the gig at fifty bills a week. Soon he was running his good-natured jive over at WEEZ in nearby Chester where he started to really involve the audience. He thanked a high school toughie for protecting him at a dance. When Elvis hit town, he leaked out the Big E's private phone number, only—wotta kidder!—it actually belonged to local police HQ. To cool the authorities, he then started "Homework Corner," a twenty minute segment where the kids could exchange questions and answers on the air.

He also spotted the potential of another dee jay—Jerry Blavat—and gave him a one-year contract to host his overflow of sock hops.

"The Geator With The Heater" as Jer called himself, got very big over at WCAM and WHAT, perfecting a near-mindless crooning style, the forerunner of late '60s Thorazine delivery. In his "Hiptionary," ladies were amazons or foxes, and guys were studs or coyotes. Over a lush

string backing, he would breathe "The coyote needs someone...and that someone...that's the fox... like the bee need the honey...like the flower need the rain...like the farmer need the crop...like the ocean need the salt...that's how the amazon needs the stud...and teenage love...wow!...it had no beginning...had no end...it will never end as long as there are teenagers."

His intro to an uptempo jam was no less goofy: "...Unh!...Unh!... Unh! Up into the sky for thee. Yuh! Teenpopulationofthishere—fabulous-nation. Once again hello and a hi! and a huh! Big boss with the big hot sauce. YourstrulyJerryBlavat. The geator with the heater. So—without furtherado. Let's try and appease huh? Your musical appetite huh? Let's try and appease you—the yon teen population. I along with you will rock the big tick tock, etc."

By the mid '50s, lotsa white dee jays were whipping themselves into a snapping fever. Cleveland had Mad Daddy, whose airchecks on cassette still circulate amongst the faithful. Pittsburgh's WAMO boasted the legendary Porky Chadwick—"the daddio of the raddio, a head snapper and dapper rapper, a porkulatin' platter pushin' poppa." He wasn't "Cary Grant but can do what he can't" and got his "PhD in insan-ity at the University of Spinner Sanctum" where he always had a grape in his ear "to make my head ferment." If listeners dug the sounds he played, he urged 'em to lean on their car horns. They did—creating godawful cacophonies all over P-burgh.

Talking of horns, yet another gimmick was coming out of the ether. Weird sound fx! Traces of this go back to the early '50s at WNEW, NY when the pope of jocks, Al "Jazzbo" Collins had his "Purple Grotto." The flipped noises, coupled with Al's inimitable free-associative

musings ("I'm talkin' about that real oleaginous egg-drop soup...") prob-ably bagged more fans than the solid sounds he spun.

Sometime later at WICC in Bridgeport, CT, Bob "Hogan's Heroes" Crane helped pioneer the super-production format with fx and way out vocal trax. NY's WKNF lured him away with a state-of-the-art console on which he could've staged the entire Battle of Little Big Horn.

Such new audience nabbers weren't lost on rock jocks. Boston's WMEX star Arnie "Woo Woo" Ginsberg—"Woo woo to you you"— backed up his gee whizz delivery with assorted pops, squawks, whis-tles, clangs, beeps, and arroogahs. His Night Train show became a New England institution. Arn even had a hamburger named after him: The Ginsburger, natch.

Fx's most baroque exponent was at KLIF in Dallas, TX. During the early '60s, Russ "Weird Beard" Knight's rhyming patter was reverbed through countless echoplexes and overlaid with so many flying saucer and rocket noises it sounded like a Joe Meek wet dream. Pick hits—the Knight Bullseyes—were intro'd by a flying arrow—WHHIIRRR!—that hit a target—THOCK! The show, "beamed from a space capsule," was so all-fired busy that the records began sounding like just more electronic novelties. And this was mild compared to the mad folly that followed.

As radio moved into the mid-'60s it aped Bill Drake's super sock it to 'em JB top-40 program-ming shtick. Drake came up with his "totally commercial radio" over at KYAN, San Francisco, and it set the lead through the decade's end. Overlap sound, no dead air time ever, stinger jingles of two seconds tops, constant harping on the station's call letters and PUSH! PUSH! PUSH!

In this hysterical straitjacket, only the hardiest could survive. Only the most hyper could squeeze in a fragment of personality. One of these was B. Mitchell Reed "The Fastest Tongue in the West" who blew in from LA to NYC's WMCA as "The Boy on the Psychiatrist's Couch," "The Mad Monk in the Monastery," or just simply "BMR." He'd prep himself for the verbal spill chute with a joint, a few amphs, and a fifth of Jack Daniels. "After that I felt loose and ready." Below is a rap the like of which beat out both Murray the K and Cousin Brucie in popular-ity. It lasted but 17 seconds. Wanna try your luck?

*Hey scooters, it's your leader BMR, WMCA jumpin' with my hat in my hand with the nuttiest show in the entire New York turf. Read me back with the smashbacks or the Good Guy's survey or headed that way. This hour: the name of the winner of the Musical Love Letters Contest. First portion to be presented from the lobby of the Nile Hilton Hotel. Hey! Nameclaimstyle will go to Connecticus (?) second call city of Lalassitude (?). Five thousand and like that there schmeer callrightnow!*

Not bad, eh? But for pure batwing madness nobody topped The Real Don Steele. In '66, the pyroma-niacal Real fired this mini-brushfire out over KHJ, Los Angeles, a city so used to glittery-eyed freaks it didn't even roll over. 16 seconds was all it took.

"Three o'clock in Boss Angeles! AndgeHEY! that's me, The Real Don Steele. A billion dollar weekend there and you're looking out of sidewalk call. I got nothing but those groovy golds. We're gonna fit Chuck out here on a fractious Friday, boy. Got to get a set outside that (indecipherable word like blow-ing in water) jumbo city. Take a trip. When you chase 'em daylight."

Perhaps these electronic mutants blew too many synapses,

for thereafter descended an endless yawn. Blavat, as has been noted, was the precursor of late '60s FM jocks like NYC's WOR Rosko quoting Khalil Gibran drool in slo-mo between psychedelic fuzz baths—sending you off on a nod before the music began. Against such soporific tapestry the mighty Wolfman Jack on XERB border station Tijuana: "CA-CA-CAREE! Dis de Woofman baybeh!" stood out like a giant amongst pygmies.

Yep, by this point if you wanted true originality, you had to search it out. For instance, in the early '70s a chappie calling himself The Black Pope hired himself out to diverse Texas/Louisiana radio stations. Like a fearsome gunslinger, the Pope would blow into Beaumont or New Orleans with contests like "Wear Out Your Favorite Dee Jay's Head," always warning people not to call him a dee jay.

"I been up and down the dial an' I ain't heard nothin' but a bunch of rootypoots! If you call them dee jays I ain't no dee jay. Unh unh. I'M A HUMAN RADIO STATION! The turntable, the transmitting tower, the tone arm—EVERYTHING!!" Soon The Black Pope had everyone

tuning him in. But the man was so egomaniacal that after a month, his ravings began to fry brains. He'd be shitcanned, forced to holster his rap, wander off to another town and save another station. Thus are legends born.

By the mid '70s things had become more rigid than an Excedrin Headache Number 2. One exception: the infamous Houston record producer Huey Meaux. His Crazy Cajun show was, like the man himself, intensely personal. If he didn't get enough callers, he simply lifted the needle until the board lit up. If people didn't like what he was playing, Huey, who claims never ever to have tucked in his shirt, advised them to "go in the kitchen and roll somethin' up."

A caller once asked if he had any Led Zeppelin. "Naw brudder I didn't bring any dis time but ya know Led and me are real tight. I'll get some from him tomorrow." When a father dedicated "Please Release Me" by Jivin' Gene Bourgeois to his daughter Maria Orlando—incarcerated with the other "boys and girls in white" at the Correctional Institute—Huey let the dad complain that Maria had been railroaded: "She just didn't

know there was marijuana in that bag." Now, Mr. Meaux himself is in the hoosegow—perhaps entertaining his fellow inmates on prison airwaves. Quien sabe?

And today? You don't need me to tell you that, for the most part, rebels, nutters, and eccentrics aren't attracted to radio anymore. If you're listening to a local show helmed by a genuine personality, color yourself lucky.

Yeah! If some Motormouth Revolution could only bust through the omnipresent tight playlists and braindead formats with new crazoid wax and stratospheric blather, wouldn't we all, including Groover Boy (wherever he may be), dig that action?

Dick Blackburn wrote the screenplay for *Eating Raoul*, universally hailed as one of the most tasteless films ever released. His vocal stylings graced the *Planet of the Apes* cartoon show of the '70s. He swings in Hollywood.

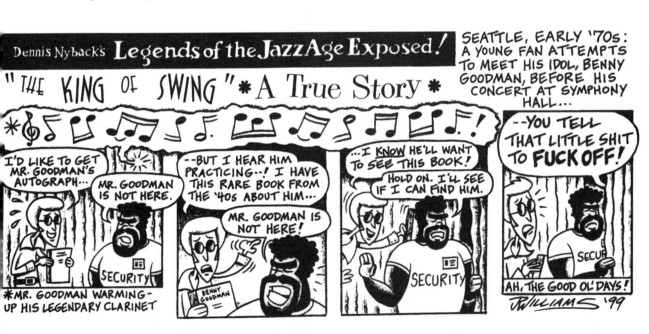

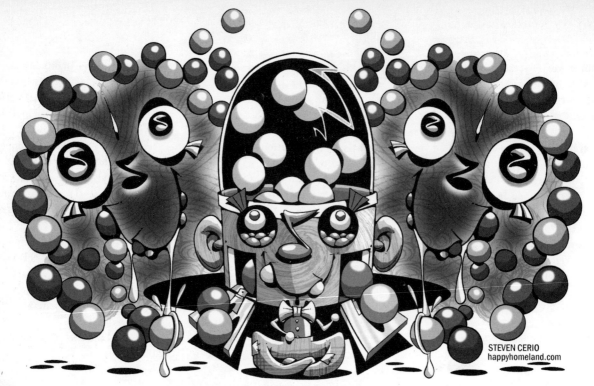

STEVEN CERIO
happyhomeland.com

# Chewing the Bubblegum with Joey Levine

## by Keith Bearden

If you've listened to the radio or watched TV semi-regularly over the past thirty years, you've surely heard the work of Joey Levine. He was one of the main songwriters behind the **Bubblegum Rock movement** of the late '60s, and his nasally, teen-sounding voice was perfect for rockin' hits by The Ohio Express ("Chewy, Chewy," "Yummy Yummy Yummy") and The Kasenetz-Katz Super Circus ("Quick Joey Small"). Fans of the Nuggets LP will know him as the leader of The Third Rail ("Run, Run, Run"), a more "adult" version of the studio musician "bands" that Joey staffed under Buddha Records producers Jerry Kasenetz and Jeff Katz. And who over the age of thirty doesn't remember being delighted/horrified by Reunion's "Life Is A Rock (But The Radio Rolled Me)"? Or getting the munchies listening to the immortal "Trust The Gorton's Fisherman" jingle for Gorton's Breaded Fish Sticks? Once again, the work of the busy Levine.

While the Bubblegum Rock movement has been critically lambasted for thirty years, its importance is undeniable. At a time in the '60s when Merseybeat and garage bands had broken up or turned hippie, pre-fab studio groups like The Monkees, The Archies, The 1910

Fruitgum Company ("Simon Says") and The Ohio Express created many beautifully crafted songs, carrying the torch of pure, simple pop/rock into the '70s, where it was picked up by bands like The Raspberries, The Shoes, and The Rubinoos, or in the UK got dressed up by The Sweet and other glam rockers. Later, punk bands like Funhouse, Slaughter & The Dogs and Joan Jett all paid a debt to their three-chord **Bubblegum** forebears by covering some of Levine's handiwork.

Getting involved in commercial jingles in the '70s, native New Yorker Levine still works in the field, and currently heads up three music companies, Crushing Music, Crushing Underground and Levine & Company.

**LCD:** What's your background as a musician?

**LEVINE:** My dad Elli Levine was a band leader in the Army and a jazz pianist under the name Elden Lewis, and my mother Marion Kingsley was a singer who had her own radio show in NYC when she was sixteen years old. My uncle Alan Stanton was a record producer at Columbia and A&M. I took piano and guitar, and did the whole teenage band

kind of things. My first band was Joey Vine & The Grapes; I was in The Pastels, playing country clubs and synagogues and sweet-sixteen parties...

**LCD:** How did you get involved with the whole NYC **Bubblegum Rock** scene?

**LEVINE:** I had been working in music publishing for a couple years over at TM Music, writing songs after school, where I met a songwriter named Artie Resnick, who had written "Under The Boardwalk." We really collaborated well, and were getting success off of some demos we were cutting. Jerry Kasenetz and Jeff Katz had heard a song I wrote called "Try It" that The Standells had, a kinda mini-hit underground thing that people were digging on, and then they recorded it with The Ohio Express after Beg Borrow & Steal. They called me and said, "We've been hearing your demos and this and that and we think you can write some of this teenybopper music," and then Artie and I wrote "Yummy Yummy Yummy."

**LCD:** How old were you when this was all happening?

**LEVINE:** Just about seventeen.

**LCD:** Wow. How was it working for Kasenetz/Katz? Was it a hit factory or did you have a lot of creative freedom?

**LEVINE:** Well, it was a factory in that there were a couple of different bands that we used—a lot of times it would be the same band—and we had a day to record and a day to do overdubs and mix. Also, when Jeff and Jerry thought a song was a hit and it didn't fly, they'd have other bands record it again, slightly different. They'd have The Ohio Express do it, then The Shadows of Knight, then The Fruitgum Company, on and on. So you'd work all week, and in-between you'd write more songs.

**LCD:** Were The Ohio Express and 1910 Fruitgum Company real bands? Did they tour?

**LEVINE:** They were all real bands, but I sang on a lot of their records. Neil Bogart [Buddha Records President and the man who later gave the world KISS and Donna Summer] heard my demo of "Yummy Yummy Yummy" and said, "Have this guy sing on the records."

**LCD:** That's why on The Ohio Express albums you have the hits with you singing and then the other tracks sound like bad Procol Harum rip-offs.

**LEVINE:** Yeah. When the bands would tour I'd stay in New York and these guys would schlep out around the country singing my songs, though they didn't sound like me.

**LCD:** What are your memories of those days?

**LEVINE:** It was great. I had Top 10 records, my voice was all over the radio, but nobody knew who I was unless I wanted them to. The best kind of fame. It got me into a lot more parties at school, for sure.

**LCD:** Studio songwriters produced some of the best pop songs of the '60s. Name some songs you and Artie Resnick wrote from back then.

**LEVINE:** Oh, God, so many. Besides all The Ohio Express stuff, we wrote some stuff for The 1910 Fruitgum Company, me and Bobbie Blum and Bo Gentry and Richie Cordell. "Gimme Gimme Good Lovin'," Tommy James stuff like "Mony Mony," "Montego Bay," lots of stuff. You lost track you worked so much, and a lot of times we

co-wrote and never gave each other credit. I also wrote stuff for Gene Pitney with Doc Pomus.

**LCD:** A lot of people interpret songs like "Yummy Yummy Yummy" and "Chewy, Chewy" as being slyly sexual. Was that your intent?

**LEVINE:** Absolutely. We were told to write these innocent songs, keep it young and poppy, but we were all in our late teens so we wanted to slide some double entendres past 'em if we could. Eating was our big thing.

**LCD:** The Ramones have mentioned numerous times that they started out wanting to sound like The Ohio Express. How does it feel to be a godfather of Punk?

**LEVINE:** [Buddha Records publicist/New York Dolls manager] Marty Thau was producing some punk bands back in the '70s, and he said, "You should produce this stuff—all these guys mention your records." To tell you the truth, even though in the '60s we were all in our own funky state, meeting these bands—I just couldn't deal. It was too weird for me.

**LCD:** Why do you think critics trash the whole Bubblegum scene?

**LEVINE:** Well, the music's a little trite. It was just played for fun, and it was a period of time that was very serious. People were looking for big, heavy themes—drugs, war, revolution—and it looked very thin under those criteria. Bubblegum to me was making fun of all that. Basically it was like, "We get the serious issues—so why not smile and dance and goof around?"

**LCD:** Tell me about The Third Rail.

**LEVINE:** The Third Rail I did before I was in The Ohio Express. I was sixteen or seventeen. It was me, Artie and Kris Resnick, some of the earliest songs we wrote that we recorded together just as songwriters. Very political, more all over the map musically. Teddy Cooper over at Epic heard the stuff we were recording and said, "Let's do an album." It just got re-released on CD in Britain.

**LCD:** The internet says you co-wrote stuff with Jim Carroll. Huh?

**LEVINE:** That's my friend Jim Carroll. Not the *Basketball Diaries* junkie poet guy.

**LCD:** OK. (sigh) Tell me about "Life is a Rock (But The Radio Rolled Me)"?

**LEVINE:** That song is imitated a lot I think, by people like REM, with "The End of The World" and Billy Joel with "We Didn't Start The Fire." Not directly, but a lot of songs are based on people's memory of our song. Some guy called me and said (affects dunderhead accent), "I think that's the first rap record!" And I said, "I don't know about that." And he said, "Well, before that you had country rap, and story raps, but just rhythmic rhyming of words flowing together, that was the first!" So I said, "Look, I'm the father of Bubblegum—don't make me the father of rap. Somebody will put me on a hit list."

**LCD:** You work exclusively in commercials now. Do you miss writing songs about love as opposed to tampons or fish sticks?

**LEVINE:** I have never written a song about tampons.

**LCD:** OK.

**LEVINE:** The jingle thing is just cleaner, more honest. You write the song, you record it, people hear it, less politics, less rip-offs, the pay is good. No muss, no fuss. I still write songs. I write songs for my wife or my kids, but now it's all fun. No headaches and ulcers wondering about having a hit or not.

**LCD:** What are some of your commercial songwriting credits?

**LEVINE:** "Sometimes You Feel Like a Nut" for Peter Paul/Mounds, (singing) "Oh, What A Feeling to Drive TOY-OTA!," "Can't Beat The Feeling" for Coca-Cola, "The Softer Side of Sears," Diet Coke, "Just For The Taste of It" . . .

**LCD:** God. People will carry those jingles with them to their graves. With your pop songs and TV, how does it feel to be so deep in the public consciousness?

**LEVINE:** Ah, I feel good about it. I feel lucky to be able to do what I do for so long.

**LCD:** Tell me something people might not guess about Joey Levine?

**LEVINE:** I always thought of myself as a soul singer.

# BALL PARK POP

#815 IN A SERIES ON BASEBALL AND MUSIC

BY TODD NORLANDER
ILLUSTRATED BY SAM HENDERSON

D.J. JASON WORE LARGE SUNGLASSES TO THE BLEACHERS...

THE CREATURES THERE ARE NOTABLY VOCAL ABOUT THE SLIGHTEST ECCENTRICITIES—

—BUT THIS NIGHT THEY WERE ODDLY DOCILE

UNTIL THE THIRD INNING...

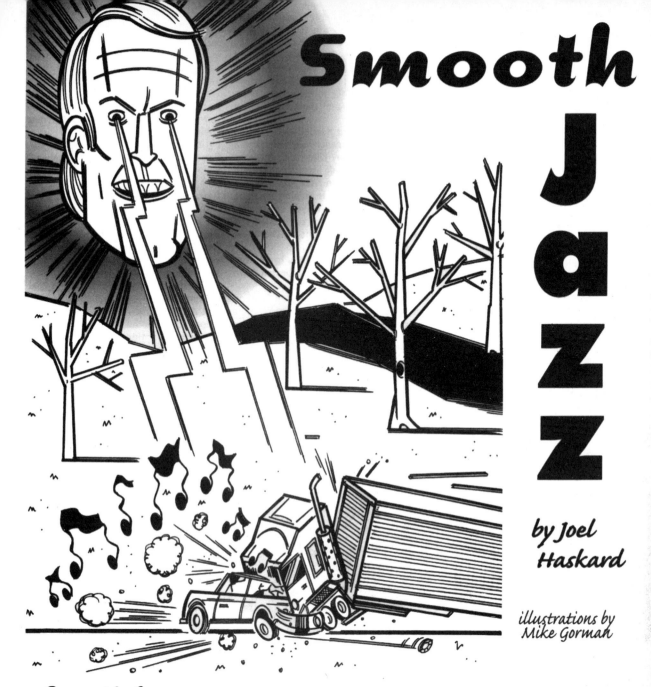

# Smooth JAZZ

by Joel Haskard

illustrations by Mike Gorman

## Smooth Jazz killed my brother Randy.

He was coming into the S-curves on I-5 just south of Seattle, listening to radio KYEZ, "Mellow Sounds Of The Spheres," when the music transported him into a trance-like state and he crashed into the side of an eighteen-wheeler bringing engine parts into Boeing.

I called Randy on his cell-phone moments before his death. We had planned to meet at the Kingdome for a Promise Keepers convention and he was late. Outside in the parking lot I could hear they had already started the sobbing and back slapping without us.

Our last worldly conversation went as follows:

**Randy:** Hello?

**Me:** Randy, it's me. You're late for Keepers, man!

**Randy:** I'm almost there. Hey, let me switch the phone to my other hand **while I turn down the smooth jazz... OH, SHIT!!**

I sued radio KYEZ. My case was basically that a lethal brew of whale calls and flaccid piano playing drove my brother to his death. I lost.

Smooth jazz killed my brother and KYEZ assassinated his character. All it took was their lawyers mentioning the Santana CD in Randy's car and the jury started muttering

and pinching fingers to their lips in the international sign for "tokin' on a fatty." I knew Randy would never have taken drugs before a Promise Keepers meeting, not even hallucinogenics, but never mind that. Soon the KYEZ lawyers were contending he was a classic rock listener. They started talking demographics: smooth jazz listeners were peaceful law-abiding citizens, but classic rock listeners, like my brother apparently, were middle-aged losers slumped on bean bags in their parents' basements, plotting half-assed crimes under the wan glow of a grow lamp. This was an alarmingly accurate portrayal of my brother, but completely circumstantial. The judge, who looked to be eating peanuts the whole trial, overruled every one of my objections, and merely snickered when a KYEZ lawyer mentioned Foghat and flapped his arms in a derisive way. Never once did one of those lawyers look me in the face or acknowledge my brother's tragic death. They seemed to think I was a crackpot.

When I stood up to make my closing statement, the courtroom grew dark and cold, like a great cloud full of snow had crept in to hear the verdict. I faced the jury and tried to make my voice sound like Gregory Peck-ish.

"Mellow Music Of The Spheres, ha! Most people worry about satanic lyrics by those long hairs that bite the heads off of bats and pee on their fans, but smooth jazz is far more insidious and harmful. Smooth jazz has an opiate effect that makes people imagine they are standing under tropical waterfalls or feeding cookies to deer. That's why people who work the cash registers in greeting card stores always look startled if you ask questions, but if you say 'Those deer sure like Fig Newtons,' they will say, 'Yes. Newtons,' in a glassy-eyed, Stepford Wives monotone.

"Mellow Music Of The Spheres, ha! More like banal tripe for people too meek for real jazz and too stupid for classical music. Smooth jazz is played in the elevators of giant corporations to keep the drones complacent. It is even the soundtrack of the porno industry! Around

the world swarthy men are watching moist crotches ricocheting all over the place to the warbles of an off-key tenor sax and the kerplunk of a drum machine.

"I believe The Lord handed us a pristine world, and we, like paper wasps, masticated it into a modern-day Babylon of concrete, tar, non-biodegradable plastics and smooth jazz. The radio station KYEZ, like the drug dealer on the corner, is keeping the good people of Seattle dull-eyed and slack-jawed. Please avenge my brother's death and stamp out this blight on The Great American Dream."

I was laughed out of court. You haven't felt low until your family honor is beaten down by a musical genre.

**It was then and there I decided to focus on one man.**

I used to respect John Tesh when he worked for Entertainment Tonight. He seemed like a decent guy, and I spent many an early evening watching him and Mary Hart chuckle over the zany criminal misadventures of former child actors. But then one day he quit all that. He quit so he could grow a goatee—or "chin vagina" as Randy used to call them—and tour the country playing smooth jazz piano.

I became the point man in the war against John Tesh. I began my duties as point man in the war against John Tesh by repeatedly calling his publicist down in Los Angeles and making fart noises, asking for "John Tush". Sophomoric sure, but it felt good to finally put a face on my anger, on my sorrow for Randy's misguided FM listening habits.

I tried soliciting funds for my crusade. Relatives and people at work were generally unsupportive, but I managed to drum up $3.47. Only my lesbian friends, Joyce and Darla, pitched in. We made posters and brainstormed slogans and t-shirts amongst the bruised fruit in the co-op where they worked. They were teeming with suggestions, and I felt renewed strength in the cause knowing that the lesbian movement supported me.

I picketed Tesh's palatial house on Lake Washington with signs reading, "A Whale Is Not An Instrument!" and "Hitler Liked Smooth Jazz." Although disappointed that the neighbors didn't rally behind these

placards, I persisted for five drizzle-filled days until informed that the house was empty. Clever Tesh was on tour.

So I waited, staking out his house.

You may wonder what kind of work I do that allows me this kind of free time. I'm a sales rep for a small company called Cheeses Loves Me. We sell semi-soft cheeses molded to resemble Christ crucified on the cross. Most of our clients are churches and religious stores in the Puget Sound area; they agree the Jesus cheeses add spirituality to a typical chip and dip tray and give the communion wafer a little extra pizzazz. Monterey Jack and Port du Salut sell well because their yellowish hues give Jesus a nice tan, but the Roquefort is a little too blue and stinky for most people's taste. Marketing has suggested Lazarus as a possible Roquefort alternative.

I do most of my cold calling on Sundays. The church secretaries, docile creatures with seemingly no decision making power, put me on hold while they scurry off to find an authority figure. I don't need to tell you what insipid music oozes out of the earpiece.

When Tesh returned, pulling into his driveway one overcast Tuesday afternoon in a sleek white all-terrain vehicle, I was ready. I watched as he and his wife, Connie Selecca, went inside. After several hours they reappeared. I followed as they drove back across the 520 bridge into downtown to The Genial Asparagus, a vegetarian restaurant they obviously intended to dine at. It was getting dark, and the rain

shone on First Street like a black snake that squeezes the world in its soul crushing coils, a cruel and banal beast that slithers through our everyday life with such cunning we are unaware of its middling and mediocre clutches until our eyes glaze over and our feet start twitching with little rhythmic taps… The taps of smooth jazz death!!!

I followed them inside, pausing in the foyer while the Teshes took a table in the back. From my vantage

point behind a hanging fern I could see the whole dim, candle-lit restaurant. The stucco walls were covered with macramé and plants; the clientele all snotty types trying to acquire bohemian airs by eating tofu and wearing North Face windbreakers. They were all gibbering gaily with seaweed and barley stuck in their teeth.

The Teshes signed a couple of autographs and then concentrated on their menus. A cold feeling of destiny pounded through my body. I reached into my duffel bag and prepared for the final confrontation.

I had dressed a blow-up sex toy in my brother's clothes, complete with Mariners baseball cap, tennis shoes and gloves. Then I had glued a picture of his face to a William Shatner Halloween mask, which I strapped onto the doll's plastic,

lamprey-like head. Although the arms and legs flapped at the ends, the posture and overall appearance was pure Randy.

Under the shirt of this effigy I had taped a cassette recorder. I pressed the play button and the poignant strains of "He Ain't Heavy, He's My Brother" by The Hollies wafted out.

I broke past the startled maitre d' and, holding the homage above my head, ran toward my nemesis. People screamed, Graham Nash sang, and Randy flew like some avenging angel out of The Old Testament!

Then the unexpected happened… John Tesh kicked my ass. He's a big man, and I hadn't even started to recite my Smooth Jazz Manifesto when he lunged forward and started to punch me about the face and neck. I went down hard, with Connie Selecca and some of the wait staff kicking me in the genitals and John Tesh yelling, "You want a piece of The Tesh?" or something like that while performing vicious flying elbow drops on my neck.

I barely made it out of The Genial Asparagus with my life. I jumped in my car and floored it. Randy was losing air fast and flying all over the place and I was bleeding and calling my lesbian friends Joyce and Darla from my cell phone when I jumped the curb, hit a telephone pole, and crashed into this Starbucks Coffee shop.

And then you found me, officer. Now you are looking at a man who has failed in all his best efforts, who battled evil and lost, whose belief system has foundered and collapsed in front of his very eyes.

**So. What kind of music do you listen to?**

**When you watch a particularly wretched film or TV show,** you probably wonder: who spent money on this piece of crap? Couldn't they tell the idea sucked when they heard it?

Well, sometimes they can, and sometimes they can't.

Occasionally, I'm in the room when these bad ideas are born. These meetings are called pitches. Today, we're going to talk about two of the worst pitches of my career. Students of bad comedy may want to sit up front.

### WORST PITCH EVER— RUNNER UP

In the mid-'80s, I was a staff writer at *Saturday Night Live*. On Tuesday nights the producers would shepherd the guest host from office to office to hear possible sketch ideas.

One week the host was Danny DeVito. He came into my office with his wife, Rhea Perlman. We chatted for a while. I made everyone laugh and feel at ease, which is easy for me because I'm so damn funny.

Thus I began my pitch. I was pretty confident. I had a killer, can't-miss idea. As I spoke, I bounced a tennis ball off the wall. I used to bounce tennis balls all the time because I thought it looked cool. Bounce. Bounce. Bounce.

My idea was about tetherball. It'd be funny to see DeVito play tetherball because the game is all about height—the tallest guy always wins. The joke of the sketch was that DeVito was the world tetherball champ because he makes his opponents feel guilty. They're too embarrassed to try. He always wins because he's so damn short! HA! HA! HA! HA!

Those ha-ha-ha's were me laughing. Nobody else laughed. After I finished there was a long, tense, em-barrassed pause. Mr. DeVito averted his eyes. He was obviously hurt. All he said was, "I'd rather not do any height jokes."

I was crushed. While I was thinking about how to apologize, I nervously bounced the tennis ball again. This time it took a bad bounce and careened off the wall and THWACK! Hit Rhea Pearlman squarely in the face! She fell backward, holding her nose, eyes tearing.

Danny DeVito, who I had just insulted, and his wife, who I had just whacked in the nose, hobbled out of my office. He's now a big producer in Hollywood. Funny—he's never called me.

# Wild Pitches
### our own Hollywood insider, Andy "Mr. Showbiz" Breckman

### WORST PITCH EVER— THE GRAND PRIZE WINNER

I guess everyone remembers where they were when they realized Joe Piscopo was nuts. Here's where I was: IN THE MIDDLE OF A PITCH FOR UNIVERSAL STUDIOS!!

For a brief shining moment in the '80s, Joe Piscopo was hot shit. He was Eddie Murphy's pal. Together, they had saved *Saturday Night Live*. So I was flattered when Piscopo called and asked me to write a movie with him. I would ride his shirttails into the heart of Hollywood.

Together, we worked out a story. It was something about Piscopo being chased by the mob and having to adopt different disguises. It was basically an excuse for Joe to do a dozen of his "lovable" characters.

We pitched the story to Universal. All the big studio execs were there. They really wanted to do a movie with Piscopo—so far so good. We took turns telling different parts. Joe did a few of his characters. Everyone listened politely.

A few chuckles. When it was over, Sean Daniel (then head of production) said something like, "Thanks, but we don't think it's for us. Do you have anything else?"

We didn't. But before I could say anything, Piscopo said, "Yes! Andy and I do have another idea! We've been working on it all year! We're very excited about it." He turned to me and said, "Do you want to tell them, or should I?"

I was stunned. What the hell was he talking about? I managed to mumble, "Uh... why don't you tell it, Joe?"

So Piscopo pitched "our" other idea. It wasn't really a pitch. It was more like a therapy session. He'd always been obsessed with Frank Sinatra. "Our" pitch was really his own twisted Sinatra fantasy. He wanted to do a sequel to *Ocean's 11*. We'll reunite the Rat Pack: Frank, Dino, Sammy, Peter, Joey, Shirley. We'd bring 'em all back from retirement. Even though they're all in their mid-70s and hadn't made a movie in 100 years, the old magic would still be there! But this time, there'll be a new member of the Pack—Joe Piscopo! The plot will be about how Sinatra takes him under his wing and they all learn to love and respect him and let him join the gang. He had a few Sinatra/Piscopo bonding scenes worked out. The New Improved Rat Pack would return to Vegas and rob another casino. It'd be like the old days, but better because our man Joe would add some '80s style hipness to the group!

Total silence. Everyone listened, stunned. I was more stunned than anyone. It was as close to an insane rant as I've ever heard.

As we left, I could tell these important, powerful, well-connected executives couldn't wait to crack up and tell everyone they knew or would ever meet about this Pitch From Neptune they just heard. And how—as far as I was concerned—it was half mine.

Two bad pitches with the same lesson: try, if at all possible, not to be me.

# Tell the Truth
## until they bleed

## BY JOSH ALAN FRIEDMAN

The author of *Tales of Times Square* recounts his ten-year friendship with Doc Pomus, the songwriter who gave the world "Lonely Avenue," "Little Sister," "A Teenager In Love," and "Save the Last Dance for Me."

For me, Doc Pomus's loss to New York City was worse than losing the Statue of Liberty. His Buddha-like presence, holding court in music saloons, would now blend into Big Apple legend, where the past seemed greater with each passing year. "At least now, they can't say I died young," he cracked, at his 60th birthday. He was 65 when he passed away in 1991.

Doc Pomus was no Damon Runyon character; he was a leading man, a great stabilizing figure of integrity in a music industry that had come to resemble a corporate cesspool.

I met him after he emerged from a sorrowful decade of retirement to collaborate with Dr. John in 1977. He retained his songwriting brilliance—so much wisdom disguised in simple street language—decades after his peers let theirs dissolve.

Shortly after Elvis died, I wrote the first of four articles on Doc, commemorating his comeback in a *Soho News* piece. In the curious way Americans honor their heroes after death, Elvis royalties intensified like a rejuvenated oil well. But Doc Pomus, who wrote twenty five songs for Elvis, never met his foremost interpreter. They'd only conferred a few minutes by phone, Elvis calling for late-night instructions during an early '60s recording session; Doc didn't even know who he was talking to.

Doc came within inches of meeting Presley at a 1974 Hilton Hotel press conference. But the hard-assed Colonel Parker, whom Doc knew well in the old days, wouldn't let Pomus through. Doc introduced himself to Vernon, who said his son would love to meet him, but Elvis had just left the hotel. Doc was heartbroken. Three years later, Doc and Elvis made solid arrangements to meet. But Presley died a week before the meeting, leaving Doc totally spooked.

Nevertheless, when I met Doc in 1977, he'd just co-produced the debut LP for Roomful of Blues, the first white boys to revive Kansas City swing. He'd also produced the very first (henceforth unreleased) Fabulous Thunderbirds album, plucking them out of Austin when they were woolly local upstarts. (The T-Birds single-handedly ended the era of white blues bands looking and playing like hippies).

He'd written the title song for some Elvis revival show on Broadway. But his vast track record—Doc had written nearly two thousand songs, sixty of them charting—intimidated potential collaborators. Even friends were often dumbstruck ("You wrote that?"). Other than Cher, to her credit, nobody recorded any of his recent material. He was hungry to write new songs, and that was the thrust of my article.

I did a hundred celeb interviews afterward, but only Doc Pomus gave me a warm post-publication call. I fell into the inner sanctum of his West 72nd Street apartment, the all-night

Doc with Big Joe Turner and Roomful of Blues.

rock and roll whirl. Doc presided bolt-uptight in his king-size invalid's bed. He was surrounded by piles of blues records shipped in from Chicago, promotional cassettes, music biz correspondence. A cable-TV channel switcher and phone operated over a swing table. He would put me at ease with his stories, fielding phone calls with child-like disbelief at the outside world. Some cracker trash country singer called at 3 am wondering if Doc knew how to lure his cat down from the roof. "Can you believe this shit?" Doc would mutter, hanging up. There were more fakers and poseurs in the music biz than anywhere, and Doc was blessed with knowing all the assholes. "Everybody's a genius," he would say, mocking the instant accolades accorded

some schlock producer who that week scored a hit.

Johnny, the current driver of Doc's bus, was Fats Domino's former road manager, who cut his teeth collecting Domino's nightly box office receipts. When Johnny went home, Doc would buzz in guests through the electronic lock on his eleventh floor door. Here I met such after-midnight visitors as Otis Blackwell, the Brooklyn pants presser who invented the rockabilly pop record ("All Shook Up" and "Don't Be Cruel"). Doc once sang in all the blues joints of Brooklyn with Otis for $8 a night. When in town, Big Joe Turner would drop in, feeble with a cane, yet still able to shout blues all night long, and every song in the key of C. So integral was Big Joe's fifty-year role in R&B evolution, Doc believed, that rock and roll would never have happened had not Turner existed. Doc was often on the phone to the committably insane Phil Spector, who gave no other man but Doc full respect.

A happenstance visit by Ronnie Spector to Doc's apartment resulted in a breakneck romance that sucked every minute of my life for four months. Then one night, Ronnie, in a hurricane of alcoholic fury after her Roy Radin Vaudeville Tour, threw me out of her apartment along with the maid—who I learned was her mother. Ronnie was Godzilla disguised as Gidget. Doc helped me regain my sanity in the year it took to recover.

Dr. John—AKA Mac Rebennack—became Doc's new collaborator. A small songwriting keyboard was always present in Doc's living room. Their first songs were lyrical beauties that triggered the renaissance in Doc's career: "Dance The Night Away With You," "He's A Hero," and the title track for City

Lights, a 1978 landmark album for Dr. John.

> Too many city lights
> Too many midnights on the
>    wrong side of life
> Too many honky-tonk-never-
>    happen women
> Gave me no time to find
> A good wife of my own

Pomus could turn the spin on a clichéd phrase and deliver it as a knockout punch, such as the gospel masterpiece "One More Time," recorded by B. B. King and Joe Cocker. The two doctors (Doc and Dr. John) wrote concept albums, with songs that rolled like honey off the tongues of B.B. King ("There Must Be A Better World Somewhere"), Jimmy Witherspoon ("Midnight Lady Called The Blues"), Jose Feliciano, Ray Charles, Irma Thomas, Johnny Adams.

During songwriting sessions, Mac would retire to the bathroom for a half hour. Each time, Doc sweated out whether he'd emerge alive or have to be carted out by ambulance. Mac later credited Doc for inspiring him to give up an old habit.

According to Mac, one of the five purest traditional blues motifs was single-handedly created by Doc in the song "Lonely Avenue," recorded by Ray Charles in 1956.

"Mac always said that was the 'junker blues'—junker being the old term for junkie," explained Doc. "It's a certain kind of monotonous, sad, melodic, and lyrical line that, because of the continuity involved, for some reason has always attracted junkies. Da-dum, da-dum, da-dum—I imagine they're shuffling along to it or something. All the junkies, Mac told me, thought I was a junkie. They said somebody who wasn't could never have written 'Lonely Avenue.' Mac couldn't believe how straight I was."

Broadly recorded and imitated (hear Iron Butterfly's "Butterfly Bleu"), the song definitely became a prototype blues. During a seren-

dipitous night going through Doc's forgotten closet, I found the original reel-to-reel. I also found crumbling tapes of Doc live at the Musicale in Manhattan, with Mickey Baker and King Curtis, circa 1954. These I transferred on my Teac to fresh tape.

In a master songwriting class he gave from his apartment, I sat as an observer. A lot of Doc's philosophy was black and white: "I look at music one way. It's either soulful…or not. If it's internal it's great, if it's exter-

Doc in the '70s.

nal it's not great. I can tell where a songwriter has sat with a line for two weeks. To me, any artist who sits there analyzing the lines should be a mathematician instead."

Each of the twenty songwriters would have their weekly assignment—a love song or a novelty song—critiqued by the class. Then Doc would point out the weaknesses and strong points. Guests like Dr. John, Otis Blackwell, Tom Waits, and Marshall Crenshaw added their two cents. Doc explained to the class why they shouldn't think in a shallow hit-song mentality. How he derived more satisfaction from a soulful rendition of an original song on a Jimmy Witherspoon record that sold ten thousand copies than a hit he wrote for, say, Andy Williams (who refused to sing Doc's "Can't Get Used To Losing You" on his TV show until it

reached Number 1). How they should immerse themselves in a regional genre of music, say New Orleans, before attempting to write honestly in that form—not just do a cynical quick study. How to listen to a singer's entire output before tailoring a song specifically for him, learning what he can sing.

In the '50s, the managers of an untalented heartthrob named Fabian approached Doc and his partner, Mort Shuman. "They gave us an assignment to write songs for someone who couldn't carry a tune. That's very difficult to do."

Doc was told Fabian caused pandemonium among the teenyboppers, but he hadn't cut a successful record. Fabian's first two hits, "Turn Me Loose" and "I'm a Man," originally written for Elvis, were watered down melodically and lyrically for the limited chops of Fabian. "I was proud of the fact that I was able to get a guy like that off the ground," Doc said.

The career of Jerome Felder—AKA Doc Pomus—might be divided into three periods. The first was as a blues singer. In 1944, at age nineteen, his debut 78 rpm record was released on the Apollo label. A middle-class Jewish kid from Brooklyn, he changed his name to "Doc" so his dad, a ghetto lawyer, and his mom, a proper English woman, wouldn't know he was headlining at Negro joints. He handpicked rookie musicians King Curtis and Mickey Baker for his live backup band. Curtis became the seminal rock and roll sax player of all time, and Baker the most prolific studio guitarist of the entire 1950s. On record, Doc was backed by sidemen from the Basie, Ellington, and Louis Armstrong bands. He recorded some thirty sides for Apollo, Chess, and Savoy. As a sideline, he wrote terrific material for all the early Atlantic Records artists: LaVern Baker, Gatemouth Moore, and his idol, Big Joe Turner.

In this era, Doc Pomus was likely the only white blues singer in

America. He always had a record out, and in those days a blues single that sold twenty thousand copies was a huge hit. But unlike his dark-skinned contemporaries, he couldn't work the South, where a white man was forbidden on the chitlin circuit. In what he once referred to as Crow Jim-ism, he was restricted to the colored joints of the Northeast, mainly a dozen establishments in Brooklyn, Harlem, and Jersey. Until he was thirty-two he never earned more than two grand a year, lived in fleabag hotels, and feared he'd wind up on the streets.

Somewhere around the time of his last and greatest single, "Heartlessly," he had an alleged affair with actress Veronica Lake. Alan Freed broke the song into heavy rotation on New York airwaves in 1955. This was a strong indicator it was destined to chart. As was common practice when a small label release made this impact, a major label—in this case RCA— bought the master. And then for reasons forever unknown, RCA killed the record, never released it. (Perhaps because Doc was on crutches, unmarketable as a matinee idol?) The experience so soured him he quit singing forever. Surely had Elvis released the rockin' ballad "Heartlessly" identical to Doc's single, it would be a standard today. (Send for the Doctor, a collection of sixteen Doc Pomus singles, was released on the Whiskey, Women, and...label in 1984.)

Doc's songs helped sculpt the dawn of rock and roll, a movement he never figured would last more than a year or two.

"Man, I been in a room with so many hits. If you wrote half a song and needed an ending, anybody who was around would come in and help, and you would do the same for them. Whenever a record was produced, we'd all be there in the rehearsals.

And now it's all Big Secret business. When I talk with contemporary artists, they're more involved with the mechanics of business than they are with the craft."

In the mid-'50s, he groomed a teenage pianist with great chops, Mort Shuman, into gradually becoming his partner. Doc had handed a rough song to Leiber and Stoller, who were producing Coasters records. They asked his permission to change it around, giving him a third interest, which Doc thought was fair. Returning from his honeymoon in early 1957, he and his wife stopped at a diner, a few dollars left to their name. Doc noticed a new song, "Youngblood" by The Coasters, on

*Painting the town red at the Lone Star Cafe, 1983; L–R: Josh's wife Peggy, Doc, singer Donna Marteri, Josh*

the jukebox and threw in his nickel. It was the same song he'd given Leiber and Stoller, entirely reworked. A delighted Doc phoned Atlantic Records, which wired him a $1,500 advance on the single, congratulating him on his first national hit.

From a penthouse cubbyhole in the Brill Building, Doc Pomus and Mort Shuman set out to reap teen coin, crafting hundreds of bluesy pop gems. They wrote twenty five songs for Elvis ("Little Sister," "His Latest Flame," "Whole Mess of Blues," "Suspicion"), hits for The Drifters ("Save The Last Dance For Me," "This Magic Moment"), Dion & The Belmonts ("A Teenager In Love"), Bobby Darin ("Plain Jane"). Twelve

songs a week they wrote, overpowering the odds of reaching the charts by sheer abundance. Doc wrote eighty percent of the lyrics, twenty percent of the melody.

"In the '50s, the kind of songs I wrote were associated with sleaze and juvenile delinquency," he told me. "I was married to an actress (Willi Burke) at the time and she was embarrassed by it all 'cause all her friends were theater people."

With Shuman as partner, Doc's yearly income shot up to fifty grand.

"I had a house, a swimming pool, all that shit, and we had nothing but these Broadway characters hanging around. None of them paid any attention to me and if they asked what kind of songs I wrote I felt embarrassed. If I had written a fifth-rate Broadway song, my God, they would have been proud."

Now, consider the context in which "Last Dance" was written. Here's Doc, married to this gorgeous blonde Broadway actress, and all her Broadway cronies are contemptuous of rock and roll. A childhood victim of polio, Doc was on crutches, never able to walk. One night he was at a dance with his wife, waiting for her to finish dancing with a bevy of partners, patient and cool on the sidelines. Though he never said so, it likely provided the inspiration for these lines:

> Don't forget who's taking
>   you home
> And in whose arms you're
>   gonna be
> So, darling, save the last dance
>   for me

This much covered Drifters hit, with the Cubano-Ricano rhythms of the early '60s, has passed the lips of several generations—none hip to the hidden meaning.

After 1965, one of pop's great songwriting teams disbanded when Mort jumped ship. By sheer coincidence, Doc's wife walked out

the same week. In crutches since polio took use of his legs during early childhood, a fall down a flight of stairs put him in a wheelchair, where he would thereafter remain.

Throughout the Beatles and Woodstock years, Doc Pomus stopped writing songs. He became a gambler, part of a sad Broadway underworld where high-stakes card games sometimes ended in robberies or kidnappings. He had no respect for his past work; his songs meant nothing to him. There were no rock critics back then, no awards or artistic recognition beyond his immediate comrades. Only once, during a 1960 trip to Europe where "A Teenager In Love" held three positions in the British Top 10, were he and Morty baffled to find newspaper reporters and cognoscenti interested in their songs.

And so by 1975, when he gave up gambling, Doc resurfaced to find a different world opinion. His songs had lasted, were in fact frequently rerecorded. The pop music he once saw as a passing trend for fifteen-year-olds had contained so many simple truths that it prevailed. "And what could be more valid than the truth," he realized. "Thank God I learned to appreciate what I had written."

I worked at Regent Sound Studios, a job I landed fresh out of high school, where former Atlantic Records producer Joel Dorn kept his offices. There on the wall was a huge blow-up poster of a proud Dorn, arm around this imposing, bearded figure in a wheelchair, with Stetson hat and fat turquoise rings. At the time of the photo, Doc had discovered and coached a young Bette Midler. He introduced her to Dorn, who produced her first album. And Dorn encouraged Doc to resume writing. Thus began the third stage of Doc's career, in partnership with Dr. John.

Doc arranged the hippest gigs in New York for the Lone Star Cafe,

corralling the likes of Van "Piano Man" Walls, the premier session pianist of the 1950s. Walls never appeared without his trademark Sherlock Holmes cape, deerstalker cap, and Calabash pipe, and often had Big Maybelle on his arm. After Walls played on Doc's Boogie Woogie Country Girl, a Big Joe Turner record, he left the country. Decades later, Doc found him in Montreal, and summoned him to the Lone Star Cafe. The Lone Star provided Doc a mere

BIG JOE TURNER
*"BOSS OF THE BLUES"*
AVAILABLE FOR:
CLUBS · CONCERTS · PARTIES · TELEVISION · RADIO
JOE & PAT TURNER
(213) 751-6500

Jerome Doc Pomus
580-7784

Apt. 1107   253 West 72nd St.   New York, NY 10023

reserved table in exchange for all the legends only he could summon to their stage. Never a free bar tab.

Painting the town red, Doc wore the snazziest alligator shoes imaginable, which he purchased in the '50s at Leighton's on Broadway, where all the blues singers, gamblers and pimps then shopped. The shoes lasted thirty years, simply because he never walked in them. Doc's bus, affectionately known as the Docmobile, had a custom pneumatic elevator lift for his wheelchair. Like a musical Ironside, he conducted business on the road from a lock-in desk by his wheelchair, and escaped to music clubs several nights each week. Bands Doc brought to the Lone Star often divided up their cash in the bus at 4 am.

But Doc was plagued by a chronic succession of chauffeurs who would disappear under bizarre circumstances. "I could write a book about drivers," he constantly complained, having to interview replacements while stuck for weeks in his apartment. The sheer logistics of getting around Manhattan, deciding which invitations to honor, lest they leave him stranded without wheelchair access, was overwhelming. These lifelong dilemmas he never once weighed upon his friends.

Doc's driver was a full-time on-call employee, required to transport Doc to his stomping grounds, clubs whose entrances could accommodate a wheelchair. Drivers were to check back periodically, but inevitably left him trapped amid torturous rock bands at Kenny's Castaways. The moment the driver arrived, he vanished backward like a ghost. This image, which I witnessed a hundred times, was a metaphor for bad music.

Most drivers, after a few weeks of good service, felt they were entitled to a songwriting partnership, or to be sponsored in some crazed business venture. Once Doc hooked up with an impeccable, well-mannered gentleman in his forties, who drove perfectly and kept his mouth shut. Sure enough, after several sterling months, the cops came by. Turned out he was a wanted pederast, a high-ranking member of NAMBLA, who suddenly ran off to Belgium to resume a relationship with a thirteen-year-old boy. Inevitably, this type of news hit Doc when the bus was double parked, the driver making a run for it and stranding him in a crowded club with a loud, poodle-faced, cucumber-pants band.

Perhaps the worst night of musical torture for both of us was the night we caught Bruce Springsteen at his Palladium debut. Passes were arranged by Karen McAvoy, a friend I

introduced to Doc who became one of his "downhill women." Karen periodically conned Doc out of a few bucks, stood him up, or hoisted her skirt over her head in public. He swore her off a dozen times. But she warmed her way back into his life by cooking up a remarkable home-made meal.

The former girlfriend of Springsteen/Conan drummer Max Weinberg, she arranged passage for us to witness the Springsteen phenom. Karen was an hour late with the tickets. When we arrived at The Palladium there was great confusion, Doc having to be wheeled through a maze of roped-off passageways. The night grew worse as the driver abandoned us for three hours of the most tedious mediocrity I'd ever heard. "Man, this stinks," Doc said. I never saw him so pained to leave a show, as Springsteen, a great crowd-pleaser, kept pouring it on. Bruce dedicated a song to Doc, but only Weinberg emerged afterward to shake his hand.

Doc was the only guy I enjoyed club-hopping with, and some of my fondest evenings were spent as a foursome, with Ronnie Spector and Karen, in 1978. From rock and roll revivals, where I'd have to defend Ronnie's questionable honor amongst horny, balding, doo-wop singers, onto the Bottom Line and the Lone Star. We'd fuel up on hot dogs from Nathan's, or stop the Docmobile at Barking Fish, a short-lived Cajun take-out phenomenon insanely locat-ed at the corner of 42nd and 8th. Doc said they served the most authentic cornbread in New York City.

By sunrise, we'd all pass out back at his apartment. I'd seen plenty of hot girls strewn across his bed in the wee hours, in various states of consciousness. But what Doc could do at this stage remained a mystery.

The yearly Doc Pomus birthday parties were attended by a few hundred guests who spilled out the hallway of his one-bedroom apartment. There were vats of Popeye's fried chicken and dirty rice. John Belushi often provided a crate of champagne, on ice in the bathtub. Otis Blackwell came alive by 2 am, reenacting his original demos for Elvis as he loosened the white hand-kerchief around his sweaty neck. The unsung Blackwell (who also wrote "Fever" and "Great Balls of Fire") was one of a handful of people in rock history on whom Doc bestowed the title of genius.

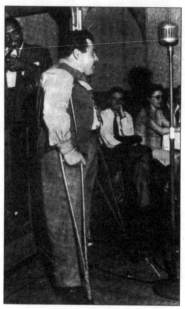
Rare photo of Doc performing during his day as a blues shouter.

Big Joe Turner, a huge squat frog in a chair beside Doc all night, abruptly woke up by 4 am, cried out, "How come the dog don't bark every time he come to our door?" then collapsed back asleep. Nobody paid poor Tiny Grimes any mind, as he quietly played four-string tenor guitar in the corner all night. (An Atlantic Records star of the late '40s, Grimes was a founder of the Art Tatum Trio, and recorded with Charlie Parker on Savoy.)

"Tell the truth until they bleed!" cackled Jerry Leiber, in call-and-response, as Doc lashed out at the memory of some thieving record company president they once knew. The older blues legends had a mystical connection with Doc Pomus, and spoke guardedly to the white rock critics. Doc would tap his coffee cup, flattered as celebs paid their respects, or whispered in his ear.

I sat at Doc's table when Mort Shuman returned after a twenty-year split to collaborate again. Shuman conceived and appeared in the '60s musical hit Jacques Brel, then became a French pop star. Dolly Parton had just recharted their song "Save The Last Dance For Me," and offered some prospective assignments, along with Julio Iglesias.

Shuman turned out to be a large, barrel-chested neo-Frenchman, who seemed to eat the furniture around him. Doc was well over three hundred pounds in his Stetson hat, so together Pomus and Shuman appeared larger than life. Their chemistry electrified the Lone Star, where Charlie Thomas and the Drifters kept an onstage patter going toward them. Mort heckled like a banshee, belting out bold new harmonies to "Hushabye," "I Count The Tears," and other Drifters songs he'd co-written. Doc rolled his eyes, ever the straight man, but seemed humbled by this lusty animal, Mort Shuman, who had been his partner in so much glory. The reunion was brief, however, Doc strangely hurt once again, and Shu-man returned to France. (Doc and Mort's life always crossed in mystical ways. Mere months after Doc died, the much younger Shuman came down with a liver disease and died in France.)

Doc taught me how blues was tongue-in-cheek, often self-mocking, all that self-pity not meant in earnest. There were happy blues and sad blues. But the two classic distinctions were between urban and delta blues. The urban had more to do with jazz, swing and big bands. City and ghetto life. Whereas the delta blues was folksy, using bottleneck guitars, cigar box instruments. "Guys mumbling," as Doc saw it, "ya never knew what the hell they were talkin' about.

The Chicago people were crossover guys, like Muddy Waters, who I eventually liked."

"You know what's amazing?" he continued. "When I made my 78 rpm records, we used to laugh at all the singers like Muddy Waters. When the rock stars started using them as opening acts, all of a sudden these guys became well known. My group of people—Joe Turner, King Curtis, Mickey Baker—used to laugh at all the country-blues singers who were backwards musically. John Lee Hooker and Lightnin' Hopkins sang out of meter—we couldn't respect them."

Naturally, the off-meter and slurred-word syndrome became copied and immortalized in the annals of rock. "Most of the black guys that sing with a rasp have a voice that's been misused from early life, from drinking and smoking since they were nine. My contention is that it comes from misusing the voice, not knowing anything about proper vocal techniques. So you get a white guy who has no reason for this—his speaking voice is clear—and he suddenly affects a rasp," he said, referring to the hippie blues bands of the '60s and '70s. "They must practice all day in college. There are black guys with very nice speaking voices, like B. B. King, who don't sing with a rasp. Joe Turner's singing the blues for fifty years; he don't have a raspy voice. He could have been an opera singer."

When Big Joe Turner died in 1985, his widow, Pat, bestowed upon Doc a shopping bag. It contained Big Joe's personal effects. The bag was spooky and Doc was unsure what the hell to do with it. He summoned me over to go through the contents which resembled the last worldly belongings of a blues Mahatma Gandhi.

I felt like I was invading a dead man's privacy. Without hesitation, Doc dumped across his bed the items of his childhood idol, the hero of Chuck Berry, Bill Haley, Ray Charles. There were assorted voodoo charms and a mojo stick.

A campy gold cigarette lighter, tacky rings, watch, a gold phone directory with no numbers. (Turner was illiterate. He memorized in quick study the songs Doc wrote for him, and never forgot a lyric). A pair of shoes, and Big Joe's wallet, for Christsake.

"Just what you'd expect a great blues singer to leave," said Doc. Within the wallet were five business cards that read: Big Joe Turner "Boss of the Blues."

I took one.

When things went bad for Turner, he'd abandon a wife, house, Cadillac, with no forwarding address, saying, "I left all those troubles behind." Doc wrote the first new song Turner recorded in twenty years, "Blues Train." He brought Turner to New York from L.A. to do a last album, backed by Roomful of Blues, and play a long engagement at Tramps. Having left copyrights under previous wives' names, Doc discovered ten years of Turner's royalty checks disappeared. Two of Turner's songs, including "Flip, Flop and Fly," were on the two-million selling Blues Brothers album. Untangling the mess, Doc stopped a $26,000 check sent out that week to an old ex-wife, Lou Willie Turner, who'd been quietly collecting checks in Florida. The check was rerouted to a startled Joe Turner, who'd never even heard of The Blues Brothers. Thus began Doc's philanthropic work with The Rhythm & Blues Foundation in Washington, aiding impoverished R&B pioneers.

The highest moments of our friendship occurred, I believe, at the mutual recognition of how much thievery, self-deception, destructiveness, and/or pomposity existed amongst the people in charge. Prominent music industry no-talents, poseurs. The lies and misinformation printed in *Rolling Stone*. "High priests of nothing," to use a phrase from one of Doc's songs. They were all part of Doc's nighttime gallery.

He collaborated with DeVille, who affected a cotton-picker's doo-rag look. Privately, he was dumbstruck that DeVille could sit for hours strumming a guitar aimlessly without an idea in his head. (Their collaboration did yield several acclaimed albums.)

Neil Sedaka, whom Doc fixed up with his first publisher in the '50s, met with Doc in the '80s for a potential collaboration. Sedaka went off into a greatest hits serenade, so lost in his piano lullabies that Doc's driver removed him, backwards, without Sedaka knowing. Dylan showed up once, anxious to collaborate, then never called again. The bullshit seemed to get to him more as time marched on. I was amazed how a guy's songs could generate a billion dollars, yet leave him less than wealthy.

I'd already moved to Texas when Doc Pomus passed away in 1991, and couldn't make the funeral. His last days of lung cancer were painless, his daughter Sharyn assured me. Big Joe Turner records played quietly in the hospital room. Doc's standing-room-only farewell at Riverside Chapel was said to be the most astonishing, touching music funeral New York ever saw. Record deals were scored by forgotten blues greats, who brought the audience to tears. Doc's own songs rang out, gospel-style, as the audience stood and cheered. This was exactly the kind of cruel irony Doc strove to prevent for so many of his peers. He knew their funerals would be sold out—it was while they were alive that he worked so hard to fill the seats, get them some cash—if only enough for a new set of dentures for some old sax player, or stage threads for a golden-voiced singer who couldn't make the rent. But mostly, to allow them the hard-earned dignity to keep playing their song.

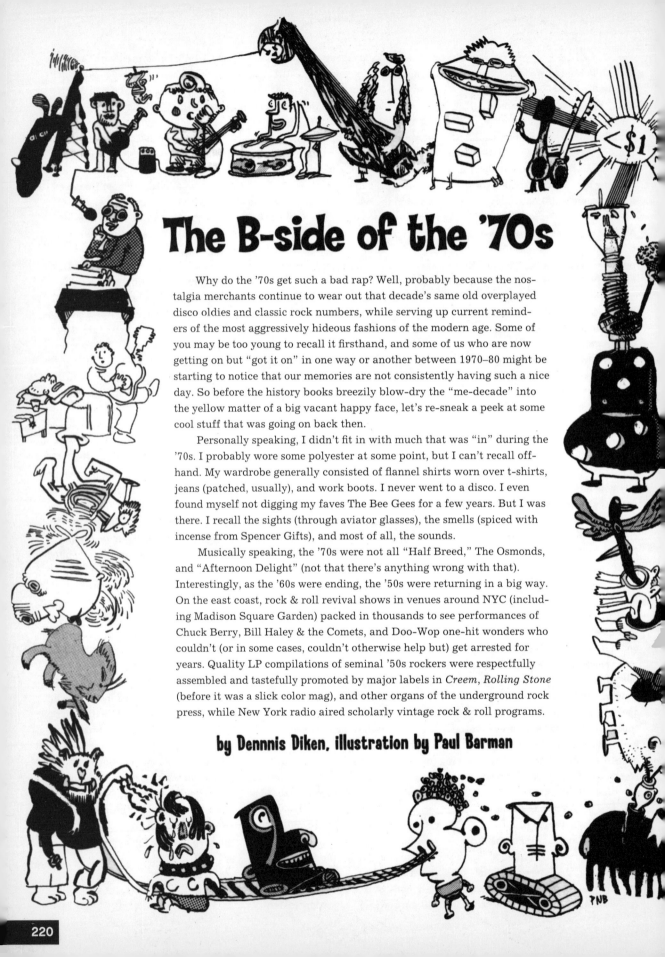

# The B-side of the '70s

Why do the '70s get such a bad rap? Well, probably because the nostalgia merchants continue to wear out that decade's same old overplayed disco oldies and classic rock numbers, while serving up current reminders of the most aggressively hideous fashions of the modern age. Some of you may be too young to recall it firsthand, and some of us who are now getting on but "got it on" in one way or another between 1970–80 might be starting to notice that our memories are not consistently having such a nice day. So before the history books breezily blow-dry the "me-decade" into the yellow matter of a big vacant happy face, let's re-sneak a peek at some cool stuff that was going on back then.

Personally speaking, I didn't fit in with much that was "in" during the '70s. I probably wore some polyester at some point, but I can't recall offhand. My wardrobe generally consisted of flannel shirts worn over t-shirts, jeans (patched, usually), and work boots. I never went to a disco. I even found myself not digging my faves The Bee Gees for a few years. But I was there. I recall the sights (through aviator glasses), the smells (spiced with incense from Spencer Gifts), and most of all, the sounds.

Musically speaking, the '70s were not all "Half Breed," The Osmonds, and "Afternoon Delight" (not that there's anything wrong with that). Interestingly, as the '60s were ending, the '50s were returning in a big way. On the east coast, rock & roll revival shows in venues around NYC (including Madison Square Garden) packed in thousands to see performances of Chuck Berry, Bill Haley & the Comets, and Doo-Wop one-hit wonders who couldn't (or in some cases, couldn't otherwise help but) get arrested for years. Quality LP compilations of seminal '50s rockers were respectfully assembled and tastefully promoted by major labels in *Creem*, *Rolling Stone* (before it was a slick color mag), and other organs of the underground rock press, while New York radio aired scholarly vintage rock & roll programs.

**by Dennnis Diken, illustration by Paul Barman**

What's more, the ubiquity of cut-out albums and tapes put cool sounds on the turntables and tape decks of us dorks with less-than-limited incomes. Many in my circle snagged our Beach Boys and the Kinks Kronikles 8-tracks at S. Kleins for $1.99, while the 69 Cent Store in Times Square overflowed with cartridges of The Zombies' Odyssey & Oracle. It was not uncommon to find LPs by Jimmy Reed, The Sunrays, and probably the entire Martin Denny catalog for under a buck each at Two Guys or Great Eastern Mills.

And dammit, the '70s offered us the last great golden age of commercial radio. New York City still proffered its fair share of free-formidity on WPLJ (named after the Doo-Wop classic "White Port Lemon Juice"), for one example, where a set of music could present a mix of cuts by T. Rex, Dan Hicks and his Hot Licks, Bessie Smith, The Move, Commander Cody and his Lost Planet Airmen, Fats Domino, Randy Newman, and Bob Dylan bootleg tracks.

And that was just FM. AM was deemed squaresville at the time (saving talk radio WMCA, where Alex Bennett and Malachy McCourt held court), so I never recognized it as a wonderland that still sported a diversity of bags and the vestiges of rapidly disappearing regional distinction. Check out the Top 40 of November 7, 1970: Number 40 was Ray Price's version of "For the Good Times," and the Jackson 5 were at Number 1 with "I'll Be There." At various spots in between, one could hear "All Right Now" by Free and "Engine Number Nine" by Wilson Pickett, to name a couple. Not too shabby. A random sampling of the '70s charts points to a golden age of soul: Al Green, Bill Withers, The Spinners, and a cornucopia of fabulous Philly Soulsters were consistent hitmakers.

And while it became increasingly difficult to get whooped-up about the pap-smeared landscape of the mid-decade AM band, some of those breeze-rock and disco records were/are fantabulous. Not that I tend to do the hustle with any regularity these days, but if you had told me I'd ever cop the stance back then, I'd have clomped you on the head with my Nuggets 2-LP set! By the summer of '79, the Hot 100 was still rife with fine singles by ABBA, Cheap Trick, Donna Summer, Blondie, Bram Tchaikovsky, Nick Lowe, Anita Ward, etc. It's in the book! You can look it up!

In addition, how many of us forged meaningful relationships during the decade's latter half at CBGB, Max's Kansas City, whatever might have been your local punk and/ or "new wave" club? Ah, memories of driving back to Jersey with the sun coming up after witnessing the Dictators' 4:00 AM set (along with less than a dozen of a remaining faithful) on July 4, 1976, at Club 82; mesmerized by hearing "Hospital" by The Modern Lovers for the first time on Vin Scelsa's show on WNEW FM; horrified at witnessing a prominent punk-rocker (who shall go nameless) gash his girlfriend with a broken beer bottle backstage at a Cramps show at CB's.

Alas, it was an era where a few shards of innocence still abounded. As the years pile on top of each other, the human spirit goes to work to keep the memories of the good times way out in front of the bad. If you can separate nostalgic feelings from musical moments from the '70s, or even if you weren't there to have a personal connection to the decade, take a listen and see if you might agree that we had a decent soundtrack during a fine time to be doing your own thing.

J. Fred Muggs was the most celebrated of all TV chimps. Innovative, charismatic, trailblazing: Muggs set the standard for performing simians worldwide. This isn't his story. We're here to discuss the ape that eclipsed him. A talking ape.

Kokomo Jr. was the first and probably the only talking chimp to come down the pike. Likewise, the first chimp to ski down a mountain, first chimp to open a checking account, first chimp with a syndicated newspaper column, first chimp on a Hallmark greeting card—you get the idea. In the '50s and '60s, he swung on the brass ring of show biz success to the accolades of humans everywhere. He rubbed hairy elbows with Presidents and First Ladies, comedians and clowns, singers and schpritzers. Kokomo spent a fair amount of time making with the personal appearances and fundraising for various charities. He also emerged at elementary schools across the land, doing tricks and teaching civic lessons to the kiddies. Can anyone truly calculate the lasting effect dapper Kokomo Jr. had on the slack-jawed youngsters? Off the clock, his swinging coterie included the likes of Julie Newmar

and Buddy Hackett. The world was his banana and he peeled it in style.

Currently retired in North Carolina, Kokomo tools his Big Wheel around the neighborhood and auctions off his paintings on the internet. What a simple, naked existence Kokomo would have endured had he not crossed paths with his

future pal and confidant Nick Carrado. Back in the heady days of '55, Carrado was an ex-marine eking out several careers in the insanity that was and still is New York City. By day, he laid bricks for skyscrapers.

Between 5 and 7 pm, he taught self defense and martial arts to NYC's Finest. Sometimes he'd ride around with the detectives and witness his teachings put into action. In the wee hours, Carrado pursued his childhood dream of prestidigitation in nightclubs and swank Italian restaurants. A little passing the coin through the table, some slight-of-hand and the ol' rabbit out of the hat. Carrado created a buzz that landed him out-of-town gigs when time permitted.

Into the spotlight swung a talented little fella, destined to change the act forever. In a recent conversation, Carrado recounted Kokomo's rise to fame and also a surprising revelation about a certain hairy doppelganger. Here is their story, in the words of the man who knows it best.

"One time I was performing up at Blimstrom's, which was the largest night spot in Boston. I stopped at a wild animal farm up on the Cape, and that's where I first saw Kokomo. I just went goo-goo over him! He was about a year old when I met him. Probably 1956. The thing was, I was tired of producing a rabbit out of my hat. The rabbit was really dumb and I could never teach it any tricks and I said, 'Wouldn't it be great

# Kokomo Jr.:
## Renaissance Chimp
### by Dave the Spazz

to get a chimp and produce him not out of a hat, but out of a foulard— a large silk. Then I could tell him to disappear and then go on with the act!' The problem was, he would clown around while I was doing my sleight of hand, which I took very seriously. The people would start laughing like crazy. So I said, 'Look Kokomo, either I'm gonna do the act or you're gonna do the act!' I guess you know who won out!

"I named him Kokomo Jr. after two of my Marine buddies who never made it back. It was 'Coco' and 'Moe' and I was the 'Jr.' Now, Kokomo didn't do tricks, per se. He was understanding and very understanding of words. Riding a bicycle, roller skating…any chimp could do that. I would teach him 'Open!' Like open a box, or open a door or close a door. Anything with open or close he was a natural at. Once you start teaching the basics— like open, close, pick up, put down, put back—a lot of things he could easily do. I was a single fella and we had a good rapport going. I spent plenty of time literally raising him like a child.

"He used to do magic tricks. He would do box magic which you don't have to be too brilliant to do. We had a bit where he would pour water in a vase, wave his magic wand then pull a never-ending foulard out of it. He'd stop in the middle and give the audience a look like, 'Is this ever gonna end?' Oh, they loved it!

"I put the show on the road. I went down to Florida with five dollars in my pocket. Just enough to feed a chimp. Sometimes in the trailer parks, I'd send him up a tree to get a couple of coconuts. Then I heard that the Today Show people were doing a remote down there. They wanted to take a look at Kokomo, as they had heard a lot about him. This was after J. Fred Muggs left the Today Show. Muggs was the granddaddy of all TV chimps. He was great. Kokomo Jr. and Muggs never did meet, though. Anyhow, NBC taped the whole show around us and we were hired on the spot.

"Koko was on the Today Show with Dave Garroway everyday for a couple of years. He'd do the weather

and lots of funny little bits. Sometimes the producers would request special routines. They would call me and say, 'Hey, can we have Kokomo play the violin?' and I'd say, 'Sure.' A few weeks later, there he is sawing out a tune.

"He always had a huge wardrobe. Brooks Brothers suits, cowboy outfits, marine uniforms, a leopard skin lounging robe. The tailors would cut the pants shorter, the sleeves a little longer and he was good to go. I used to take him for a shave and a haircut once a week. He loved it. He also ate with a knife and fork.

"In his heyday, he was on most of the big TV shows: *What's my Line, I've Got a Secret, To Tell the Truth*—he done all those shows. We worked with some big celebrities: Bill Cullen, Charlie Weaver, Jake LaMotta, Jack Paar, Merv Griffin—worked with them all. He was a regular on the Howdy Doody Show for over a year. One time on Candid Camera they had him in a dry cleaner's store. He took the tickets and brought back the clothing and some people didn't even notice that a chimp was waiting on them! That's New York for you.

"Teaching him to talk, well, that was difficult. I took him to psychologists, speech therapists, they all told me, 'Chimps just don't talk.' I spent about four months getting him to make a sound with his vocal cords. Then another three months to make him shape his mouth, lips, and jaws. I found that he couldn't make the 'M' sound without overlapping his upper lip with his lower lip by about a half an inch. When he said 'Mama' on the Today Show, it was all worth it. The Daily News gave us a full page, the Associated Press, you name it. One time a reporter

challenged me on it, so I said, 'I'll come down there and I'll show ya,' which I did! I could've taught Koko to say more words. I have no doubt in my mind about that. I was busy trying to earn a living and I didn't have the time it would take to do that. It could get a little hectic.

"You gotta remember we were on live TV back then. You didn't get no second chance. By the time we shot the Kokomo Jr. Show on film everyone called him 'One Take Koko.' Tell him what to do one time, run him through once, and he knew it. A lot of the actors would blow it and have to do it again and again. Koko'd come over to me and be like, 'Man, I'm not gonna do this scene one more time!'

"At the '64 World's Fair, Kodak used

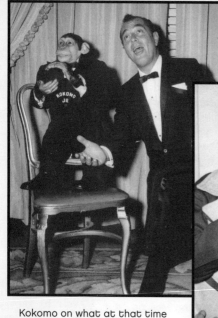

Kokomo on what at that time was the largest photograph in the world. They were looking for a chimp that played baseball and I said, 'I've got two chimps that work together. They never played baseball before but I can teach them.' See, I've always had two chimps. I would rotate them between shows so they wouldn't get burned out or tired. I was always concerned about not pushing them too hard. You know—it's like Lassie. Some Lassies would run through smoke and fire, some wouldn't. The chimps are both named Kokomo. They know which one I'm talking to. One's Kokomo Jr. and the other one I say, 'Hey Koko Koko.' It's all in the inflection of the voice. It's been seventeen years since we performed, so I guess we don't need to keep this a secret anymore. In the end, I'd rather that people know that I'm humane.

"They both like to sleep in. My wife is an early riser. We run a company called Monkey Packaging Tape. They like to watch TV and flip through National Geographic. We have an island in the backyard where they run out to play. I don't dress them up any more. Usually if they go out on the island, I'll put red sweaters on them so I can keep an eye on them from a distance. Only a couple of hours and then they're back in. They like the air conditioning. They got the refrigerator—they love to snack all day. Chimps really like to make a big deal out of eating. When they're in the jungle, they'll eat all day long. They'll travel and pick a little here, pick on this berry, what have you.

"They like biking around on Big Wheels. That's something they do for pleasure. They've gotten more interested in painting lately. I leave the brushes and acrylics out in their room, and they'll just go over and start painting. Always nice to have a hobby."

## KOKOMO JR.—OLD-TIME HOLLYWOOD'S FAVORITE APE

**Top Left:** Singing with Tony Martin

**Left:** Enjoying a Monkey Mind Meld with Joey Bishop

**Above:** Having to buy his own 50¢ sandwich with Jack Benny

**Below:** Tickling the ivories with Buddy Hackett

**Bottom Left and Right:** Swingin' with Julie Newmar and Terry Thomas

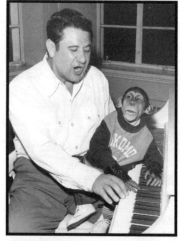

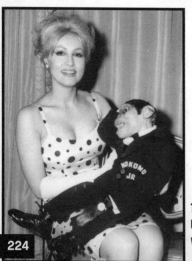

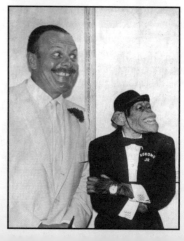

**To find out more about Kokomo Jr. or to see his paintings, go online at:** www.kokomojr-tvchimp.com

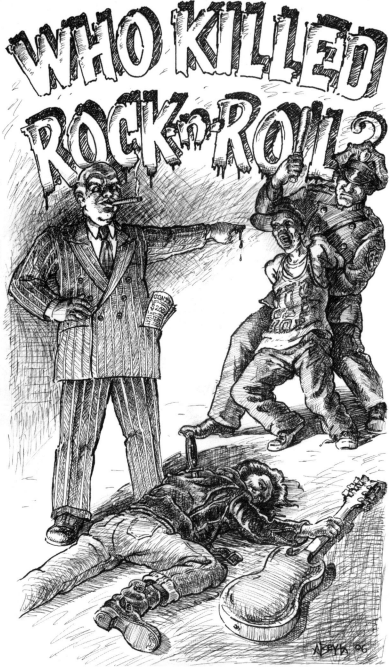

# WHO KILLED ROCK 'n' ROLL?

*by Gene Sculatti*

## Who's the perp? Somebody must've done this.

The victim's been lying there on life-support for years. Once a big, strapping music, light on its feet, unstoppable in its ability to move and shake all kinds of listeners, it fades in and out of consciousness, listless and unfocused.

Even without invoking the golden days of two and three decades ago, popular music today—an enervating mix of a-melodic R&B, lachrymose little-girl songwriter shlock, and brutish fratboy B.S.—and posing, ever more posing—pales against any measurement standard.

As the wise solon Andy Kim once inquired, "Baby, how'd we ever get this way?"

Well, some folks suspect corporate-driven record companies, others point to research-run radio. Those two've done their damage, sure, but I think the real culprits are myths. For almost thirty years, rock music's been a prisoner of some powerful, essentially bogus "natural laws" that have shaped artists' and audiences' perceptions and behavior. Unchecked and unchallenged, these myths have resulted in an ever-narrowing definition of what rock 'n' roll is and how it works; they've gutted its vocabulary, limited its expressiveness and left us with the soul-numbing jive that now surrounds us.

Now, ladies and gentlemen, let's meet our myths...

## Myth #1: Rock Is Art

This nifty bondage outfit dates back to 1967. That's when the mainstream media declared legit the music it had dissed for more than a decade. Sgt. Pepper was, of course, High Art; no less a cultural court than *Newsweek*, in its review of the album (6/26/67) declared the Beatles the equal of Wordsworth, Eliot, Tennyson, Harold Pinter, Donald Barthelme, Charlie Chaplin and Edith Sitwell.

Okay, rock did do some real growing up in the '60s: "Like a Rolling Stone"—one of the twentieth century's true cosmos-rattling works—was surely no "Teen Angel." But then "White Room" and "Marrakesh Express" were no "Like A Rolling Stone."

The Rock is Art myth was largely institutionalized by the late-'60s/early-'70s advent of rock journalism: if rock was legit enough to be written about, it must be Saying Something. And unless it was Saying Something, it wasn't rock. Since the principal means of saying anything is words, the gradual ascent of lyrics over sound was assured (*Rolling Stone* found little to evaluate in the output of such lyrically irrelevant acts as Slade, T. Rex, the Dolls or Ramones—just as it would've been speechless on Big Joe Turner or the Trashmen or, for that matter, the Marcels).

In time, audience and artists alike came to assume that pop music was supposed to carry content.

Which meant that, before long, you had only to present yourself as a poet—the jasmine-sniffing psychedelic clods, the prog-rockers, smug-ass solo Lennon or the gifted seer Jimbo M—to be taken as one. The Lizard King, in fact, created the Tortured Artist template for all who've followed. See his intense gaze and self-absorption, his irrefutable claim to be dropping science big-time, in Stipe and Sting, in Amos, Bono, Badu, and Vedder, and Ndegeocello and hundreds of others.

The irony is that now, after thirty years of Myth No. 1's dominance, the thousands of kids who yearly make pop music a

career choice (you could've gotten committed for this in pre-Beatles days) probably think their songs (or "works") are going to change the world.

Either that or they're paying obeisance to...

## Myth #2: Rock is Rebel Music

Everything is so tame and so driven by corporations. But it hasn't been possible for them to take over and use the images of serial killers. It's the only thing that's still truly underground and alternative.

—James, publisher of *PopSmear* magazine, quoted in the *L.A. Times*, 8/4/99

But of course. The fallout from Myth No. 2 is everywhere; you can't walk anywhere without stepping in it. Its origins, too, lie deep in the mainstream's earliest attempts to understand the music—i.e., Catholic and fundamentalist-clergy denunciations of rock 'n' roll as a soundtrack for juvenile delinquency, Sinatra's pronouncements against Presley, racist tirades about the rise of "jungle music." And, as with the music's '60s adolescence, there's truth here: to old-line publishers, promoters, and broadcasters, this new thing really was wild and threatening.

It wasn't until the '60s and '70s that the rock = rebellion myth was institutionalized and, it often seems, stamped into the genetic code of almost everyone who would ever listen to the music. Key players include Stones manager Andrew Oldham, who shrewdly marketed his act as the anti-Beatles, and, later, the rock-crit establishment. Pop-music histories of the '70s, '80s and '90s tell and re-tell the tale of rock's rebel roots—for example, reserving major props for Gene Vincent (pain-addled, pill-addicted, died poor) while skimming over Fats Domino (mild-mannered family man, made some of the most joyous rock 'n' roll the world's ever heard). (In the liner notes to a recent Faces reissue, Dave Marsh feverishly recalls the band's concerts: "They took the stage the way a teenage gang takes over a corner." Careful with that truncheon, Roddy.)

By now, rock's parade of self-proclaimed rebels resembles a clogged freeway. Stuck in traffic: Jefferson Airplane and the MC5 (raised-fist leftist rants signifying nothing), the Metal nation (thirty years of taking Halloween seriously), country-rock's "outlaw movement" (millionaire songwriters revolt against bridges and choruses), and first-gen punks (did anyone really expect Western society to slip into anarchy?). In the driver's seat today: gangsta rap (endless tales of unsavory behavior, inspired by fascinating "real life" experiences) and the "hard music" wing of Alternative Nation (white guys' tales of unsavory behavior, often inspired by an endless fascination with Chuck Manson). Memo to James c PopSmear: Don't flatter yourself, Ford and GMC will one day u images of Gacy and Dahmer to move tough trucks.)

The net effect of these two myths has been a gradual strangulation of rock 'n' roll, ever tightening the popular definition of the music. An aesthetic freeze-out now rules: If the music you're making isn't Serious (self-fixated, "poetic" proclamations: Morissette is Jewel is Rollins) or Dangerous (NIN, Marilyn Manson, Korn, Rage), you're engaged in frivolous activity—in a word, "pop." (Fear of the p-word is epidemic: Dig the way so many alt-rock bands craft catchy-as-hell melodies, then sing them with deliberately "off" vocals—to make sure you know they're not trying to be Anka or Astley.)

I'm not saying there's no room for introspection or anger. The drag is that the new rock orthodoxy excludes so many other elements that have made the music so enjoyable over the years: exuberance (over calculated provocation), wit (over misogyny), heart (over histrionics), aspirations to beauty ("We made sure Public Enemy was going to keep portraying ugly music"—canny marketeer Chuck D, in the *L.A. Times*, 7/25/99). What audience niche/radio format today would embrace "Be My Baby," Pet Sounds, "Peggy Sue," "Shout," "Blitzkrieg Bop," or "Wooly Bully"?

So, with the patient hanging on by a thread, is there a chance of recovery? Maybe. If artists can break the myth-mold and restore the musical vocabulary, they might find the inspiration to revive the old dame.

As a listener, I know that my favorite rock 'n' roll CDs lately are albums that were either produced before the rule of Myths 1 and 2 or, because of cultural lag-time, transcend them altogether. Norton's reissue of Detroit soulster Gino Washington's lost catalog is a pre-myth monster: melodic, celebratory, so raggedly noisy it's almost out of control. Bossa Cubana, by Cuba's '50s/early '60s vocal group Los Zafiros, is sublimely beautiful (if Happy Days stereotyping has stood in the way of your appreciating the soul and sonic sculpture of doo wop, try this). Gear Blues, by Japan's contemporary four-piece Thee Michelle Gun Elephant (one theory suggests the name's a misreading of "Machine Gun Etiquette"), relentlessly rocks out with Dictators/MC5 fury—and you needn't understand a syllable to catch the fire.

Are any of these records Saying Something about life today or man's fate? Probably not. Are they dangerous acts of rebellion? In a world so suspicious of spontaneity, unfaked emotion and fun, you bet they are.

James Brown is, of course, the Amazing Mr. Please Please Himself, the Godfather of Soul, the Hardest Working Man in Show Business. But, as he sang, "There Was a Time" (specifically in the fall of 1969) when he saw what looked like his biggest opportunity ever, and devoted the not-inconsiderable resources of his not-inconsiderable crew toward the goal of his immortality—as the architect of the "Popcorn."

The first hint of Popcornitude turned up in January of 1968, with the release of an inconspicuous instrumental single called "Bringing Up The Guitar," credited to the Dapps, featuring Alfred Ellis. The Dapps were the all-white funk band Brown had fronted on his gigantic hit "I Can't Stand Myself When You Touch Me," though it's not terribly clear if they were the Dapps on this particular record. (Brown tended to throw that name around a lot. The classic 1970 band including Bootsy Collins that recorded "Sex Machine" and "Soul Power," for instance, recorded an unreleased single, "More Mess On My Thing," under the name The New Dapps.) Alfred "Pee Wee" Ellis played sax on most of JB's mid-'60s hits; "Bringing Up The Guitar" itself was basically just an extension of the "Cold Sweat" beat, featuring a decent sax solo, a guitar playing octaves on a pentatonic scale, a little walking-upward bass figure, and the band chanting "C'mon! Yeah!" Not much to it but the groove.

Brown started doing a little dance to "Bringing Up The Guitar" on stage, and it caught on. He called the dance the Popcorn, and in late August 1968, the band re-recorded the instrumental as "The Popcorn" (credited to James Brown Plays & Directs). In fact, he wasn't playing, though he can be heard yelping a little; this time, Ellis switched to organ, and Maceo Parker contributed a smoking, curlicuing tenor sax part. It's not quite as crisp or funky as the first version, but when it was released in May 1969, it clicked, going to #11 on the R&B chart.

Now, let's backtrack a little. In January of '69, he'd recorded a song called "You Got to Have a Mother For Me," the first blatant lyrical indication of what an ass-man he is. (It got a little more blatant later on with

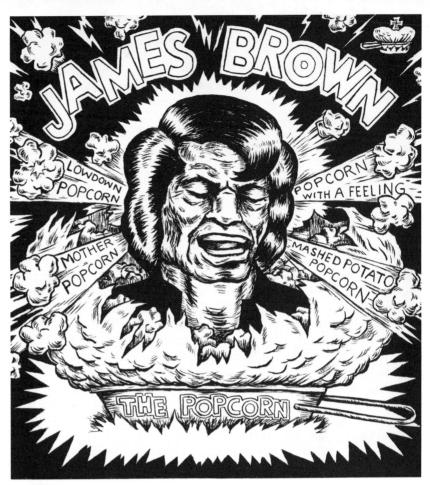

TOM MARSAN

# Popcorn Unlimited

### by Douglas Wolk

"Hot Pants"; a decade later, he was recording "For Goodness Sakes, Look At Those Cakes.") It had a great, insistent groove, and was originally scheduled to be a single in March, but got yanked in favor of "I Don't Want Nobody To Give Me Nothing (Open Up The Door, I'll Get It Myself)," which had the twin advantages of better politics and a longer title. JB, not one to waste the funk, eventually used the instrumental track on his 1970 instrumental album Ain't It Funky, under the name "Use Your Mother," and also considerably gave it to Bobby Byrd for his 1970 single "I Need Help (I Can't Do It Alone)."

When "The Popcorn" clicked, though, the Godfather moved—fast. (This, please note, was in a year when he released 13 singles and 4 albums, and that's just counting the ones under his own name.) On May 13, he

hybridized the words of "You Got To Have A Mother For Me" with the basic groove of "The Popcorn," and came up with "Mother Popcorn," one of the most monstrously funky records ever made. I will, in fact, nominate Clyde Stubblefield's cymbal smash four minutes or so into it as the single greatest instant in the history of recorded sound. Released in June, "Mother Popcorn," despite its weird title, became a humongous hit: #1 on the R&B charts, #11 pop.

Now, James Brown was not a man to linger on his successes; he'd record the same song over and over, a few years apart, but he was too busy making his groove evolve to stick with a formula. But something about the Popcorn was different. A month to the day after he recorded "Mother Popcorn," he was back in the studio, recording the instrumental "Lowdown Popcorn." It frankly didn't bear much relation to the Popcorn groove, other than its cyclical walking bass part, but that didn't matter: you could do the dance to it, after all. (Well, you could do the dance to anything, actually.) It wasn't one of Brown's best instrumentals, but it still went to #16 on the R&B charts when it came out in August.

After that, all bets were off. Brown had a huge revue he traveled with; there was always a woman singer, whose job was to sing backup, warm up the crowd (usually with a short set that ended with "People"), and generally do the diva thing. In the fall of 1969, that was Vicki Anderson (the wife of Brown's longtime right-hand-man Bobby Byrd). In an attempt to cover the potentially lucrative answer-song market, he assigned her "Answer To Mother Popcorn (I Got a Mother For You)," and she co-wrote and sang the living hell out of it. It came out in September, and it wasn't a hit, but it's become a collectors' favorite, with an amazing screaming-diva vocal and a magnificently tense groove.

Then there were various also-rans, has-beens, and wanna-bes who sang with the Brown revue and generally took shelter under his wing. R&B organist Bill Doggett had had a great big hit in the '50s with "Honky Tonk," which Brown covered a few times in various guises; in September, Doggett released a new, Brown-produced version of "Honky Tonk," backed with "Honky Tonk Popcorn"—the latter with a composition credit reading "James Brown." Charles Spurling came up with "Popcorn Charlie," and semi-fallen '50s star Hank Ballard had a fabulous little stop-start blaster called "Butter Your Popcorn," which he couldn't quite sing in tune. Classic opening: a smarmy woman's voice says, "Mr. Ballard—may I help you with something?" (Crack!) "Butter your popcorn! Come on, children!"

(Those curious about the Brown-Ballard connection should also track down JB's 1972 album Get On The Good Foot, with its drunken six-minute "Recitation by Hank Ballard": "Yeah, I got caught running around in the graveyard of losers! But I had an unshakeable determination…and I was coming out…out of my place, you know…so I came out and joined the James Brown productions. James was the only one besides myself that had a strong belief in my talent. I knew he could formulate a groove that could put my star back in this galaxy, you know…James Brown world! James Brown world of music! And wow, I'm glad I'm part of his world…")

Brown did his part to fuel the not-terribly-genuine craze on his own, too, releasing the LPs The Popcorn (all instrumentals) and It's A Mother. The latter appears to have been assembled in a hell of a hurry—"You're Still Out Of Sight" is actually sung by somebody else who has a voice kind of like Brown's. Fortunately, the album also includes the two-part "Mashed Potato Popcorn," which sounds a little starchy but is really just fine, and "Popcorn With A Feeling," which has a really unfortunate flute part.

In October, he followed it up with "Let A Man Come In And Do The Popcorn," one of the strongest singles of the entire series, with a fabulous, sneaky beat; it had been recorded the same day as "Mother Popcorn," in fact. The title is fairly arbitrary—Brown had kind of given up on the idea of choruses and vocal hooks by that point—though he does mention the Popcorn twice in its lyrics (the title never appears in its entirety). It was another great big hit, going to #2 on the R&B charts, so he had a brilliant idea for the follow-up, released in November: "Part Two (Let a Man Come In And Do The Popcorn)," not a single but literally the second part of the same take, starting with 30 seconds of a different vamp and then going back to the one from Part One. This one mentions neither the Popcorn nor men coming in, though Brown does yelp, "Gonna give you a taste of Part Two!"

That was the last of the original round of Popcorn songs, though the name of the album containing "L.A.M.C.I.A.D.T.P.," released in June 1970, combined its title with another contemporaneous hit for the mindboggling result: It's A New Day—Let A Man Come In. (The opener of 1971's live Revolution Of The Mind album is actually just the former, but it's credited as "It's A New Day So Let A Man Come In And Do The Popcorn.")

The theme had one final moment of glory, though. Maceo and the Macks' "Parrty" [sic], released in August 1973 on Brown's label People Records (they were actually just his band, with Maceo Parker getting a taste of glory for a change). It's simply a remake of "The Popcorn," with the band chanting "parrr-TY! parrr-TY!" over it. Also released on People, a little later that fall, were Lyn Collins' soul simmerer "We Want To Parrty Parrty Parrty" and a fun little stomp by Fred Wesley and the JB's called "If You Don't Get It The First Time, Back Up And Try It Again, Party." One assumes that there simply wasn't room on the label for the extra R.

# THE BENDABLE SOUNDS OF FLEXI-DISCS

*by Mike Cumella*

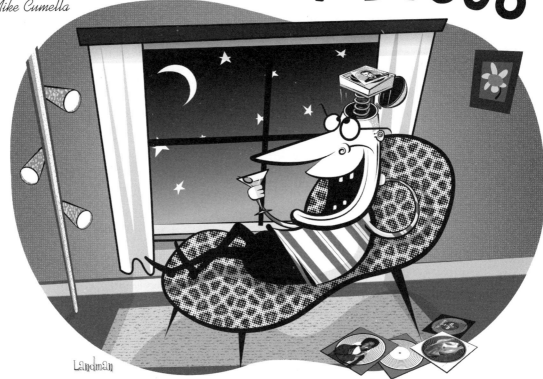

Landman

I love lo-fi. Playing a cereal box on my Kenner Close 'n' Play record player was a defining experience, so it is not with much surprise that this seed has grown into a warped branch of my collecting interests.

Most think of records as round, black, and stiff, with little holes in the center, but for the last ten years, I have been fascinated with records that were anything except that. The flexi-disc has had a long but somewhat obscured history, probably due to its very disposable nature. So let's take a moment to reflect upon another dead media format as it passes into that great pile of trash culture that America piles higher than any other nation.

My record collecting interests have gone through many evolutionary stages since first beginning as an adolescent. From what was fashionable as a teen, to what was anti-establishment (which pretended not to be fashionable, but was) as a young man, to just plain weird stuff (also fashionable), with many sub-divisions along the way. I can't even count how many unusual flexis I had seen and dismissed as trash in those early years. Why would I want a paper record that advertised the merits of a fire alarm from the 1950s when there were several more Led Zeppelin and Pink Floyd records I had yet to hear? Oh how unenlightened I was!

After realizing the limitations of collecting based on the sound of a record, I started to move towards the look. The playable audio of these flexis was only one part of the package, which often was a means to some other end. Whether it

was to get you to buy this cereal, visit this luxury retirement home, buy this car, or realize what a great guy Nixon was, these flexi-discs were an inexpensive way to reach consumers and get them to do something, buy something, or react in a certain way.

As I started to collect these unusual items, I soon realized that this was an area of recording that was never fully chronicled, and could lead me on a voyage of discovery I could spend a lifetime pursuing. Like knowledge itself, I realized that the more I discovered, the more there was to look for. I realized that one could never amass all the examples of these artifacts, and therein would lie the fun. I have found a few books on the subject, but it has been mostly through talking with other esoteric collectors and those who were directly involved in the business that a chronicle is slowly revealing itself. But the question remains...Who cares?! After reading this, perhaps you will care enough to consider saving these records from the trash heap when you see them.

It might surprise you to know that the first records ever made were flexis! When Thomas Edison built the first phonograph, sheets of tin foil were wrapped around the mandrel and recorded directly on the machine. Theoretically, one could then unwrap the sheet from the player to be put on another phonograph. TUCKS manufactured postcards starting in 1905 with records attached to the front so the receiver could hear as well as read them. DURIUM mass-manufactured paper records in the '30s called "Hit of the

Week," which were sold at newsstands. These are a favorite novelty record among flexi collectors and 78 enthusiasts as well. They also made advertising records as small as four inches that were mailed directly to potential customers in a given area. These have a deep brown shiny playable side, and a pinkish plain paper side that was blank or could include print or pictures.

Record books were another interesting format that were made as early as the '40s though to the '70s. With these, the cover (or pages) would have a record and by placing the entire book on your turntable, you could hear it as well as see it. This was a successful product for the JOHN C. WINSTON CO., which produced twenty or so "Magic Talking Books" for children in the late '50s. ECHO was a magazine that was produced in 1949 for adults, featuring contemporary artists, lots of info about them, and picture flexi records for some of the pages. I have Volume One, and have never seen any other volumes, probably because it was a complete failure. Many folks remember the great flexis that came in the pages of MAD magazine. Many kids drove their parents crazy with "It's a Gas" until it was completely worn out.

AURAVISION, a division of Columbia records, manufactured records on baseball cards in the '60s, and also made many records that accompanied toys for a personal play soundtrack. They were usually a paper core with a laminated record sheet bonded to the surface. The records were clear so that the message printed on the paper could show through and come across perhaps louder than sound itself. They also used this format for

self-promotion of their record clubs through direct mail campaigns and magazine record inserts. If you have a FLEXIPOP record, which are made out of the nice translucent plastic material made famous by EVA-TONE (the undisputed flexi manufacturing king), then you have a good shot at getting it to play. Records made by this company always carried their logo, and if a printed message was to accompany the record, it was usually stapled to the edge and placed behind the record. They also produced a folder format so that you could read all the information, then fold it in a certain way so the entire package would be on your turntable.

Some food-packaging-oriented flexis were items like the tops of frozen food containers, tops of Borden cottage cheese, tops of margarine tubs, and flexi-discs included inside boxes of Quaker granola bars. TOPPS, the company known for baseball cards, sold flexi picture records of Motown stars in the late '60s that included a stick of bubble gum from candy stores for fifteen cents.

Who could forget "Sugar Sugar" by the Archies?

AMERICAN AUDIOGRAPHICS was the manufacturer of many of the infamous cereal box records made in the '60s and '70s that brought woe to so many parents' hi-fi stereos. Cereal boxes with record premiums as a ploy to get kids to hound their parents to death so they will buy a certain brand was nothing new when I partook in the ritual in the late '60s. Records were not only attached to the outside of the boxes, but also included inside "specially marked boxes" too. Wheaties had done this a genera-

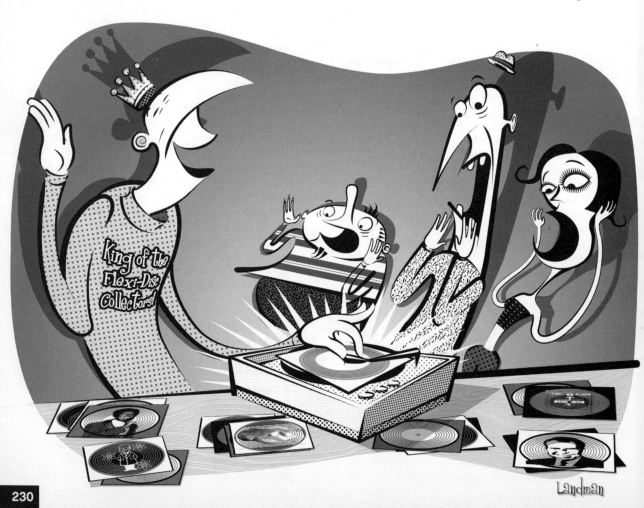

Landman

tion before mine in the 1950s with records on the box, as well as giving the consumer the ability to mail in proof of purchases and get records through the mail.

AMERICAN AUDIOGRAPHICS was one of the last major manufacturers to do a booming business in this now dead medium. They made records for a wide range of business and industry promo needs, and featured great pictures and graphics. One of their last products in high demand were flexi picture records in the pages of B-grade porn magazines featuring laughable recordings of guys and girls getting it on.

While there are many other makers through the history of flexi-discs, many of these records bear no mention of a maker. Certain items retain the trademarks of sub-contracting deals, but there are many one-of-a-kind items that have no mention of manufacturer.

Some of the other applications in the nearly hundred-year history of the flexi are contest records that invited the listener to participate, promos that were tie-ins to stores to entice customers, fan club give-aways, political messages, movie and album promos, event souvenirs, children's songs, personal recordings, religious messages, holiday recordings, WWII soldiers record

letters, zodiac records, greeting cards, fast food give-aways, and cartoon character records. Some of this stuff defies categorization, but always pushes the envelope of record uses in some way.

One of the aspects that I find really appealing about these records is that this format, this little floppy thing, is probably the only way this sound artifact exists. Unless some nut like me has the self-indulgent audacity to produce a CD, the only way to hear it is to manage to play it. I say manage because there are many tricks using various combinations of coins, rubber bands, tape, and strong breaths of air that are needed to get these records to play.

Then there are the entire areas of toys with records, oddity records, and self-amplified units that take the idea of playing back sound to another level...but those will have to be for another time. So there it is! A little overview of the obscure world of flexi-discs. The next time you see one, perhaps allow yourself to take it home and keep it to remind yourself of one bizarre artifact from our recorded history. But be careful, you may get caught up in a world from where you may never return.

# WORLD WAR IX: PEOPLE I'M GLAD I DON'T PLAY IN A BAND WITH

BY JUSTIN MELKMANN
CHECKOUT WORLDWARIX.COM

231

JIM TOROK

# A BRIEF HISTORY OF DISEMBODIED DOG HEADS
## BY KEN FREEDMAN

Did Soviet scientists actually keep a disembodied dog head alive back in the 1940s? Did those crazed Stalinist Frankensteins then follow up that stunt by surgically creating a two-headed dog in 1954? (That is, if "two-headed" is accurate—it's more like two heads, six legs, and one-and-a-half torsi.)

Sorry, I just wanted to use the word "torsi."

And forget the Soviets—what about the monkey brain that a Cleveland surgeon transplanted from one primate to another? Are these all internet hoaxes, or the only known evidence of a subject too taboo to be taken seriously—the research into head and brain transplants that's been going on for decades?

I wish I had definitive answers for you—I don't. But I'm more inclined toward believing that these experiments actually took place than when I first stumbled onto this weird medical sub-culture. After starting off as a skeptic, I've come to believe that organisms have indeed been revived. Heads have been lopped off. Brains have been perfused. Cephalic members transplanted. Glucose permeated in isolated canine craniums. The works.

This all started a few weeks back, while browsing through the Prelinger archives.[1] I came across the movie Experiments in the Revival of Organisms,[2] which purports to show a 1940 Soviet experiment in which a dog's head was kept "alive" after being removed from its body. If you haven't seen this yet, be careful—it's not for the squeamish. And I might as well say up front that I'm against the removal and reanimation of heads, even for scientific or culinary purposes. Fascinating though it may be, it amounts to torture. It's one thing to keep a dog's lungs pumping outside of its deceased body, and quite another to maintain consciousness and pain receptiveness in a disembodied head. Maybe the imagined horror of this is what has kept this research relegated to the status of science fiction and hoaxology for so long.

But that didn't stop me from wanting to find out if this was a hoax or not. When you read the comments on the Prelinger page,[3] you'll see that about half the people who saw the movie felt it was a hoax and half were inclined to believe it. I wanted to find out for myself. Surely, if this film was a hoax, it would be relatively easy to demonstrate that, if somebody hadn't done so already. But rather than uncovering any evidence of a hoax, my hours of hunting led to dozens of medical papers and abstracts which backed the film up, as well as uncovering more cases of head transplant experimentation in the U.S. and U.S.S.R., not to mention a crew of scientists that would make Mary Shelley proud.

First, download and watch the movie, since the puzzle starts there. At first glance, Experiments in the Revival of Organisms comes off as a piece of World War II–era Soviet propaganda. The arteries and blood vessels leading in and out of the dog head aren't made visible to the viewer, and the narration that accompanies the film (by the pro-Communist British Biologist J.B.S. Haldane) leaves much to be desired in terms of medical accuracy, so dumbed down is his description of the experiment. The film supposedly documents experiments performed by Dr. S. S. Bryukhonenko at the Institute of Experimental Physiology and Therapy in the U.S.S.R. It was premiered in November 1943, when the National Council of American-Soviet Friendship and the American-Soviet Medical Society showed it to a thousand American scientists in New York City. There were articles about that 1943 showing published in the New York Times and Time magazine.[4]

So what about this Bryukhonenko character—did he even exist? He did indeed.[5] He invented the autojector, the artificial circulation machine shown in the film, and he was a well-known figure in the field of human biology in the '30s and '40s. The National Institute of Health website has indices of papers referencing his work, including a 1969 article,[6] which describes (in Russian) some of the same work shown in this film. While I wasn't able to find any papers written by Bryukhonenko himself, I also didn't search using Cyrillic fonts, or go to a medical library to dig up the papers, which are referenced on the National Institute of Health's website.

Despite his significant contributions to science and medicine, Bryukhonenko will forever be remembered as the dog-head doctor, due mostly to his depiction as the disembodied head of Professor Dowell

in Alexander Beliaev's science-fiction novel, *The Head of Professor Dowell*,[7] which was later made into the movie Professor Dowell's Testament.[8]

Bryukhonenko wasn't alone in his fascination with bringing dead things back to life. As one might expect from a nation that lost six million people to the Nazis during World War II, the science of resuscitation was something of a scientific and medical obsession. The Institute of Experimental Physiology and Therapy, where Bryukhonenko's dog experiments took place, was founded in 1936 by Vladimir Negovsky,[9] a Soviet doctor who spent much of the '40s working on the front lines of the war with resuscitation teams, working to revive Soviet soldiers who were bleeding to death (and who, in some cases, had already bled to death). Negovsky's work prior to the war involved experiments with dogs, and Bryukhonenko was but one of many Soviet scientists working in this field.

In 1961, Negovsky defined his peculiar scientific specialty as "reanimatology." From his obituary

**Negovsky was able to develop reanimatology as a new medical discipline in the Soviet Union and trained and mentored several generations of "reanimatologists" in the communist countries, for whom anesthesiology, out-of-hospital emergency care and other acute clinical practices, became sub-specialties of reanimatology. Every hospital in Russia and former Soviet Republics has a Department of Reanimatology lead mostly by Negovsky's trainees.**

Bryukhonenko also had protégés of his own, most notably Vladimir Demikhov,[10] who in 1954 reportedly grafted a second head onto a living dog.

It's hard to out-weird a two-headed dog, but the odd gentleman who narrates Experiments in the Revival of Organisms has a bizarre back story all his own. J.B.S. Haldane[11] was an influential Scottish geneticist and biologist who staked his substantial reputation on Bryukhonenko's work. In this film, Haldane claims to have seen these experiments with his own eyes.

Haldane got his start in genetics by breeding guinea pigs for his scientist father and acting as one himself from time to time. From the Stephen Jay Gould Archive entry on Haldane:

**In one childhood episode, the elder Haldane made him recite a long Shakespearean speech in the depths of a mine shaft to demonstrate the effects of rising gases. When the gasping boy finally fell to the floor, he found he could breathe the air there, a lesson that served him well in the trenches of World War I. A physically courageous 200-pounder, Haldane continued the family tradition of using his own body for dangerous tests. In one experiment, he drank quantities of hydrochloric acid to observe its effects on muscle action; another time he exercised to exhaustion while measuring carbon dioxide pressures in his lungs.[12]**

His penchant for self-experimentation stayed with him. In his decompression chamber experiments, he and his volunteers suffered perforated eardrums, but, as Haldane stated in his book *What is Life*, "The drum generally heals up; and if a hole remains in it, although one is somewhat deaf, one can blow tobacco smoke out of the ear in question, which is a social accomplishment."

Haldane was a real renaissance guy; he spoke many languages, wrote extensively on history and politics, and made important research contributions to chemistry, biology, mathematics, and genetics. He reshaped modern evolutionary biology with his studies in population genetics. His interest in genetics and biology influenced his 1924 book and essay, *Daedalus, or Science and The Future*,[13] which imagined a day when people would control their own evolution through ectogenesis—the care and feeding of test-tube babies.

Daedalus created quite a sensation in 1924, and Bertrand Russell was so appalled by its implications that he wrote his own book, *Icarus, or the Future of Science*,[14] in response. Another writer and friend of Haldane's named Aldous Huxley was also inspired enough by Daedalus and Russell's response to it that he based his own 1932 novel, *Brave New World*, on the questions raised by Haldane and Russell.

Ten years earlier, Huxley had used his friend Haldane as the inspiration for the character Shearwater in his novel *Antic Hay* (1923), as "the biologist too absorbed in his experiments to notice his friends bedding his wife."

Haldane was a committed Marxist for much of his career, which is why we find him narrating a film distributed by The National Council of American-Soviet Friendship. But by the end of World War II, Haldane disavowed Marxism and moved to India to continue his studies and writing until his death in 1964.

Maybe you're thinking that there could be something to all this head removal business back in the U.S.S.R, but it couldn't possibly happen in the U.S.A., with our long history of mostly ethical medical practices.

Think again.

In the '60s and '70s, Dr. David Gilboe of the University of Wisconsin removed the brains of over forty dogs, removing their blood to suffocate them and then reviving them by pumping the blood back in, not unlike Bryukhonenko's experiments in the '30s and '40s. Measuring the activity of the dog brains with an electroencephalograph, Gilboe concluded that it was possible to keep the dog brains functioning for approximately two hours outside of the body. Unlike Bryukhonenko, Gilboe wasn't studying the revival of organisms—he was studying the chemistry of brain metabolism

during the process of suffocation and recovery. And what better way to do it than by removing dozens of dog brains? An article by Gilboe appeared in April 1973 in *The Journal of Biological Chemistry*,[15] and in 1964, Gilboe and two other scientists wrote a paper entitled "Extracorporeal Perfusion of the Isolated Head of a Dog."[16]

Gilboe stayed true to the Soviet tradition of dog-head removal, but another Midwestern scientist started with dogs and then moved up the evolutionary ladder. In the 1960s, a Cleveland brain surgeon named Robert J. White[17] attached an isolated dog brain to a second dog to see if he could get some action out of the newly homeless brain. The experiment was a success, if you consider a dog with two working brains "successful," which White did. But this experiment was merely a warm up for White's most notorious experiment[18] in which he transplanted the head of one monkey onto the body of another. When the newly re-headed monkey tried to bite off the finger of a researcher, White's entire team reportedly cheered.

White was on a roll, and was all set to try the concept out on *Homo sapiens*, when something or someone stepped in and put an end to it—but not before he had somehow dabbled with a few human brains: "We discovered that you can keep a human brain going without any circulation," he says. "It's dead for all practical purpose—for over an hour—then bring it back to life. If you want something that's a little bit science fiction, that is it, man, that is it!"

Perhaps this is why White was later appointed as an adviser to Pope John Paul II's Committee on Bioethics. Perhaps the Pope didn't know about Craig Vetovitz, a paralyzed biker buddy of White's who is patiently waiting and hoping for Dr. White to remove his head and graft it onto a working body. Or maybe the Pope did know about all that, and that's why he's on the committee. It all gets very confusing.

Perhaps tales like this are the reason that head and brain transplantation isn't taken seriously. As soon as you get into the realm of people shopping around for other people's bodies to carry their heads around, it gets a little hard to stop giggling. But it's no laughing matter for some. (And no, I'm not referring to Walt Disney, whose head, contrary to popular belief, was never put on ice awaiting a better day and body.)

There is one company out there called Brain Trans[19] for which this is serious business. I'm afraid I can't tell you where Brain Trans is located because the nature of their work violates various ethical and medical laws, some of which are still honored internationally. But I can tell you that they are located somewhere in Asia, they have a lot of brains on ice, and they have an even bigger choice of human bodies. If you go to their website, visit their body gallery![20]

But don't ask too many questions. As they say on their site, "Because of the ethical aspects we do not discuss how and were we getting new human bodies for brain transplantation." [sic]

It doesn't take long to realize that the Brain Trans site is one of the funniest websites ever, even if the fraudulent purposes for which it was created are genuine. And it's the sites like Brain Trans, and the urban legends like the one about Walt Disney's brain, and the dozens of science fiction books and movies about living disembodied heads, that has kept the science of brain and head transplantation tucked away in the realm of rumor and fiction. As long as the horror of such research outstrips our fascination with it, legitimate versions of companies like Brain Trans will never be realized and brain transplantation will be another medical sub-specialty that's gone to the dogs.

FOOTNOTES:

1. **Prelinger Archives:** http://www.archive.org/details/prelinger

2. **Experiments in the Revival of Organisms:** http://www.archive.org/details/Experime1940. Download video from http://blogfiles.wfmu.org/KF/2006/01/soviet_dog_experiment.mp4 (49 Mb file).

3. **Prelinger webpage comments:** http://www.archive.org/details/Experime1940

4. *Time* **article:** http://blogfiles.wfmu.org/KF/2006/01/0,10987,851883,00.html

5. **Bryukhonenko:** http://analytics.ex.ru/cgi-bin/txtnscr.pl?node=578&txt=460&lang=2&sh=1

6. **NIH index of Bryukhonenko's articles:** http://www.ncbi.nlm.nih.gov/entrez/query.fcgi?cmd=Retrieve&db=PubMed&list_uids=5264992&dopt=Abstract

7. *The Head of Professor Dowell* **book:** http://www.allreaders.com/Topics/info_9700.asp?BSID=34735401

8. **Professor Dowell's Testament Film:** http://www.dvdtimes.co.uk/content.php?contentid=3561

9. **Vladimir Negovsky:** http://www.erc.edu/index.php/newsItem/en/nid=136/

10. **Vladimir Demikhov clips:** http://www.tvdata.ru/catalog.php?dir=11&did=365&lang=eng (The best view of Demikhov's creature is in the sixth clip, marked number "005.")

11. **J.B.S. Haldane:** http://www.firstfoot.com/Great%20Scot/haldane.htm

12. **Stephen Jay Gould Archive entry on Haldane:** http://www.stephenjaygould.org/people/john_haldane.html

13. *Daedalus, or Science and The Future:* http://www.cscs.umich.edu/%7Ecrshalizi/Daedalus.html

14. *Icarus, or the Future of Science:* http://www.marxists.org/reference/subject/philosophy/works/en/russell2.htm

15. **Gilboe article in** *The Journal of Biological Chemistry:* pdf file (http://www.jbc.org/cgi/reprint/248/7/2489); abstract of article (http://www.jbc.org/cgi/content/abstract/248/7/2489)

16. **An index of "Extracorporeal Perfusion of the Isolated Head of a Dog" can be viewed here** (http://www.ncbi.nlm.nih.gov/entrez/query.fcgi?cmd=Retrieve&db=PubMed&list_uids=14152833&dopt=Abstract), but you will need to register to read the article.

17. **Robert J. White:** http://www.clevescene.com/issues/1999-12-09/putre.html

18. **You can see the index of this experiment, entitled "Cephalic Exchange Transplantation In The Monkey" here** (http://www.ncbi.nlm.nih.gov/entrez/query.fcgi?cmd=Retrieve&db=PubMed&list_uids=4997130&dopt=Abstract).

19. **Brain Trans:** http://216.247.9.207/bthtml/about.htm

20. **body gallery:** http://216.247.9.207/bthtml/bodies_gallery.htm

# WHY I HATE RADIO

by Chris T.
Illustrations by Ivan Brunetti

depressing, machinery-crammed rectangle with a high ceiling and a permanent lingering smell comprised of equal parts lubricating oil, raw plastic, metal shavings, and dust. It was no place to spend any time at all, yet for six months I was there from 8 am in the morning until 4 pm in the afternoon.

Those hours crawled by on their filthy belly, mocking me with their sing-song chant: "The world is continuing outside, where people are living and doing and going and smiling and breathing deeply, purely, lovingly, ecstatically, and you are here and you are stuck here because you are too damn stupid to be anywhere else and too damn poor not to work and if you only had a rich daddy or enough sense to go to college or the will to leave then this wouldn't be the place where you spend your days and we crawl by on our filthy belly, mocking you as we go with our sing-song chant."

I spent those endless, numbing hours assembling relays, which are electrical shunting devices used in devices that must shunt electricity or suffer the consequences. Anybody who can't shunt when the time comes will tell you how truly awful it can be.

My part in the shunting scheme of things was to attach a tiny copper contact to a piece of plastic by means of a foot-operated riveting machine. For eight hours a day I'd fish the plastic relay bases out of a bottomless bin, place them on the machine's "nipple," fish a contact out of another bin, position its keyhole over the corresponding keyway on the plastic base, and fasten them together with a rivet by stamping down on the machine's foot-pad— KA-CHUNK. All day long I'd fish, place, fish, place, stamp, KA-CHUNK.

I hate radio. Correction: I hate commercial radio. Clarification: I hate MODERN commercial radio.

Commercial radio has been around for a long time, since nearly the dawn of AM broadcasting. Yet with entertainment and commerce being the Siamese twins of the "American Way," it was inevitable that broadcasters would seek sponsors for a medium with such high operating costs. Carrying commercials to pay the nut was seen as a necessary accommodation, not the engine driving the train.

The music and other entertainment didn't suffer too greatly, as there were still "artists" involved, programming and piloting individual stations and networks. Words like "ratings," "format," and "demographics" hadn't yet entered the radio lexicon. But the money was so good that station owners found themselves increasingly beholden to sponsors, who began taking over complete shows, then buying radio stations from which to launch media empires.

Gone was a willingness to break NEW ARTISTS by spinning NEW RECORDS. With all that money at stake, no station owner was willing to gamble on the taste of individual "star" DJs. The choice of what to play became a crucial matter, driven by market research, proved on the testing grounds of college radio and MTV. Before long, content became safe filler between the truly important elements of a radio broadcast: the commercials.

Commercial radio—programmed by consultants, spat out by computers like some kind of extrusion—exists purely to create the highest dollar rate for ad time. It hinges on an arbitrary roster of "hot" songs, old or new, repeated ad nauseum in a blatant effort to "hook" the listener long enough for exposure to the ad. It's the repetition and lack of innovation that keeps me away. That and some bad memories.

When I was twenty years old I worked in an assembly factory called Vector Research in my hometown. The building was a huge, drab, dirty,

And over again: fish, place, fish, place, stamp, KA-CHUNK, fish, place, fish, place, stamp, KA-CHUNK, fish, place, fish, place, stamp, KA-CHUNK. On and on until blessed release came in the form of a lunch break or the four o' clock whistle.

Lunch breaks, actually, weren't a form of release at all; they were a different kind of hell. There was nowhere nearby to go and eat. We were in an industrial park, and there was nothing I could drive to and back in half an hour. My lunch breaks were spent with my co-workers: four women much older than myself. The youngest among them was twice as old as me, the oldest three times my age, and I had absolutely nothing in common with any of them. They had completely and utterly caved into life and were far more stuck than I'd ever be, earning two-thirds what I earned (which was nothing) and rotting away before my very eyes. These women were, simply put, a fright. They wore WAY too much makeup, clothes from K-Mart's bargain rack, bad wigs, and overpowering amounts of the latest deliveries from the Avon lady. Hell, they WERE Avon ladies. And they disliked me intensely.

We went days without saying anything to each other. They'd sit at one end of the long folding lunch table and I'd sit at the other. It might as well have been a yawning chasm no living thing would dare cross. They all had children and grandchildren, and were too happy to share their icky-sweet stories of the baby's latest doings, pushing photos across

the table while gumming their tuna sandwiches, washing them down with battered thermoses full of Shop-Rite apple cider. Every day we'd spend half an hour together, yet completely apart, my head buried in a guitar magazine or a copy of *Creem* or a book with a picture-to-text ratio of 10:1. I didn't dare speak for fear of being drawn into a discussion about absolutely nothing from which there was no graceful exit.

Lack of a graceful exit wasn't a problem with the white-haired manager, Mr. C.—who may have been

older than the four women and myself combined. He was a squat, smelly, miserable man with a perfectly white mustache, forever-dingy shop coat, celluloid visor, and black heart. He never spoke to me, except to begrudgingly teach me how to do something or tell me when I was doing it wrong. Then he'd come up behind me to tap me on the shoulder and lecture me, or scold me, or shove something in my face that I'd screwed up.

But the worst thing about Mr. C. was his death-hold on Vector Research's radio, a large, old Fisher, located high on a shelf and robust enough to blanket the whole building with its vile, putrid retching. Every minute of every day I spent beneath it, this instrument of torture, tuned to

what was surely the crappiest radio station that's existed since wireless broadcasting began, emanated the most insipid pop songs ever recorded. I can no longer remember what station this worst of all possible stations was because I've repressed the memory to an entirely successful (yet dangerous) degree. I live in perpetual dread that someday, someone, somewhere will innocently mention the call letters of that filthy station, and the memory will surface and whip me into a homicidal rage.

This "radio station" was nothing less than the devil's mouthpiece in electrical form. Every day I dreamt of conveying myself to the originating site of its awful transmissions to drive an oversized stake into its black soul. That was, however, as unlikely as convincing my co-workers or boss to change the station, if even for a minute. I begged and pleaded for a switch to something less irritating: WCBS-FM or even WNEW-AM, anything even the slightest bit less awful.

Why was it so irritating? This was a top 40 "hits" radio station and it played these "hits" OVER AND OVER AND OVER AGAIN UNTIL YOU'D WISH SOMEONE WOULD JUST STOMP ON YOUR HEAD AND CRACK IT LIKE AN EGG, LEAVING YOU TO DIE QUIETLY.

Every hour on the hour they'd begin their playlist over, so that eight times a day I'd hear Stacy Lattisaw's thrilling rendition of "I found love on a two way street/but lost it on a lonely highway," or Grover Washington's so fine "Just the two of us/we can make

it if we try/just the two of us/you and I," or Michael Jackson's "Billie Jean is not my lover/she's just a girl"...blah, blah, blah. Or the Saint of Long Island himself, Billy Joel, and his timeless classic "I love you just the way you are," a song written about his FIRST ex-wife. This station NEVER strayed from the "hits," playing them constantly, until the chosen medium of such radio stations, quarter-inch reel-to-reel tape, probably gave out from the strain, to be replaced by new versions.

Forbidden to wear a Walkman ("Regulations," said Mr. C.), I was getting stupider every moment I stayed there, being fully bombarded with every note of every overwrought, incredibly clichéd, throwaway piece of Tin Pan Alley tripe. Mr. C., despite my pleading, wouldn't change the station because "the ladies like it." That was it, end of discussion, you're outvoted, sit down, shut up, get used to it, learn to love it, and get with the program. So, on and on the torment went, placing me at the brittle edge of sanity. I was trapped like a bug under a glass, until eventually I began to find ways to leave early or not come in at all, creating ever more brazen excuses.

Once, I had a friend's girlfriend call Mr. C., saying she was from my dentist's office and I was missing a very crucial root canal appointment. Committed to her role, she even played dental-office muzak in the background, to heighten the illusion. Each time I gave him the slip, Mr. C.'s head would shake in wider and wider arcs, the disbelief finding it increasingly difficult not to register on his face. My lying in search of release eventually became an art form. Finally, my own personal "Guernica" came one fine autumn day when I realized I was just over the mark needed to collect unemployment. Clearly, drastic steps were needed to be free of Vector Research.

Sometime during lunch, I went out to my car, climbed into the passenger's side, and pulled from my glove compartment a secret stash of Vampire's Blood (fake blood, sold in toothpaste-size tubes around Halloween, in finer convenience stores everywhere). I squirted some into my hands and rubbed my hands on my nose. Then I spurted a little into my right nostril, untied my right shoelace and walked back inside to tell Mr. C. one of the most bald-faced lies I've ever spoken with a straight face. With my right hand cupped over my nose, I said, "I was headed out to my car to get some lunch and I tripped over my shoelace and landed on my nose." Mr. C. said, "Let me see. Tilt your head back." He looked up my nostril, handed me a tissue and said, "Keep your head tilted back. You'll be okay in no time."

I thought, "No, you schmuck... send me home! Please, for God's sake, send me home before I go berserk and kill you all with your own radio. Please make the bad music stop or there'll be more than Vampire Blood flowing at Vector Research!" But he wasn't getting the mental message I was sending. So I finally had to tell him what I wanted: "Mr. C., can I go home and lie down? I don't feel so good." Mr. C. said, "Fine. But if you go home now, don't come back."

I don't think it was because he saw through my little charade, but because he probably felt I was just too frail to be an effective employee, what with the upset stomachs, the rotting teeth, the killer headaches, and now bloody noses. I was already planning even more outrageous excuses for the future, as I wanted to push the envelope of unbelievable lies until I could believably pin my four-hour post-lunch disappearance on an alien abduction.

Sensing I had achieved my personal best, I handed Mr. C. the "blood"-soaked tissue, collected my lunch bag and coat, stepped out into the brilliant midday sunshine, climbed into my car, popped a Black Flag cassette into the tape deck, and floored it home, singing all the way.

I don't listen to other people's radio stations anymore.

# Credits